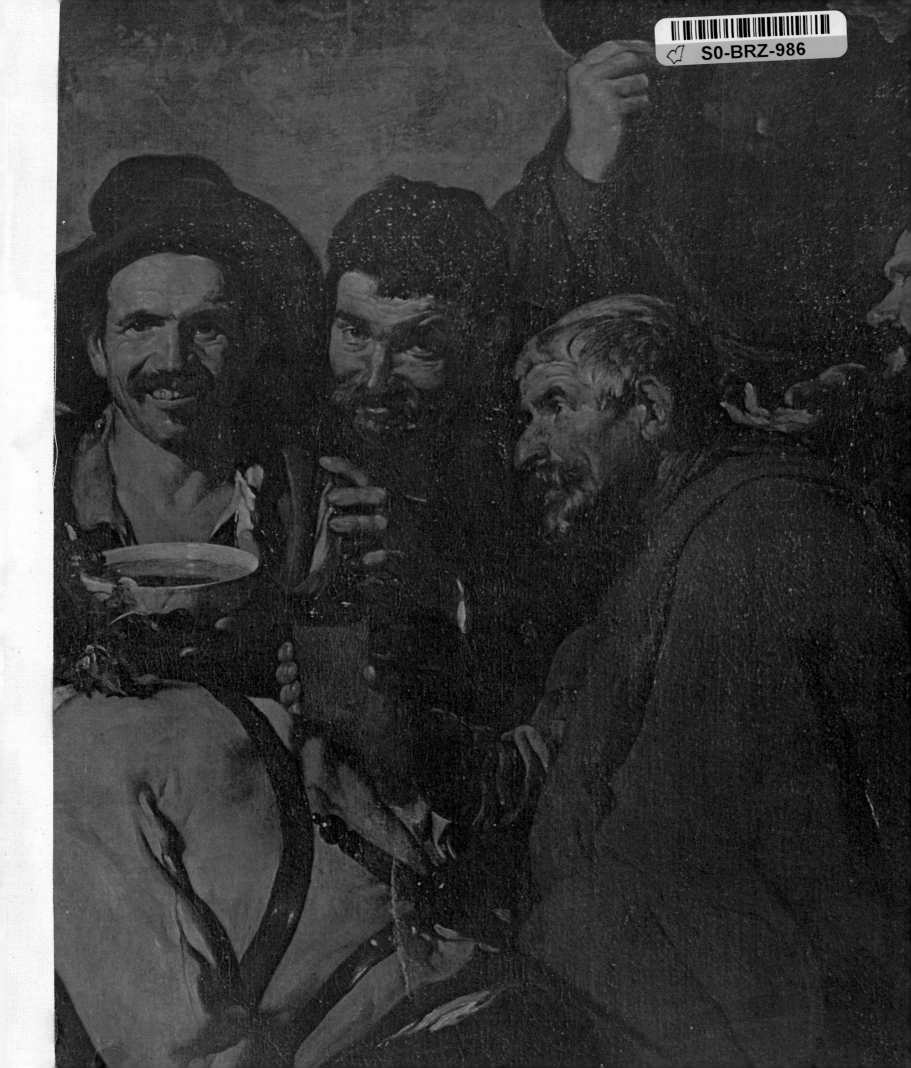

VELÁZQUEZ

VELÁZQUEZ

1599-1660

BY

JOSÉ GUDIOL

TRANSLATED FROM THE SPANISH BY
KENNETH LYONS

A STUDIO BOOK
THE VIKING PRESS
NEW YORK

© Ediciones Polígrafa, S. A. - 1973

English language translation Copyright © 1974
by Ediciones Polígrafa, S. A.

Published in 1974 by The Viking Press, Inc.
625 Madison Avenue, New York, N. Y. 10022

SBN 670-74394-1
Library of Congress catalog card number: 74-7000

Printed and bound in Spain by La Poligrafa, S. A. - Balmes, 54 - Barcelona-7 Spain - Dep. Legal: B. 36.709- 1974

CONTENTS

PROLOGUE

Velázquez's bibliography begins in the painter's own lifetime, with the pages devoted to his work by his master and father-in-law, Francisco Pacheco, in *El Arte de la Pintura*, and continues with the lengthy biographical sketch in Palomino's *Museo Pictórico* (1715-24). The historico-analytical studies began with the first attempt at a catalogue, in Curtis's *Velázquez and Murillo* (1883), which was soon followed by Cruzada Villamil's *Anales* in 1885 and Justi's *Diego Velázquez und sein Jahrhundert,* first published in 1888. In the present century innumerable monographs and studies, some of them of the first importance, have contributed to the historical and analytical reconstruction of Velázquez's life and work. Particularly worth mentioning are those by Angulo Iñiguez, Azcárate, Camón Aznar, María Luisa Caturla, Gaya Nuño, Lafuente Ferrari, Pantorba, Pita Andrade, de Salas, Sánchez Cantón and Trapier.

The first *catalogue raisonné* of Velázquez's work was published in 1936 by Mayer, who accomplished the considerable task of bringing together the data collected by his predecessors and adding an analytical study of the 600 works he considered to be originals, from the painter's workshop, or by his imitators. The second was compiled by López-Rey in 1963 and dealt with 130 works which this author considered original Velázquez's and a further 420 attributed to the painter by earlier authors. In the same year Gaya Nuño published his excellent "Critical and anthological bibliography", with its incisive commentaries. But there has been no end to discoveries and writings on the subject, and now it is very difficult to keep up with everything published. My own bibliography consists of the books and other texts consulted when preparing this book. The indispensable publications for the study of each work are quoted in the corresponding section of the catalogue.

This book includes all the paintings and drawings that I consider to be by Velázquez himself, some which were executed in his workshop – only partly by him – and, finally, others which may be copies of lost originals and were also painted in the master's workshop. All of these works have been studied in the original — an assertion not made in order to boast of all the travelling this has meant, but rather to make it clear that the work has been undertaken with a most sincere regard for authenticity. As regards the principles followed in structuring the book, instead of dividing my text into three parts – the artist's biography, the analysis of his works and the general considerations arising out of his work – I have preferred to blend these into one, since I believe there is a very close relationship between Velázquez's life and his work, bearing in mind the very different places in which he painted and all the contacts and journeys he made.

To synthesize Velázquez's development, giving a thorough account of his innovations in technique and pictorial concepts, is all but impossible; but what we can do is indicate the various stages – or, rather, the decisive moments – of his career. Velázquez was always a baroque artist, but one who succeeded in retaining and even strengthening certain classical elements. Conversely, it might also be said that Velázquez was a great classical artist, simultaneously inspired by reality and by the principles of baroque art, to the evolution of which he contributed greatly. Though his career, if studied properly and in detail, can – and even should – be divided into many different phases, there are three

moments that are really basic to his development. The first is the period between 1618 and 1622, when he was still living in Seville. For while the *Old Woman Frying Eggs* shows a tendency to noticeably realistic frieze-like composition, though tone already predominates over colour and the form is closed and dense, *The Water-seller* has a gradation of tones progressively merging into the penumbra, so that the figure which is enveloped in shadows hardly possesses any pictorial reality, an example of the technical virtuosity that was to culminate thirty-four years later in *The Maids of Honour*.

After an important transitional work – *The Topers*, paid for in 1629 – we come to the second of these moments in Velázquez's development: the works done in 1634 and 1635. This period, which confirms the artist's maturity, is marked by formidable figures in grandiose outdoor settings, much more open in form than in the preceding phase and with a much richer range of colours. Though the frieze composition in successive parallel planes is maintained in *The Surrender of Breda*, the oblique axis, with its tendency to give life to the third dimension, is intensely present in the equestrian portraits of the Count-Duke of Olivares and Prince Baltasar Carlos. Also at this time we find, as a consequence of the open form and of a deeper understanding of the mutual relationship between light and colour, a tendency to eliminate linear elements and replace them with the effect of a mass which seems to be imprecisely modelled, but in the exact complexity of which the eye can infallibly reconstruct the form.

The third essential "moment" in Velázquez's career is to be found in the works of the last ten years of his life, works which represent the perfecting of all he had hitherto achieved. Their most important characteristic is the use of different techniques in one and the same picture, with *sfumati*, apparently arbitrary strokes, scumblings and clots of paint, which only reveal themselves to a meticulously objective analysis, for at first sight the work as a whole is one of grandiose unity: each of these techniques is in strict correspondence with the degree of distance and illumination of the part of the composition in which it is used. This is more evident in *The Maids of Honour* (1656) than in any other work.

To conclude this brief prologue, I should like to say something of the principles I have followed in accepting or rejecting the attributions of works to Velázquez. Really, we cannot speak here of theoretical norms or, indeed, of any premises other than those established by an analytical method of study, perfected over many years, with the help of the excellent collection of photographs in the Instituto Amatller. This is the only way in which we can gradually reach a total understanding and conviction of what the artist's work was like at each stage of his career. There are two essential factors: that of style and that of the quality of each individual work. The first helps us to identify the works of each period; but this would not suffice to determine with certainty whether they are by the master himself or by his assistants, who copied his work with incredible fidelity. It is then that the factor of quality comes into play, for the cleverest of pupils or copyists will never attain to the greatness of the genius with whom he works. And so by combining these two factors, based on constant examination and analysis of the painter's works, an affirmative or negative decision can finally be reached. I do not pretend to have arrived at any incontrovertible results, nor do I believe that my conclusions will be totally valid in the future; but if in this book I have succeeded in taking the study of Velázquez one step further, I will consider myself amply rewarded, bearing in mind the enormous difficulties of this task. It only remains for me to express my gratitude for the facilities given me by institutions, museums and collections in Europe and America for the study and reproduction of the works in this book.

I

VELAZQUEZ IN SEVILLE

1599-1623

THE RODRIGUEZ DE SILVA AND VELAZQUEZ DE BUENROSTRO FAMILIES. – CHILDHOOD AND APPRENTICESHIP TO FRANCISCO PACHECO. – VELAZQUEZ'S PARTICIPATION IN THE WORK OF PACHECO. – 1617. VELAZQUEZ MASTER PAINTER. – 1622. FIRST VISIT TO MADRID. – WORKS OF THE APPRENTICESHIP PERIOD. – FIRST *BODEGONES*. PASSAGES FROM PACHECO AND PALOMINO. – *BODEGONES* PAINTED IN 1618. – *THE WATER-SELLER OF SEVILLE*. – CONSIDERATIONS PROMPTED BY THE STUDY OF VELAZQUEZ'S *BODEGONES*. – WORKS PAINTED BEFORE 1619. – WORKS DATED IN 1619 AND 1620. – WORKS PAINTED AFTER 1619. – THE LAST CANVASES OF THE SEVILLIAN PERIOD. – PORTRAITS.

At the start of the proceedings instituted in Madrid in 1658 for Velázquez's entry into the Order of St. James, the painter declared that his parents, Juan Rodríguez de Silva and Jerónima Velázquez de Buenrostro, were natives of the city of Seville and that his paternal grandparents were from Oporto, in the kingdom of Portugal. During the same proceedings Alonso Cano declared that he had known Velázquez's parents since 1614 and that "he considered them, and knew them to be considered, as noble gentlefolk by blood... who had never engaged in any low, base or mechanical calling". According to Palomino, the Silvas "descended from the most noble family of the Silvas, whose surname came to them from Silvius, posthumous son of Aeneas Silvius, King of Alvalonga".

Velázquez's parents were married on December 28th 1597 and made their home in a house in the Calle de la Gorgoja in Seville. In this house the painter was born, the first of their eight children; he was christened in the parish church of San Pedro on June 6th 1599. Rodríguez de Silva was probably a fairly well-to-do man, though once Velázquez had really made his name in Madrid he obtained certain benefits for his father from the King. According to

Pacheco, "in seven years he has given his father three secretaryships... each of them worth a thousand ducats a year". He was still living in Seville in 1638 and the date of his death is unknown.

Despite the ancient nobility of the name Silva, even as a child the painter used his maternal surname, Velázquez. The articles of his apprenticeship to the painter Francisco Pacheco begin with the following words: "I, Juan Rodríguez, resident in this city of Seville, being the legitimate father and administrator of the person and property of Diego Velázquez, my son...". In the minutes of his professional examination the young painter signs himself "Diego Velázquez de Silva", while in his marriage certificate he figures simply as Diego Velázquez and he continued to use this latter style in all the documents of his remaining years in Seville and in his appointment as one of the "Royal Painters", which is dated in Madrid on October 6th 1623.

Thus his maternal surname definitively became the great painter's official designation. In Madrid he was always referred to by the more popular title of "the Sevillian". The reintegration of the surname Silva came in 1650, with the portrait of Pope Innocent X, which is rather magniloquently signed *Diego*

de Silva Velázquez de la Camera di S. Mt^a. Catt^{ca}. (Diego de Silva Velázquez, Court Painter to his Catholic Majesty). But this surname really acquired particular importance in the aforesaid proceedings for the granting to the painter of the habit of the Order of St. James and the subsequent official documents. It was a rather belated – and not very successful – fancy on the part of the painter in his efforts to enter the ranks of the aristocracy. We should be showing little understanding of human nature, however, if we refused to admit this frivolity as justifiable in the light of the scant attention the courtiers were to pay to his art. It was only natural for the painter to attempt to reach their level by some other means.

Childhood and apprenticeship to Francisco Pacheco

According to Palomino, Velázquez "applied himself to the study of literature and was superior to many men of his time in his knowledge of languages and philosophy". His parents "entrusted him to the care and teaching of Francisco Herrera, a stiff and not very pious man, but one of consummate taste in painting and other arts". This may be true, for we find in Velázquez's articles of apprenticeship to Francisco Pacheco, dated September 27th 1611, that the six years of training required by the rules of his guild were to be counted as having begun on December 1st 1610. This implies the recognition of a year's training in some other workshop. Many years later Herrera, or whoever it was that first put a brush into Velázquez's hand, was to claim the honour of having been the great painter's first teacher, for Pacheco complains of this in his "Arte de la Pintura", saying: "And since the honour of the teacher is greater than that of the father-in-law, it is only just that I should put down the pretensions of anybody who attempts to claim this glory and rob me of this crown of my latter years".

Little is known either of Pacheco's teaching methods or of the work done by Velázquez in his establishment, and it is a pity that the former should make so brief a reference to himself in his book: "... I abide by nature in everything; and if I could have my subject before me at every moment, not only for heads, nudes, hands and feet, but also for stuffs, silks and the rest, this would be best". Palomino tells us that Pacheco's house was "a gilded cage of art, the academy and school of the best minds in Seville, where Diego Velázquez lived happily engrossed in the constant exercise of drawing, that first element in painting and chief gateway to all art". These few lines give us an outline of the personality of that painter whose chief claim to fame in the history of Spanish painting rests on his having been Velázquez's teacher and father-in-law, on his "Arte de la Pintura", published in 1649, and on his "Book of Portraits", which shows the wide range of his connections and interests in the intellectual circles of his day. Considering this man's importance to our subject, it might be as well to give a brief account of his life and work.

Francisco Pacheco was born in Sanlúcar de Barrameda in 1564, into a family of sailors, but at an early age he began to study painting in Seville. He spent some time in Flanders, as the pupil of one Lucas de Here, a painter whose work has not yet been identified by historians. It was probably then that he acquired his mannerist and rather angular style, a style quite opposed to the baroque forms favoured by the School of Seville. His first work as a fully-fledged artist was the series of pictures painted between 1600 and 1602 for the Mercedarian monastery in Seville. These are works done in a style that was rather old-fashioned for his time, though with a tendency to the monumental in form. Rather than forming a part of the whole, each of the figures is an isolated element planted in the middle of a conventional landscape. The arrangement of figures, gestures and attitudes corresponds exactly to the narrative nature of the subject. Everything is determined in accordance with a linear system that defines the folds of cloaks and draperies rather stiffly, while pictorial values are reduced to a minimum. The modelling is soft enough, but it suffers from the systematic use of underdeveloped chiaroscuro, which he employs rather to solve problems.of detailing than to orchestrate the compositions. Nevertheless, there is a roundness of form and even, at times, a certain density which seem to herald the early work of Velázquez, allowing for the natural difference in quality

and the undeniable fact that each generation – in an ascendant period like the one in question – is predisposed from the start to improve on the advances made by its immediate predecessors, the men from whom it learns.

Like all basically conservative artists, Pacheco never really developed at all, though he lived long enough –80 years– to be a witness to the successes of Velázquez, as also to those of Zurbarán and Murillo, among others. He remained faithful all his life to the rather hieratic style that was typical, albeit with variations, of 16th-century Spanish painting, even though, as I have said, his style was very different from that of the other painters of his time in Seville.

Let us examine, by way of illustration, two works by Pacheco signed during the years when Velázquez was working with him: a *Crucifix* done in 1614 (*Fig. 1*) and *St. Sebastian nursed by St. Irene*, painted in 1616 (*Fig. 2*). There is a noticeable absence of spatial values in the hieratic and anachronistic formula used by the painter. Pacheco's work is abundant to the point of lavishness in dated paintings, but we do not know the dates of a certain number of paintings attributed to him in which the collaboration of other painters, presumably his pupils, is evident. In his later paintings more striking archaisms may be observed. A good example of this is an *Immaculate Conception* painted in 1638 (*Fig. 3*).

Undoubtedly Pacheco's vocation for teaching and interest in humanistic subjects distracted him from his actual painting, for which he had no outstanding talent anyway, and it is possible that he painted mainly as a way of earning his living, his real interests lying rather in the fields of literature and human contacts. This, apart from the fact that he never set himself any problems to solve in his painting, would explain his almost non-existent development –which does reveal, however, a certain transition from mannerism to realism, with the final relapse that I have just mentioned.

That Pacheco was a good portraitist is proved by the series of drawings contained in the "Book of Portraits", now in the Museo Lázaro Galdiano in Madrid, which was patiently compiled over the years, from 1599 until his death. There are also some portraits extant which he painted in oils on wood or canvas, outstanding among them being the one here published (*Fig. 4*), which figured as the effigy of a donor on the predella of an altar-piece from the Alms-house of San Fernando in Seville.

Velázquez's participation in the work of Pacheco

"Team-work" in painting, so firmly established in Spain throughout the Middle Ages, also survived into slightly more recent times, though the new dimension assigned to the personality by the humanists of the Renaissance gave rise to an individualism that was hardly compatible with such collaboration. But this was, of course, a question of personal psychology and circumstances. Velázquez, who was undoubtedly a precocious artist, was to make an effective contribution to his master's work from the very beginning of his apprenticeship and naturally his participation in this work is perceptible. Unfortunately, no analytical study has yet been made of the paintings of Pacheco; and it would be a difficult task, since most of those extant are covered with dust, with old varnishes and sometimes with repaintings.

I think it is of interest to mention, as a working hypothesis, some of the paintings considered to be by Pacheco in which I believe Velázquez's hand can be detected. First of all, an oil painting on canvas representing the *Crowning with thorns* (*Fig. 5*) in the Museum of Seville, which was part of an altar-piece painted by Pacheco for the convent of the Dominican Passionist nuns in Seville and has suffered considerable repainting; it has the colourless, opaque quality of many old, neglected paintings, but under a powerful light we can see a head of Christ, feet and bound hands that are of a quality never achieved by Pacheco even in his finest works, apart from the fact that these details do not show the slightest sign of the geometrizing that defines that painter's style. On the contrary, in fact, we can already find signs here of the young Velázquez's characteristic way of representing form by painting the reflections of the light that falls on it, which suggests the substance perfectly. Other works almost certainly the result of collaboration between Velázquez and his master are the portraits of a couple and a woman in attitudes of prayer (*Figs. 6 & 7*), which are now in a collection in Granada and

which figured in the exhibition entitled "Velázquez y lo velazqueño" held in Madrid in 1960. In these canvases the modelling of the man's face is conventional, while those of the women in both pictures are treated with a depth and intensity which Pacheco could never reach. The impasto of the modelling is solid and the brushwork very firm, two features that were to be characteristic of Velázquez in his earliest period. In my opinion the hands of the figures in the double portrait are also the work of Velázquez.

It is undeniable that in the study of a painter's life and work – and the more meticulous the study the more this is the case – there are always a great number of questions that will go largely unanswered. Velázquez very probably began to work on his own account, with permission from Pacheco, in his spare time. This must have been an established rule in the religious painters' workshops of the time, for it figures expressly in Zurbarán's articles of apprenticeship, dated in Seville in January 1614. I mention this because I am convinced that some of the first paintings studied in the following pages were wholly the work of Velázquez during the final stages of his apprenticeship. The following paragraph from the "Arte de la Pintura" refers to the studies done by Velázquez on his own account at that time: "Diego Velázquez de Silva, while still a boy, had a little apprentice lad from the country in his pay whom he used as a model in different poses and attitudes: crying, laughing and in all the most difficult postures. And he drew many heads of this boy in charcoal and with high lights, on blue paper, and many other such studies from life, which gave him great accuracy in portraiture".

1617. Velázquez master painter

When the six years of apprenticeship were up, Velázquez applied to the Painters' Guild for permission to take his official examination. Before the "supervising judges", Francisco Pacheco and Juan de Uceda, he demonstrated his skill "through the works he carried out with his hands before the said judges" and "gave satisfactory answers to all the questions

they asked him... swore by God and the Cross that... he will observe the ordinances established by the master painters of this city". He was then granted his Diploma, dated March 14th 1617, with which "he obtained licence and permission to practise the said art in the city and the kingdom, to establish a public shop and to have assistants and apprentices".

And this he was to do, as we can see from the good number of extant works from this period, which are certainly more eloquent than the scant information we possess about the great painter's life in his younger days. He soon established his own workshop, but without losing contact with his teacher. On April 23rd 1618, before reaching his nineteenth birthday, he was married to Juana Pacheco Miranda, who had been born on June 1st 1602. It should be mentioned that Pacheco's daughter brought him a dowry consisting of some houses in Seville and 500 ducats. Two daughters were born of this union, the first christened Francisca, on May 18th 1619, and the second Ignacia, on January 29th 1621, but the latter died at a very early age, though the exact date of her death is unknown.

The only piece of information we have regarding the internal organization of Velázquez's first workshop is the execution, on February 1st 1620, of articles of apprenticeship in the name of Diego Melgar, a boy of thirteen or fourteen of whom nothing else is known. Apart from these articles there are the leases executed by Velázquez on the occasion of changes in the tenancy of the houses Juana Pacheco brought him as part of her dowry and his signature on the contract for an altar-piece that Pacheco had been commissioned to paint for the parish church of San Lorenzo in Seville. Not a single document refers to his practice of his profession in Seville during the six years between his admission into the Guild of St. Luke and his settling in Madrid. Needless to say, this is a most regrettable lacuna, and one that can only partly be filled with justifiable hypotheses.

1622. First visit to Madrid

In April 1622, at the age of twenty-three, Velázquez visited Madrid for the first time, probably

encouraged by Pacheco, who had good friends at Court and knew that his young son-in-law – as to whose gifts he would have been in no doubt – could succeed in having a very different career in art from his own. King Philip, born in 1605, had then been reigning for one year and Don Gaspar de Guzmán, Conde de Sanlúcar, his former tutor, was then beginning his long career as the King's favourite and gradually becoming the real political ruler of the country. Of Andalusian stock himself, he surrounded himself with people from the south. I think it might be of interest here to quote Pacheco's reference, in his "Arte de la Pintura", to Velázquez's first visit to Madrid: "Wishing to see the Escorial, he left Seville for Madrid in the month of April 1622. He was very well entertained by the brothers Don Luis and Don Melchior de Alcázar, and also most particularly by Don Juan de Fonseca, His Majesty's palace chaplain, who is an admirer of his painting. At my instance, he painted a portrait of Don Luis de Góngora, which was much admired in Madrid, but on this occasion he was not given an opportunity of painting portraits of the King and Queen, though he did obtain permission for this".

We do not know how long this visit lasted, probably no more than about two months, but Velázquez was able to visit the Alcázar and the palaces of El Pardo and Aranjuez. Juan de Fonseca, a canon of Seville Cathedral who was also a writer on art and a collector, was Velázquez's first protector in Madrid. He was a friend of Pacheco's and a leading member of the Andalusian clique that had formed around the all-powerful Don Gaspar de Guzmán, the future Duke of Olivares (a title he was to be given in 1626) and a very important figure in Velázquez's life. In speaking of him in these pages I will use the composite title of Count-Duke of Olivares by which he has passed into history.

Velázquez probably went home to Seville with the firm intention of returning to the capital at the earliest opportunity – which was not long in coming. Although there was quite a good school of painters in Seville at that time, thanks to the prosperity created by the trade with America, still Madrid obviously seemed to him a richer and more aristocratic world, a world to which the young painter would feel drawn by temperament and, above all, by the opportunity of furthering his acquaintance with the important Royal Collection.

* * *

The total absence of documentary references to any works done by Velázquez in Seville – and the lack of precision in the texts of Pacheco and Palomino – made the task of analytical research a really difficult one for early historians, since practically all they had to go on were attributions handed down by word of mouth. The number of paintings assigned to the great painter's early career gradually grew and, with more or less felicitous additions and suppressions, had become quite considerable by the time Justi's book appeared in 1888. Nor has the problem grown any simpler with the new discoveries made in the present century: the signed and dated portraits of *Jerónima de la Fuente,* the monogrammed canvases *The Virgin Mary (Magnificat)* and *Portrait of Suárez de Ribera* and the date 1618 on the *Old Woman Frying Eggs,* in the National Gallery of Scotland. These works, together with the *Epiphany* in the Prado, dated in 1619, and the portrait of Góngora done in 1622 on the occasion of the painter's first visit to Madrid, provide us with firm foundations for reviewing the old attributions and, at the same time, attempting a new chronological arrangement of the originals painted by Velázquez between 1615 and 1623.

Works of the apprenticeship period

I have already mentioned the fact that Velázquez was permitted some measure of freedom to paint on his own account during the closing stages of his long apprenticeship in Pacheco's workshop. This is a problem of analysis which has never yet been specifically stated and, though it is not possible here to discuss it at as great a length as one might wish, I should like to indicate a possible solution. From their affinity of concept with the paintings of Pache-

co, from their evident archaism and even from their slightly hesitant technique, I am convinced that at least two of these works were painted by Velázquez before 1617: *The Virgin Mary (Magnificat)* already referred to and *The Musicians* in the Staatliche Museen of Berlin. The first *(Fig. 8 - Cat. 1)* is a half-length image of the Blessed Virgin above the inscription MAGNIFICAT ANIMA MEA DOMINUM, which specifies its iconographical significance. It was Gómez Moreno who identified the monogram that can be seen on the lower of the two central scrolls in the frame of this inscription. He pointed out its similarity to the monograms with which Pacheco signed some of his works and determined how it should be read.

If we reconstruct the curve of the D and the lower stroke of the E, which have been partly worn away in the general deterioration of the lower part of the picture, we cannot fail to distinguish the outlines of the following capital letters: D V E L A Z. The little circle that ends the prolongation of the first descending stroke of the V is the Q, which continues the painter's name with the repetition of some of the other capitals: the V as U, the E and the Z. A similar monogram, though in a more simplified form, appears on another of Velázquez's canvases: the portrait of Cristóbal Suárez de Ribera, dated in 1620, which we shall be studying in the following pages *(page 27)*. The difficulty of reading the monogram on the "Magnificat" canvas led Martín de Soria to interpret it as that of Zurbarán, a mistaken interpretation which was later admitted by López-Rey. It is indeed true that there is a certain technical similarity between the earlier works of Zurbarán and those of Velázquez, who were separated by only a year's difference in age and were working as apprentices in Seville in the period now under consideration.

But the young Zurbarán, as may be seen in his *Immaculate Conception* dated in 1616 (now in the Valdés Collection in Bilbao), never achieved either the finer nuances of modelling, light and shade or the vibrant sensibility to be found in each and every element of the canvas we are now studying – or of Velázquez's other early works. The most notable characteristic of Zurbarán's first style is the accentuation of tonal contrasts by the repeated use of pure white, without much shading and with an almost schematic simplification of the half-tones. The white in the monogrammed "Magnificat", apart from its use as background to the inscription, merely helps to create a broad range of whitish tones in the clouds surrounding the figure of the Virgin. Her mantle, blue against a yellowish background, harmonizes beautifully with the crimson of her robe. This latter pigment, modelled with judicious admixtures of black and white, is one of the most constant and characteristic elements of Velázquez's palette throughout his career. The hands, too, confirm the paternity of this painting. In Zurbarán's work the hands are often modelled without much attention to half-tones or reflections, whereas in that of Velázquez both of these factors receive particular attention – and very noticeably so in this picture, which he may have painted at the age of sixteen; i.e., in 1615. In his pursuit of naturalism he studiously avoids any representation of detail, as we may see in the nails, which are suggested only by the tone, not by the line. The same synthesis is to be found in the face. This is the formula of Velázquez's first period, within which the painter was to advance in the direction of ever greater solidity.

The brushstrokes are not very heavy and the transitions are skilfully managed, while those strokes in which the hairs of the brush are noticeable help to accentuate the strength of the outlines. This technique, in which we can still detect the influence of Pacheco's conventional ideas, is very characteristic of Velázquez's first paintings.

Going by the various points it has in common with the "Magnificat" canvas, I believe that the second painting mentioned, representing a trio of musicians *(Fig. 9 - Cat. 2)*, was done long after the first. The composition makes use of rather naïve contrasts, mingled or juxtaposed with undeniably original elements. The left hand of the violinist and

certain areas in the clothing of the three figures are already of brilliant quality. The light, which comes from a single source, does not yet produce that rich gradation of tones that was soon to become an integral part of Velázquez's method, while the harshness of the facial features is still very noticeable, though this does not lessen their picturesqueness. There is some uncertainty in the spatial relationships between the figures and objects that go to make up the composition, a really ambitious one for a painter not yet eighteen years old. The more skilful technique in some of the objects – the plate with bread and a napkin, for instance – reflects the amount of constructive work put into apprentice exercises and preliminary studies in composition.

As in the case of the "Magnificat", this canvas gains enormously by being seen in the original, for the warm colour and the immediacy of the brushwork soften a certain harshness in the facial features and the rather arbitrary chiaroscuro, which are coldly betrayed in reproduction. The white napkin acts as a catalyst on the arrangement of the great masses of ochre which predominate over the general dark tone of the picture and the intensely black clothing of the musician seen in full face in the centre of the composition.

First bodegones. *Passages from Pacheco and Palomino*

The technique of *The Musicians* is continued without a break in another famous canvas, which represents two men eating at a table in an inn *(Fig. 10 - Cat. 3)*. And this work is the first in a series of pictures by Velázquez grouped under the general heading of *bodegones.* The word *bodegón,* which really means a modest establishment serving food and drink, has passed into Spanish art terminology as an equivalent of "still life" and into the universal language of art with a more restricted meaning. In the 17th century the term *bodegón* may possibly have been applied only to pictures showing one or more characters in a tavern interior. They would then have been considered as works of a minor art, despite the masterpieces produced in this *genre* both in the north of Europe and in Spain itself, where we have eloquent

examples in the famous paintings of Sánchez Cotán. In Seville and Madrid, at all events, this kind of subject - matter seems to have been rather looked down on by painters who had reached any position. According to Pacheco, "*bodegones* should be appreciated ... if they are painted as my son-in-law paints them, for he far outstrips all others in this field ... and they deserve the highest appreciation, for with these early works and his portraits ... he discovered the true imitations of nature". Pacheco, unfortunately, gives no further details, nor does he mention any specific work.

In his biography of Velázquez, Palomino quotes Pacheco's words and enlarges upon them in the following passage, which I consider interesting enough to be transcribed in its entirety:

"He had a fondness for painting – with most singular fantasy and notable genius – beasts, birds, fish and *bodegones,* which imitated nature perfectly, with beautiful landscapes and figures; different kinds of food and drink; fruit and other poor and humble trifles, with such audacity and such drawing and colouring that they seemed real; and he showed such skill in this, surpassing all others, that he achieved great fame and well-deserved appreciation for his works, among which we must not fail to mention the painting called the Water-seller; which is a picture of an old man, very badly dressed, in a torn and dirty smock that reveals his chest and belly, with scabs and horny calluses: and beside him he has a boy, to whom he is giving some water. And this work has become so famous that it has been kept till our own time in the Palace of El Buen Retiro.

Another painting he made of two poor men eating at a humble table, on which there are different earthenware beakers, oranges, bread and other things, the whole observed with rare diligence. Similar to this is another of an ill-dressed boy, with a cloth cap on his head, counting out money on a table and counting on the fingers of his left hand with particular care; and behind him there is a dog, sniffing at some sword-fish and other fish, like sardines, that are on the table; there is also a curly lettuce (the sort they call *cogollo* in Madrid) and a pot turned upsidedown; on the left there is a dresser with two shelves;

on the first there are some herrings and a loaf of Seville bread on a white cloth, on the second there are two china plates and a little earthenware oil-cruse with green glazing; and on this painting he put his name, although by now it is much worn away and effaced with time. Like this one there is another, where you can see a board, serving as a table, with a little brazier and on top of it a pot boiling, covered with a bowl, and you can see the fire, the flames and the sparks most vividly, a tin kettle, a jug, some plates and bowls, a glazed pitcher, a mortar with its pestle and a bulb of garlic beside it; and hanging from a spike in the wall can be seen a basket with a rag in it and other trifles; and guarding all this a boy with a jug in his hand and a kerchief on his head, whose terrible rags make him a very ludicrous, amusing subject.

In this tone were all the things done at that time by our Velázquez, to show himself to be different from others and follow new directions... Some reproached him for not painting, in smoothness and beauty, subjects of greater weight, in which he could rival Raphael of Urbino, and these he would answer wittily, saying: 'That he would rather be the first in that coarse work than the second in delicacy'."

The foregoing text identifies *The Water-seller of Seville* and *Two Men Eating,* both in the Wellington Museum, though its description of the former reveals suspicious discrepancies with regard to the clothing. The signed painting of the "boy and dog" and that of the "boiling pot" have both disappeared, but certainly the "sword-fish", the "loaf of bread", the "bulb of garlic", the "china plates", the "little earthenware oil-cruse with green glazing", the "brazier", the "mortar", the "glazed pitcher" and the "basket with a rag in it" are all to be found in the series of *bodegones* by Velázquez that we shall be studying in the following pages, arranged in hypothetical order as far as time is concerned. They form a very characteristic and homogeneous group, and one that is markedly different from true "still life", which constituted a specialist field of its own. And it should be admitted that many of the practitioners in this field devoted themselves to their limited *genre* rather because circumstances obliged them to than on account of any lack of ability, though the constant depicting of just one sector of visual reality — whether *bodegones,* landscapes or *genre* scenes with their conventional formulas — often impaired their early talents in the end.

At the beginning of his career Velázquez himself was obliged to paint works intended to please possible patrons. His extraordinary gifts led him to choose the field of *genre* subjects, so different from mere "still life", though to a large extent they belong to the same generic concept, for the inanimate objects in those paintings are treated with just as much care as the figures.

In my opinion the most archaic of the Velázquez *bodegones* is the one entitled *Two Men Eating*, which Fernando VII presented to the Duke of Wellington *(Fig. 10 - Cat. 3).* The distribution of the masses in the space and the opposition of two foreshortened figures are both very original and magnificently carried out. The colour range is still restrained, whites, ochres and blacks predominating, though green makes an appearance in some of the minor details. The rather hesitant technique and a certain lack of precision make it clear that this work was painted before the end of the artist's apprenticeship. There is a very evident difference between the technique of this canvas and that of the *Old Woman Frying Eggs,* dated in 1618 *(Figs. 16 & 17 – Cat. 8).*

In a collection in Italy there is a small canvas which is said to be a sketch for this picture, but I only know it from a photograph reproduced, without stating its provenance, in the "Archivo Español de Arte" (1945, page 257), and it would be rash to express an opinion without having studied the original. The variations between this possible sketch and the work in London, however, seem to favour the hypothesis. What can be seen of the technique in the photogravure reproduction does not prevent our attributing it to Velázquez, and it seems logical to suppose that the painter would have done sketches of his compositions before starting work on the definitive picture, at least in his earlier years. It is a great pity that lack of information should prevent us from studying the evidence — both interesting and problematic — of such a work as this sketch, for there are no sketches extant that can be attributed to Velázquez with absolute certainty.

The work entitled *The Maidservant* in the Chicago Art Institute *(Fig. 11 - Cat. 4)* reflects the young painter's rise in his profession. It shows a woman with thick, almost negroid features, standing behind a table with various metal and earthenware objects on it. Hanging from the wall on the right we can see a basket of plaited straw, which is remarkably well executed. In comparison with the earlier works we have already studied, there is an obvious use of the idea of rounded form as the clearest link between volume and space. There is also greater precision in the treatment of the light, which slants down from the upper left hand side, but from a point somewhat to the rear of the figure. As a result, most of the face is left in deep shadow, an effect which is the starting-point for Velázquez's peculiar treatment of certain figures, which he envelops in varying degrees of shadow, so that the features range from total definition to maximum vagueness — a concept wholly in line with the baroque aesthetic, some of the principles of which he developed to an unequalled degree, though others he dispensed with entirely.

The technique of *The Maidservant* is the same as that used in the preceding canvases, but simpler. The brushwork concentrates more on plastic values, which reflects his greater mastery of form. There is also an appreciable refinement of the composition, though Velázquez's realism, throughout his Sevillian period particularly, was always to retain a certain popular feeling. The young man who was to be the most elegant of all baroque painters always based his work on strictly artistic standards and thus, as we shall see later on, reached heights of refinement that extended to his subject-matter as much as to his technique and concept.

In most books on Velázquez two *bodegones* of very similar characteristics *(Figs. 12 & 13 - Cat. 5 & 7)* are generally placed at the head of his early works. They have been given various titles, from among which I have chosen *The Luncheon,* as being the most widely accepted, though perhaps "Waiting for Luncheon" would be more suitable, since we see two men, one old and the other young, sitting at a table covered with a white cloth, with just a few objects on it. The older man, with his greying beard, figures in both compositions: in the picture in the Hermitage he is shown eating a kind of turnip, while in the Budapest version his right hand is extended to take the wine-glass that is being filled by a girl, the third figure in the composition.

His younger companion is different in the two pictures, though his clothing and the gesture of his right hand are essentially the same. But what does vary radically is the central figure: the smiling boy of the canvas in the Hermitage has been replaced in the Budapest version by a young serving-wench. Also different in the two compositions are the few and frugal elements on the table. The three figures in the first canvas stand out against a wall parallel to the background of the composition, from which hang a felt hat, a detachable collar of white linen and a typical sword of the period. In the second picture the figures contrast with a dark, indeterminate background, without any details worth mentioning.

The last journey I made in preparing this book was to visit the museums of Leningrad and Budapest. The two canvases we are now considering were taken to the restoring workshop in each of these museums, where I was able to examine them at my leisure in excellent light.

The Hermitage *Luncheon* is in an excellent state of preservation, though its extraordinary beauty is dimmed as to colour and form by old varnishes and by some unnecessary retouching from past "restorations" *(Figs. 13 & 15 - Cat. 7)*. There is a very noticeable distance between this canvas and the others we have been studying, though if *The Maidservant (Fig. 11)* were not in such poor repair it might be seen to reach the same aesthetic and technical level, which leads me to consider these two works absolutely contemporary (1617 ?). The technique is essentially the same as in the other canvases studied. The brushstrokes are still fine, with alternating light touches and absolute clarity in everything. The palette is rather austere in the larger areas, but is very finely nuanced with slight touches of bright colours, which give a new vivacity to Velázquez's pictorial formula. This change, at first sight insignificant, enriches the light areas considerably. But it is impossible to judge the beauty of this picture without seeing the original from close at hand in a good light. The representation of air and atmos-

phere, which is one of Velázquez's greatest qualities, is completely successful here. Were it not for the fact that in the canvas dated in 1618 *(Fig. 16)*, which is studied below, we see the appearance of a new technique (and one that is confirmed and heightened in the 1619 *Epiphany (Fig. 27)*), it would be easy to believe that the Leningrad *Luncheon* was painted long after Velázquez qualified as a professional painter in 1617.

From the standpoint of the colour, though the ochre and chestnut range is still predominant, the details have been suffused by a new subtlety. Touches of red, softened with white or grey, give an extremely beautiful shade of pink to some of the details, like the tape that fastens the collar of the boy seen in full face or the goffered collar hanging on the wall. The skilful use of shadows, moreover, which darken the local colour, as may be seen in the orange-tinted ochre of the younger man's clothing, is quite perfect. The same clarity of vision and execution is to be found in the white table-cloth, with its grey, pink, yellowish and ochre tones, all blended together by the unifying strength of the white.

The feeling of space, above all, has been considerably heightened. The geometrical perspective created by the form of the table and by the table-cloth is further strengthened by the semi-darkness of the background, in contrast with the brightness of the foreground, particularly vivid in the younger man's face and right hand. Though the painter is not aiming at any psychological effect, I would say that he does show a certain interest in balancing the serenity and slight sadness of maturity — in the man on the left — against the spontaneous gaiety of youth. Velázquez, however, had little interest in symbolism and most probably painted the scene just as it presented itself by chance, limiting himself to choosing the angle of vision, the lighting and possibly the arrangement of the objects on the table, though these would also seem to have been placed where they are more or less by chance. In later years he was to continue working like this, though at times he did prepare the arrangement of the elements in his compositions.

Another exceptional achievement that should be mentioned, almost entirely obtained by textures and reflections of the light, is the contrast between the older man's clothing and the tone of the background wall, which are within the same range of dark chestnut with a violet tinge. The shading and reflections of light in the clothing create the necessary contrast, which is heightened by the man's flesh tints.

The little canvas entitled *Man's Head (Fig. 14 - Cat. 6)*, which is also in the Hermitage, is a work painted at exactly the same period as the canvas I have just been speaking of; contrary to what has hitherto been believed, however, it is not a complete study but a fragment taken from a larger canvas. The strength of the brushwork, the construction of the form and the sureness of execution are really surprising and prefigure the great achievements that were to crown the artist's first Sevillian period. There is a certain simplification of the living model, as in all Velázquez's other works of this period, which proves that from the very beginning the painter understood that the "subject" of a painting is one thing and the painting itself quite another, and that realism should not be a matter of meticulous description or facile illusionism, but rather a synthesis that to some extent exceeds reality.

In this little picture a series of brightly-coloured points, appearing in certain areas which have been affected by the rubbing inevitably suffered by paintings that have seen a lot of travelling over the centuries, indicate that this head was done over another painting. The charming Dr. Levina, who is the curator of the great Spanish collection in the Hermitage, tells me that X-rays have, in fact, revealed more precisely what exists beneath this male profile and that she is now preparing the publication of her discovery.

The *bodegón* in the Budapest Museum *(Fig. 12 - Cat. 5)* is a much deteriorated canvas, having been damaged in the past by lamentable repainting which a recent cleaning has not succeeded in eliminating. Little can now be seen of what the older man and the servant were like in their original form. The table and the objects on it do show some signs of having been painted by Velázquez, but the young painter's masterly brushwork is no longer evident in the present state of this work. The quality of the figure on the right, however, is quite good, though it has not entirely escaped the drastic repainting of the whole;

under the excellently rendered thumb of the man's right hand it is very easy to detect another finger in a vertical position, following the model of the almost identical hand of the younger man in the Hermitage *Luncheon*. The present state of this picture is really regrettable, for in its time it must have been a most important example of Velázquez's early work and a notable proof of the artist's astonishingly rapid development. At all events this painting must be appreciated for what it represents, since it really shows us what the complete canvas of the head in profile in the Hermitage *(Fig. 14)* must have been like.

Bodegones *painted in 1618*

The fundamental work in any study of Velázquez's *bodegones* is the *Old Woman Frying Eggs*, dated in 1618, which is one of the treasures of the National Gallery of Scotland *(Figs. 16 & 17 - Cat. 8)*. The image is rather like a relief in its solidity and its spatial relationships, which tend rather to unite than to dilate. The form is closed and dense and its details are studied with the strictest objectivity. The pigment, thick and flexible, follows the form closely and produces a very effective modelling, while the pictorial quality is so outstanding that it unquestionably dominates the subject-matter. In Velázquez's later works space, air and the subtleties of execution were to take pride of place, but in this canvas, painted at the age of nineteen, he paid more attention to tactile effects and the real qualities of objects than to colour. In his desire to show his powers in the field of a strict representation that would be more realistic than baroque, he shunned both a Caravaggio-like striving for effect and any sort of movement — intense, heroic or passionate. He already felt the attractions of serenity, but this calm cannot be mistaken for the traditional archaism still in force in the work of Pacheco.

Velázquez did not base his harmonies of colour on complementaries, but on very closely related chromatic consonances. Thus the reddish ochre of the old woman's dress is linked with the brighter red of the earthenware casserole in which she is frying the eggs, while the golden yellow of the mortar takes on a warmer tone in the copper pot on the left. By "floating" these simple consonances on the depths of a very dark background, against which the forms are powerfully modelled and accentuated by black contours, he achieves an effect of incomparable gravity and objectivity. This almost systematic use of outline, which cannot be found in any of his contemporaries of the Seville school, is a feature that reappears in other works by Velázquez, even in canvases of his last period, and one that is always surprisingly effective.

The colour range in this picture differs very little, in essentials, from that of the *bodegones* we have decided to consider as its chronological predecessors, but the nuances have become much richer. The fine canvas used in earlier works has been replaced by a linen of coarser weave also primed with *tierra de Sevilla,* a reddish earth colour, which shows through and influences the general tonality of the picture, particularly in the present state of the background, which, when the painting was finished, must have been almost black. The rubbing down of the black scumbling that covered the background makes the black outlining, which was done with very thick pigment, more visible today.

The figures and accessories were also done with very thick pigment. The modelling is very strong and the brushstrokes clearly visible, despite the many layers of working. By using heavy impasto in the lighter tones the painter was able to give considerable emphasis to the contrasts, which permitted him to use simple scumblings in the shadows. The woman's face is painted with the objectivity of a sculptor and very little idealization, but also with simplifications which are not seen at first glance. Of greater effect, in the roundness of the form and the vigorous chiaroscuro, is the face of the boy *(Fig. 17)*. In this picture we find once more some of the objects used in earlier *bodegones:* the glazed pitchers in green and white, the carafe of wine, the mortar and the basket hanging on the wall.

This work reflects a radical change from the technique of fluid pigment that characterized the earlier *bodegones*. It marks the beginning of a new pictorial concept, which was confirmed in the 1619 *Epiphany (Fig. 27)* and continued for several years,

gradually increasing the intensity of the luminous tones and the freedom and spontaneity of the brushwork. By and large we might say that in this painting Velázquez found an exact formula for separating light and shade which permitted him to work much faster. This technique of the constant superimposition of luminous tones done in thick pigment on shadows and half-lights previously laid in with fluid colour which barely covered the red priming of the canvas was not, of course, first discovered by the young Velázquez; but it may safely be said that nobody else attained to such tremendous mastery in it. In this technique it is the light rather than the shade that predominates. The most important factor is the precise determination of the luminous areas. In the half-tones the modelling is simplified, but in the really intense shadows it simply disappears. This is the beginning of that brilliant technique of Velázquez's, based on forms suggested rather than depicted, which was to culminate in *The Maids of Honour*. The palette is still reduced to a minimum, the colour blue being suppressed altogether.

The fact that this *bodegón,* of which there are no known replicas or old copies, was a first version is proved by the retouchings which reveal the considerable alterations made in the composition while the work was being painted. The most visible is the change in the position of the hand holding the spoon, slightly to the left of the centre.

According to MacLaren, the canvas in the National Gallery in London entitled *Jesus in the House of Martha and Mary (Figs. 18, 20 & 21 - Cat. 9)* bears very incomplete traces of the date, 1618. Thus we have another *bodegón* painted in the same year as the one just studied. Its title comes from the group of three figures in the light-filled panel on the right. López-Rey has pointed out that the seated Jesus raises his left hand as he speaks and that the young girl raises her left hand to support her head, from which he deduces that the little scene is intended to be an image reflected in a looking-glass. If this were so, we would have here a very early forerunner of the famous looking-glass in *The Maids of Honour*. But MacLaren — who supervised the cleaning of the painting – considers that the scene in question is

taking place in an adjoining room and is viewed through a window-opening. Other authorities hold it to be a painted canvas hanging in a room where an elderly woman is supervising the work of a young cook. According to the Gospel, it was Martha who prepared the meal offered to Jesus, while her sister listened to the divine word.

However that may be, and quite apart from its iconographical significance, this canvas reaffirms Velázquez's talent for balanced composition, a talent which is shown in this asymmetrically conceived picture by the unerring contrast of the empty space with the two figures, solid and human, on the left. Despite their summary execution, the little figures in the background are extremely vigorous. Rather than providing "a way out" of the enclosed setting of the whole, their aesthetic purpose seems to be that of creating a contrast with the total realism of the foreground: a table with one of the most wonderful still lifes ever painted. In conjunction with the limited colour range already discussed, the technique of firm, tight drawing and thick impasto, which characterizes this phase of Velázquez's work, here produces a really extraordinary work *(Fig. 21).*

The servant's head is on the same lines as that of the boy in the preceding work, but the modelling is made more effective by a progressive simplification of the texture *(Fig. 20)*. It is curious to observe how the modelling in this painting penetrates into the darker areas and achieves effects of incomparable precision. The focal point of the whole picture is really the plate of fish, which is outstanding both for the restraint of its colour and the realistic intensity of its modelling, to such an extent that it has no rivals in the whole history of Spanish still-life painting. The general range of this work, dominated by ochre, white and black, is enriched by the appearance of blue and crimson in the group of little figures. There are some signs of second thoughts: the girl's arm has been changed from its initial position and on the bare space of the background wall there are traces of the representation of something hanging, perhaps a basket as in some of the other works studied.

The development of Velázquez's technique as revealed in the series of *bodegones* induces me to give

a rather late date to the "Woman with a pewter jug and a loaf" (*The Maidservant*) which Martín de Soria discovered in an American collection *(Fig. 19 - Cat. 10)*, a work that is very similar to all the other *bodegones* we have been studying. The execution in thick pigment, with very vigorous brushwork, establishes a line of contact between this canvas and the two foregoing works. In the simplicity of the scheme, moreover, we can see one of the painter's tendencies at this later stage in the series of *bodegones*. Within the overall predominance of the volumes the extraordinary execution of the jug and the extremely delicate study of shadows, reflections and half-tones are sharply contrasted with the freer technique of the clothing and the superb modelling of the flesh tints. Several retouchings can be perceived in the lower part of the face and in the right arm, while the model herself seems to be the same one who was used for the young servant in *Jesus in the House of Martha and Mary (Fig. 20)*. The outlining in space and the placing of the subject are quite perfect and contribute greatly to the beauty of this work.

The Water-seller of Seville

This series of Velázquez's *bodegones* is rounded off by the justly famous *Water-seller of Seville (Figs. 22, 23 & 24 - Cat. 11)*. It is an extraordinary painting, the work that crowns a whole method and concept of representation. The advance over earlier paintings is enormous and the plastic achievement of depth is of unsurpassable mastery.

The penumbra created by the subordination of details and their replacement by a carefully managed scheme of diffused light contrasts with the inert objects in the foreground, in which realistic representation is taken to a simply unheard-of degree of naturalism.

In the two principal figures we have the technique already described: the intense modelling of luminous areas, superimposed on areas of shadow that are left as the merest suggestion of scumbling, here attains absolute perfection. And just the same perfection is achieved in the modelling of the space, of the actual voids and even of the air.

The colour range still comes from an extremely limited palette — it is hard to know whether this was a question of self-discipline, *esprit d'école* or personal taste — and in this case the white almost succeeds in predominating over the ochre. Black is still a decisive factor in the accentuation of tone and the gradation of depth.

In my opinion this canvas was painted by Velázquez shortly before he moved to Madrid. The incomparable nuances of the technique are the final result of the immense amount of work done between 1618 and 1622, as we shall see in the series of works studied in the following pages. I have placed this picture at the end of these *bodegones* with figures since it seems probable that it was, in fact, the last. Velázquez may have painted the canvas to take with him on his first visit to Madrid as a specimen of his work. At any rate a "Water-seller" by Velázquez is mentioned in the inventory of the estate of Juan de Fonseca, his first protector at the Court of Spain.

I think it would be advisable to reconsider here, along with the *bodegones,* a *Still Life* attributed to Velázquez which is in the Rijksmuseum in Amsterdam *(Fig. 25 - Cat. 12)*. It has never received the attention it deserves and has been unjustly neglected in recent studies. It would seem natural for the artist to have alternated *bodegones* properly so called with the painting of small compositions of inanimate objects, following a fashion which, at the beginning of the 17th century, had its most gifted Spanish practitioner in the person of Sánchez Cotán. The work in question is an intense but controlled piece of painting, in which the objects seem to be endowed with a mysterious force instead of a strikingly decorative effect, as is the case with so many still lifes of the period. I have little doubt that this work is an authentic Velázquez, as much because of the vigour and precision of the brushwork as for its concept and the similarity of its technique to that of the paintings described above.

An analytical study of the many still lifes painted in Spain during the 17th century will confirm this hypothesis and make any other attribution impossible. The dominant factor in this work is the basic realism imposed by the limiting of the colour range,

which gives noticeable precedence to the drawing and the pictorial material. The nearness of the objects and the intentional impression of relief indicate a comparatively late development in Velázquez's concept of representation. The light grey background, which enables him to strike a more dynamic balance between the blacks of the parts seen against the light and the brilliant whites of the plate and of the eggs in the foreground, is a considerable innovation in tone. This is certainly a work from his Sevillian period and was probably painted in 1620 or thereabouts.

Considerations prompted by the study of Velázquez's bodegones

The problem of Velázquez's *bodegones* is much more far-reaching and complex than might be supposed from reading the foregoing pages. However unfamiliar he may be with the great painter's biography, the reader will surely have noticed the omission of a certain number of *bodegones* frequently published and even presented as prototypes. Most of these are really other versions of the canvases studied here, sometimes with very obvious variations. Others are different models, absolutely original works, but not works that can be indisputably attributed to Velázquez himself, despite the fact that they reflect the master's style with amazing fidelity. Some of them show a certain affinity to some of the subjects included in the list by Palomino transcribed above. They are certainly old works, some of them being attributed to Velázquez in the inventories of estates and collections formed before 1800.

In their respective catalogues of Velázquez's works, A. Mayer and López-Rey both made abundant references to these canvases. They are, indeed, of great interest and their analytical study may yet hold surprises in store. I find them a fascinating subject and one that may well help to solve the mystery of the work done by Velázquez in the last years of his apprenticeship and the first – very short – stage of his career as a professional painter.

I prefer not to give any more specific references, in order to leave intact the mystery surrounding a large number of canvases which really constitute a link between the young Velázquez and those as yet very little-known painters who went to make up the "School of Seville" in the early 17th century. This group of *bodegones* may one day lead us to the discovery that Velázquez began his career by setting up a workshop for the production of *bodegones* in which his models would be repeated under different aspects and with variations in the position and typology of some of the figures. These works would have been intended to attract possible new patrons and for the decoration of private houses. Though works of this kind – which must have been produced in enormous quantities – have been destroyed in their thousands over the years, enough remain to show us that the production of *bodegones,* still lifes, flower pieces and other such decorative works must have kept a great number of artists busy throughout the 17th century.

Another possibility, considering the number of "Velázquez" *bodegones* in existence, is that the painter's original models were much copied and plagiarized after the move to Madrid in 1623, which interrupted his direct contacts with Seville.

An implicit rider to all the foregoing is the fact that some of the *bodegones* not included in my catalogue possess too many of Velázquez's characteristics to be categorically rejected as works the painter may have done during his Sevillian period; but there are also some features — and even, at times, an obvious inferiority to the works we have been studying — which make it impossible to affirm that they are really by him.

Works painted before 1619

Let us now turn our attention to a group of works which, judging by their technique, may well have been painted shortly before the 1619 *Epiphany* studied in the following pages. The first, in the Museo Lázaro Galdiano in Madrid, is a *Woman's Head* which may be either a small portrait or simply a study for a more important composition *(Fig. 26 - Cat. 13)*. The most appealing feature of this simple painting is the restrained, severe sensuousness of the paint. Various lines in different tones are superimposed to create a proper transition at the base of the neck; but

the profile is outlined quite cleanly, though without any harshness, against the black background.

It is with absolute conviction that I have also included in my catalogue the *Job* in the Chicago Art Institute, which was attributed to Zurbarán when it hung in the Spanish Gallery of Louis Philippe of France *(Fig. 30 - Cat. 14)*. Against a dark background, unrelieved by details except for an inscription and two pieces of material, the seated figure of this archetype of human patience is presented in profile. The extremely powerful lighting produces very rigorous alternations in the chiaroscuro which make the silhouette a secondary factor, and there is an evident desire to emphasize the contrast between dazzlingly bright patches and areas of impenetrable darkness, with half-tones that demand an effort of the imagination to reconstruct the form. Velázquez had already attempted this sort of thing in minor background details of his *bodegones*, as may be seen in the sword hanging on the wall in the Hermitage *Luncheon,* for instance; but in this *Job* the effect is accentuated and generalized. I think this was an attempt at simplifying the form by endowing it with areas that are barely suggested.

These experiments with lighting attain greater complexity and refinement in another work painted at this time: a figure of *St. Francis*, praying before a skull and with a cross in his hand *(Fig. 34 - Cat. 15)*. The body is silhouetted against a rocky background, with open landscape to left and right. The evening cloud effects give a poetic beauty to the whole, as do the tendrils of ivy traditional in this type of iconography. The skull in the foreground gleams horridly forth from the deeply blended shadows, with the light coming from behind the viewer and vigorously modelling the magnificent grey of the saint's habit. Human rather than emotive qualities are predominant in the face, as is the case in the vast majority of Velázquez's religious paintings.

Works dated in 1619 and 1620

A second stage in Velázquez's work begins with a group of four dated canvases which, by their quality and the fact that they were specially commissioned, reveal that the young painter was by then considered one of the leading artists of Seville. These canvases are the *Epiphany* in the Prado (1619), the portrait of *Cristóbal Suárez de Ribera* in the Museo de Pintura of Seville (monogrammed and dated in 1620) and the portrait of *Jerónima de la Fuente* in the Prado (signed "Diego Velázquez, f. en 1620"), of which two replicas exist, one in the Fernández de Araoz Collection in Madrid and the other in the collection of Sir William Fitzherbert in Derbyshire. They all show a concept and technique that are essentially the same as those of the two 1618 *bodegones,* but here they are taken to an extraordinary degree of sureness and maturity. This sureness, indeed, is possibly their most outstanding quality, apart from the virtuosity expended in the cause of simplicity, an innate characteristic that Velázquez was never to lose. The instinctive humanism here is that of a wholly formed personality which, though still capable of rich and wide-ranging development, never abandons the principles of sensibility and perfection in drawing, monumental (but not exaggerated or "heroic") form and solidity in that form. In these three compositions tone is more important than colour, but all three possess original chromatic harmonies that are at once sumptuous and spiritual, bold and well-disciplined.

Velázquez skilfully solves the problem of composition in the *Epiphany* through his arrangement of the lights and a proper appraisal of the qualities of his materials *(Figs. 27, 28 & 29 - Cat. 16)*. He places the scene against a wall plunged in darkness, an opening on the left revealing a distant landscape with vivid effects of evening light. The painter clearly wishes to neutralize the setting as much as possible and concentrate on the figures. In the foreground we see one of the Magi kneeling to offer his gift to the Child Jesus, sitting up very straight in the Virgin's lap, and a heap of stones with a blackberry bush and another wild plant growing among them. The blackberry bush, wonderfully realistic, is highlighted by the direct impact of the rays of light. Some of its branches and the whole of the other plant are left in shadow against the luminous riser of the high step that separates the foreground from the middle distance.

To give greater emphasis to the middle distance than to the foreground, Velázquez made white the

dominant colour in the Child's clothing and the Virgin's ample shawl. As in other works of his, the lighting is apparently naturalistic, though of a rather arbitrary character. In front of the Magi and their young attendant we see the three members of the Holy Family with dazzling clarity, touched by the slanting rays of the sun. Their features are largely left in a penumbra that is magnificently modelled with half-tones, a lighting effect previously attempted in the Hermitage *Luncheon* and other youthful works.

Velázquez makes no perceptible effort to give his characters any mystical significance, though he does endow them with a definite feeling of grace and inner majesty. We shall never know whether this lack of manifest emotionalism was that of a faith so integral and absolute that it rejected the least hint of spiritual "exaltation" or whether, on the contrary, it denotes lack of interest in the content of the theme. Since 17th-century society paid little or no attention to the vast majority of artists, there is no way of discovering something that might be of great importance: Velázquez's feeling with regard to religious questions. All that can be said by way of hypothesis is that he was, above all, a very human artist, who always sought to capture the reality of his sitter, whether buffoon or nobleman, and never did much to idealize the models he used for the figures in his religious paintings. But it might as well be admitted, here and now, that we know nothing of the painter's ideology, of his opinions on any subject whatsoever. All we have is his work, which gives us very little to go on with any certainty; the more so since it tended to deal with the external and objective rather than with the personal or subjective.

In the *Epiphany* the pigment is dense, but without any harshness; very plastic, in fact. The kneeling figure in the foreground gives Velázquez the chance to create one of those amazing combinations of material and colour that were to distinguish his work all his life, in the densely-painted ochre mantle and the blue robe that varnishing has turned greenish. Something new in his palette is the vivid red of Balthazar's mantle, while crimson makes a reappearance, this time splendidly offset with white and black. As can be seen, colour is of greater importance in this painting than in the *Old Woman Frying Eggs,* but tonal contrast still prevails. Predominant in the work are the intense modelling, the closed form and the growing importance of rhythm.

The impact of Caravaggio is evident, though Velázquez never used chiaroscuro in the same way as his greatest Italian contemporaries or predecessors. Not only did he always try to avoid the theatrical effects produced by absolute contrasts of light and shade; he also rejected the use of physical darkness as a "synonym" of mystery. Tonal contrasts for him were simply a technical means that he used consistently and vigorously to give life to the form, and nothing else. From the very beginning of his career he made the subject-matter serve the painting, but this does not imply any attempt at "art for art's sake", since a sense of balance was probably his most constant and deeply-ingrained characteristic.

Nor was his painting a mere tool of psychology or of any kind of striving for effect. In his art we find a serene severity that is neither tormented nor even ascetic, a natural approach to reality and a profound interest in the means used for solving each pictorial problem that arose in the course of his various periods of development.

In the *Epiphany* the date 1619 is clearly traced in black on the step that forms a base for the seated figure of the Blessed Virgin. When Velázquez painted this picture, therefore, he was twenty years old and had already reached the highest point of the first stage in his career.

There is a similar absence of detailed setting in the portrait of the nun *Jerónima de la Fuente,* painted when she was in Seville on her way to the Philippines, between the first and the tenth of June 1620 *(Figs. 31 & 32 - Cat. 17, 18 & 19).* This picture shows us a mature woman, whose face bears the traces of great struggles, material and spiritual. Eloquent clues to her character are her look, which is harsh rather than kind, her compressed lips and the strength with which she grasps her crucifix. Apart from the value of the painting in itself, this portrait is of documentary interest for what it tells us of those inspired and tenacious people who travelled all over the world to implant their concept of life, their religion and their culture.

As occurs in so many of Velázquez's works, there is paradox in the fact that the very intensity of the almost violently realistic technique used to produce absolute realism momentarily makes us forget the technique itself and see only the wonderful way in which the subject is depicted. An outstanding feature is the skill used in shading and in reproducing the tactile qualities. This is certainly one of Velázquez's most vigorous works and one of the truest, most vivid portraits ever painted. A total absence of baroque illusionism and an equally total absence of "impressionism" are the characteristics that define a technique and an aesthetic that are so closely tied to reality.

The dark brown of the habit is barely contrasted with the greenish background, so that it is only the light notes of the hands, the face and the wimple surrounding it that really produce the profound effect of corporeality, the magnificently three-dimensional image. The differences in depth of such a dense and vigorously-worked mass are enough to determine this effect, which is combined with an absolute predominance of chiaroscuro and minimal colour values. The form drawn – or, we might almost say, modelled – is all that matters. The body is shown objectively, with reflections of light on the thick, full mantle, and its effect is subordinated to that of the face, which is deeper and more alive.

In the second version (in the Fernández de Araoz Collection in Madrid) the nun's features are somewhat geometrized, as a result of the analysis carried out to facilitate the copying. All the elements, whether animate or inert, are more precisely described. In the carved figure of Christ on the cross she is carrying, for instance, apart from the beauty of the forceful and accurate drawing, the paint models the forms with impressive fidelity. The white wimple, the hands and the face lined by years of ascetic living are truly astounding. The expression of goodness that shows through the stern look is one of Velázquez's greatest achievements. Later years were to bring him other triumphs, richer and more subtle, but in its way this work is unsurpassable.

Both of these versions bear the following signature, painted in black and in cursive script: "Diego Velázquez 1620". The third version – of which I cannot speak with any authority, since my only acquaintance with it is through imperfect reproductions – is the same as the other two but in half-length. In the picture in the Fernández de Araoz Collection there is a phylactery with an inscription encircling the crucifix, but this was eliminated in the Prado version.

The portrait of *Cristóbal Suárez de Ribera* (Juana Pacheco's godfather, who died in 1618) is subtly different, with a rather hesitant facial modelling that may be due to the fact that this portrait was based on one by another artist or on an earlier study by Velázquez himself *(Fig. 33 - Cat. 20)*. It is a very objective and rather cold portrayal, only enlivened by the brilliance of the technique. The kneeling figure wears black and there are hardly any tonal contrasts in his clothing except the white line of his collar. The whole force of the work is concentrated in the hands and face. The thoroughly-finished drawing and the thickness of the paint tend to geometrize the image, but without thereby lessening its naturalism. The emblem of the Inquisition is the only piece of detailed setting in the room, but through the window we can see a garden plunged in shadows which has evident affinities with the very few landscapes painted by Pacheco. Velázquez marks the lighter areas with loose white brushstrokes, in a blended modelling. The monogram and date, painted in black under the window-sill, can hardly be distinguished from the general tone of this area. I have already spoken of this monogram in connection with the one on the first canvas in my catalogue *(page 16)*.

Works painted after 1619

The technique of dense modelling reached the highest degree of balance in the *St. Thomas the Apostle* in the Orleans Musée des Beaux-Arts *(Figs. 35 & 36 - Cat. 21),* a picture that may have formed

part of an Apostle series, which would imply twelve lost works. The figure of the saint, shown in profile from very near at hand, is another proof of the systematic realism of Velázquez's approach to hagiography, an approach prompted by his lively pictorial imagination rather than by any intellectual prejudices. There is no special feeling, no mysticism, no perceptible desire to create an image suitable for devotional purposes. The painter simply portrays his model, with all the propriety, strength and skill permitted by his extraordinary gifts.

In the structure of the hands *(Fig. 36)* the synthesis of drawing and painting is really masterly, as are the simplicity, flexibility and direct tactile impression of the voluminous ochre cloak that dominates the picture, contrasting with the dark background; Velázquez remained faithful to his range of earth colours. His knowledge of the function of tone in representing form may be observed, for instance, in the admirable structure of the saint's ear. In the more luminous areas the shading of the modelling is incomparably sensitive and the shadows perfectly calculated to make the form stand out. The predominance of the head and hands in no way lessens the folds of the cloak. Another expressive quality that should be mentioned is the intense virility, that gravity that was so manifest in this painter from the very beginning, together with his total contempt for sentimental story-telling. From the start Velázquez's art chose the most ambitious paths, for his intentions were always proportional to his potentialities, as the future would not fail to confirm.

The impressive *St. John on the Island of Patmos (Figs. 37 & 38 - Cat. 22)* and *Immaculate Conception (Figs. 39 & 40 - Cat. 23),* both from the Carmelite Monastery in Seville, show an increased insouciance in the handling of the dense pigment and a notable advance in the achievement of luminous shadows. In the first the tendency to realism of the Orleans *St. Thomas* goes still further, though here there is something of an attempt at religious expressiveness. The effect of relief is more intense and to achieve this the painter made a greater use of chiaroscuro from background to foreground and gave the saint's clothing and flesh-tints a more luminous quality. The

superb bare feet and the hands are particularly worth noticing, as is the mass formed by the cloak and the books on the ground. With subtlety and great virtuosity Velázquez uses the saint's clothing to produce tonal effects that are at once austere and delicate. The robe is white, modelled as a grey tinged with magenta, while the cloak is light crimson, modelled with white and black. The figure stands out dramatically against the dark background, into which the eagle and the gnarled tree-trunk blend, and which is enlivened only by the yellowish lights of the tiny image of the Virgin that appears in the sky.

In the *Immaculate Conception,* which is very much in the same style of painting, the Virgin is represented standing on a transparent floating sphere surrounded by dense white clouds shot with pink and yellow reflections; clouds which, though bolder, are reminiscent of those in the first work in the present catalogue. The image, naturalistic rather than idealized, possesses a sculptural sense of form. Both in the magenta-tinged light blue robe and in the dark blue cloak we find immense technical expertise and an evident interest in plastic effects, as is also the case in the *St. John.* In the *Immaculate Conception,* however, there is a certain degree of idealization, thanks to the clouds and bursts of light in the background and to the various allegories of the Virgin in the lower part of the picture.

Even at this early stage, though in not at all the same way as in his last period, Velázquez was really concerned about the economy of means, concentrating and intensifying rather than diffusing. His sober range of colours was matched by the conciseness of his form and his slight (at times almost non-existent) interest in expression; he sought purely formal effects instead, which he achieved with that wonderful sensation of relief that he knew so well how to obtain. As I said before, his concept of chiaroscuro is never theatrical, being used only to unify the composition and heighten details of the form.

In the evolution of the analytical period that begins with the 1619 *Epiphany* we find an evident step forward in a canvas that represents *St. Jerome (Figs. 41 & 42 - Cat. 24).* Here the linear factor is still of less importance than the form and the strict idea

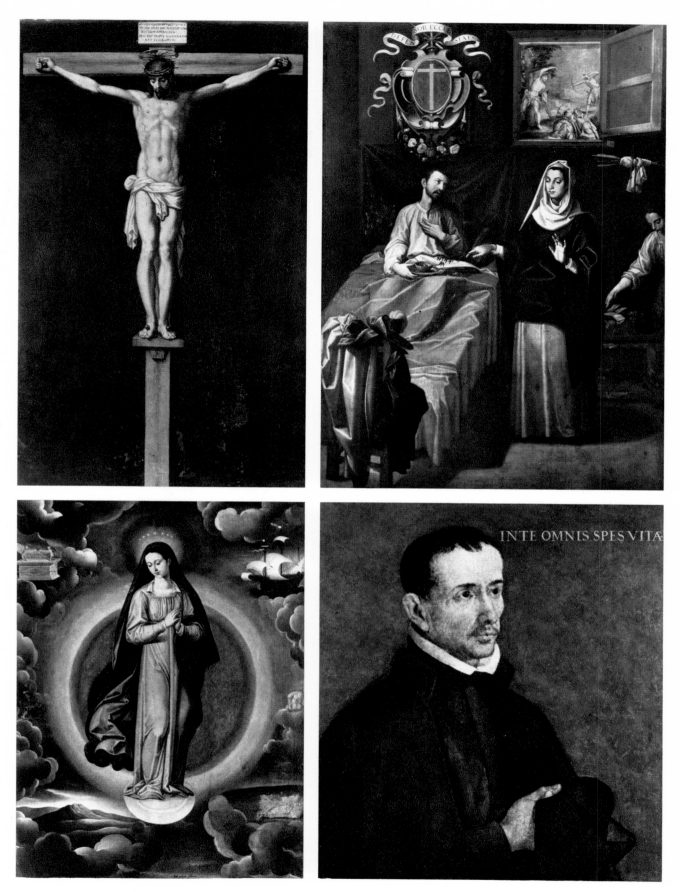

Fig. 1. Francisco Pacheco. CRUCIFIX. 1614. Gómez Moreno Collection, Madrid.
Fig. 2. Francisco Pacheco. SAINT SEBASTIAN NURSED BY SAINT IRENE. 1616. Destroyed in 1936.
Fig. 3. Francisco Pacheco. IMMACULATE CONCEPTION. 1638. Barón de Terrateig Collection, Valencia.
Fig. 4. Francisco Pacheco. PORTRAIT. Almshouse of San Fernando, Seville.

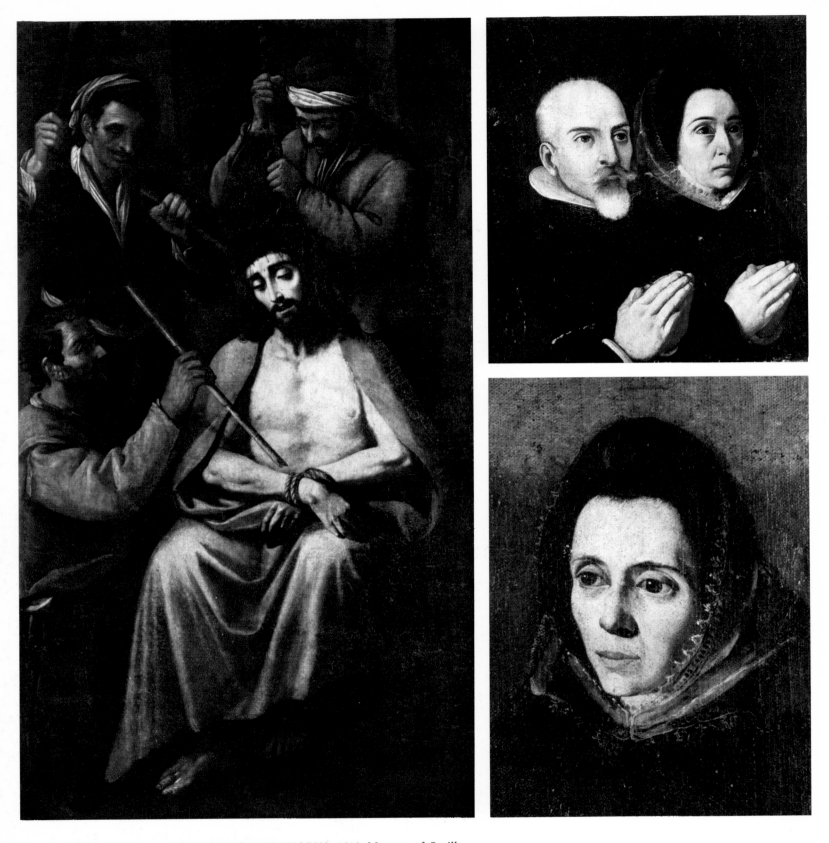

Fig. 5. Pacheco-Velázquez. CROWNING WITH THORNS. 1616. Museum of Seville.
Figs. 6 & 7. Pacheco-Velázquez. PORTRAITS. Private collection, Granada.
Fig. 8. THE VIRGIN MARY (MAGNIFICAT). C. 1615-1616. Private collection. Cat. No. 1.

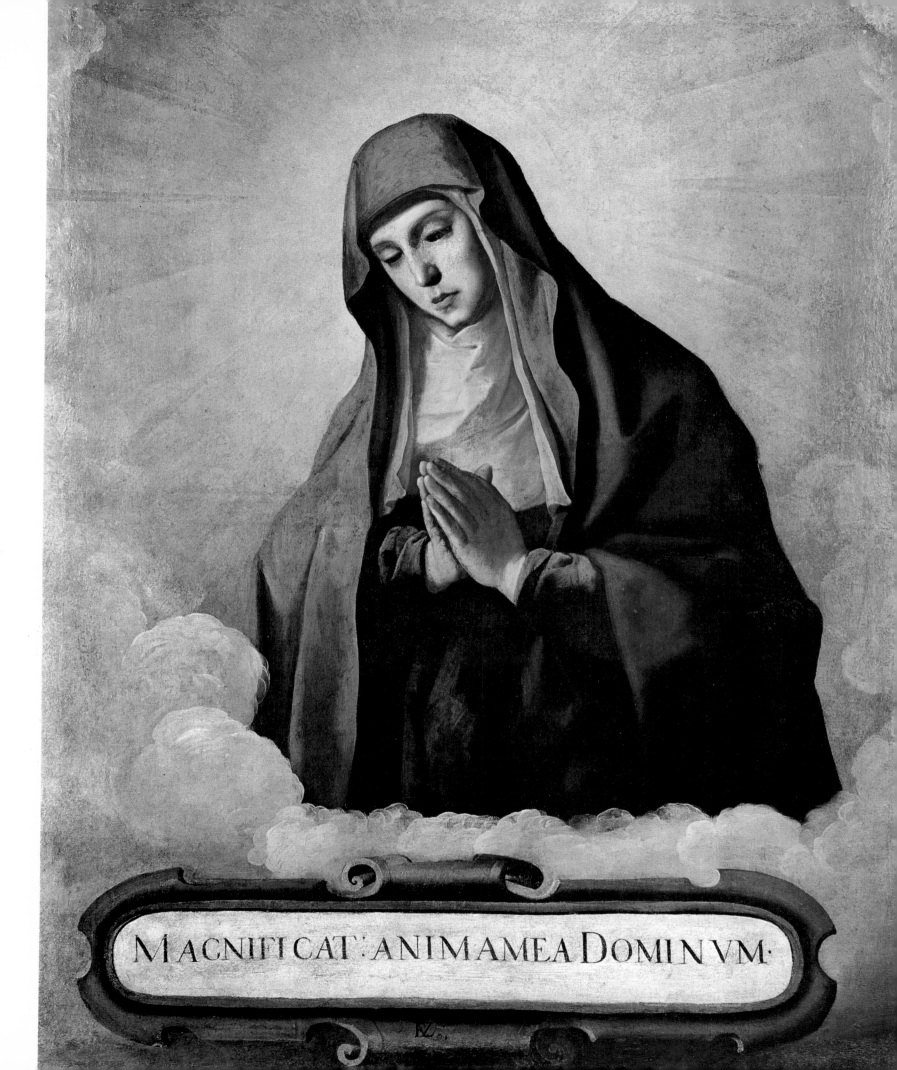

MAGNIFICAT·ANIMAMEA DOMINVM·

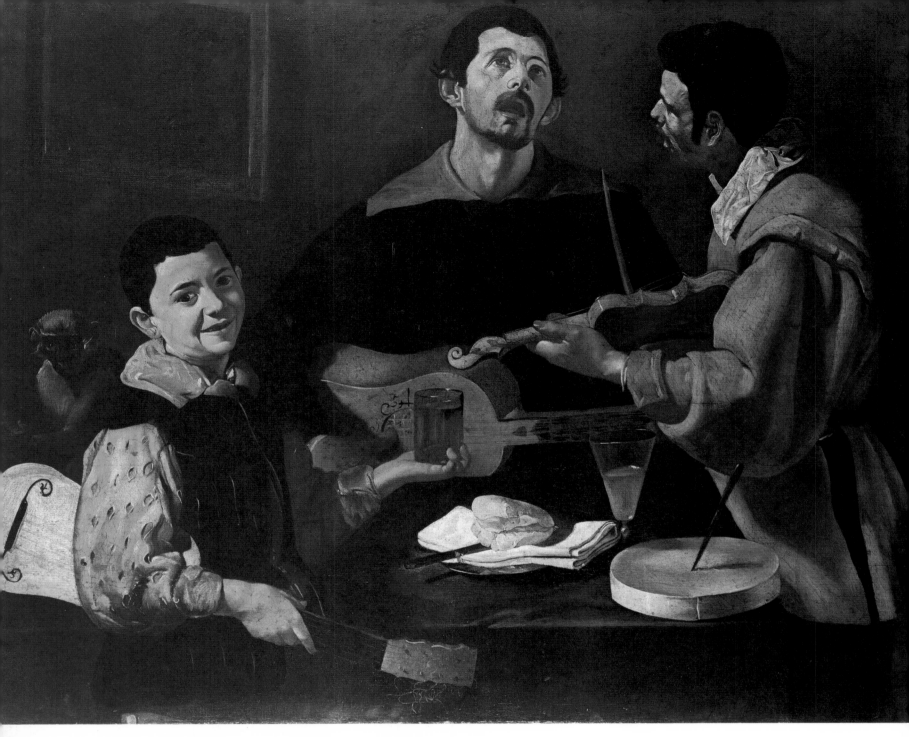

Fig. 9. THE MUSICIANS. C. 1616-1617. West Berlin: Staatliche Museen. Cat. No. 2.
Fig. 10. TWO MEN EATING. C. 1616-1617. London: Wellington Museum. Cat. No. 3.
Fig. 11. THE MAIDSERVANT. C. 1617-1618. Chicago: Art Institute. Cat. No. 4.

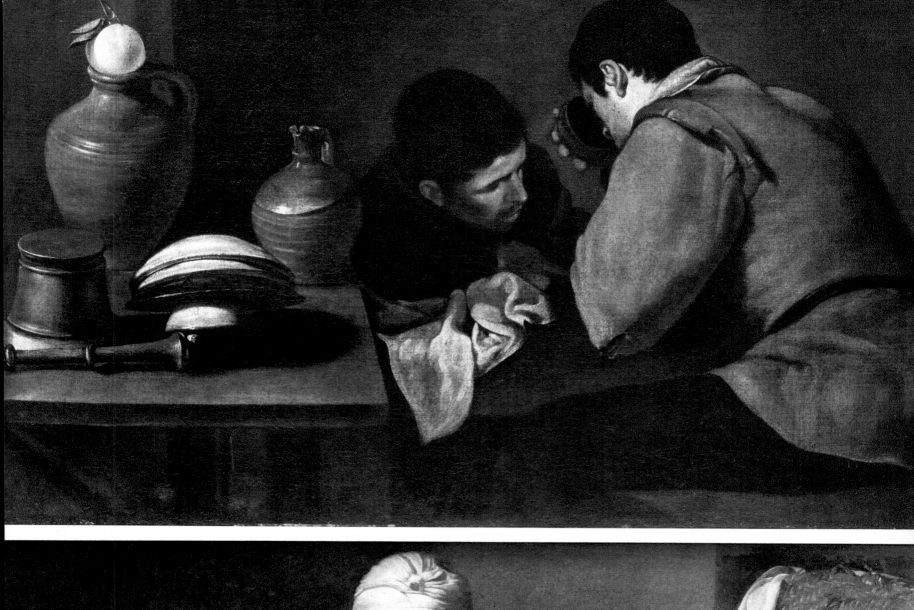

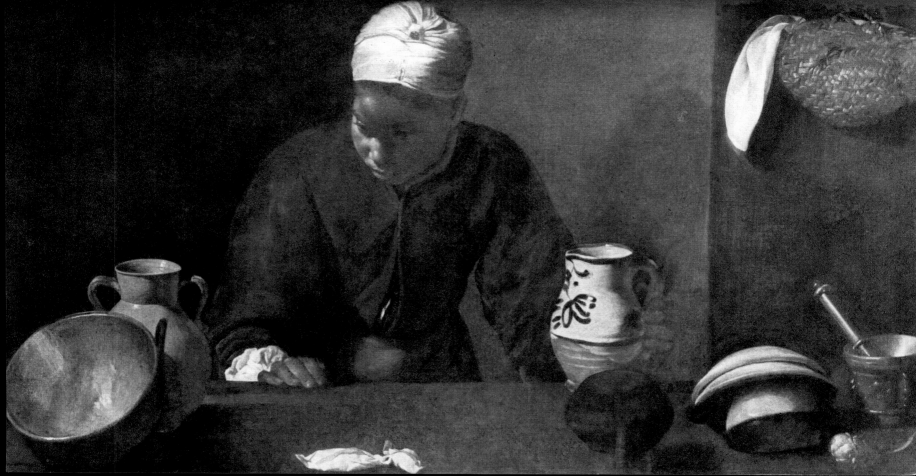

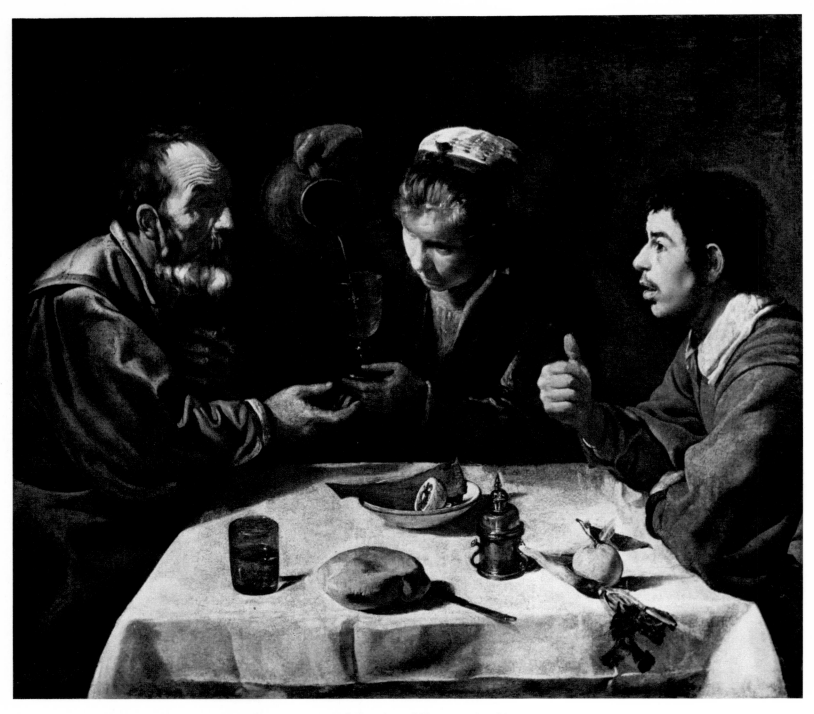

Fig. 12. THE LUNCHEON. C. 1617-1618. Budapest: Museum of Fine Arts of Hungary. Cat. No. 5.

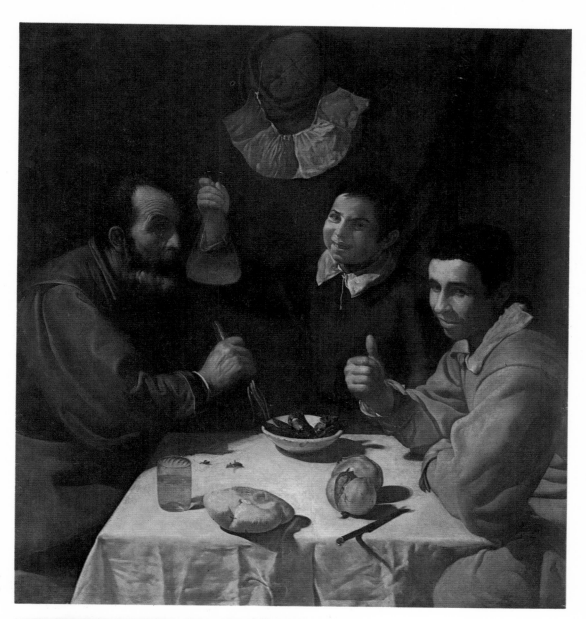

Fig. 13. THE LUNCHEON. C. 1617-
1618. Leningrad: Hermitage Museum.
Cat. No. 7.

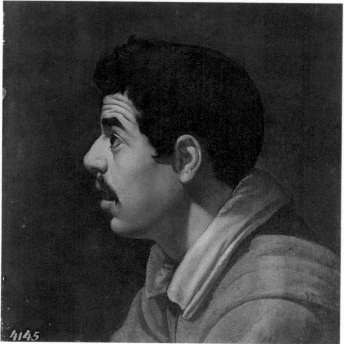

Fig. 14. MAN'S HEAD. C. 1617-1618.
Leningrad: Hermitage Museum.
Cat. No. 6.

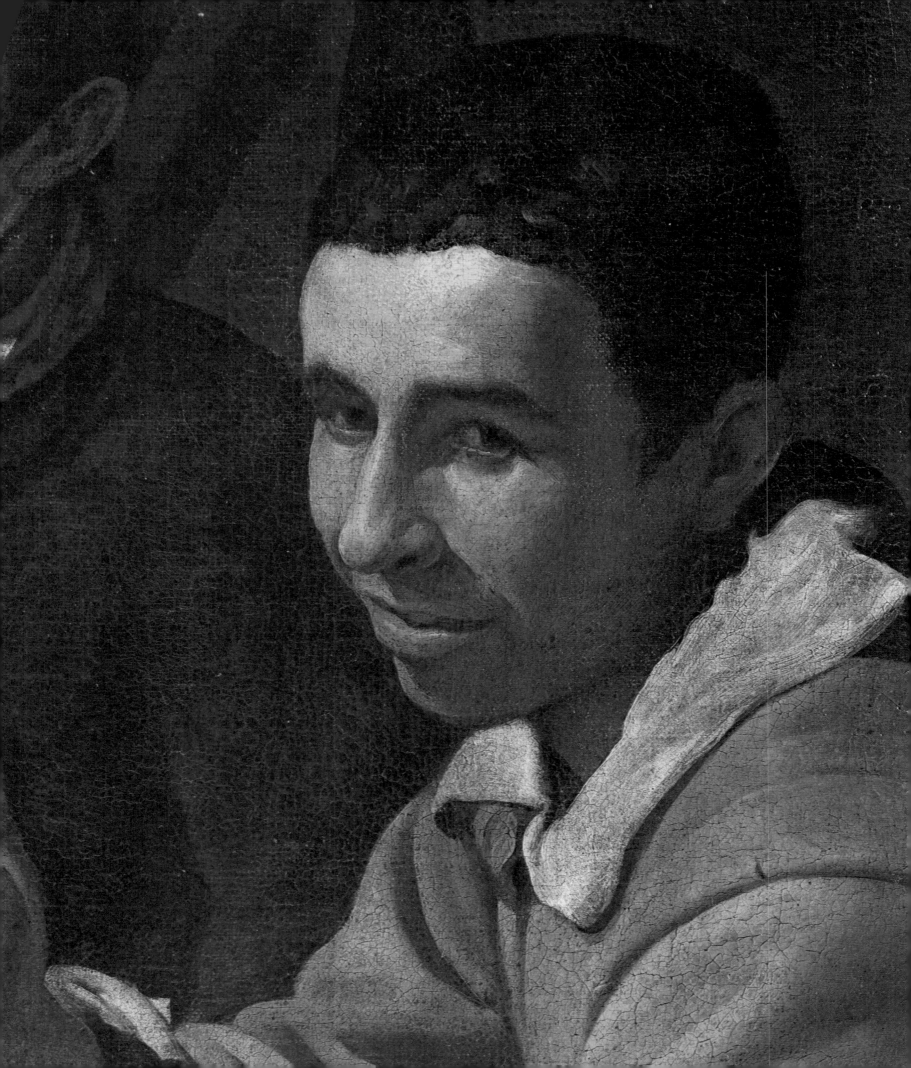

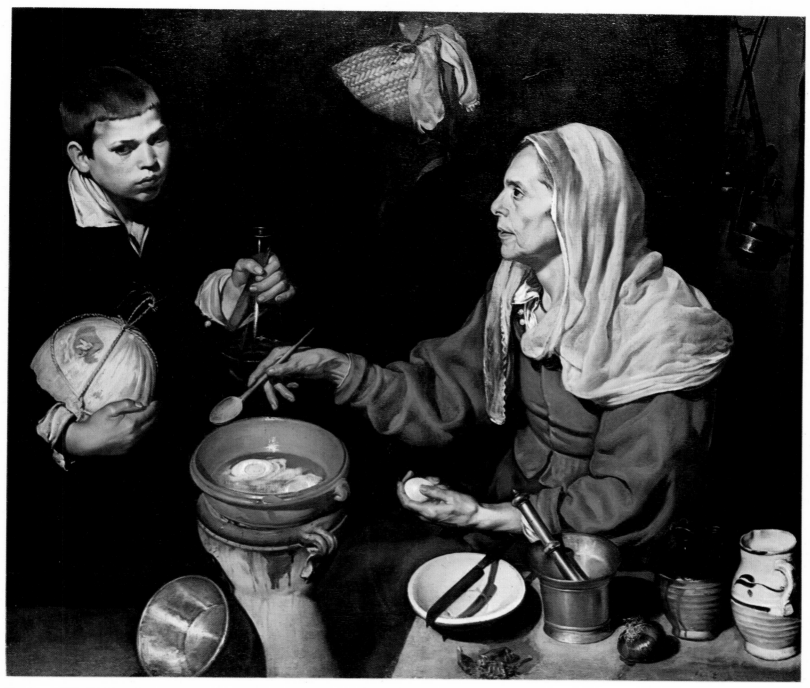

Fig. 15. THE LUNCHEON. Detail of figure 13.
Fig. 16. OLD WOMAN FRYING EGGS. C. 1618. Edinburgh: National Gallery of Scotland. Cat. No. 8.

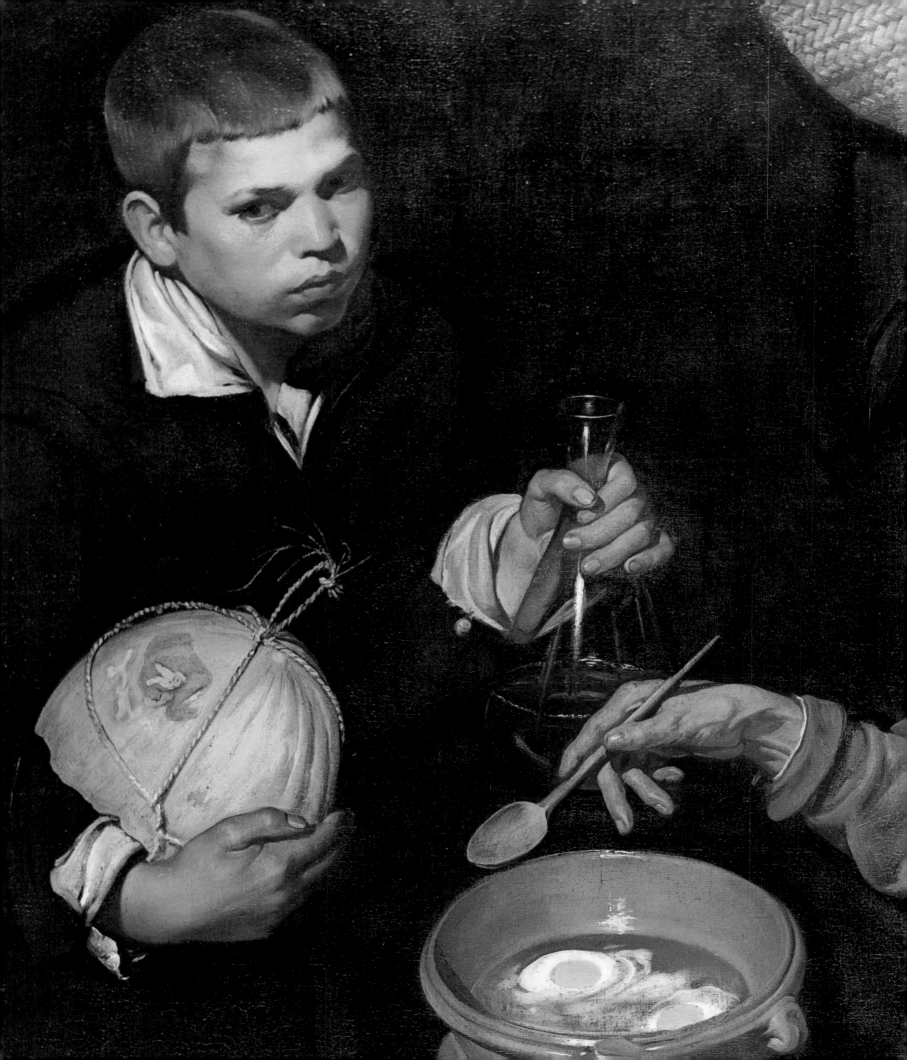

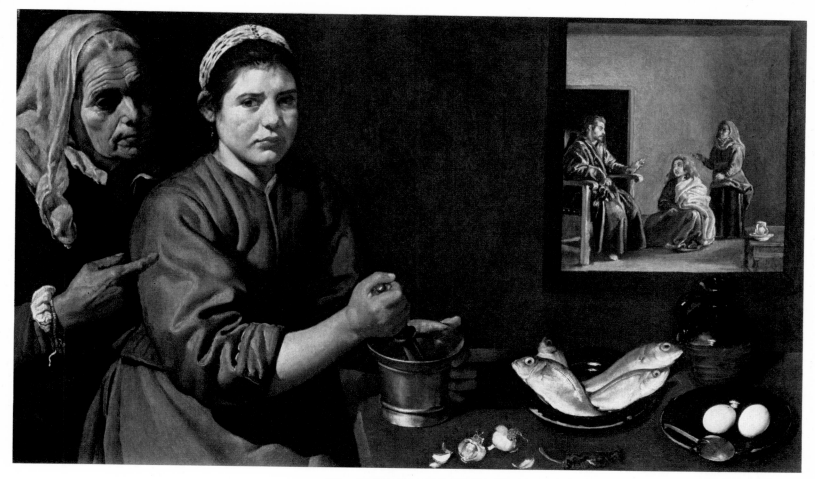

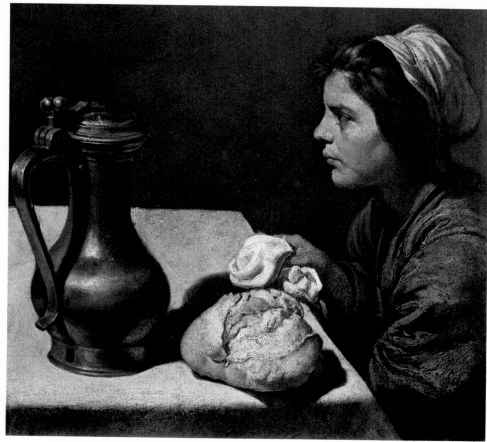

Fig. 17. OLD WOMAN FRYING EGGS. Detail of figure 16.

Fig. 18. JESUS IN THE HOUSE OF MARTHA AND MARY. 1618. London: National Gallery. Cat. No. 9.

Fig. 19. THE MAIDSERVANT. C. 1618. Los Angeles: Maric Collection. Cat. No. 10.

Figs. 20 & 21. JESUS IN THE HOUSE OF MARTHA AND MARY. Details of figure 18.

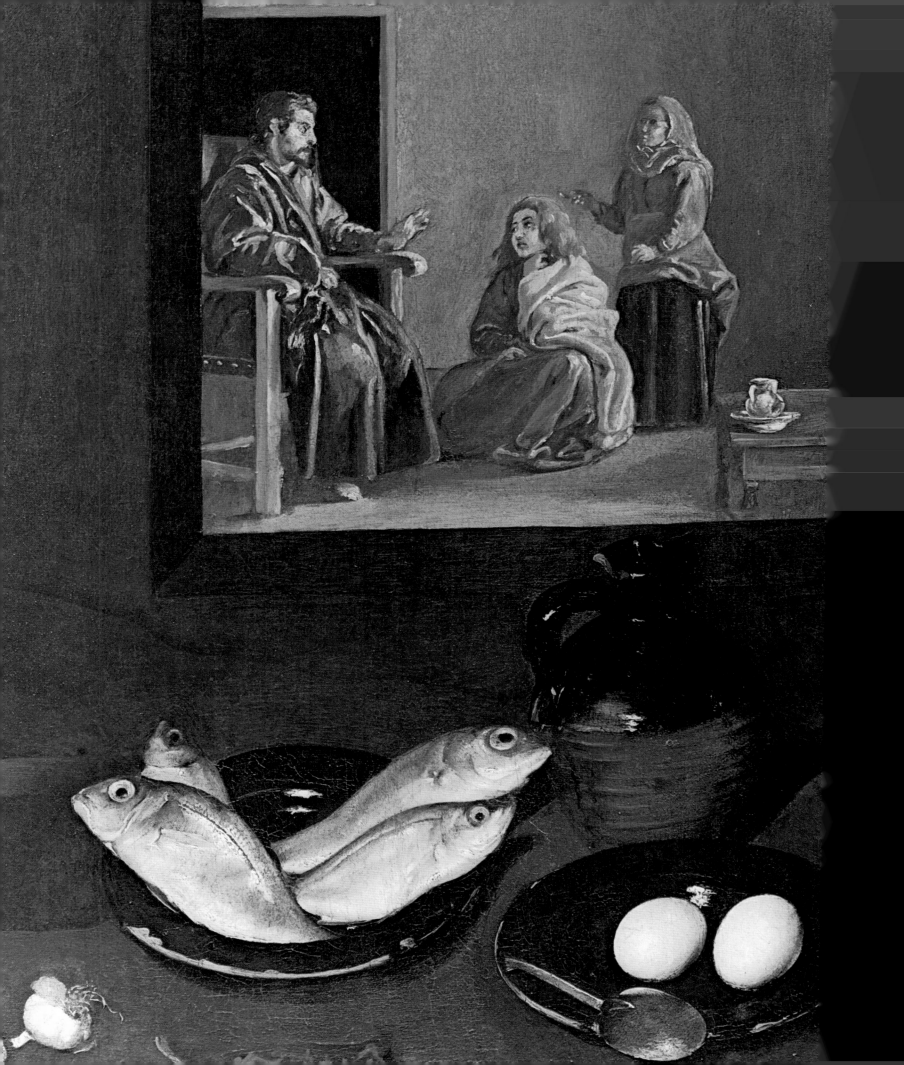

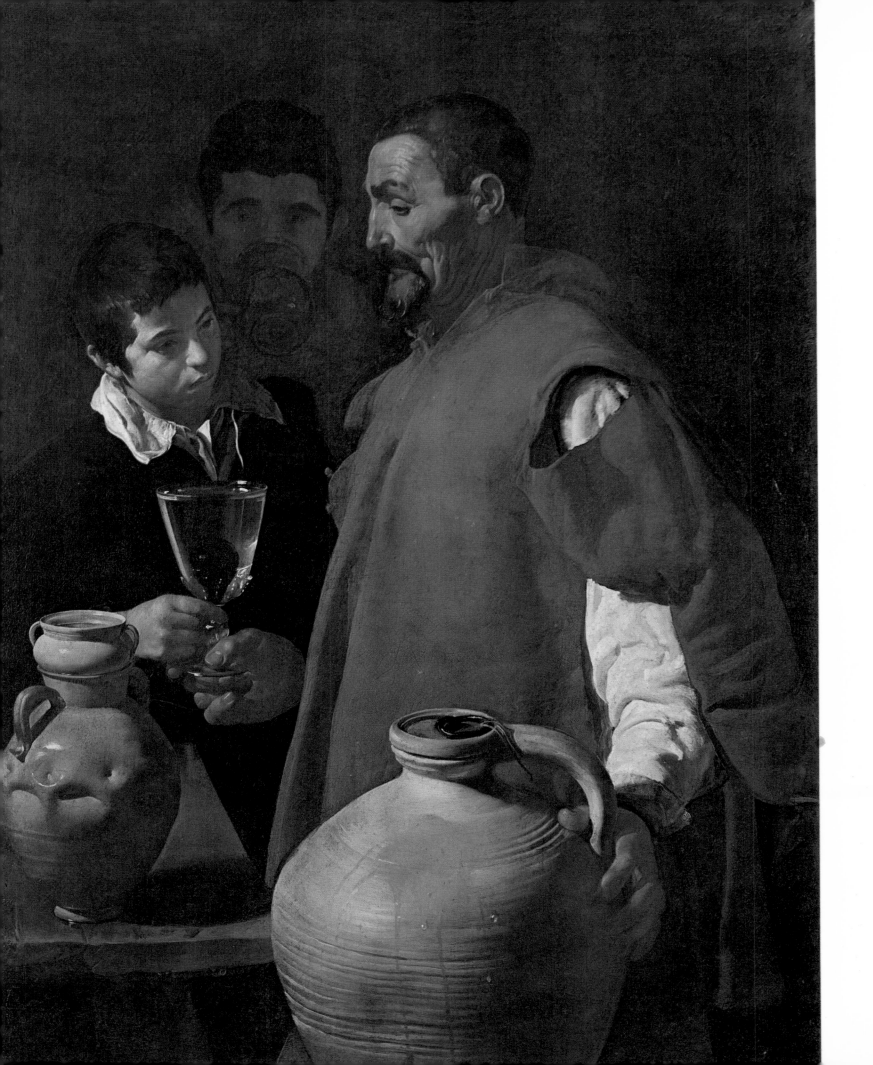

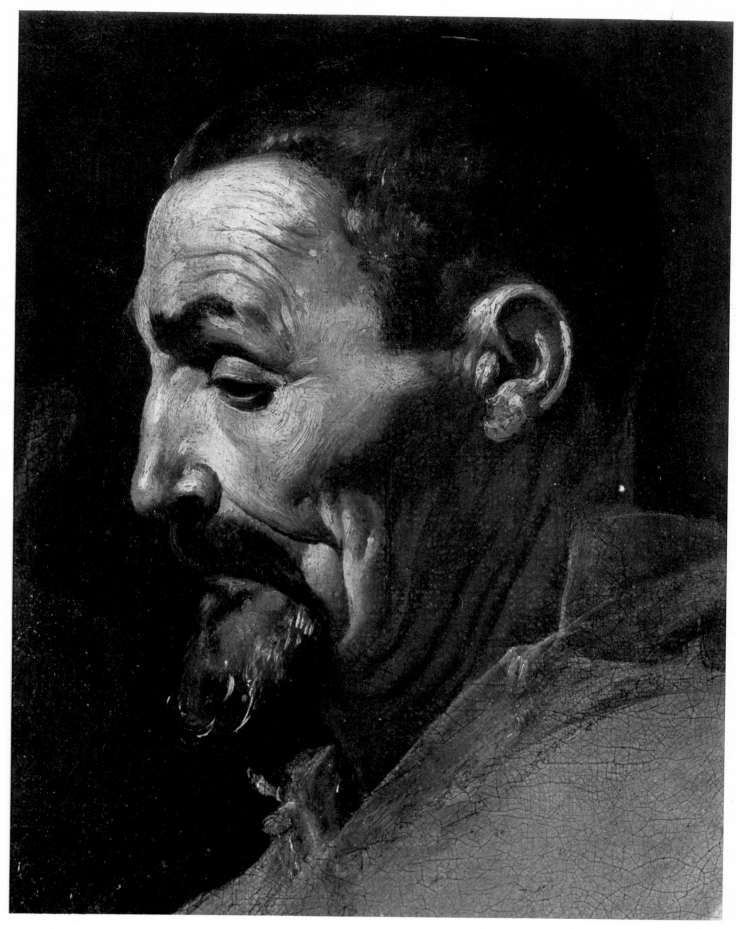

Figs. 22 & 23. THE WATER-SELLER OF SEVILLE. C. 1622. London: Wellington Museum. Cat. No. 11.

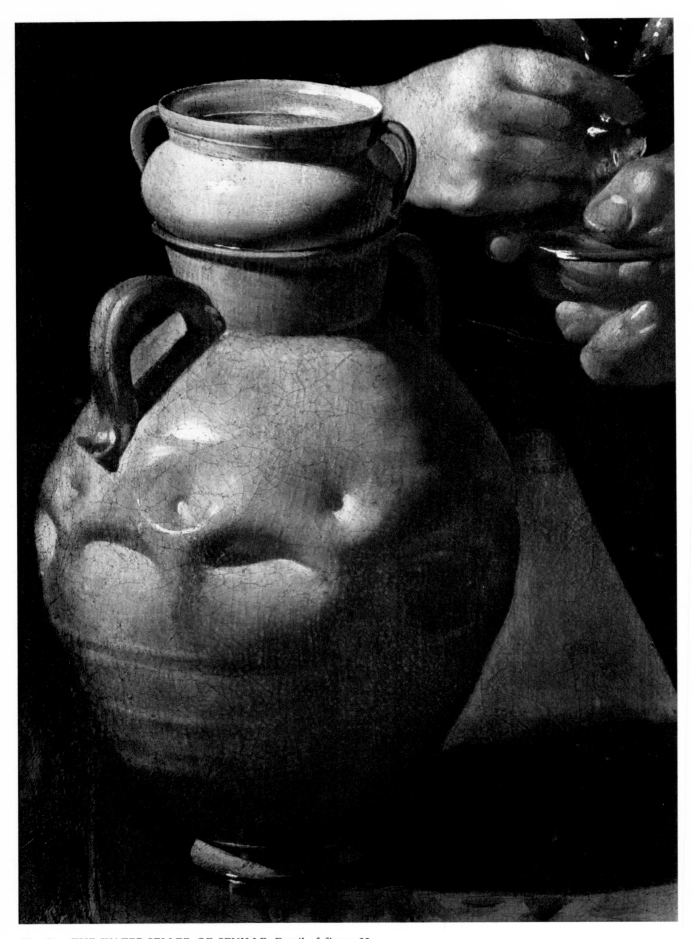

Fig. 24. THE WATER-SELLER OF SEVILLE. Detail of figure 22.

Fig. 25. STILL LIFE. C. 1620. Amsterdam: Rijksmuseum. Cat. No. 12.

Fig. 26. WOMAN'S HEAD. C. 1618. Madrid: Museo Lázaro Galdiano. Cat. No. 13.
Figs. 27, 28 & 29. EPIPHANY. 1619. Madrid: Prado Museum. Cat. No. 16.

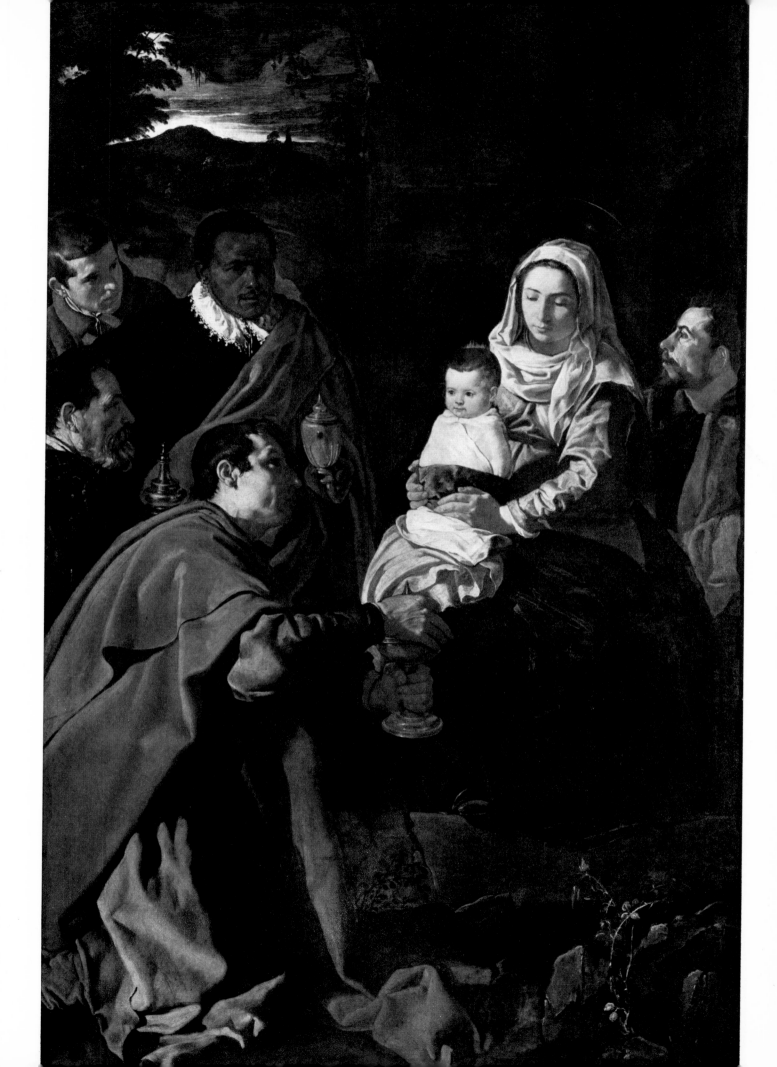

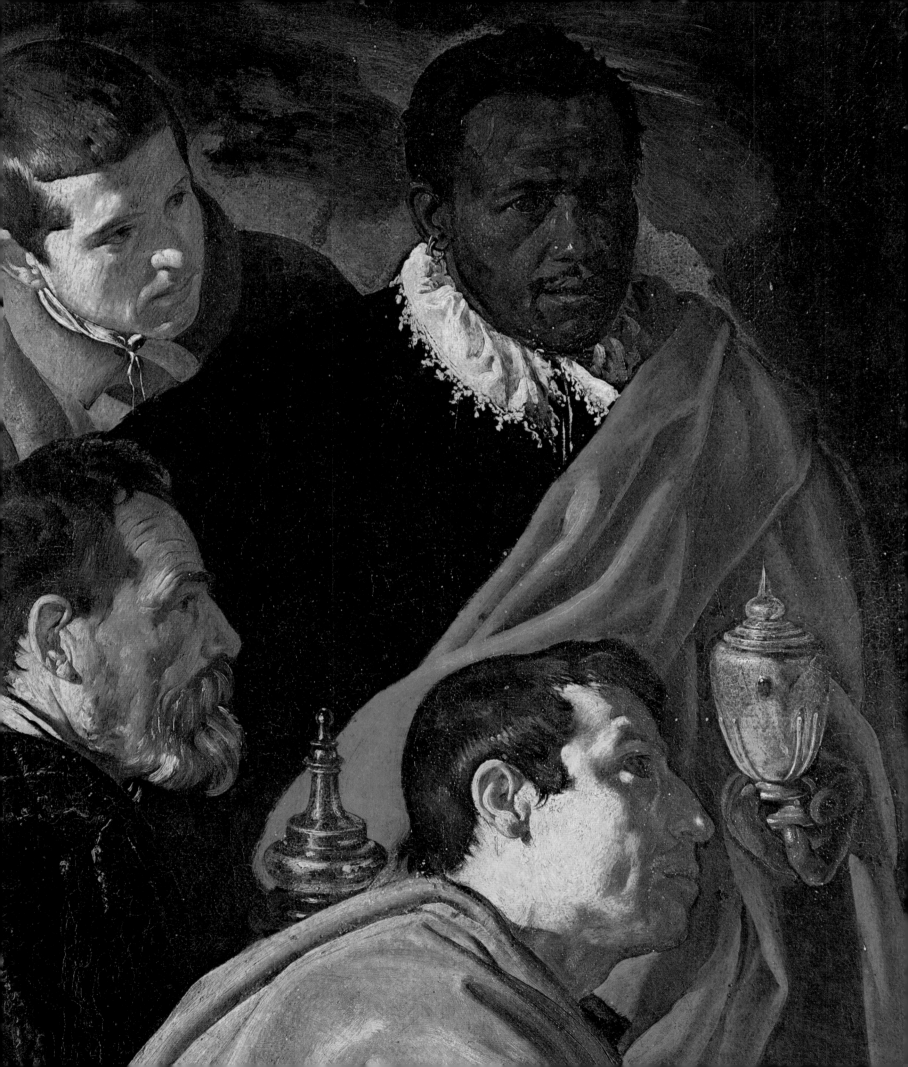

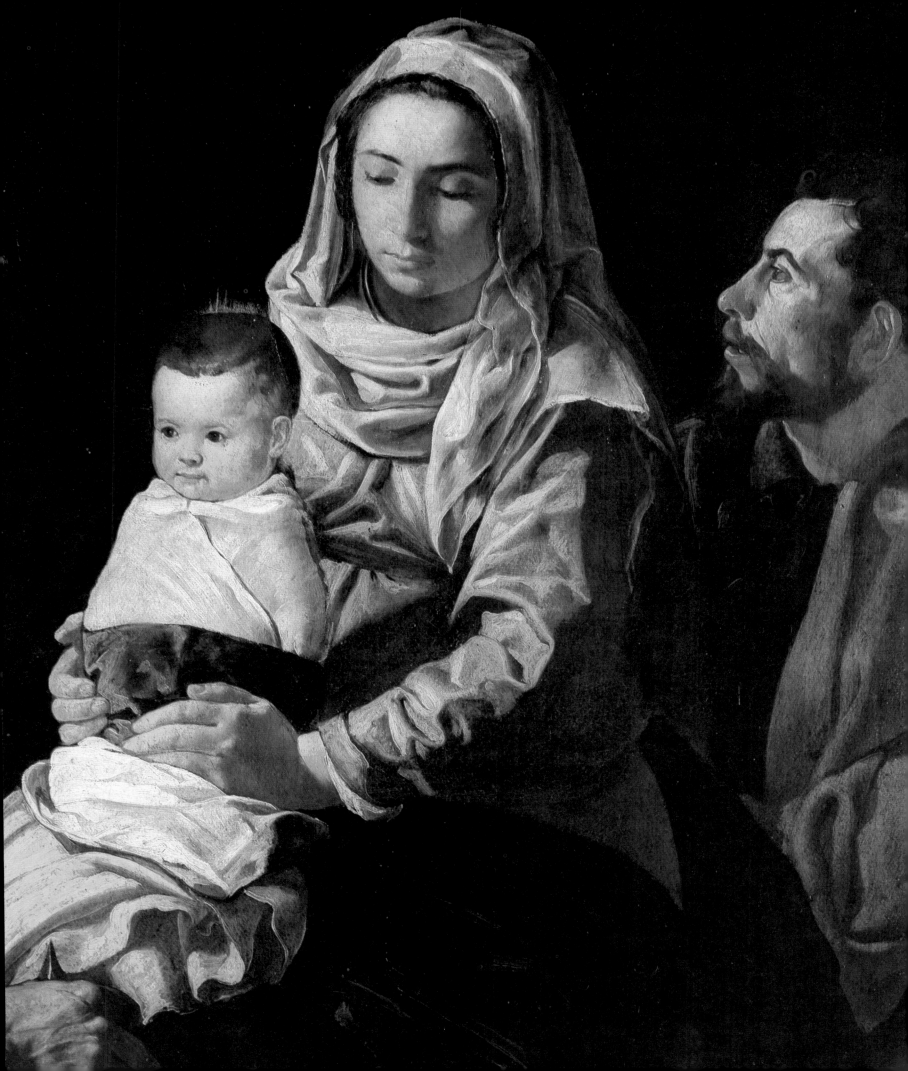

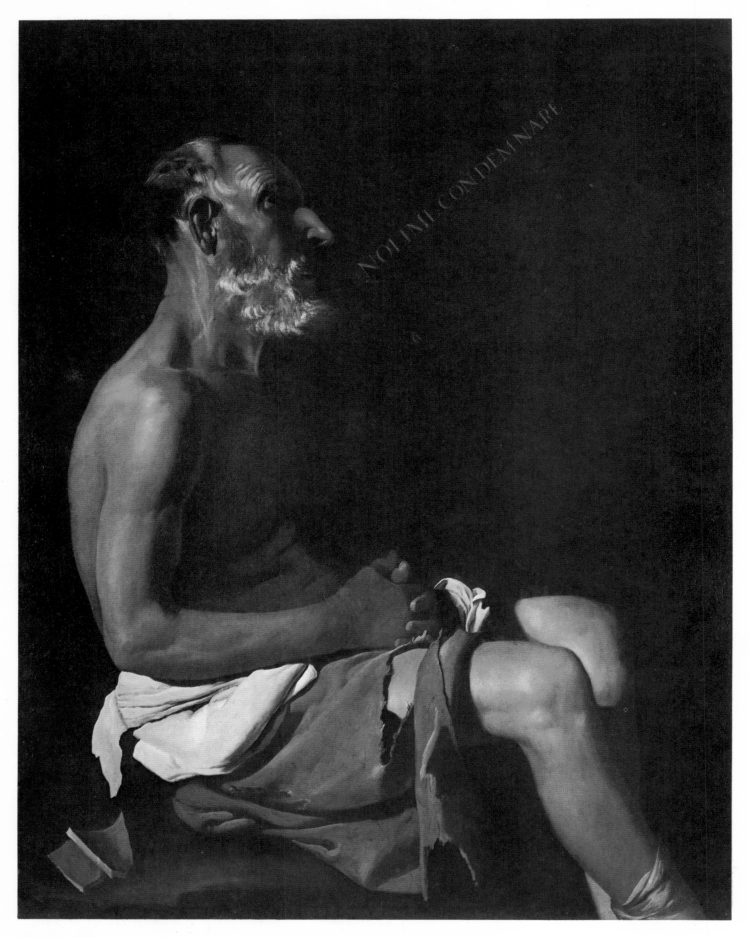

Fig. 30. JOB. C. 1618. Chicago: Art Institute. Cat. No. 14.
Fig. 31. JERONIMA DE LA FUENTE. 1620. Madrid: Prado Museum. Cat. No. 17.

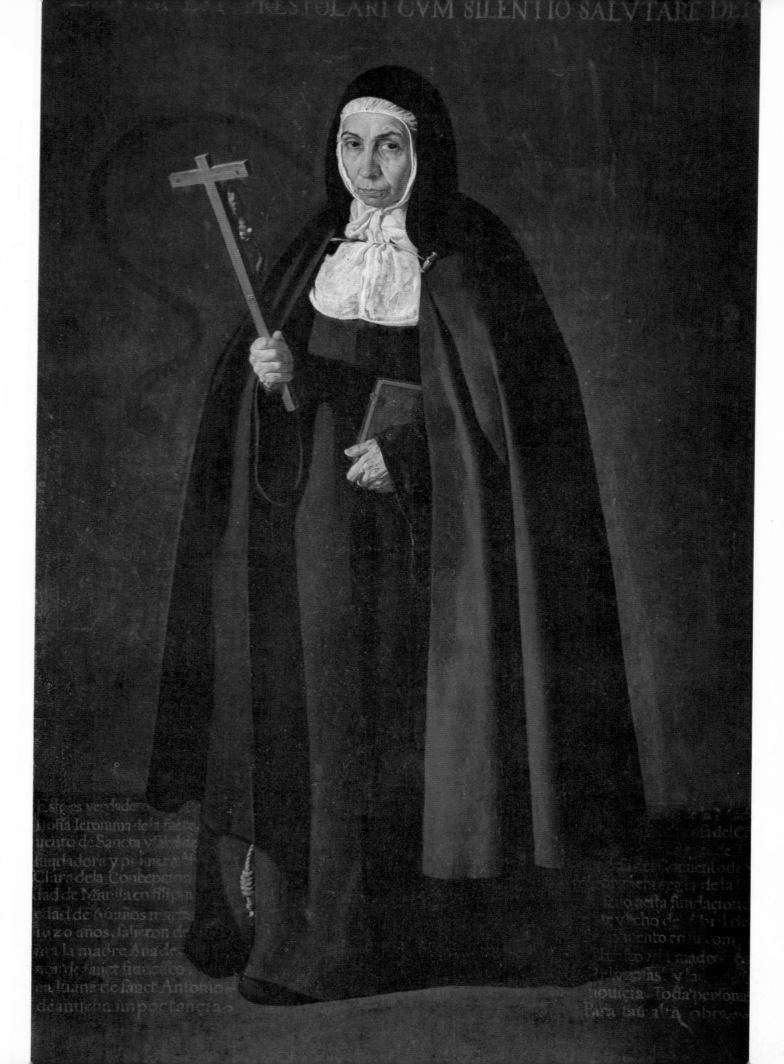

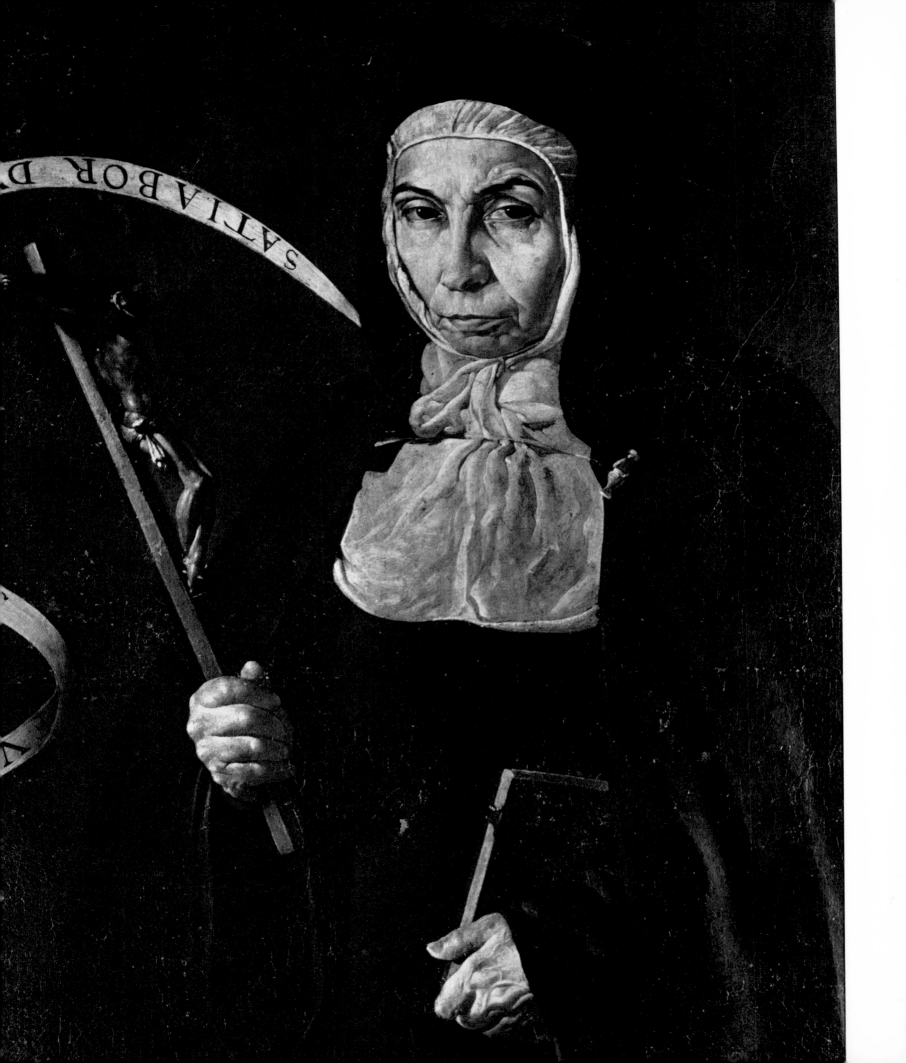

Fig. 32. JERONIMA DE LA FUENTE. 1620. Detail. Madrid: Araoz Collection. Cat. No. 18.
Fig. 33. CRISTOBAL SUAREZ DE RIBERA. 1620. Museum of Seville. Cat. No. 20.

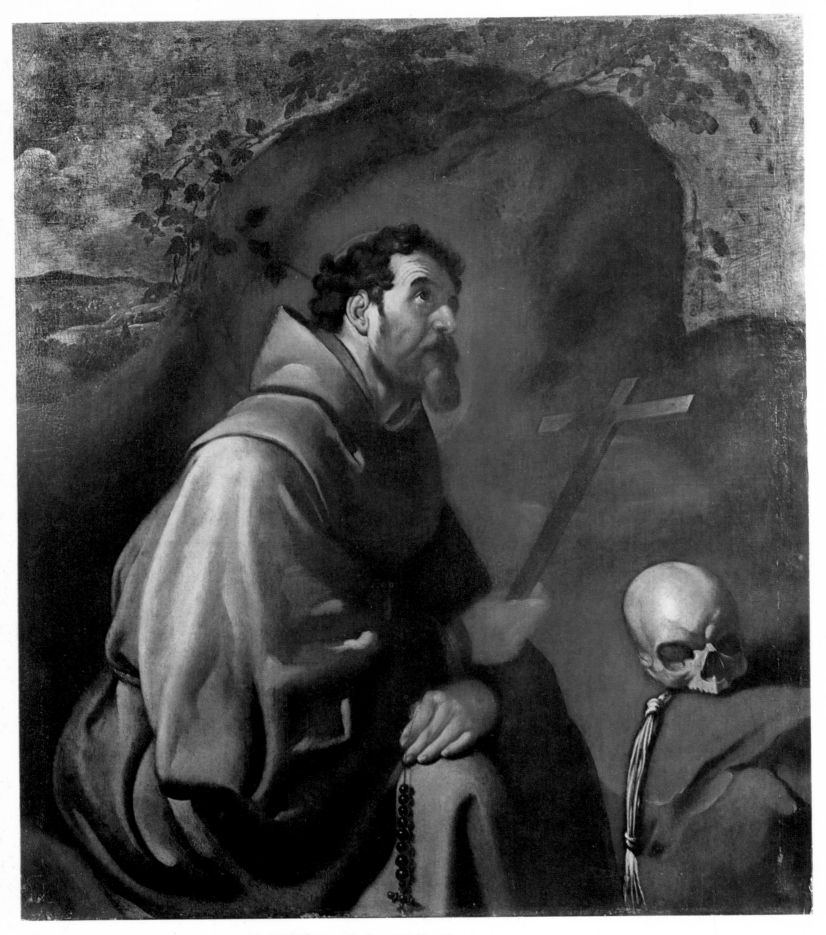

Fig. 34. SAINT FRANCIS. C. 1618-1619. Madrid: Private collection. Cat. No. 15.
Fig. 35. SAINT THOMAS THE APOSTLE. C. 1619-1620. Orleans: Musée des Beaux-Arts. Cat. No. 21.

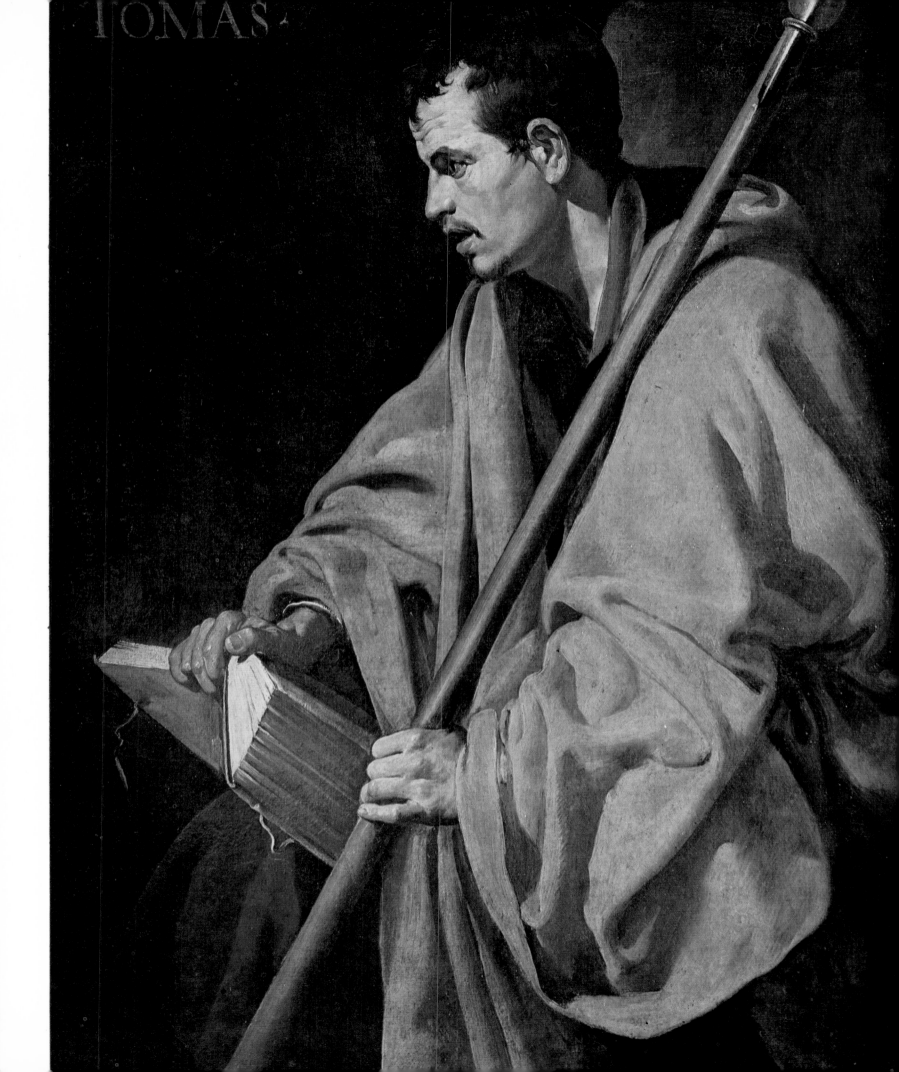

Fig. 36. SAINT THOMAS THE APOSTLE. Detail of figure 35.
Figs. 37 & 38. SAINT JOHN ON THE ISLAND OF PATMOS. C. 1619-1620. London: National Gallery. Cat. No. 22.

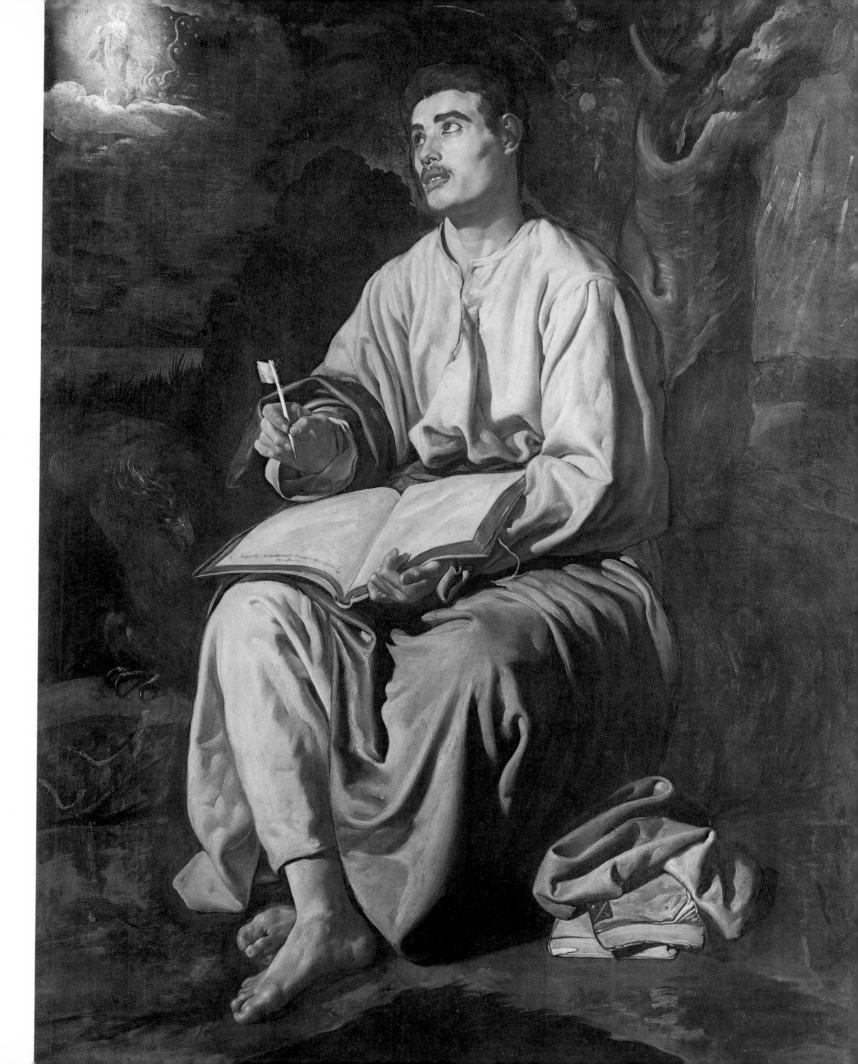

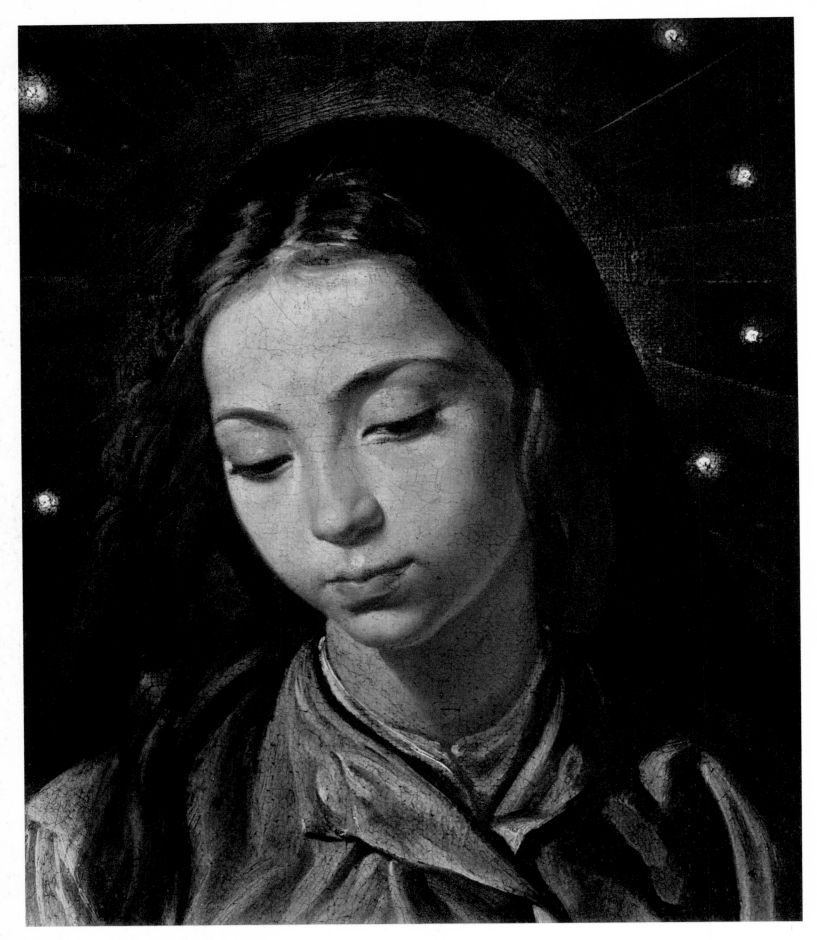

Figs. 39 & 40. IMMACULATE CONCEPTION. C. 1619-1620. London: National Gallery (1974). Cat. No. 23.

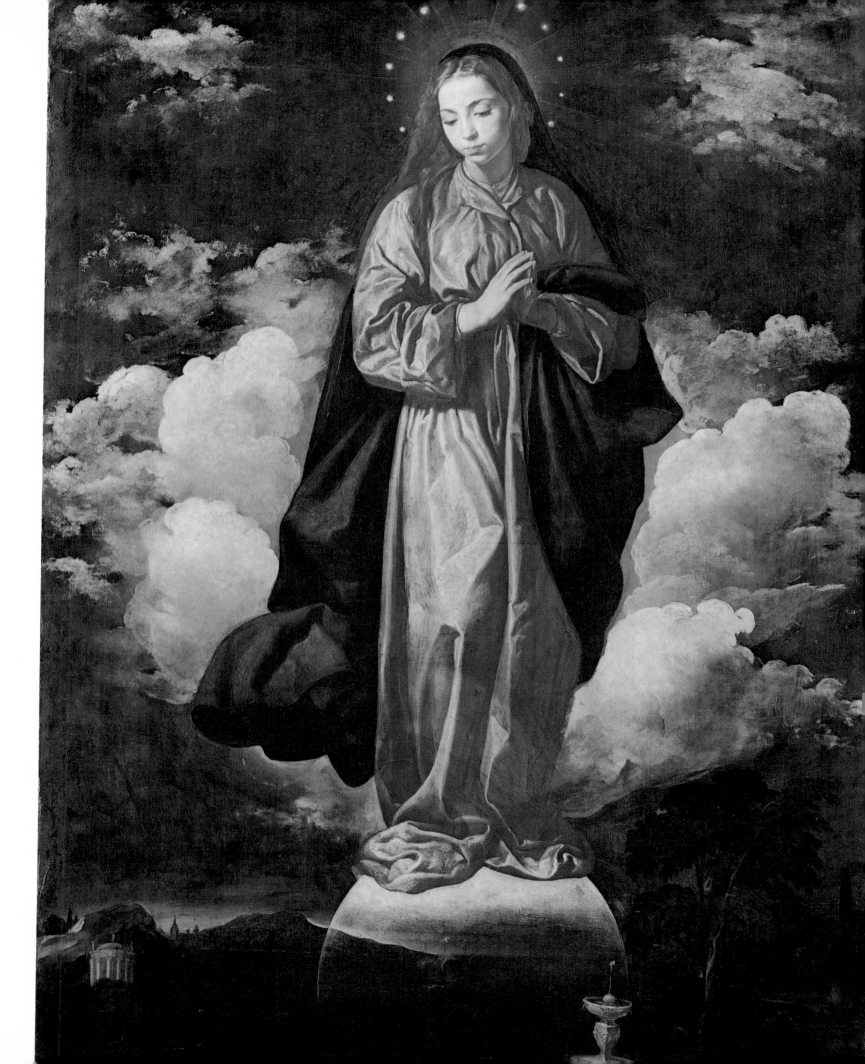

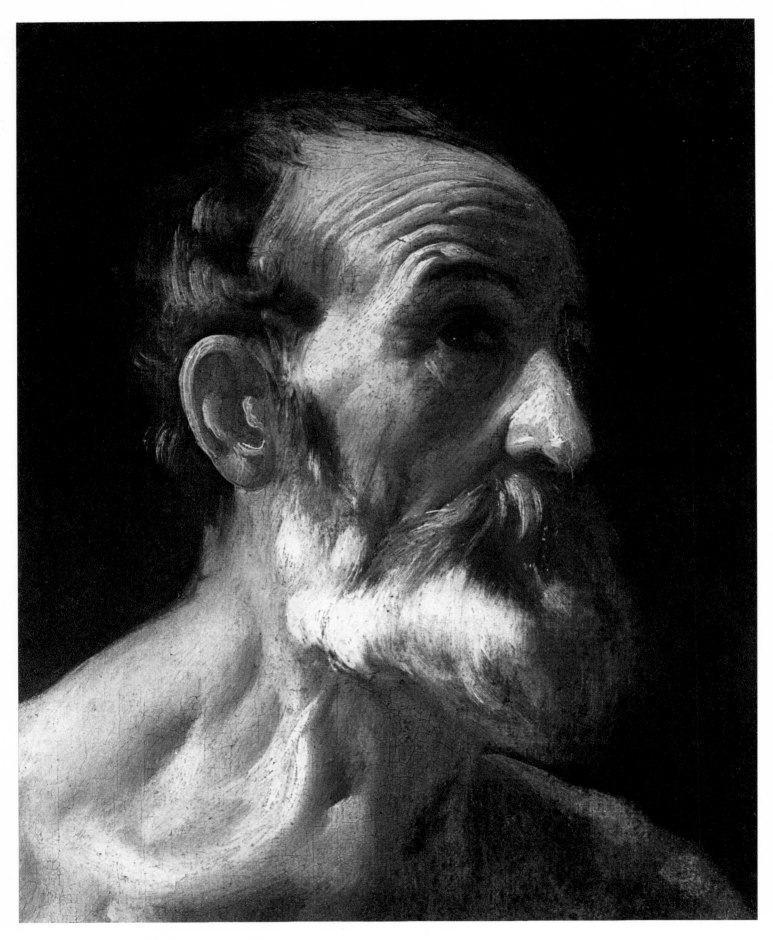

Figs. 41 & 42. SAINT JEROME. C. 1619-1620. Madrid: Private collection. Cat. No. 24.

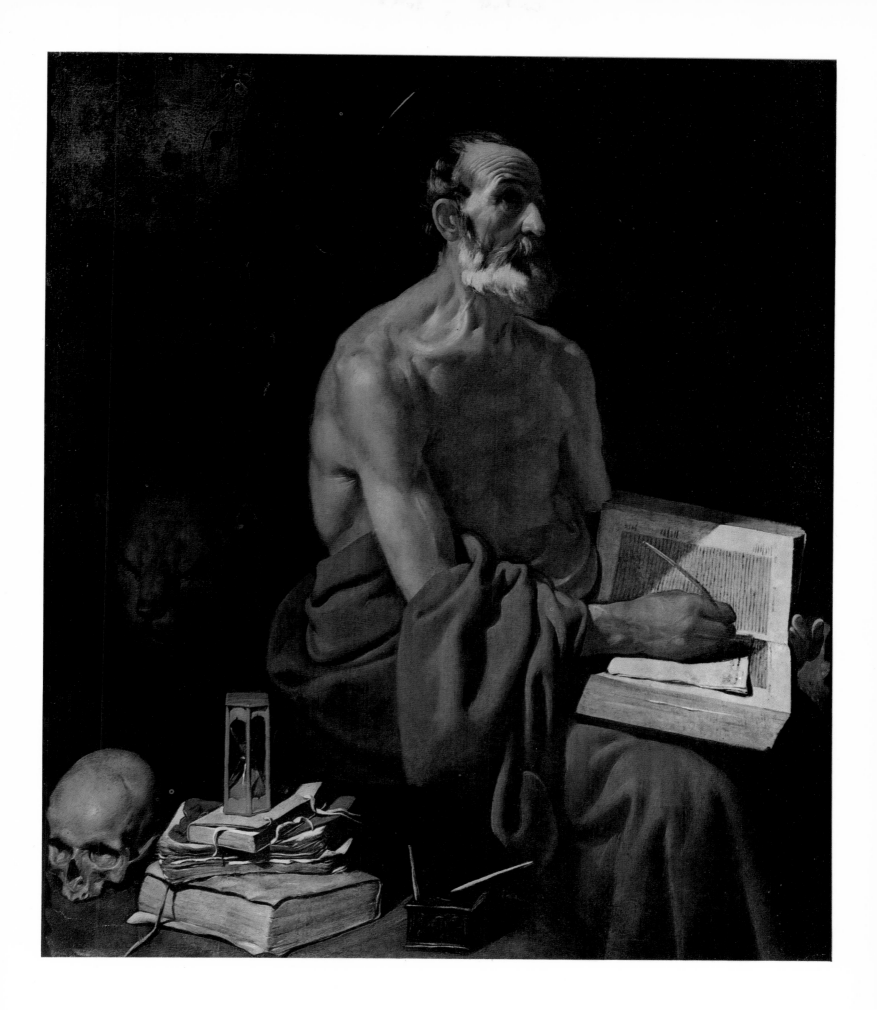

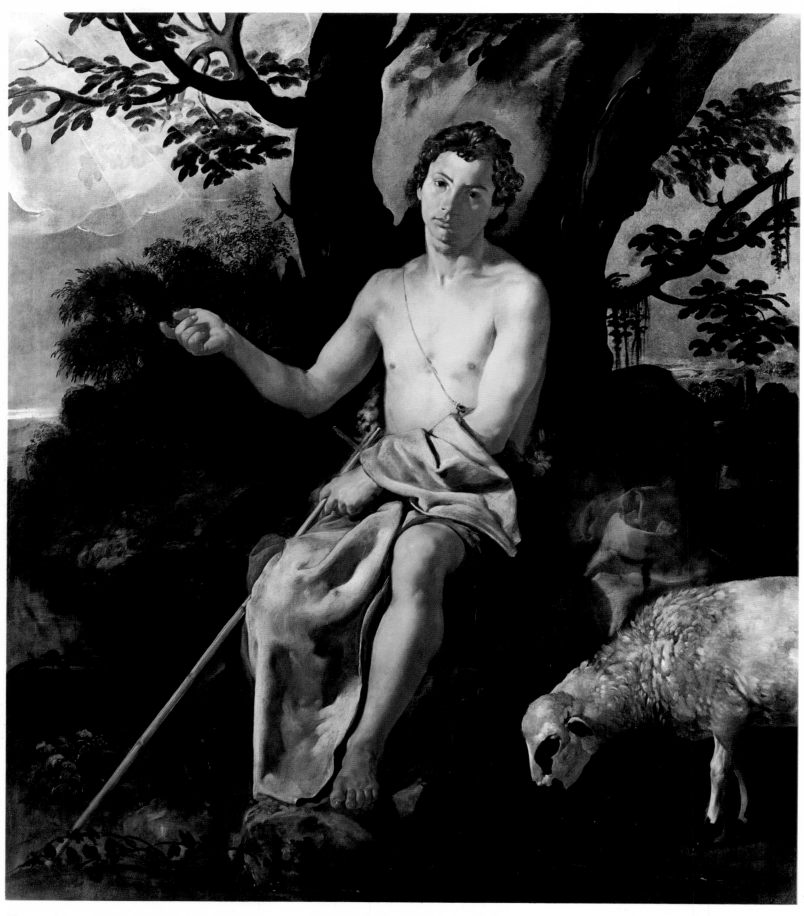

Figs. 43 & 44. SAINT JOHN THE BAPTIST. C. 1620-1622. Croton, Mass.: Danielson Collection. (On loan to the Art Institute of Chicago.)
Cat. No. 25.

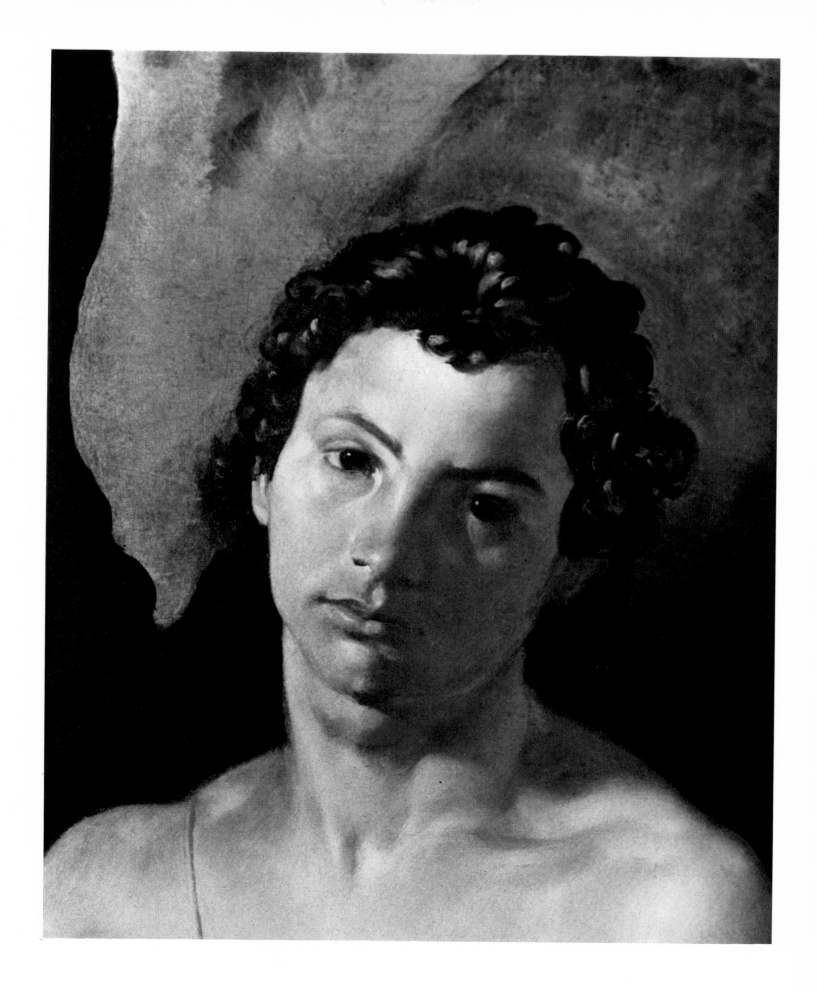

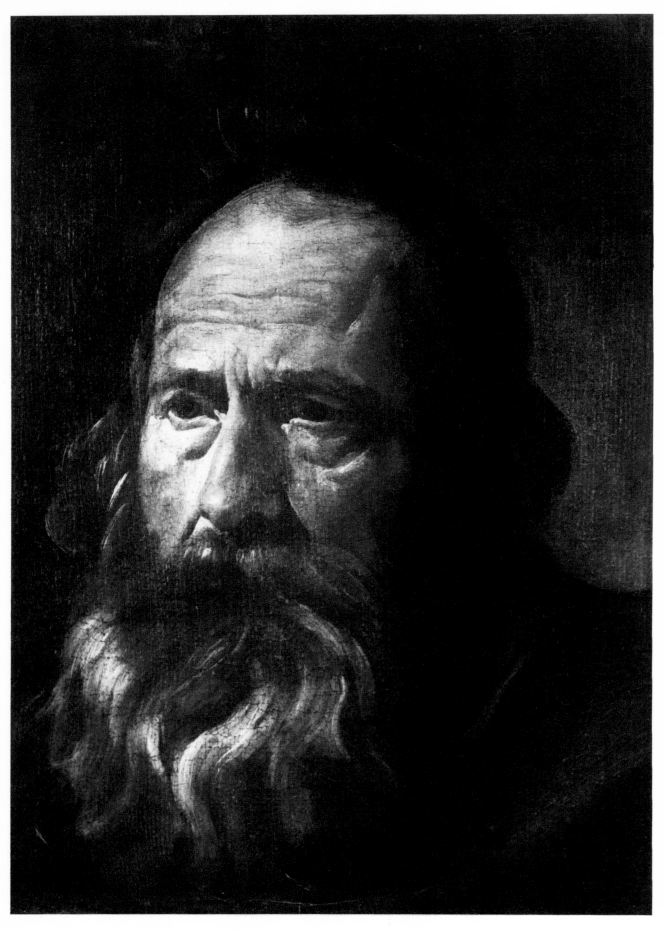

Fig. 45. HEAD OF AN APOSTLE. C. 1620-1622. Madrid: Condesa de Saltes Collection. Cat. No. 26.

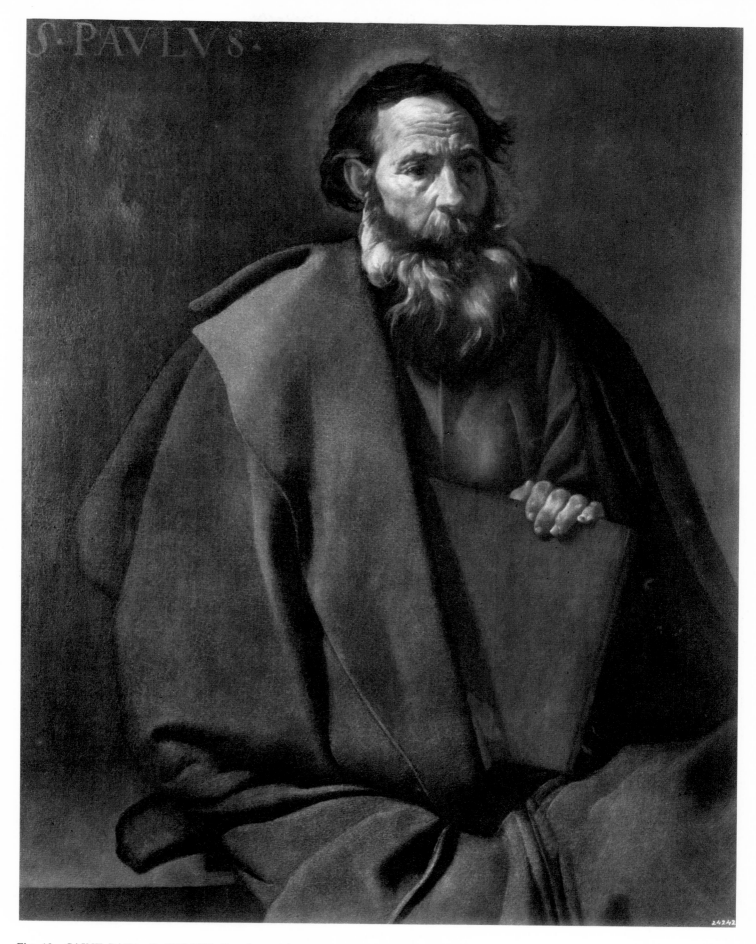

Fig. 46. SAINT PAUL. C. 1620-1622. Barcelona: Museo de Arte de Cataluña. Cat. No. 27.

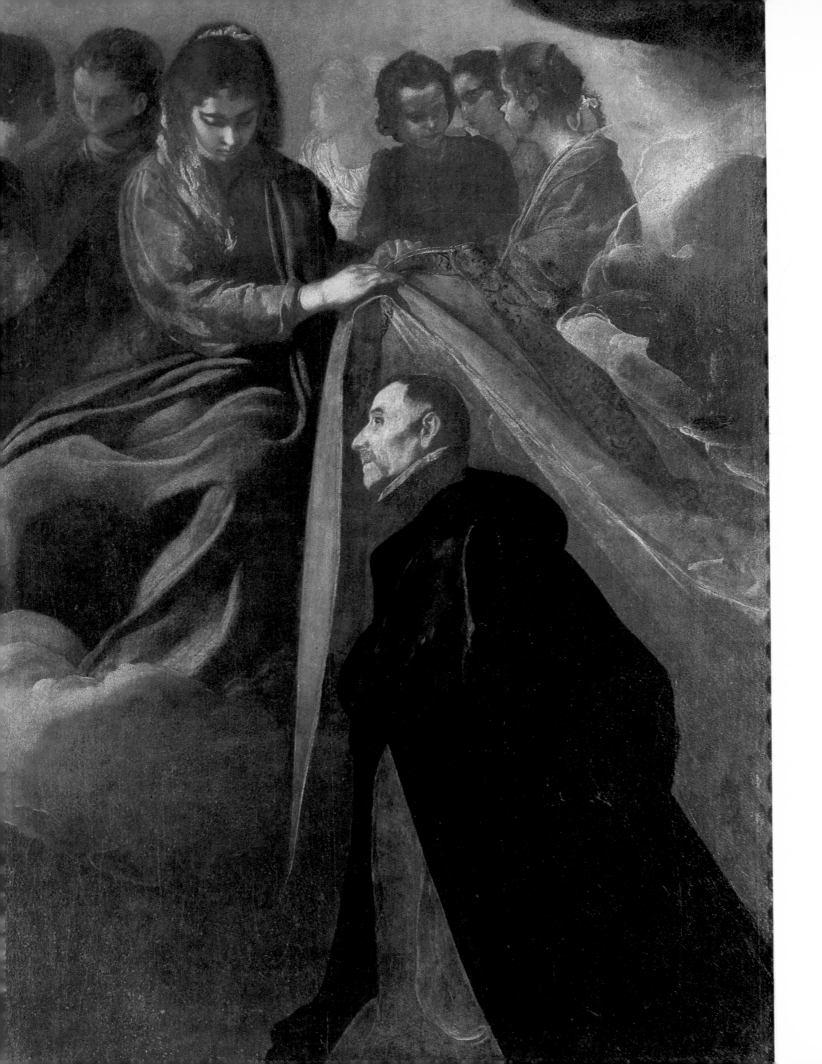

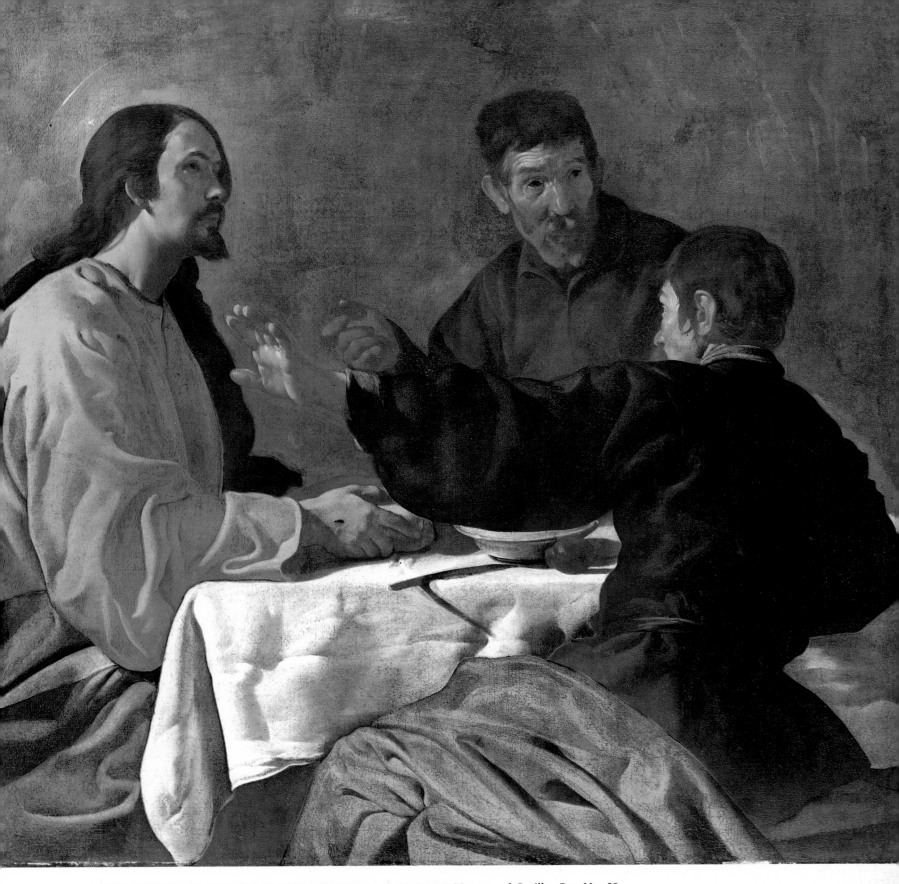

Fig. 47. SAINT ILDEFONSO RECEIVING THE CHASUBLE. C. 1622-1623. Museum of Seville. Cat. No. 28.
Fig. 48. CHRIST AT EMMAUS. C. 1622-1623. New York: Metropolitan Museum. Cat. No. 29.

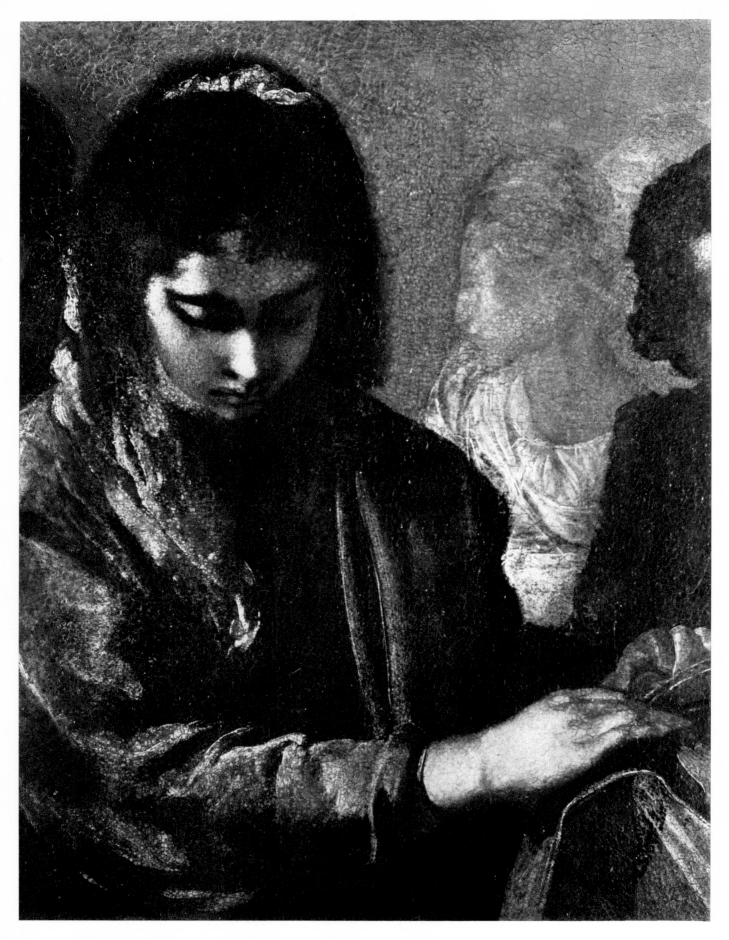

Fig. 49. SAINT ILDEFONSO RECEIVING THE CHASUBLE. Detail of figure 47.

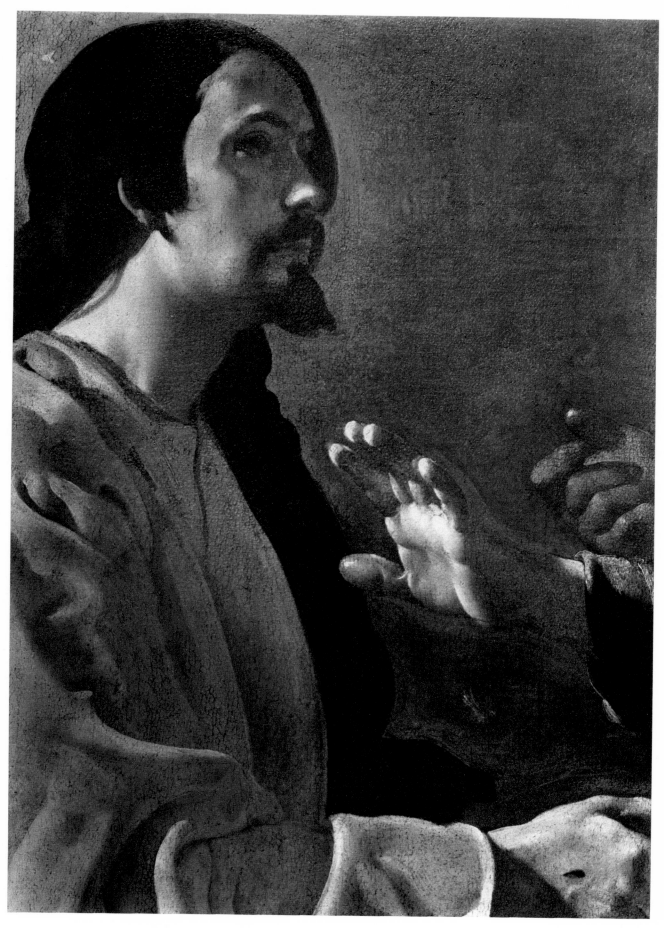

Fig. 50. CHRIST AT EMMAUS. Detail of figure 48.

Fig. 51. KNIGHT OF MALTA WITH A SKULL. C. 1620. Milan: Private collection. Cat. No. 30.

Fig. 52. MAN WITH RUFF. C. 1621-1622. Madrid: Prado Museum. Cat. No. 31.

Fig. 53. LUIS DE GONGORA. 1622. Boston: Museum of Fine Arts. Cat. No. 32

of modelling, but the pigment has become more flexible. The intensely realistic textures – almost like reliefs – which in the London *St. John* produced an effect that showed Velázquez's concern for tactile qualities, have been softened in this work. The open form is treated with more delicate contrasts of tone and a richer variety of shades. The penitent saint is shown sitting in a cave, the entrance to which is almost hidden by trailing ivy. The rays of light fall on the open book and the paper on which the saint is writing notes, as well as on the pile of manuscripts in the foreground with an hour-glass on top of them and a skull beside them. The drapery in which half the figure is wrapped is wonderfully treated and the anatomy of the bare torso and the strength of the head are equally impressive. The lion that accompanies the saint is only just visible in the mysterious half-light of the background. It is interesting to notice that the model for this self-absorbed, absent-minded figure was the old man with the unkempt beard in the two versions of *The Luncheon (Figs. 12 & 13).* This is a further proof of the short space of time between those two paintings and the *St. Jerome,* which was probably painted early in the third decade of the 17th century.

After this series of figure-paintings, in which the background is neutralized or eliminated as much as possible, we come to a new instance of attention being paid to the setting: the admirable *St. John the Baptist* in the Art Institute of Chicago *(Figs. 43 & 44 - Cat. 25).* Even the most superficial comparison of this work with the *St. John on the Island of Patmos* — which is to some extent similar — will show quite clearly this evolution of the artist's concept of painting. The landscape becomes more important, with masses of penumbra marking the various planes, though the central figure of the composition is still evidently predominant. By now Velázquez had totally mastered the art of representing the male nude, a theme which was later to lead him to further discoveries. The progress made in the art of representing saints convincingly is confirmed, for though this picture cannot be called a mystical work, it is no less true that the nobility and spirituality of the figure make it permissible to accept the work as an excellent youthful portrait of the Baptist. In the face there

is a blended modelling that eliminates any harshness and the painting shows a tendency towards an aesthetic that was to grow and develop in years to come, once the closed-form style characteristic of Velázquez's first period had been outgrown. Other interesting features of this picture are the tactile qualities and the beautiful effects of the light which filters towards the viewer through the branches, creating meticulously drawn *contre-jour* effects. The landscape gradually loses any kind of conventionalism and becomes truer and more naturalistic.

It is not that the painter has forgotten the intense effect of relief that can be obtained by placing a light-coloured figure against a dark background; but he has seen that without destroying this effect he can greatly enhance it by introducing a more distant, luminous plane and using the *contre-jour* effects to blur the middle distance.

This softer brushwork becomes more evident in the canvases studied below, which I believe to have been painted between 1621 and 1623. The softening process, which led to a more open treatment of form, eventually became a whole new concept of painting, culminating in the first portraits painted in Madrid. The beginning of this process may be detected in a vigorous representation of *St. Paul (Fig. 46 - Cat. 27),* on which the saint's name is painted in capital letters of the type used by Velázquez in inscriptions on canvases from his Sevillian period. This picture most probably belonged to an Apostle series, which undoubtedly also included the bearded head in the fragment of a canvas now in the Condesa de Saltes Collection *(Fig. 45 - Cat. 26).*

As in the preceding canvases, in these two the light comes from a single source, which produces intense shadows. If we compare them with his earlier representations of saints we shall see that the painter has now attained a certain inner maturity and that his purely painterly gifts developed before his capacity for – or interest in – the creation of typologies or the transformation of his models into sacred images that would inspire respect if not devotion. In painting so eminently figurative and thematic as that of the 17th century, the factor of typology is not without importance. These apostles, like the saints studied

earlier on, are images of inquietude with a certain dramatic feeling; this, however, is something that is hinted at rather than openly stated.

The last canvases of the Sevillian period

This evolution towards a subtler style of painting, with rather less abrupt gradations of tone, reaches a climax in the interesting *Christ at Emmaus* in the Metropolitan Museum of New York *(Figs. 48 & 50 - Cat. 29)*. Here Velázquez makes an effort to achieve a typology more attuned to traditional ideas of iconography, presenting us with a figure of the Saviour quite at odds with the naturalistic realism adopted for religious characters by the painters of the Sevillian school. Though without any especially expressive character, the harmony of the face and the goodness emanating from it are admirable. To accentuate the contrast Velázquez intensifies the realism of the pilgrims, who seem to be not so much apostles as just any two individuals chosen at random from the common mass of humanity — almost as if they were characters from one of his early *bodegones*. A bold stroke is the arrangement of the figures in a triangle, which he underlines with the axes determined by the pilgrims' gestures. Undoubtedly this work has certain affinities with Caravaggio's painting of the same theme in the National Gallery in London. It may have been one of the last works painted by Velázquez in his native city; the change from all that went before is so noticeable that it was probably painted in the months between the painter's first visit to Madrid (April-June 1622) and his definitive move to the capital, in July 1623. In my opinion, the radical transformation – or, rather, considerable mutation – that this canvas represents in the tempestuous progress of his first seven years as a professional painter reflects something of what Velázquez must have seen and assimilated during his first visit to Madrid.

Special attention must be paid to the very interesting canvas depicting *St. Ildefonso Receiving the Chasuble*, which was recently transferred from the Archbishop's Palace of Seville to the Museo de Pin-tura in the same city *(Figs. 47 & 49 - Cat. 28)*. Its poor state of repair and the restorations to which it has been subjected make it impossible to speak of its technique with any precision, but enough can be seen to justify us in ascribing it to the end of the Sevillian period. An interesting feature of this original composition is the contrast between the ascetic expression on the saint's face and the surpassing joy of the group of figures in Heaven, a group that is rich in tonal contrasts, particularly charming foreshortenings and splendid effects produced by the intermingling clouds. The Virgin, represented naturalistically, inclines her head in perfect foreshortening; also noticeable in this figure are the total harmony of the face and the bright areas of the clothing. Velázquez undoubtedly painted this work, as he did the *Christ at Emmaus*, after having seen something more than the work of his Sevillian colleagues, or so we may believe from the sense of form, the complexity of composition and the variety of problems faced and successfully solved. This may well have been one of the very last canvases he painted in Seville, during the brief period of waiting for the promised call to Madrid.

Portraits

I will close this chapter on Velázquez's first period with two male portraits that may be considered the immediate forerunners of the portrait of the poet Góngora, which was done during the painter's brief visit to Madrid in the spring of 1622. The first is the *Knight of Malta with a Skull (Fig. 51 - Cat. 30)*, of which there is a replica in the Royal Palace in Madrid and which I consider to have been painted in 1620, judging by its technical similarity to the portrait of the nun Jerónima de la Fuente. In its naked symbolism of death, the skull in the foreground in the lower part of the picture seems to reflect the ideology of the man portrayed. The latter's bald head, moreover, appears to be intended as an analogy in form. Also evident is the meditative character of this man, who carries himself nobly but wears a sad, weary expression. In this very sharply-caught likeness the material qualities are perfectly depicted, from the sparse hair,

the vein standing out in the forehead and the man's glance, to the dynamic rhythm of the ruff and the precise modelling of the skull.

The second of these canvases is the *Man with Ruff* in the Prado (*Fig. 52 - Cat. 31*), popularly known (without the slightest foundation) as the "Portrait of Pacheco". The sitter is portrayed in bust-length and, like the Knight of Malta, wears the goffered ruff that was forbidden in 1623 by order of Philip IV. It is an intense, vivid portrait in which the sitter is painted at very close range. The chiaroscuro plays an important role and the right side of the splendid head – unlike the one in the preceding portrait – is left in shadow. Though the other side of his face is adequately lit, the contrast is gentle and subtly nuanced, while the rhythms of the ruff harmonize with certain details of the figure. The technique used in this work is the same as that of the *St. Paul* in Barcelona (*Fig. 46*).

In these two portraits, which are important milestones in Velázquez's career, the drawing continues to assert itself through the painting and the colour is still strictly subordinated to the modelling of the form. They do not show any desire to achieve restless vivacity or to capture a specific moment, but rather the artist's intention of representing the essence of his sitters, statically but with no trace of archaism. They are portraits which, like El Greco's best work, confront us not only with the persons portrayed but also with the social and spiritual world to which they belonged; they are, in short, representatives of their age and – to an even greater extent, perhaps – of Spanish severity. As regards the execution, the artist's ability in modelling has evidently attained to greater intensity and the range of subtly different textures to be found in a face is wonderfully established in each of the two portraits.

Of the portrait of *Luis de Góngora*, which is mentioned by Pacheco, there are three practically identical versions extant (*Fig. 53 - Cat. 32, 33 & 34*). This is certainly an impressive picture, part of its impressiveness being due to the fact that the sitter was no ordinary mortal and even to the psychological factor of our knowledge that the face before us is that of

one of the most original lyric poets of his age. Though this face is hard and bitter, it is neither tense nor restless but rather seems to possess a certain serenity and indifference. From the pictorial point of view, this whole work is carried out with inexorable objectiveness and extreme simplicity in a brilliant exercise of austere virtuosity. The most fascinating aspect is the deeply shaded modelling, which follows the structures of the face so closely that it makes us feel the presence of the bone under the skin and muscles. There is a certain amount of geometrization, half-hidden by the fine elasticity of the pigment but intensified by the precise effects of the chiaroscuro.

In my opinion all of these three versions of the portrait of Góngora, of which there also exist several contemporary copies, are certainly by Velázquez himself. The one in Boston, painted with thicker pigment and richer in shading than the other two, was most probably the first; indeed there are noticeable traces of corrections that to some extent confirm this. X-rays have revealed that the poet's head was at first crowned with laurels, which were painted over when the artist was giving the last touches to the grey background. The replicas in the Prado and the Museo Lázaro Galdiano reveal slight technical simplifications, carried out in such masterly fashion that they could only have been done by Velázquez himself. This impressive portrait of Góngora brings to a close the first chapter in the prodigious story of Velázquez's life and work.

To make a brief recapitulation of the essential features of this first period, we might say that it is chiefly distinguished by the following: a) direct confrontation with the living model, which argues a deep sense of humanity and a passion for veracity; b) a skilful and efficacious use of chiaroscuro in the modelling, precise in technique and without indulging in any spectacular use of foreshortening to give the composition a more theatrical effect; c) the consolidation of a limited colour range – based chiefly on ochres, subtly-shaded tones in the flesh-tints and contrasting lights – that was to become representative of the Spanish school of painting as a whole, though on account of the frequency of its use in that school rather than its absolute consistency; d) a roundness of form that was to be the basis of his pro-

gressive dematerialization in technique, without any tendency either to expressionism or to idealism.

Velázquez's painting had yet to pass through many different stages, which we will gradually analyse in chronological order; and although his great middle period, with its various sub-periods, saw the development of a particular interest in colour and the qualities of air, his art was always to give pride of place to tone over colour and to the direct and human over the grandiloquent and literary.

II

VELÁZQUEZ PAINTER TO THE KING

1623-1629

DATA CONCERNING THE FIRST PERIOD IN MADRID. – TEXT BY PACHECO. – THE FIRST PORTRAITS AT THE COURT. – THE SECOND PORTRAIT OF PHILIP IV. – THE SECOND PORTRAIT OF THE COUNT-DUKE. – PORTRAITS OF THE ROYAL FAMILY. – ANONYMOUS PORTRAITS. – *BACCHUS (THE TOPERS)*. PAINTINGS ATTRIBUTED TO THE END OF THE PERIOD 1623-1629" – *THE TEMPTATION OF ST. THOMAS AQUINAS*.

In this chapter I intend to deal with Velázquez's life and work in the period between his removal to Madrid and his first journey to Italy. The documentary evidence for this period is scanty indeed and the texts of Pacheco and Palomino extremely vague. Our knowledge of the great painter's life at the time is consequently very slight, despite his rapid success. His first portrait of Philip IV was so successful that he was appointed one of the "Royal Painters" at the age of twenty-four; he won a competition suggested by the King himself to stop the grumblings of the other royal painters; he made the acquaintance of Rubens, who recognized his extraordinary talent; and the fame of his works and some of the works themselves went beyond the Spanish frontiers. Very few of the works from this period are still extant; indeed only a very small proportion of all Velázquez then painted has come down to our own days. It is curious to realize that there are fewer works preserved from this first stage in his career at the Court than there are of his Sevillian period.

He was still in Seville on July 27th 1623, for on that date he signed, as guarantor for his father-in-law, the contract for an altar-piece in the Chapel of the Conception in the parish church of San Lorenzo.

Shortly after that he set out for Madrid, expressly summoned by the Count-Duke of Olivares, who had sent him fifty ducats for his expenses through the good offices of Juan de Fonseca. Pacheco, who was his companion on this second journey to the capital, tells about it in the following terms.

Text by Pacheco

"In 1623 he was summoned by this same Don Juan (by order of the Count-Duke); he was lodged in his house, where he was well-treated and well-served, and he painted his portrait. It was taken to the Palace that night by a son of the Conde de Peñaranda, chamberlain to the Infante-Cardinal, and in an hour it had been seen by everyone in the Palace, including the Infantes and the King, which was the highest honour accorded to it. He was ordered to paint the portrait of the Infante, but it seemed more advisable to do that of the King himself first, though it could not be done so quickly on account of his more important concerns; it was done, in fact, on August 30th 1623 and was praised by the King, the Infantes and the Count-Duke, who declared that the King had never been properly portrayed till then; and the same opinion was expressed by all the gentlemen who saw it. He also did, in passing, a sketch of the Prince of Wales, who gave him a hundred escudos.

He was first received by His Excellency the Count-

Duke, who encouraged him to work for the honour of his country and promised him that he had only to paint the portrait of His Majesty and other portraits would immediately be ordered. He instructed him to move his household to Madrid and dispatched his certificate of appointment on the last day of October 1623, with a salary of twenty ducats a month and all his works to be paid for, and with all costs of doctors and medicines besides."

I think it is of interest to include here a transcription of the actual text of the royal order with Velázquez's appointment to the post of "Royal Painter", which confirms and completes Pacheco's rather vague account:

"In view of the good accounts I have received of the skill and ability of the painter Diego Velázquez, I have decided to admit him to my service for such time as may seem good to me, with a salary of twenty ducats, worth seven thousand four hundred and eighty maravedís, per month, and the obligation to exercise his profession at my Court, or wherever he should be sent, being paid for such works as he may do according to appraisal or previous agreement; and it is my wish that, as from the sixth day of this month of October and for as long as he may remain in my service, you pay him these twenty ducats each month out of any sum in my account, on the same date as the others are paid their salaries..." (October 31st 1623).

It would appear that Velázquez and his family were given lodgings on the fourth floor of the "Casa de la Panadería", the elegant building erected by Philip III in that most beautiful square, the Plaza Mayor of Madrid.

It seems only natural that the date assigned by Pacheco to Velázquez's first portrait of Philip IV should be that on which the work was begun. It may also be supposed that it was a full-length portrait rather than a "sketch" like the one he did of the Prince of Wales. It should be remembered that the heir to the throne of England, the future Charles I, was then in Madrid for negotiations concerning his possible marriage to Philip IV's sister, the Infanta María, negotiations that came to nothing in the end, apparently on account of the difference in religion, an all but insuperable barrier at that time.

1624-1626

The first document concerning any of the works of Velázquez still in existence is one signed by the painter on December 4th 1624, in which he acknowledges receipt of eight hundred reales "for the three portraits, of the King and the Count-Duke and Señor Garciperes". These were commissioned by Doña Antonia de Ipeñarrieta, the widow of Don García Pérez de Araciel, a Knight of the Order of St. James who had been treasurer of the Council of Castile and secretary to Olivares. Two of these portraits are the *Philip IV* in the Metropolitan Museum in New York and the *Count-Duke of Olivares* in the Museum of São Paulo, both of which we shall be studying in the following pages (*Figs. 54 & 58*).

In his valuable – though vague – chronicles of the life of Velázquez, Pacheco mentions, without giving the date, the painter's first illness in Madrid: "By order of His Majesty ... the Count-Duke sent the King's own doctor to examine him." The text later continues: "After having finished the portrait of His Majesty on horseback, taken from life, as well as landscape ..., it was placed in the Calle Mayor in front of (the church of) San Felipe, to the admiration of the whole Court and the envy of other artists, as I can bear witness. And some very elegant verses were composed on it. His Majesty gave orders for him to be paid three hundred ducats to cover his expenses and an allowance of a further three hundred, to receive which he was granted a dispensation by His Holiness Pope Urban VIII in the year 1626. He was later granted the favour of a lodging, worth 200 ducats each year." Quite well-known, indeed, are the sonnets by Vélez de Guevara and Pacheco himself, as well as the eulogy in verse by Jerónimo González de Villanueva, all dedicated to the equestrian portrait of the young Philip IV. According to Palomino, this portrait was dedicated and dated "Anno Christi XXV Saeculi XVII Era XXA."

Of great interest are the following notes from royal archives published by Azcárate. On August 22nd 1625, 299 reales were paid to the gilder Julio César Semin, "for gilding a wooden frame for the portrait painted by Diego Velázquez". Shortly afterwards orders were given for the removal, from the Palace

of El Pardo to the Alcázar of Madrid, of the equestrian portrait of Charles V by Titian, to adorn a new drawing-room built over the main entrance. In the same room, apparently, an equestrian portrait of Philip IV was to be hung, in all probability the one mentioned by Pacheco. In an appraisal of frames carried out on April 6th 1626, mention is made of "a large frame for the portrait of His Majesty that is in the new drawing-room, with its stretcher thirteen and three-quarter feet high and eleven and three-quarters wide", and with "the moulding the same as in that of the Emperor". In the note of payment for the gilding of this we find: "a canvas on which is painted our lord the King on horseback, in dimensions more than life-size, for the new drawing-room over the porch of the Alcázar". Another document of 1625 reveals that in the same room three other equestrian portraits were to be placed, "of the same size as the portrait of His Majesty on horseback in the new drawing-room", and they were to be done by the painters Vicente Carducho, Eugenio Caxés and Bartolomé González.

This information is evidence of the greatest importance for the solution of the problem of the equestrian portraits that adorned the drawing-room known as the "Salón de Reinos" in the Palace of El Buen Retiro, which we shall be studying in Chapter IV of this book.

There is still very little information about Velázquez in 1626. On March 7th he applied, on Francisco Pacheco's behalf, for the post of royal painter left vacant by the death of Santiago Morán. It was not a particularly important post, for the salary was only eighty ducats. Nor is there any record of the request having been granted.

1627

Don Juan de Fonseca, that patron of the arts in whose house Velázquez lodged on his arrival in the capital in 1623, died in Madrid on January 15th 1627. And it was Velázquez who was given the task of drawing up the inventory and valuation of his collection of paintings. In the inventory there is "a picture of a water-seller, by the hand of Diego Velázquez", which was assessed at a value of 400 reales, the highest in the whole inventory. As I said in the first chapter, this was probably a picture painted in Seville which Velázquez took with him to Madrid to give to Fonseca. As it was bought by Gaspar de Bracamonte at the sale of the pictures in the inventory, it was probably the latter who gave it to the Infante Fernando, whose chamberlain he was. It is therefore logical enough to identify the "Water-seller" in the Fonseca inventory as the famous picture presented by Fernando VII to Wellington which we studied in the preceding chapter (*Fig. 22*).

1627 was also the year of the celebrated competition for a painting on the subject of "The Expulsion of the Moriscos". Palomino's account of this, rather more detailed than Pacheco's, runs in part as follows: "lately he executed, by order of His Majesty, the Canvas depicting the Expulsion of the Moriscos ... Don Diego Velázquez painted this event in competition with three other royal painters (Eugenio Caxés, Vicente Carducho and Angelo Nardi), and since his was the best of all, in the opinion of the persons appointed for the purpose by His Majesty (who were the reverend father Fray Juan Bautista Mayno and Don Juan Bautista Crescencio, Marqués de la Torre), it was the one chosen to be placed in the drawing-room in which it hangs today.

In the middle of this picture stands King Philip the Third, armed and with a stick in his hand, pointing to a troop of men, women and children who are being led, weeping, by some soldiers, and in the distance some carts and a view of the sea with some ships waiting to transport them.

On the King's right hand is Spain, represented as a majestic matron sitting at the foot of a building, armed in the Roman fashion with a shield and some darts in her right hand and some ears of corn in her left.

It was finished by Velázquez ..., as is attested by the signature, which he placed on a vellum painted on the inner step, reading as follows: *Didacus Velazquez Hispalensis. Philip. IV Regis Hispan. Pictor ipsiusque iusu, fecit, anno 1627.*"

This canvas was intended as a pair to the Titian in the Prado that shows "Philip II offering Prince Fernando to heaven", which, as a result of its "enlarge-

ment" by Vicente Carducho, measures 3.35 metres in height by 2.74 in width. It must have been a difficult task to paint such a complex composition in a vertical format.

It appears that Velázquez's reward for this victory was his appointment to the "honourable office" of usher of the bedchamber, and he was sworn into this post on March 7th 1627. Its emoluments consisted of twelve *placas* a day (the *placa* was worth about a quarter of a real), lodging and his medical and apothecary's expenses.

In a letter dated March 24th 1627, the ambassador in Madrid of Vincenzo Gonzaga II, Duke of Mantua, says that he had ordered two small equestrian portraits to be painted, one of Philip II and the other of the Count-Duke, and that on showing them to the favourite the latter told him that Velázquez would have painted them better: "and since they were to be sent to Your Highness ..., he ordered the said painter, who was painting the queen, to leave any other work and do these portraits". On May 22nd the Duke of Mantua wrote to say that he had received the two portraits, "che ci sono estati cari".

On August 3rd of the same year Velázquez and his wife empowered Pacheco to sell the houses they owned in the Alameda of Seville, which had been part of Juana Pacheco's dowry. This is the last we hear of any connection between Velázquez and his native city.

At about this time the royal painter Bartolomé González died and on December 1st 1627 Velázquez, Vicente Carducho and Eugenio Caxés submitted reports on possible candidates for his post. Velázquez recommended the appointment of Antonio Lanchares.

1628-1629

In a document dated September 18th 1628, the King ordered that, in addition to his emoluments as a royal painter, Velázquez should receive a daily payment of twelve reales, "as is received by the royal barbers, in consideration of his having agreed to cancel all that is owing to him to date for such of his professional works as he has done for me and all such as I may in future order him to do". This amounts to a tacit admission that the palace accounts were in a bad way and that Velázquez, apart from receiving his normal salary long after it was due, was not to be paid the amounts at which some of his works had been valued.

Another document made it clear to the painter that the phrase "such as I may in future order him to do" referred only to royal portraits. Thus Velázquez's permanent salary was increased to the sum of 11,500 reales a year, plus his medical and apothecary's expenses.

In August 1628 Peter Rubens arrived in Madrid. His stay in the capital lasted nine months and is described by Palomino in the following terms: "In this same year there came to Spain Peter Paul Rubens (that monster of talent, skill and fortune, as he is called by diverse authors and seen to be in his works), as Ambassador Extraordinary of the King of England, to negotiate the peace with Spain, by the express wish of the Archduke Albert and Her Serene Highness Doña Isabel Clara Eugenia, his wife, on account of their high opinion of Rubens and the great fame of his learning and talent.

With painters (as Pacheco tells us) he had little communication; only with Don Diego Velázquez (with whom he had already corresponded) did he strike up a very close friendship, admiring his works, on account of his great virtue and modesty; and they went together to the Escorial to see the celebrated Monastery of San Lorenzo el Real; they both took especial delight in seeing and marvelling at so many admirable prodigies as there are in that sublime mansion, and most particularly in the original paintings by the greatest artists that have flourished in Europe, whose example served as a fresh stimulus to the desire Velázquez had always felt of going to Italy to see, speculate and study among those eminent works and statues which are the glowing torch of Art and the fittest subject of admiration."

Rubens' personality had a great impact on Velázquez and, though the great Flemish artist's concept of painting did not influence either his technique or his inner vision, a whole world of qualities and lofty ambitions was now revealed to him. And in another aspect Velázquez was able to see for himself Rubens' incredible capacity for work, for besides accomplishing

his diplomatic mission the visitor painted a score of portraits and copied as many again from the royal collections.

It was also Azcárate who published the following evidence of what Velázquez was paid by the royal treasury: a first payment of 21,300 maravedís was made on January 9th 1624. In late December of the following year he received 90,000 maravedís (which made 240 ducats) and the same sum at the end of the year after that. His 1627 salary was not paid until the beginning of January 1628 and that of this latter year was not finally settled until June 20th 1629.

A royal order of July 22nd 1629 grants Velázquez the sum of 400 ducats, "worth one hundred and fifty thousand maravedís. Three hundred of these in payment for a painting of Bacchus which he has done to my order". This interesting piece of information that reveals the date of payment for Velázquez's *Bacchus* – that famous composition in the Prado better known by the title of *The Topers* – really marks the beginning of the chronicle of the painter's first journey to Italy, which we shall be studying in the next chapter.

* * *

The first portraits at the Court

Pacheco mentions three paintings as having been done by Velázquez in Madrid between August 1623 and December 1624: the portrait of Juan de Fonseca, the first portrait of Philip IV and a sketch of the Prince of Wales, all three since lost. He must, of course, have painted many more, especially as he was such a rapid and prolific painter. He certainly painted other likenesses of the King and the Count-Duke and the production of royal portraits probably continued throughout Velázquez's early years at Court. We have evidence, moreover, that his work for the Crown did not prevent his accepting private commissions. One proof of this is the receipt dated December 4th 1624 for the portraits of the King, the Count-Duke of Olivares and Señor Garciperez (d. 1624), which had been commissioned by Doña Anto-

nia de Ipeñarrieta. The first two figure in the 1668 inventory of the Palace of Narros, in Zarauz, and they were still there in 1905, being the only documented evidence of the work done by Velázquez in his early days as a royal painter. They were offered to the Prado by the ducal family of Villahermosa, but owing to a lamentable error of technical appraisal they were considered to be from Velázquez's workshop but not by the great painter himself, with the result that the offer was turned down. It is true, indeed, that the receipt proving their authenticity was not found until some time later. At all events, both canvases were sold outside Spain and the portrait of Philip IV is now in the Metropolitan Museum of New York, while that of the Count-Duke hangs in the Museum of São Paulo.

In the first the young king is portrayed standing beside a table covered with red velvet, in a pose that shows self-assurance, but without any haughtiness or tendency to the hieratic *(Fig. 54 - Cat. 35)*. In a black silk suit, a wide, flat ruff with only the simplest of radial pleating and a black woollen cape, he wears the Order of the Golden Fleece with an elaborate chain. This chain and the flesh-tints are the only notes of colour in this elegant figure, surely the soberest of all royal portraits of the 17th century.

This portrait belongs to the same concept of painting as that of Góngora, done in 1622 *(Fig. 53)*. In his second year as a royal painter Velázquez was still perfecting his closed structures, attenuating contrasts and giving even greater sharpness to the focal precision of each element and the sensitivity of the line. Predominant features are the simplification of objective reality and the indomitable urge to synthesize the qualities of the materials. It is easy to see that Velázquez is thinking of the idea of "representation" and is perfectly aware that it can never be an exact copy but only a translation into pictorial terms within a balanced arrangement of values. By this I mean that in his treatment of hair, for instance, we can see how he succeeded in suggesting the idea of loose hairs in all their fineness and flexibility without attempting an over-analytical drawing or producing such a fleeting idea of form as he was to achieve in his last period, when a reflection of golden light was sufficient to give

a perfect suggestion of a woman's or child's head of hair. The background of brownish yellow complements the blacks and greys of the costume.

In the portrait of Olivares mentioned in the 1624 receipt we find the same concept of painting, the same technique and the same colour range *(Figs. 57 & 58 - Cat. 38)*. The favourite is wearing the red cross of the Order of St. James and his figure is more carefully modelled, as if some intense, subtle impulse of the imagination had led Velázquez to embellish this image – though it is only a replica of another – with even more care and effort. The tactile qualities are depicted with unusual virtuosity, above all in the silky folds of the right sleeve or in the whole central area of the figure, with the chain, key and golden spurs belonging to the offices of Master of the Royal Horse and Chief Steward of the Palace. In certain areas the apparently simple technique employed conceals a complex superimposition of impasto and fine scumblings, which in some cases modify the initial structure. The second background coat – i.e., the one painted in the final stages of the picture – reduced the outline of the skull and widened the fold of cloth hanging behind the left hand by about eight centimetres. The painter also modified the position of the legs and feet and made slight alterations to the hand resting on the table. All this shows us how Velázquez regarded each canvas as a living thing that gradually took shape throughout the painting process, with such modifications as might be necessary to produce the best result. This portrait is evidently the product of many sittings and a considerable amount of work on the part of the artist. We shall see how Velázquez, in time, gradually succeeded in reducing the intensity of this work and achieving in the preliminary stages effects even subtler and more complex than the ones in this portrait.

Apparently these two canvases, which show us how Velázquez painted at the beginning of his career at Court, are really replicas, by his own hand, of lost prototypes. The portrait of Philip IV must have been an exact reproduction of the canvas painted, according to Pacheco, in August 1623. This seems to be confirmed by X-ray photographs of the portrait of the King in the Prado, which, as it is a later work, will be studied in the following pages *(Fig. 59)*.

Beneath the elegant figure in this canvas, indeed, there is a blurred image of Philip IV himself that coincides with the royal portrait painted for Doña Antonia de Ipeñarrieta. It is surprising that Velázquez, to paint what was to be the second in his long series of royal likenesses, should have re-used the canvas of an earlier portrait, thus destroying the work that had won him his appointment as a royal painter. This hypothesis, first advanced by López-Rey, is a very likely one for, as we shall see, this sort of radical repainting was to be repeated in other royal portraits by Velázquez.

Needless to say, working methods such as these implied both an absolute faith in his capacity for surpassing himself on the part of the artist and an immense belief in his talents on the part of his powerful clients and patrons.

There are two further versions of this portrait of Philip IV, differing only in those slight – but sometimes very important – variations of nuance to be found in all replicas of their own works painted by great artists. One is the full-length replica in the Boston Museum of Fine Arts *(Fig. 56 - Cat. 37)* and the other a bust-length version – without the chain of the Golden Fleece – apparently preserved in its original format, which is in the Meadows Museum in Dallas *(Fig. 55 - Cat. 36)*. The hypercritical attitude that committed the lamentable error of closing the doors of the Prado to the two portraits just studied was also guilty of relegating the Boston canvas to the joyless limbo of "workshop copies". I can see no reason whatsoever for this condemnation and as I consider, indeed, that this work is in no way inferior to the portrait authenticated by Velázquez's original receipt, I have absolutely no hesitation in restoring it to the list of the painter's genuine works.

Before going any further, I should like to make one incidental observation. Until his first portraits of Philip IV and Olivares, Velázquez had always shown himself to be a realist attuned to the rather popular world that surrounded him in Seville, but he reacted quite naturally to working at Court, revealing the aristocratic temper of his character. Thus he depicted the King and the most important personages of the realm with the same directness and simplicity,

but at the same time reflected a sense of nobility that we do not find in the characters of his Sevillian works. Apart from his capacity for adaptation and development, this shows his sensitivity to different atmospheres.

The second portrait of Philip IV

It would seem probable that the first full-length portrait of Philip IV was the prototype for another likeness of the King, formerly in the Palace of El Buen Retiro and now in the Prado *(Figs. 59 & 61 - Cat. 39)*. In this portrait Philip, who had reached the age of twenty on April 8th 1625, is wearing an incipient blonde moustache. The face has changed only as much as might be expected in a young man of his age over a period of less than three years. It is the expression that has altered subtly. The King's consciousness of his own rank and responsibility, already present in the first portrait, was in time to become more noticeable in successive portrayals, until this expression was changed, years later, to one of weariness and dramatic disillusionment, while the eyes became more slanted and the jaw rather more prominent. In this second portrait the erect figure is very similar to the 1623 model, though the position of the legs is more elegant. The suit, though different, is still black and very similar to the one in the earlier picture, while the ruff is smaller and flatter. The posture is, in general, stiffer and more ceremonious. The work may be considered a prototype, as the thickness of the pigment betrays the hard work that usually goes into a first version. This is the portrait which was proved by X-rays to have been painted over another likeness of the King, possibly the one mentioned as having been done by Velázquez in August 1623.

The Prado has another portrait using the same facial model, in which the King is wearing armour *(Fig. 63 - Cat. 43)*. In it a sash of crimson silk crosses the chest, coming from the right shoulder. As this is a canvas that has been cut, it has been suggested that it may have been the central part of an equestrian portrait, perhaps the one Pacheco tells us was exhibited publicly in Madrid. As in the preceding work, X-rays have revealed the existence, beneath the portrait as it is now, of another version, without the armour and with the radially-goffered ruff so prominent in the first portrait of the King.

It is with absolute conviction that I also feel obliged to restore to the list of authentic works by Velázquez the portrait in the Isabella Stewart Gardner Museum in Boston *(Cat. 40)*, which is an exact replica of the full-length *Philip IV* in the Prado *(Fig. 59)*. I can see no reason for asserting that either of these is a workshop copy. Velázquez could not have organized a full-scale workshop so early in his career, nor is it even likely that there should have been some unknown painter working for him who was capable of reproducing his works so perfectly. Even Mazo, who painted copies of extraordinary quality from the technical point of view, never attained the marvellous simplicity of either the portrait in the Prado or the one in Boston, both condemned by an opinion which I do not hesitate to describe as dangerously rash.

The second portrait of the Count-Duke

We now come to a second portrait of the Count-Duke of Olivares, in which he is shown wearing an elaborate black silk suit and a black woollen cape, both with the green cross of the Order of Alcántara, to which he was admitted in 1625 *(Figs. 60 & 62 - Cat. 42)*. In his right hand, with a gesture that is at once arrogant and discreet, he carries the rod of the Master of the Royal Horse, while the golden key of his office hangs at his waist.

There are two virtually identical versions of this portrait, one in the Hispanic Society of America *(Cat. 41)* and the other in the Várez Collection *(Fig. 60)*. Though differing in certain details, they were both based on the same preparatory drawing and their general lines coincide quite exactly; so similar are they, in fact, that in at least one long and important study one of them was reproduced with the description of the other. The most evident difference is an accessory element: the red curtain in the Hispa-

nic Society's version, which does not appear in the other work. Both were painted with oil which, though very opaque, had a fluid quality that permitted superimpositions without increasing the thickness of the pigment. In large areas of the canvas this fluidity eliminates the traces of the brushwork, but it does not prevent the artist from achieving a perfect shading of gradations, a moderate but most effective chiaroscuro and a modelling that is blended but very intense.

The brushwork is at once masterly and spontaneous in the two versions. Not a single pictorial element is repeated with that slavishness so common in copies, nor is there the slightest sign of the vacillating persistence that betrays the intervention of another hand. I believe that, as in the case of the first portraits of Philip IV, these two canvases are replicas by Velázquez himself of a lost original. The silhouette of the principal elements, especially the lines marking the contact between the clothing and the background or outlining the hands against the velvet of the cloth or the silk of the suit, appears to have been painted in red, though this effect really comes from the visible portions of the red priming of the canvas, which seems to indicate that the picture was painted over an original drawing traced in chalk or some other material that could be easily removed once outlines had been sketched in. This would explain the exact uniformity of the two canvases and the almost total absence of any retouching.

These twin versions of the second portrait of the Count-Duke are evidence of the greatest importance in ascertaining how Velázquez managed in his early days in Madrid when dealing with portraits such as those of the King and his all-powerful favourite. portraits of which he would be obliged to paint several identical copies. In this Velázquez shows us an interesting facet of his method and capacity: his ability to repeat himself without any loss of pictorial quality, thanks to a brilliant simplification of his technique.

Painted in white on the grey of the floor in the Hispanic Society's version we find the abbreviation +A625+, which Miss du Gué Trapier interprets – correctly, in my opinion – as "Año 1625". This dating, which would apply to both versions of the portrait, is borne out by the slight change in physiognomy to be noticed when we compare this portrait with the one in the Museum of São Paulo already studied *(Fig. 58),* for which the painter was paid in 1624. As we have seen, moreover, it was in 1625 that Olivares was admitted to the Order of Alcántara, the insignia of which he is wearing here. This model was to be considered the official portrait of the favourite for some time, since it was used as the original of an engraving by Paul Pontius dated in 1626 and for a bust in grisaille painted by Rubens which is now in the Musée du Cinquantenaire in Brussels. It would seem, therefore, that another replica of this portrait of Olivares was sent to Flanders.

Portraits of the royal family

The series of portraits of the Spanish royal family done by Velázquez before his first visit to Italy is completed by that of the Infante Don Carlos and another of Philip IV himself. The portrait of the King's brother, Don Carlos of Austria *(Fig. 64 - Cat. 44),* whose rather insignificant life lasted from 1607 to 1632, is done on the same lines as those of the King himself, with the same sobriety and the same predominance of blacks and greys. To judge by his appearance, it was probably painted in or about 1627. The brushwork seems freer and looser and the pigment thicker, showing less concern about obtaining a smooth surface. In few of the pictures of this early period in Madrid can we see so clearly as in this one the artist's capacity for maximum achievement with minimum means: in other words, the absolute precision of his brushwork. In this portrait we find a slightly idealized realism, but one which, I am convinced, does not modify either the sitter's physiognomy or his bearing. For Velázquez never flattered his sitters, though he never felt tempted to distort them either, or to seek out their weaker points and exaggerate them, as Goya was to do so spectacularly in *The Family of Carlos IV*.

Again we must consider this way of painting as a natural result of Velázquez's character. These

portraits tell us much of the serenity of an artist who, as a very young man and one of comparatively modest background, succeeded in facing the most important personages of a great empire with as much assurance as he had shown with his professional or occasional models from the lower classes.

I can see no reason for not attributing to Velázquez the portrait of Philip IV, now in the John and Mabel Ringling Museum in Sarasota (Florida), that closes the first Madrid period *(Fig. 66 - Cat. 45)*. In this portrait, probably painted about 1628, the King is shown wearing a picturesque campaigning suit. The facial model is much the same as in the previous portraits, though the shadows have been slightly modified, the moustache is a little fuller and the lower lip somewhat more prominent. Neither the expression nor the pose has changed much either. In this portrait the painter could find no other outlet for his virtuosity than the qualities and warm range of colours in the clothing. The spatial treatment is more complex than in other portraits of the King, thanks to the interplay of shadows, which also gives a greater sensation of depth. The ground in front is very brightly lit, but the background is totally wrapped in shadows. Velázquez probably did this in order to highlight the overall pale tone of the figure, giving it a psychological effect of optimism. The technique has become more spontaneous, a tendency that began with the portrait of the Infante Carlos.

Palomino tells us that during his stay in Naples in December of 1630 Velázquez painted a portrait of Doña María of Austria, Philip IV's sister. This Infanta (1606-1646), who married Ferdinand III of Hungary in 1631, was in Naples between August 13th and December 18th of the previous year, on her way to her wedding. The identification of the bust of the Infanta in the Prado *(Fig. 69 - Cat. 46)* as the portrait mentioned by Palomino has been universally accepted, in my opinion mistakenly. Its closed technique, very similar to that used in the portraits of the King and Don Carlos that we have just been studying, induces me to place it among the works done before Velázquez's journey to Italy. I believe that this beautiful work is really a study painted about 1628, which

was probably used in the royal workshops as a model for portraits of this princess by other artists. To support my argument I would refer the reader to the full-length portrait of the future Queen of Hungary in Berlin and another very similar one in the Oliva Collection in Madrid, works which in their stiffness – due partly to the requirements of protocol and partly to the stiff costumes of the period – are reminiscent of the style of portraiture practised at the Austrian court in the second half of the 16th century.

As we have seen, Velázquez always succeeded in reconciling his obligations as official portraitist to the Court with the creation of real works of art, rich in plastic values; and it is this that saves his work from the coldness and the impersonal quality that they might so easily have had. And so, in this bust of the Infanta María, the aesthetic triumphs over the iconographical, though the realistic concept is not forgotten. Portrait-painting is a definite *genre*, after all, and Velázquez respects it and tries to produce as close a likeness (physical and moral) as possible. But he does not confine himself to this, for his masterly execution puts the portrait on the plane of sheer visual pleasure, of a synthesis between tonal sensuousness and severely logical arrangement. His perfect command of drawing permits him – paradoxically – to forget about drawing and concentrate on the beauty of the brushwork, unlike the linear artists of the preceding generation, who gave all their attention to the meticulously descriptive analytical factor, without establishing any focal or tonal distinctions. And all Velázquez's future career was to be based on the development to their ultimate consequences of these principles, qualities and tendencies.

It is curious that Velázquez, who painted so many portraits of his King, should have left us comparatively few likenesses of the ladies of the royal family. Of all the portraits of Queen Elizabeth still extant, not one is entirely by his hand. This daughter of Henri IV of France and Marie de Médicis, born in November 1602, was married to Philip IV in 1615, though the marriage was not consummated until November 25th 1620. There are some youthful portraits of her, done before Velázquez's arrival in Madrid, and some others – rather uneven in quality –

painted after his influence had begun to make itself felt. The most interesting, perhaps, are the one in the Copenhagen Museum and one in a private collection in Florence *(Figs. 67 & 68)*. They show the Queen as she must have looked in the third decade of the century and undoubtedly derive from a lost original by Velázquez, though we cannot dismiss the possibility that the great painter himself took a hand in painting the heads. The clothing and accessories, which are beautifully done, are probably the work of Bartolomé González, an artist who specialized in the (somewhat mechanical) painting of royal portraits, from his appointment as a royal painter in 1617 until his death in 1627. Another portrait of the Queen, which was certainly painted after 1631, will be studied in Chapter IV.

Anonymous portraits

For technical reasons – difficult and subtly elusive but imperative – I am including in the period ending in 1625 three unidentified male portraits which are undoubtedly by Velázquez.

The first is the *Head of a Young Man* in the Prado *(Fig. 70 - Cat. 47)*, commonly regarded as a self-portrait, though without the slightest documentary or iconographical foundation. This is a really intense work, the most vivid and spontaneous of all Velázquez's works of this period. The light source is situated at a point slightly to the left of the viewer. It is a direct portrait, painted with very fluid pigment. Particularly interesting are the liveliness of the free brushstrokes, the precise effect of the black outlining of the chin and the touch of light on the upper part of the forehead, just where the hair begins. This is a frank, openly realistic work.

The second of these portraits is the *Bust of an Old Man* in the Detroit Institute of Arts *(Fig. 71 - Cat. 48)*. Its technique is the same as that of the early royal portraits, but as it is almost certainly a work painted directly in front of the unknown sitter, the modelling is richer in tonal contrasts. The structure is determined quite objectively with sharp, perfect gradations of shadow. As in other portraits of the period, the black suit and the short, rather wrinkled white collar make the face stand out with unmitigated starkness. This is an authentic masterpiece, though unfortunately incomplete, for the edges of the canvas reveal that it is only a part cut out of what was probably a full-length portrait.

In the *Portrait of a Gentleman* in the Fondazione Contini-Bonacossi in Florence *(Fig. 72 - Cat. 49)*, which is also incomplete, Velázquez used the same technique as in the portraits of Philip IV and Olivares – and within the same aesthetic. Catching the psychology of his sitters was beginning to be as spontaneous a skill for the young artist as the representation of textures; it is, indeed, a question of extraordinary receptiveness rather than of any conscious effort to penetrate to the inner depths of his models. This portrait may not have the direct character of the head in the Detroit Institute, but the method followed is the same. Portraitists, of course, have always produced works of varying intensity, depending on such circumstances as the importance of the sitter, etc. In Velázquez simplification never implies any loss of quality or pictorial interest, but it cannot be denied that variations in the degree of his concern for results make some of his portraits more effective than others.

In this group of portraits painted between 1623 and 1625, which was undoubtedly a kind of trial period for Velázquez, we can see that he considers colour secondary to the idea of form and the sensuous integration of the pictorial quality and the quality of the material represented. For colouring is a thing of vehement, sensual, sensuous temperaments and Velázquez's was rather of the meditative kind. Perceptive to a degree, he was interested in the human qualities of his sitters and the possibilities they offered him for his work. He never gave himself up to orgies of sheer paint or to the slightest wantonness. And in this lies the inimitable originality of his work, together with that tendency to eliminate the unnecessary that was to lead him to the art of suggestion that characterized his final period.

Last in the series of portraits of this period comes the *Portrait of a Young Man* in the Alte Pinakothek of Munich *(Fig. 73 - Cat. 50)*. The technique of this painting is more advanced than that used in the

portrait of Don Carlos. I would consider it to have been painted in or about 1628; the sitter's psychology is caught with such vividness and intensity that it has been considered – on no grounds at all – a self-portrait. Painting with thick but extraordinarily flexible pigment, the artist obtains a very rich variety of nuances within the sober palette of his early Court portraits. The modelling is masterly, comparable with the best achieved by Velázquez in his whole career. The lighting and the concept of chiaroscuro follow the same line. The man's hand, lightly sketched in with black strokes, provides important evidence of the way in which Velázquez laid in his paintings when they were first versions rather than replicas: probably without any preliminary drawing other than some strokes of highly diluted sienna or black on the priming of the canvas, which in this case was pale grey.

Every detail of this work is a delight to the spirit, not only on account of its technical excellence or the nobility of the model, but also because of the aesthetic power of the whole, which comes primarily from that realistic feeling of Velázquez's that was to be the basis for his prodigies of creative synthesis.

Let us now examine two similar works, which critics and art historians have more or less unanimously assigned to Velázquez's first Madrid period: the *Democritus* in the Musée des Beaux-Arts of Rouen *(Figs. 74 & 75 - Cat. 51)* and the *Court Jester with a Wineglass* in the Museum of Art of Toledo (Ohio) *(Fig. 76 - Cat. 52)*. The first is painted with very fluid pigment and close, fine, regular brush-strokes. It is very carefully done, in a rather simplified realistic style, with very precise chiaroscuro. In technique it provides a link with the portrait of Góngora done in 1622, which, as we have seen, marked an important point in the artist's development. But this is true only of the smiling philosopher's clothing, his book and the globe he is pointing to with his left hand. The artist repainted the head and the white lace collar with abrupt strokes of thick pigment and an only partially blended modelling: the same procedure as we shall find in *The Topers*. Very probably, as several critics agree, this model was painted by Velázquez at the beginning of his career in Madrid,

the model being one of the court jesters. This would make it the first in one of the painter's most brilliant series, retouched several years later for reasons unknown to us. Velázquez did well to leave the cloak and the globe untouched, for they represent a very high point in one of the successive phases of his technique, a phase during which he attained to the heights of Vermeer and even of Leonardo's most famous studies of drapery.

This retouching several years later by the artist himself is of particular interest inasmuch as it reveals two different phases in his development painted and superimposed in one and the same work. The untouched part has a simplicity and nobility of form that come directly from the Renaissance. But the technique of the face and the hand, in which the brushwork is used to heighten both the effect of light (rather than the pure relief of the form in itself) and the baroque pictorialism of the pigment, shows us the course the painter was to follow in the decades to come. His final period, indeed, was to be characterized by the use of various techniques in one and the same painting.

But the problem implicit in the work just studied becomes more acute in the second of these canvases, the *Court Jester with a Wineglass,* which uses the same model but with very different intentions. Here the smiling jester seems to be raising the elegant glass of white wine in a toast. Though this canvas has been accepted by most historians as an authentic Velázquez, more recent critics have rejected it as such. While admitting it to be a rather puzzling work, I think it is by Velázquez himself and derives from the *Democritus.*

The technique, however, is rather more advanced, using a dense, blended pigment that is laid on in consistent, meticulously modelled layers to form unusually regular surfaces. The background here is light, while in the *Democritus* it is dark, and this helps to alter the effect of the work to some extent. The technique, again, bears a certain similarity to that used in the portrait of Don Carlos in the Prado *(Figs. 64 & 65)*. Are we to infer, then, that this second portrait of the unknown jester was painted between 1627 and 1628? Everything would seem to point to this.

The critics who do not accept its authenticity have suggested that this work is a comparatively modern "pastiche", but this idea can be dismissed by merely examining the original canvas, for thanks to its splendid state of repair we can see for ourselves the excellence of the technique and the inferences to be drawn. And our conviction that this painting is an authentic Velázquez will be even further strengthened if we compare it with an old copy of the same work, in which the composition is identical but the quality, though respectable, is undeniably different and inferior; this latter canvas is in the Zornamuseet of Mora (Sweden).

Bacchus (The Topers)

There is a royal order still extant, dated July 22nd 1629, which gives instructions for the delivery to Velázquez of 100 ducats, on account for his painting of *Bacchus,* the canvas more popularly known as *The Topers (Figs. 77 to 80 - Cat. 53).* This is a key work in the evolution of Velázquez's technique, a painting of great breadth of vision which sums up, as it were, all that the painter had learnt in his first years in Madrid. It still shows certain archaizing details: the artist's interest in materials, the density of the pigment in certain areas, his taste for the inclusion of simple, everyday objects like the tin plate and earthenware pitcher in the foreground. The composition is very well planned and carried out. The Bacchus is a rather commonplace young man, half-naked and crowned with large vine leaves. The creamy pallor of his torso divides the composition into two areas. On the right we see a group of men, indefinable as to trade or social class and of various ages, but all with the look of beggars. The only slight traces of distinction are to be found in the figure of the man with a dagger being crowned by Bacchus and the sturdy youth offering the deity a glass of white wine. In the foreground below this latter there is a figure seen against the light that is magnificently treated in a flat monochrome. The best of this canvas – apart from the quality of the execution and the superbly skilful drawing this implies – is the articu-

lation of the forms by the projection of light on dark and vice versa, a principle Velázquez was to follow for years in his group compositions (and which may already be found in some works by the Sevillian painter Roelas). Apart from the greenish grey of the sky and some touches of yellow, the predominant range is that of ochre, which also helps to accentuate this picture's affinities with those of the painter's Sevillian period.

The present work is different from those earlier paintings, however, in the evident freedom of the composition, the unconstrained attitude of the figures and the overall sense of volume, which had an excessively hieratic quality in the Sevillian period. Here we have a work of the most absolute naturalism, which is the result both of the painter's conceptual premise and of his mastery of his medium. From the iconographical point of view, this work is not only naturalistic but also quite openly anti-idealistic.

Paintings attributed to the end of the period 1623-1629

I will close this chapter with four canvases of uncertain date: two connected with shooting, Philip IV's favourite occupation and the most popular sport with the nobility of the time, and two large compositions on religious subjects.

The first of these paintings, a recent addition to the Velázquez catalogue, is the *Stag's Antlers* in the Royal Palace of Ríofrío, near Segovia, first made known by Angulo Iñiguez, which is described in a 1636 inventory as "Another canvas in oils of a Stag's Antlers, painted by Diego Velázquez, with an inscription that says that [this stag] was killed by the King our Ld. Phil. fourth in the year 1626" *(Fig. 81 - Cat. 54);* it is similarly described in several other royal inventories and is also mentioned in 1735 as being one of the paintings saved from the fire in the Alcázar of Madrid. The original composition, a simple stag's head with magnificent antlers, was enlarged in the 18th century by having strips of new canvas sewn on, with additions to the picture: four heads of wild animals and a large owl with outspread wings. From the technique, in Angulo's opinion, the original painting was

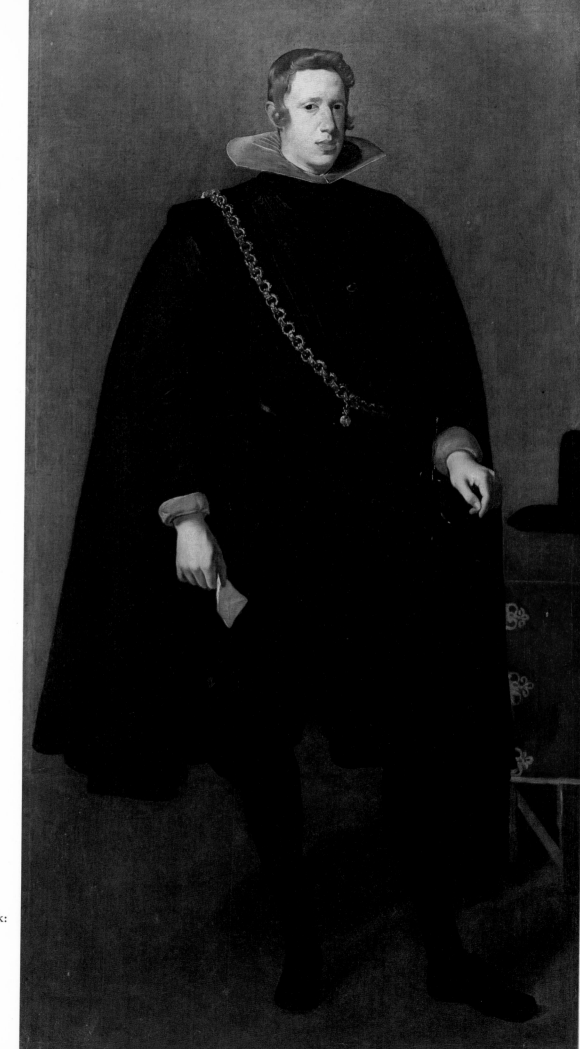

Fig. 54. PHILIP IV. 1624. New York: Metropolitan Museum. Cat. No. 35.

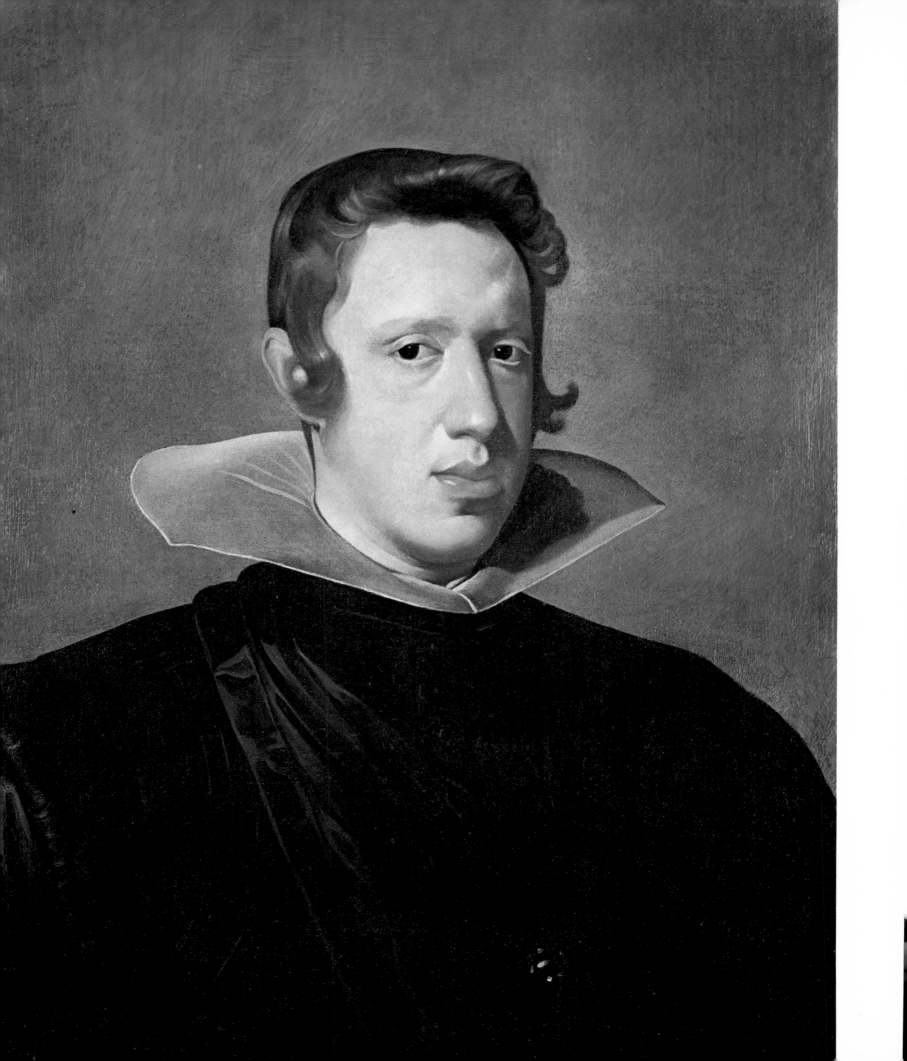

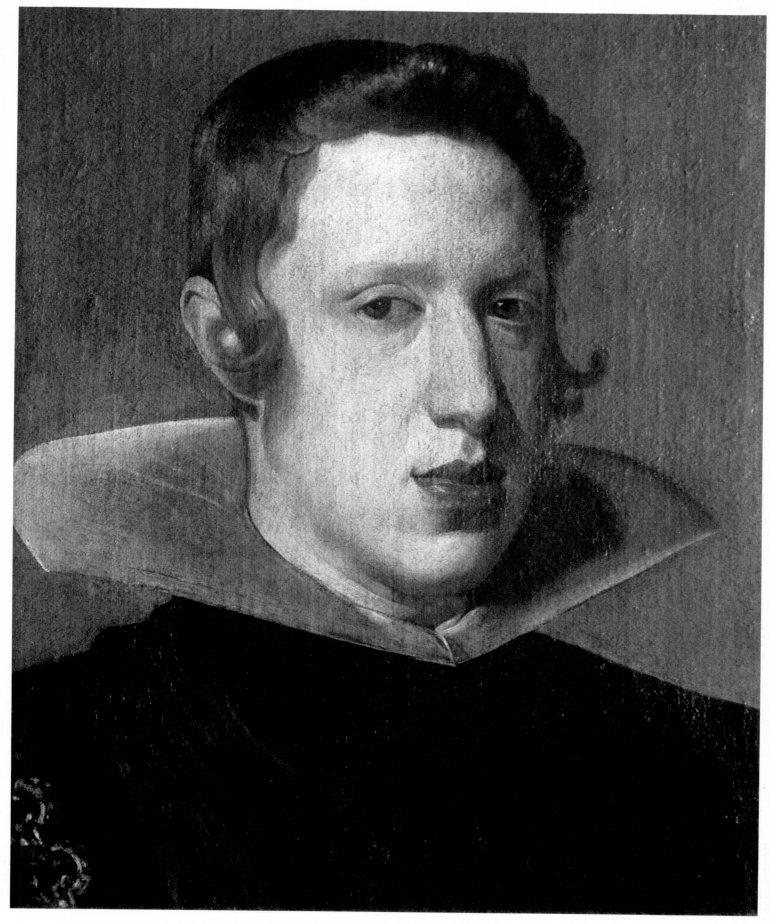

Fig. 55. PHILIP IV. C. 1624. Dallas, Texas: The Meadows Museum. Cat. No. 36.
Fig. 56. PHILIP IV. C. 1624. Boston: Museum of Fine Arts. Cat. No. 37.

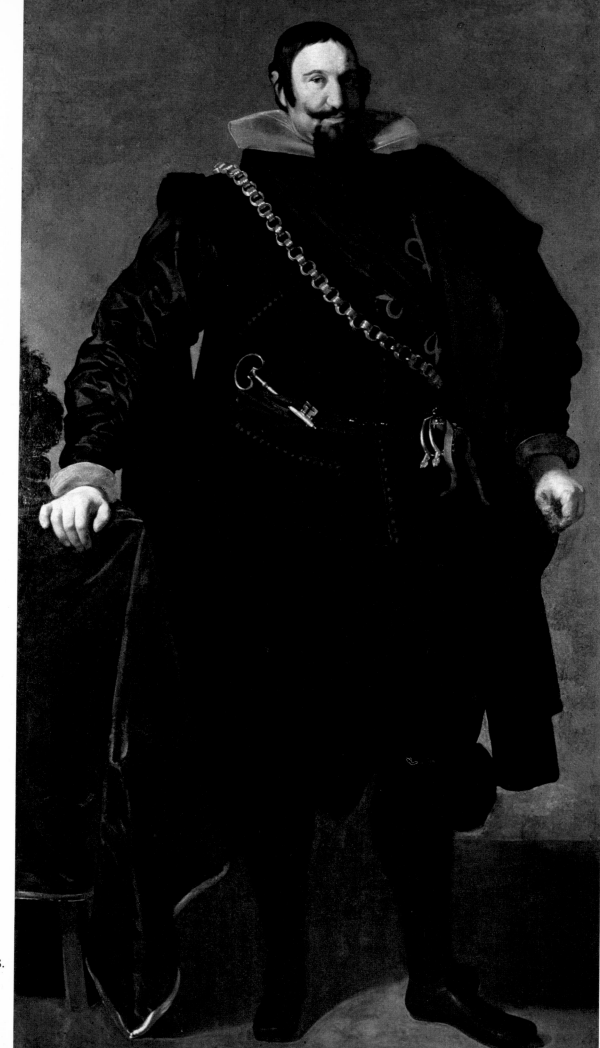

Figs. 57 & 58.
THE COUNT-DUKE OF OLIVARES.
1624. São Paulo: Museo de Arte.
Cat. No. 38.

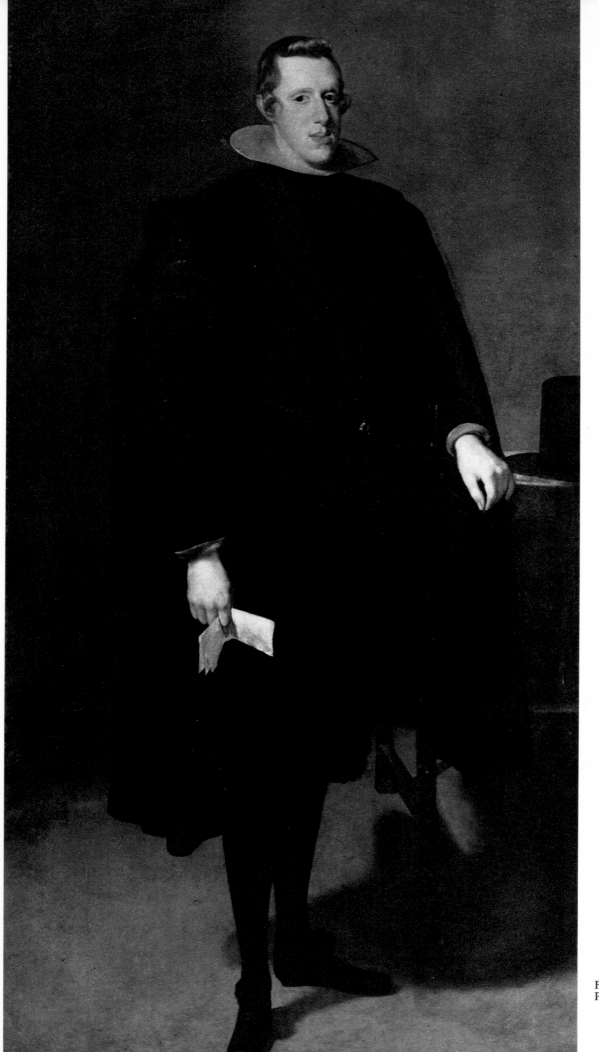

Fig. 59. PHILIP IV. C. 1625. Madrid: Prado Museum. Cat. No. 39.

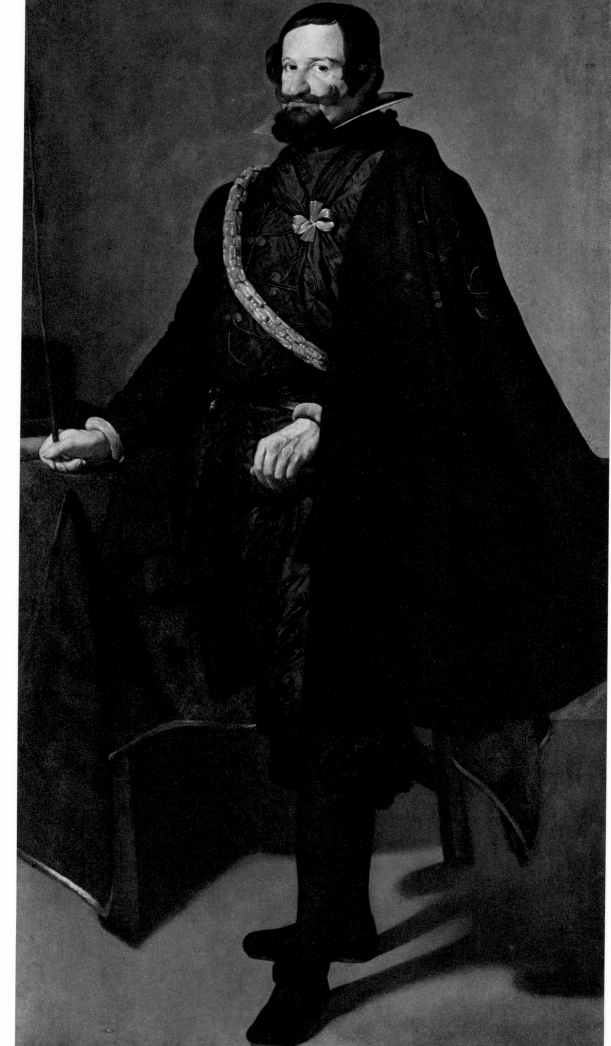

Fig. 60.
THE COUNT-DUKE OF OLIVARES.
C. 1625. Madrid: José Luis Várez Fisa
Collection. Cat. No. 42.

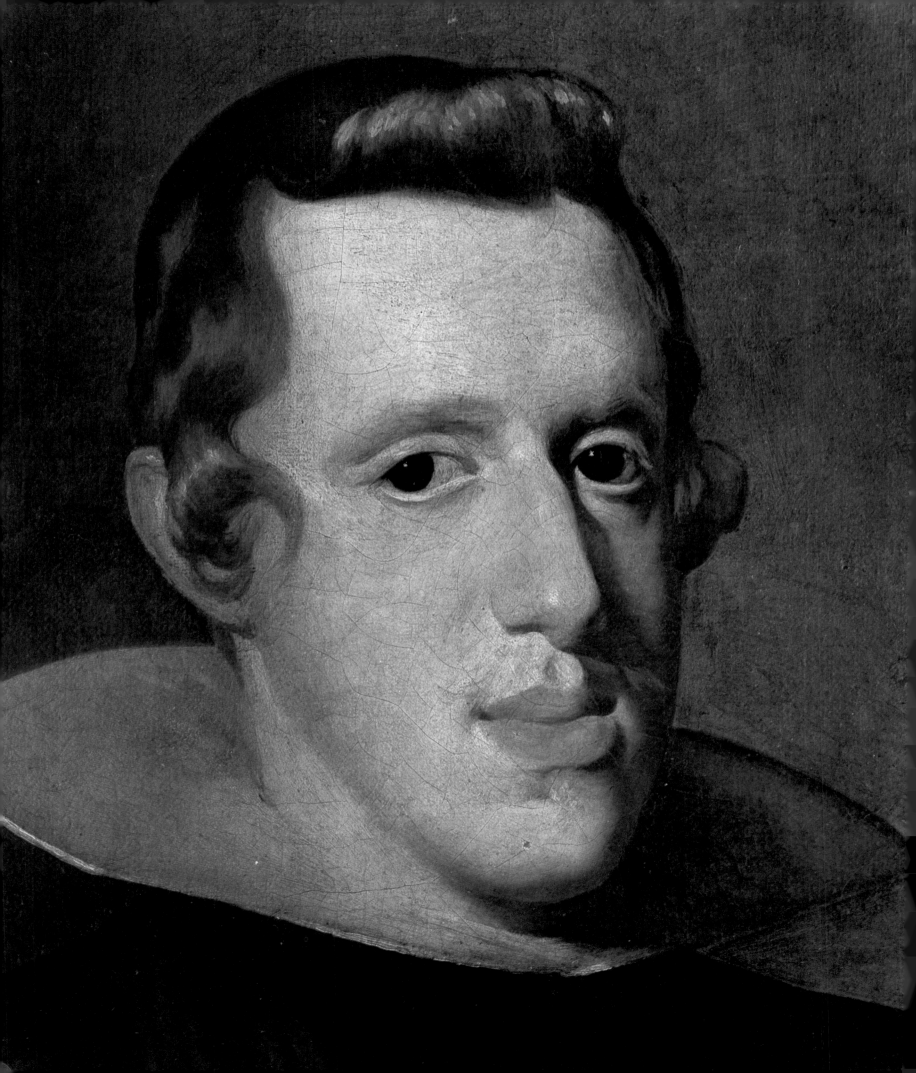

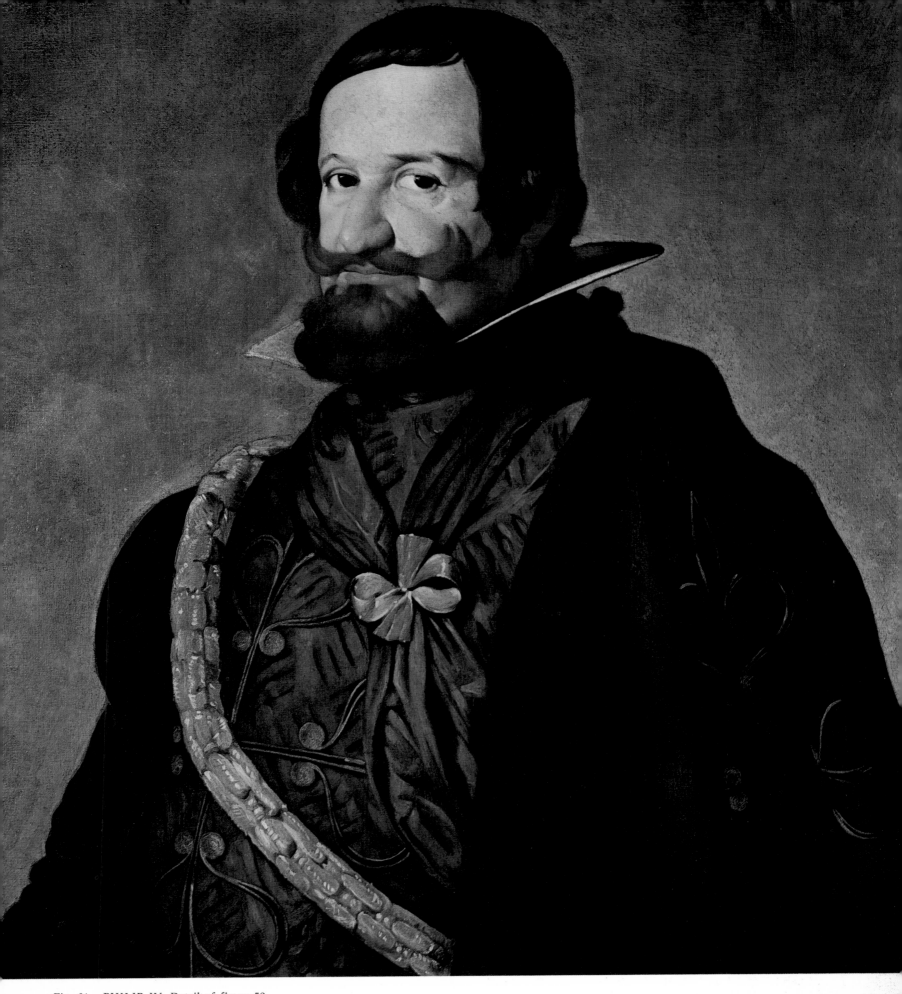

Fig. 61. PHILIP IV. Detail of figure 59.
Fig. 62. THE COUNT-DUKE OF OLIVARES. Detail of figure 60.

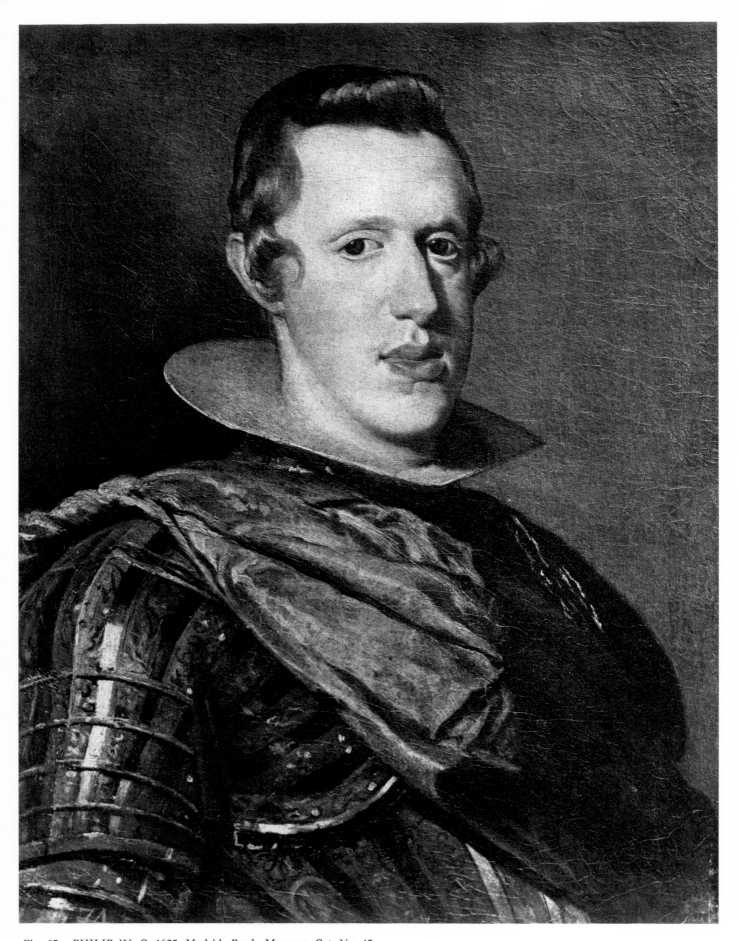

Fig. 63. PHILIP IV. C. 1625. Madrid: Prado Museum. Cat. No. 43.
Fig. 64. THE INFANTE CARLOS. C. 1627. Madrid: Prado Museum. Cat. No. 44.

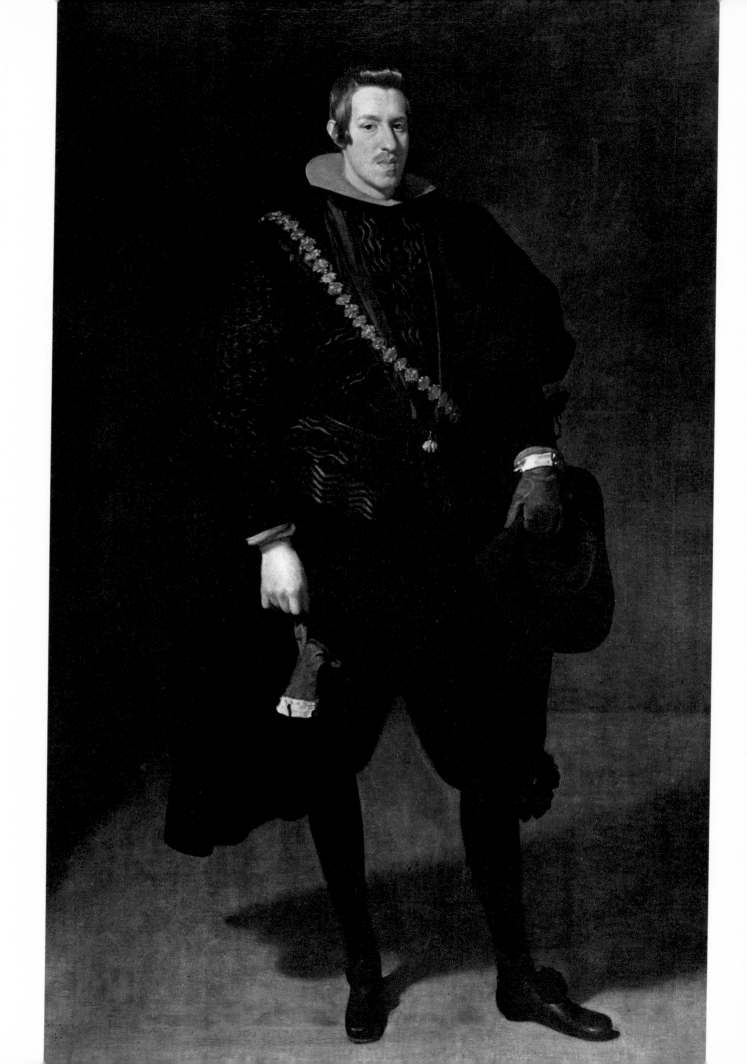

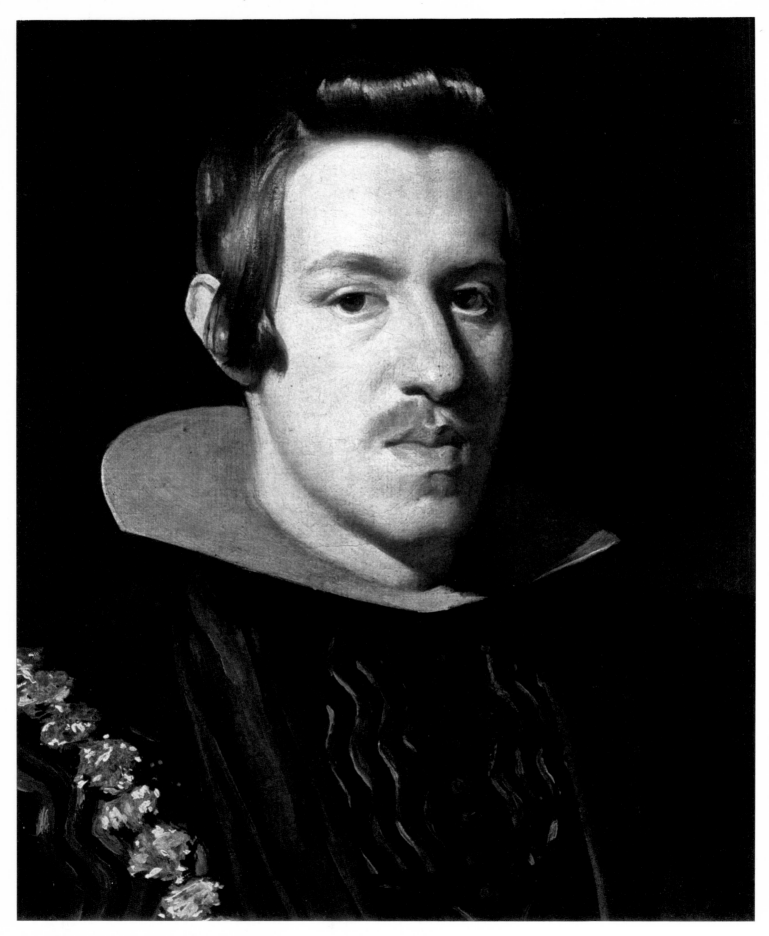

Fig. 65. THE INFANTE CARLOS. Detail of figure 64.
Fig. 66. PHILIP IV. C. 1628. Sarasota, Florida: John and Mabel Ringling Museum of Art. Cat. No. 45.

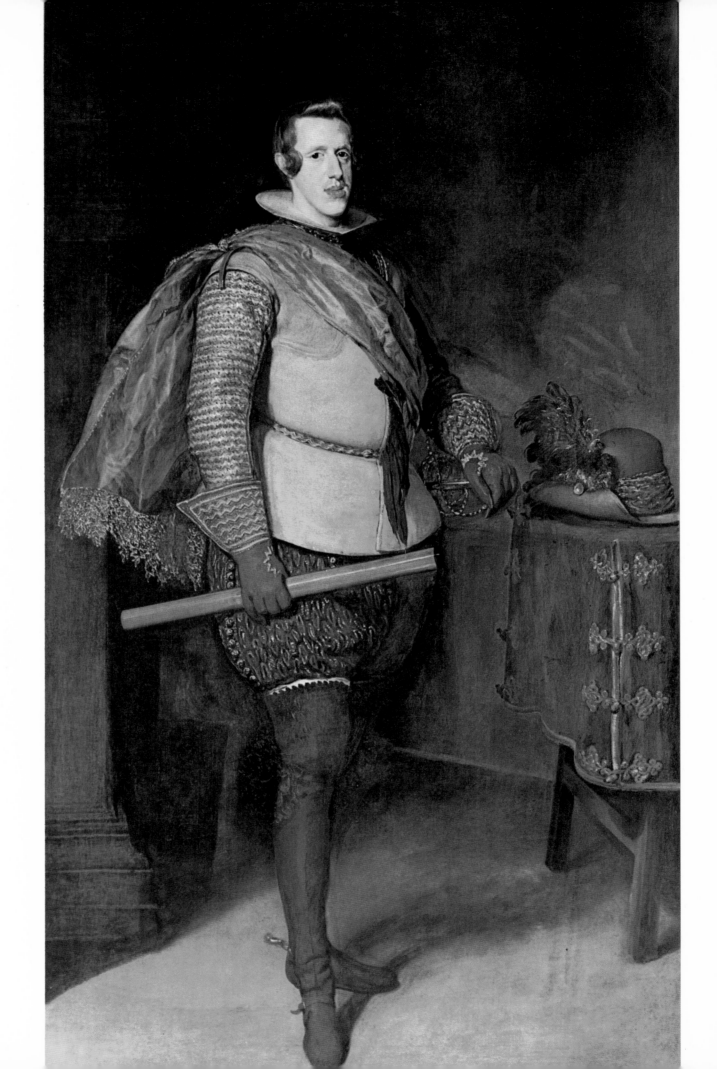

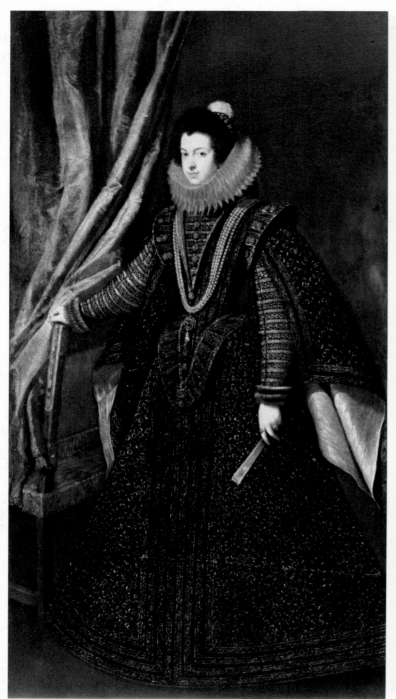
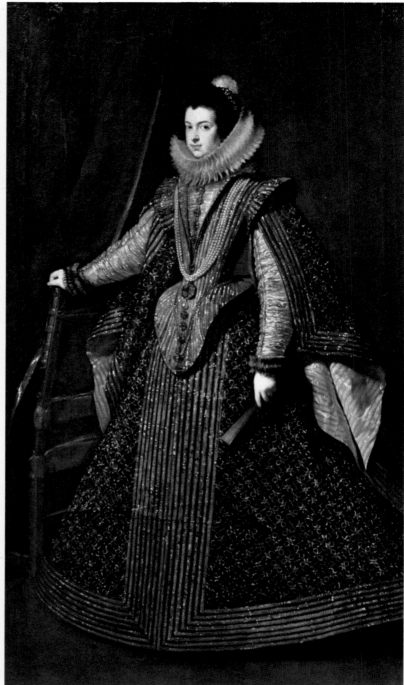

Fig. 67. QUEEN ELIZABETH OF BOURBON. Florence: Private collection.
Fig. 68. QUEEN ELIZABETH OF BOURBON. Copenhagen Museum.
Fig. 69. THE INFANTA MARIA OF AUSTRIA. C. 1628. Madrid: Prado Museum. Cat. No. 46.

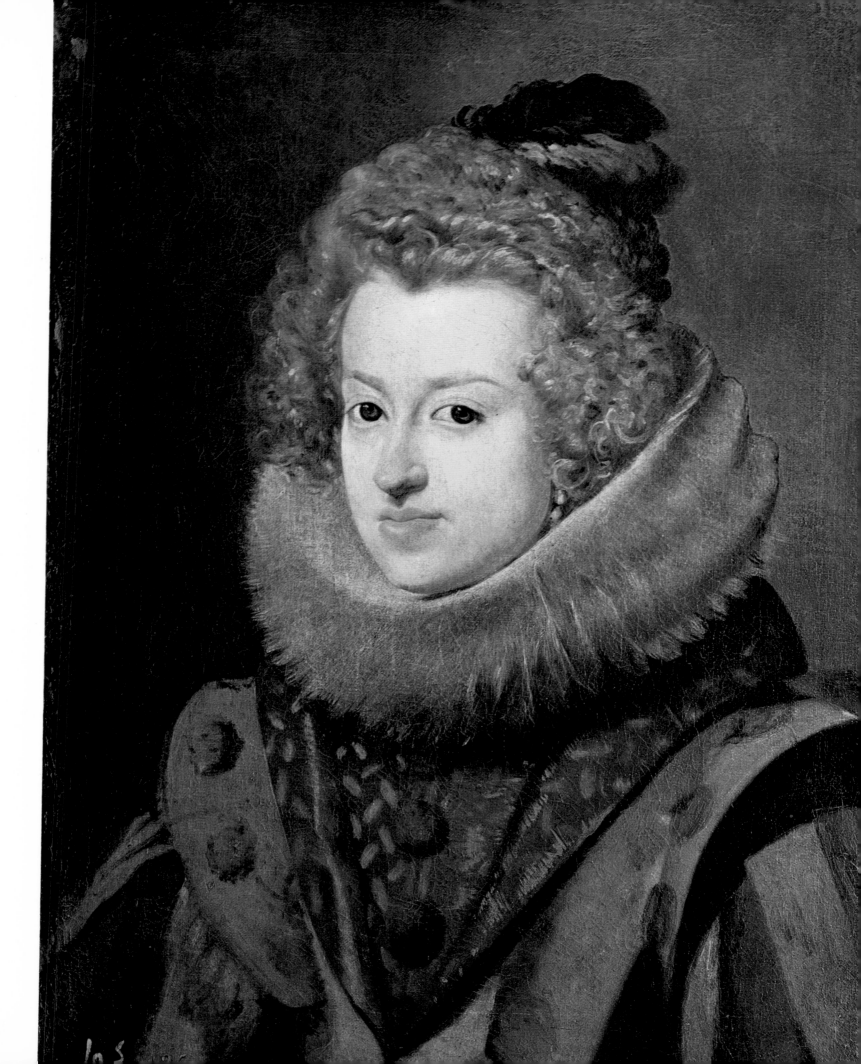

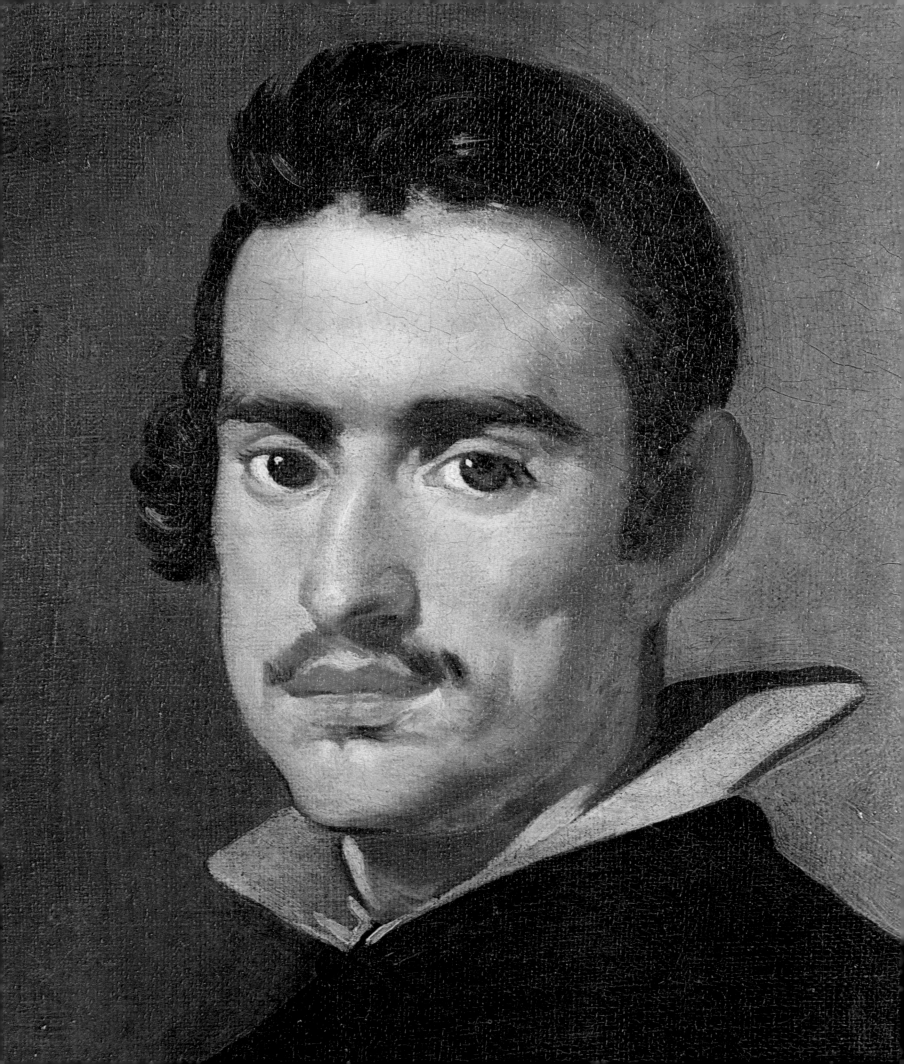

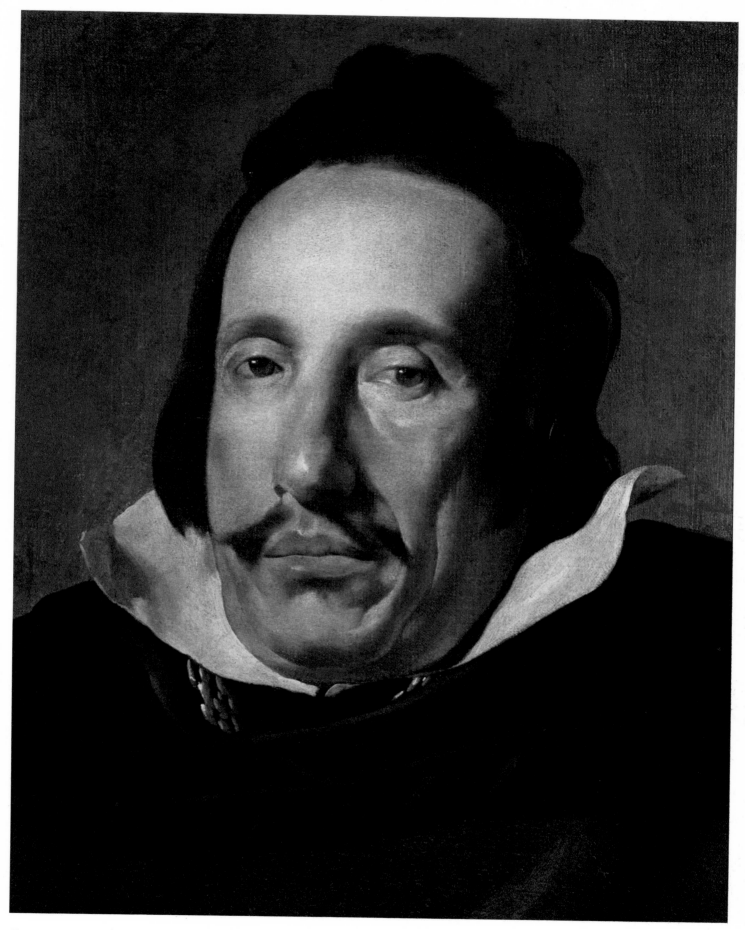

Fig. 70. HEAD OF A YOUNG MAN. C. 1623-1625. Madrid: Prado Museum. Cat. No. 47.
Fig. 71. BUST OF AN OLD MAN. C. 1623-1625. Detroit: Institute of Arts. Cat. No. 48.

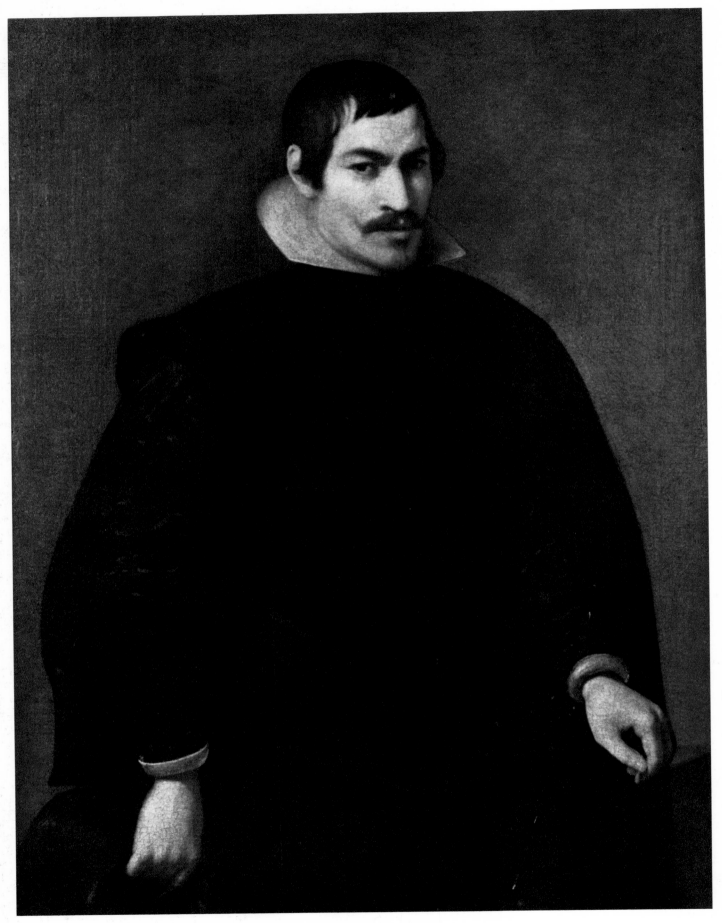

Fig. 72. PORTRAIT OF A GENTLEMAN. C. 1625. Florence: Fondazione Contini-Bonacossi. Cat. No. 49.
Fig. 73. PORTRAIT OF A YOUNG MAN. C. 1628. Munich: Alte Pinakothek. Cat. No. 50.

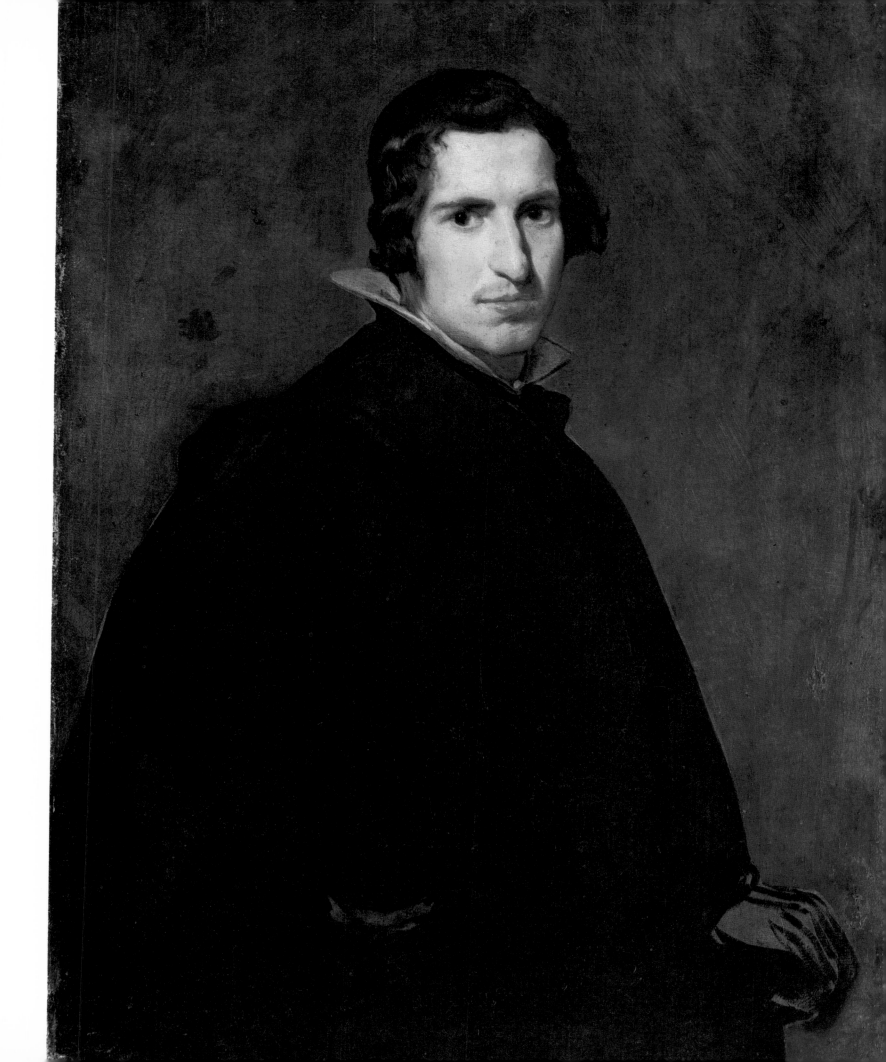

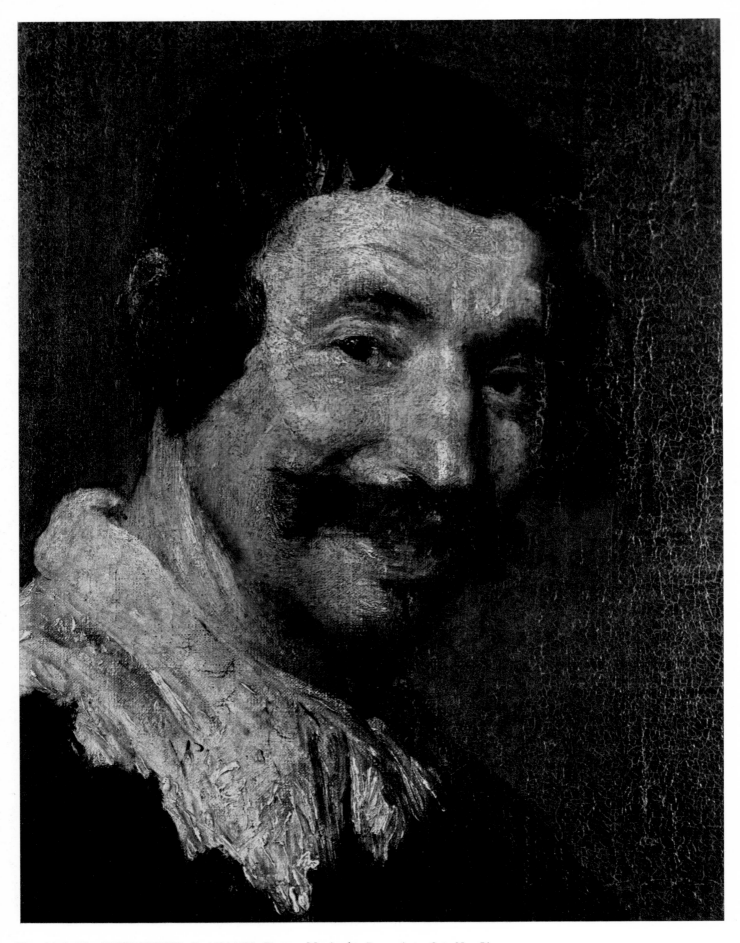

Figs. 74 & 75. DEMOCRITUS. C. 1624-1628. Rouen: Musée des Beaux-Arts. Cat. No. 51.

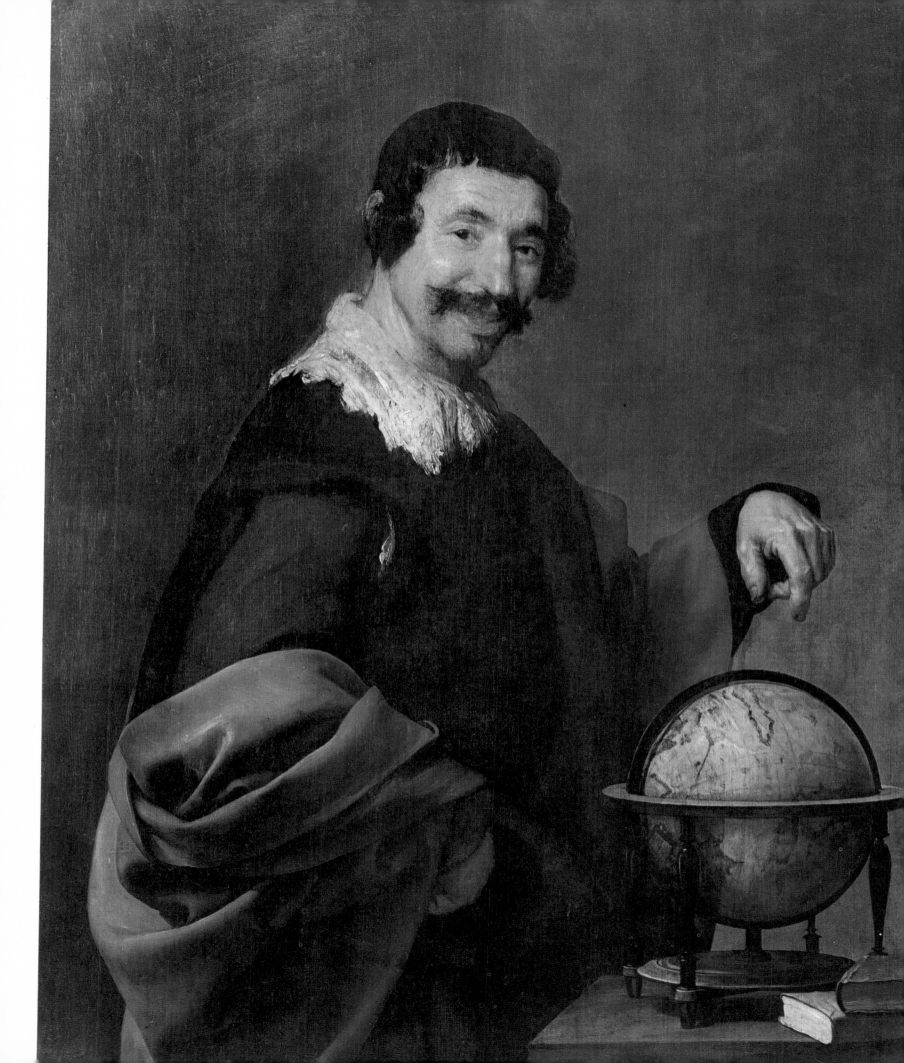

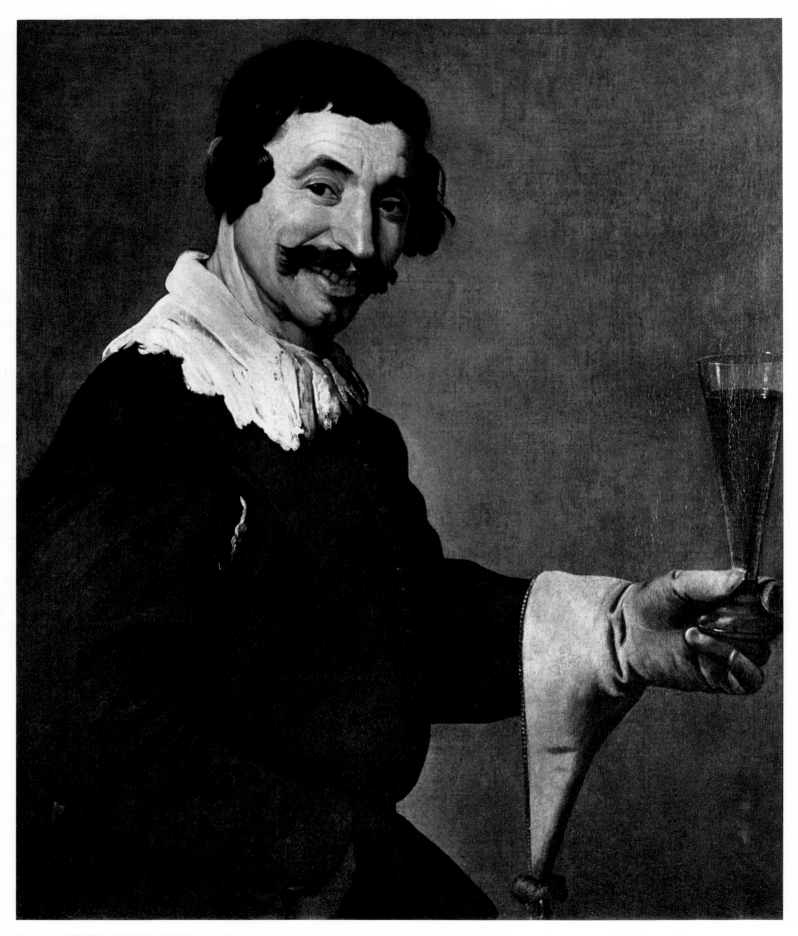

Fig. 76. COURT JESTER WITH A WINEGLASS. C. 1627-1628. Toledo (Ohio): Toledo Museum of Art. Cat. No. 52.

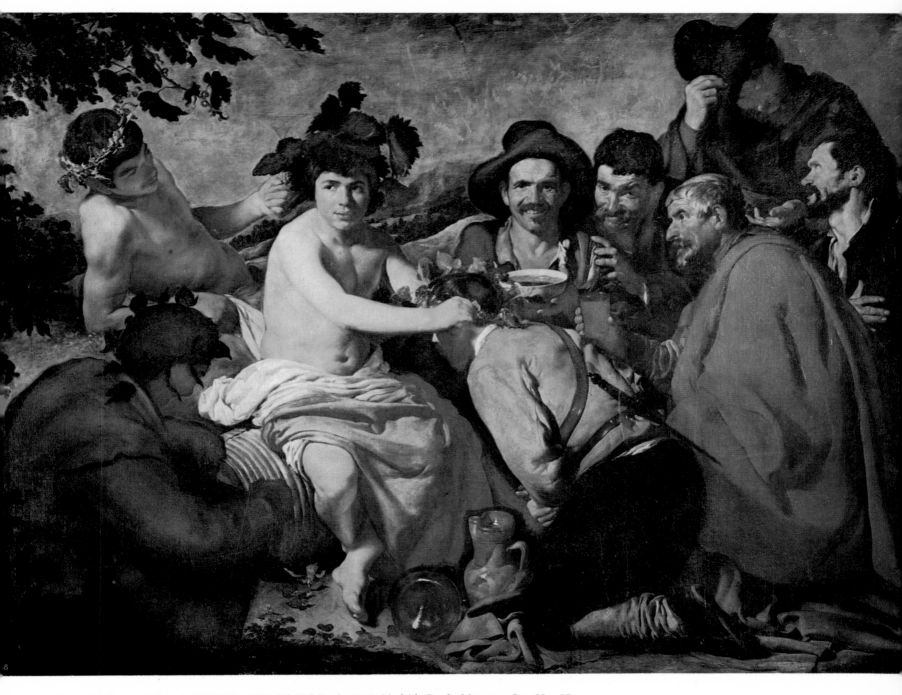

Figs. 77, 78, 79 & 80. BACCHUS (THE TOPERS). C. 1629. Madrid: Prado Museum. Cat. No. 53.

Fig. 81. STAG'S ANTLERS. C. 1626. Segovia: Palacio de Riofrío. Cat. No. 54.

Fig. 82. STAG'S HEAD. Madrid: Vizconde de Baïguer Collection. Cat. No. 55.

Figs. 83 & 84. CHRIST AFTER THE FLAGELLATION CONTEMPLATED BY THE CHRISTIAN SOUL. C. 1628-1629. London: National Gallery. Cat. No. 56.

Figs. 85 & 86. THE TEMPTATION OF SAINT THOMAS AQUINAS. C. 1628-1629. Orihuela: Museo Episcopal. Cat. No. 57.

Fig. 87. THE TEMPTATION OF SAINT THOMAS AQUINAS. Detail of figure 85.

done some years after 1626. The truth is that it is very difficult to arrive at any categorical conclusion regarding a work that has been considerably modified and one on so minor a theme.

The finding of this painting has altered the situation in the Velázquez catalogue of the *Stag's Head*, an incomplete canvas in a Madrid collection which was hitherto considered to be the one mentioned in the aforesaid 1636 inventory. This latter is a beautiful representation of a live stag, which may be the work of Velázquez *(Fig. 82 - Cat. 55)*. Though its authenticity is generally accepted, in view of the little it gives us to go on I cannot give any opinion as to its date.

The third of the four compositions referred to is the *Guardian Angel showing Christ after the Scourging to a Child*, a symbol of the Christian soul and a work now housed in the National Gallery in London *(Figs. 83 & 84 - Cat. 56)*. In form and technique the body of Christ still shows something of the influence of Rubens. The whole composition is difficult to explain, moreover, without carefully observing the eclectic sequence of the works done in Italy, which naturally affected Velázquez's aesthetic. The technical characteristics of this work are its blended brushwork and firm modelling, with a clean, well-balanced chiaroscuro that is not wholly innocent of striving for effect. The clarity of the form and the magnificent drawing are also among the predominant features of this work, the iconography of which is rather unusual in Spanish tradition, though not unprecedented. The great sweep of background is used in masterly fashion to highlight the body of Christ against its darkness, which is somewhat lightened towards the right. The expressions on the faces of both Christ and the child are amazingly true to life. We may detect, too, a desire for visual beauty, which may be another result of the painter's Italian experiences, like the restrained, sober expressionism of the gestures. The angel is depicted in a realistic style very different from that of traditional iconography. He appears as a figure of humility, or at least one who seems to be trying to hide in anonymity or self-effacement before the figure of the scourged Christ. This is, in short, an admirably constructed work and one that is full of life, both pictorial and spiritual.

The Temptation of St. Thomas Aquinas

The uncertainty as to the dates of the foregoing works is still greater with regard to the *Temptation of St. Thomas Aquinas,* originally hung in the Dominican School of Orihuela and now in the Cathedral Museum of the same city *(Figs. 85 to 87 - Cat. 57)*. In it we see the young saint being comforted by two angels after his fight, with a burning brand, against temptation in the person of the young woman we can see making off in haste. In my opinion this is one of the finest religious paintings of Velázquez's youth. There is a superimposition of very different techniques, either linked by subtle gradations or frankly opposed, but forming an harmonious whole. Particularly worth noticing is the contrast between the heads of the saint and the angel beside him, which are rendered almost immaterial by the sfumato of the brushwork, and the technique used for the other angel —who holds up the girdle of chastity so gracefully— and the abrupt brushwork that defines the woman's fleeing figure in a few strokes. The whole is arranged within the space of a room, with a beautifully precise and detailed chimney-piece, the most notable features being the drawing and a rather summary chiaroscuro, with greys, which is enormously effective. In later years Velázquez was to paint works that were more vividly coloured, more important in theme and composition or more successful by reason of the virtuosity of certain effects bordering on the unattainable; but we cannot truly say that he ever surpassed the beauty that emanates from these figures in the *Temptation of St. Thomas Aquinas.*

It is works like this that prove the truth of the saying that "art is transformed, it does not progress". For technical advances are agents of tranformation rather than progress, if we understand progress in the absolute sense of an approach to an equally absolute beauty. And that is why the concepts of art criticism are always of relative value, conditioned by such factors as period, tendency, country, school, the particular artist in question, etc. In saying this, however, I am far from meaning that a scale of values cannot be established. Transformation does imply something which, if not exactly progress, is nevertheless fairly similar. Undoubtedly, the transition from Romanesque

to Gothic, or from the latter to the art of the 17th century, entailed some difficulties that may be described as "growing pains". To succeed in the world of art in the 17th century, therefore, is an achievement of greater merit than to attain a similar success in the 12th or 15th century, for instance. This, however, is a matter of aesthetics and technique. As far as style is concerned, it is true that art does not progress at all, since each work in its time is as it should be in order to express its own age and no other.

III

FIRST VISIT TO ITALY

1629-1631

DOCUMENTARY CHRONICLE. – ITINERARY OF THE JOURNEY ACCORDING TO PACHECO AND PALOMINO. – *THE FORGE OF VULCAN.* – *JOSEPH'S COAT.* – TRAVELLER'S SKETCHES.

On June 28th 1629, Velázquez received the King's permission to make a journey to Italy, permission which included the provision that "so long as his absence may last, he shall continue to be paid what he receives today, both in salary and in other emoluments". He was likewise given the sum of four hundred ducats, in payment for *The Topers* and other paintings. Pacheco tells us that the Count-Duke made him a present of two hundred ducats of gold and a medallion with a portrait of Philip IV, besides providing him with "many letters of favour". The ambassadors of Parma, Venice and Florence were informed of his journey and all three hastened to communicate this news to their respective governments. The importance attributed to this journey is confirmed by the letters and dispatches of these ambassadors, which contain some interesting comments.

Thus Flavio Atti, the ambassador of Parma in Madrid, in a letter to the Dowager Duchess dated June 26th, says that he has furnished Velázquez with a letter of introduction to his lord, the Duke of Parma, in which he tells him that the painter is going to Italy "to improve his knowledge of his art..." But the ambassador reveals his suspicion in the following phrase, sent in cipher: "At any rate I think that behind this stratagem lies the hidden purpose of harvesting a little crop of presents for this painter". He adds, however, that Velázquez is a specialist in portraiture and even mentions that the King often goes to watch him paint-

ing, which gives us yet another reference to Philip's interest in the artist's work.

Another letter from Atti to the same lady goes even further in its mistrustful suppositions as to the "true" purpose of Velázquez's journey to Italy and says, again in cipher: "I fear he comes to spy..." He then adds that he has seen the communication sent from the Count-Duke of Olivares to Don Gio. di Vilela asking the latter to facilitate Velázquez's access to ministers and other important personages. This second letter is dated on July 26th.

Similarly the Venetian ambassador to Madrid, writing to the vice-president of the Council of Ten on the 28th of the same month, shows a certain prudent caution, though he is not so openly mistrustful as Flavio Atti, for he admits that it is natural that a young painter like Velázquez should be interested in visiting various Italian cities with a view to furthering his acquaintance with the painting of the country; he does, however, recommend his correspondent to "do what you think fit with regard to this person".

But the Florentine ambassador, Averardo de Medici, in a letter to the Archbishop of Pisa dated September 22nd, does not seem to share the preoccupations expressed by his colleagues. He says that Diego Velázquez is the favourite painter of both the King and the Count-Duke, that he has gone to Italy with the Marqués de Spinola and that he intends first to visit Lombardy and Venice and then Florence and Rome. After mentioning that Ve-

lázquez, besides being a painter, is a royal usher, he adds the curious recommendation that the painter should be well treated, but not too well, and warns the Florentines against having conversations in his presence that they might not wish to come to Philip's ears, for Velázquez, being on friendly terms with both the King and the powerful favourite, might very easily report such talk to them.

Apart from what these letters reveal of the mentality of these three diplomats and their way of judging things, or of what they considered their duty, from their various suppositions we may really gather that in 1629 Velázquez had not yet become such a very important personage in Madrid, probably being thought of as no more than a skilful painter who had succeeded in winning favour with the King and the Count-Duke. During his visit to Italy, with the wider scope it afforded his talents, Velázquez was to prove that the purely artistic purpose of his travelling was more than justified.

Itinerary of the journey according to Pacheco and Palomino

Pacheco gives us a detailed account of the journey, which began in Barcelona, where the painter embarked for Genoa on the galley carrying Ambrogio Spinola (the central figure of *The Surrender of Breda*), the Marqués de Santa Cruz and the Duke of Lerma.

"He went to stay in Venice and lodged in the house of the Spanish Ambassador, who showed him great honour and invited him to sit at his own table; and because of the troubles at the time, when he went out to see the city the ambassador's servants were sent with him as body-guards. Then (leaving all that turbulence) he came from Venice to Rome, passing through Ferrara, then governed for the Pope by Cardinal Sacchetti, the former Papal Nuncio in Spain, to whom he went to present some letters and to kiss hands (though omitting to present other letters to another Cardinal), and who received him with honour and insisted that during his stay he must lodge in his Palace and eat at his table; and [Velázquez] humbly excused himself, saying that he did not

eat at the usual hours, but withal if His Eminence so desired he would obey and change his habits, whereupon [the Cardinal] ordered one of the Spanish gentlemen in his suite to look after him with particular care, preparing rooms for him and his servant, regaling him with the same dishes as were sent to his own table and showing him all the most noteworthy things in the city. There he stayed two days; and on his last evening, when he went to take his leave, [the Cardinal] kept him with him for over three hours, speaking of different things; and he ordered the gentleman who was looking after him to provide horses for the following day and accompany him for 16 miles, until they reached a place called Cento, where his stay was short but very pleasant. And then, taking leave of his guide, he continued on his way to Rome by way of Nostra Signora di Loreto and Bologna, where he did not stop to present letters either to Cardinal Ludovicio or to Cardinal Spada, who were both there.

He arrived in Rome, where he stayed for a year and was given most distinguished treatment by Cardinal Barberini, the Pontiff's nephew, by whose order he was lodged in the Vatican Palace and given the keys to some of the apartments; the most important of these had all its walls above the hangings painted in fresco, with representations of episodes from the Scriptures, by Federico Zuccaro, among them the scene of Moses before Pharaoh, as in the account of Cornelius. But he left this lodging because it was very out of the way and he did not wish to be so much alone, being content to have the guards admit him whenever he wished without any difficulties, to take copies from Michelangelo's Last Judgment or from the works of Raphael; and he went there on many occasions, to his great advantage. Later he discovered the mansion, or vineyard, of the Medici, which is in Trinità del Monte, and since it seemed a suitable place in which to spend the summer studying, he asked the Spanish Ambassador, the Conde de Monterrey to arrange with his colleague from Florence for him to be given a place there; and though it was necessary to write to the Duke himself, he was successful in his request and stayed there over two months, until a tertian ague forced him to come down [to quarters] near the Conde's house. And while he was sick the Conde showed him great kindness, send-

ing his own doctor to him with medicines and giving orders for him to have whatever he wanted from his house, apart from many presents of sweetmeats and frequent gifts of money.

Among other studies that he did in Rome is a famous portrait of his which I have now, to the admiration of connoisseurs and the glory of art. Now he determined to return to Spain, where he was much needed, and on his way home from Rome he stopped in Naples, where he painted a beautiful portrait of the Queen of Hungary, to bring to His Majesty."

In his biography of Velázquez Palomino, as usual, adopts this part of Pacheco's text. Regarding the painter's stay in Venice, however, he adds some information worth bearing in mind in view of what comes later: "During the days he spent here, he did many drawings, particularly from Tintoretto's picture of the Crucifixion of Our Lord Jesus Christ, with its many figures and admirable invention, of which a print has been made. And he made a copy of another picture by Tintoretto, representing Christ administering the communion to his disciples, the which copy he brought to Spain and presented to His Majesty."

Velázquez returned to Madrid in January of 1631. According to Pacheco "he was very well received by the Count-Duke, who told him to go afterwards to kiss His Majesty's hand and thank him for not having permitted any other artist to paint his portrait, and commissioned Velázquez to paint the Prince's portrait, which he did punctually, so that His Majesty was very pleased at his coming." We are also told that Velázquez brought 18 pictures from Italy, among them Titian's *Danae* and another painting by Bassano.

The Forge of Vulcan

The two most important works painted by Velázquez during his first visit to Italy are *The Forge of Vulcan*, in the Prado *(Figs. 91 to 93 - Cat. 59)*, and *Joseph's Coat*, which is in the Escorial *(Figs. 88 to 90 - Cat. 58)*. According to Palomino, Velázquez gave these to the King on his return from Italy. But there is also evidence that he was paid for the pictures he had brought from Italy, among which would be these two.

There is a study still extant for the head of Apollo in *The Forge of Vulcan*, a study which Velázquez changed partially in the definitive work *(Fig. 94 - Cat. 60)*. This study is an extraordinarily beautiful little canvas, with an effect of great freedom and with innovations of technique and pictorial concept that betray the influence of the great Venetian masters as much as the definitive work, or even more so. The finished work itself differs from *The Topers* in the less crowded grouping of the figures, which presupposes a more carefully studied and more effective spatial construction. We can see at a glance that the painter wished to dignify the figure of Apollo, though without thereby forsaking the realism of the overall treatment. The ochre range is enriched here by blue, green and yellow. The artist does not use the metal objects – pieces of armour, hammers and other tools – to produce brilliant effects; or, rather, he achieves these effects but manages to give them a rather neutral character. For Velázquez always shuns any kind of excess or meretricious sparkle; even his virtuosity is latent rather than openly displayed. This may be the result of a modest temperament, or possibly of one too proud to be content with facile triumphs, with "impressing" the public. On the other hand, we should not forget that one of the great tendencies of baroque art was to give tone predominance over colour. This composition is more naturalistic than baroque, unless we reject the idea of baroque as an exaltation of movement and think of it rather as an opposition to the classical canons imposed on the naturalistic vision.

Joseph's Coat

Velázquez laid the dramatic scene of the delivery of the blood-stained coat in a spacious entrance hall, with a window-opening on the left revealing a patch of landscape beyond. The half-naked figures in this painting differ from those in *The Forge of Vulcan* in the way in which the light falls upon them; they are also more naturalistically modelled, though simpler. The figure of the old man, though somewhat theatrical, is nevertheless full of nobility; though placed in

the shadows, there is no lack of clarity in the form or in the treatment of the textures. Perhaps the most novel feature of this picture, which foreshadows effects that were adopted more wholeheartedly by the artist in later years, is in the two figures that stand out against the smooth wall in the central area. Surrounded by shadows, they are given an impasto so extremely light that they seem to be suggested rather than represented, and this effect is still further heightened by the contrast with the sturdiness of the figures holding the coat. All in all, this is a work that is brilliant without being showy and also very clear, thanks to the simplicity of the painter's vision of his characters. The execution is based on rounded forms, with naturalistic flesh-tints. Moderate baroque, in short, with a distinct leaning towards the painter's own realism. Another interesting feature of this work is the original treatment of the piece of landscape referred to above, though this is merely an anecdotal detail.

Traveller's sketches

Modern historians – rightly, in my opinion – have included among the works painted by Velázquez during his first visit to Italy the two little sketches of the *Garden of the Villa Medici*, both in the Prado *(Figs. 95 & 96 - Cat. 61 & 62)*. Their character, their colouring and the freshness of their inspiration also place them among those works that have provided most of their grounds for those who see Velázquez as a forerunner of Impressionism. This may be true to some extent if we are to go by the more general principles of the Impressionist aesthetic, but not as far as technique is concerned. While the Impressionists mix the form of material objects in light and make the brushwork produce the two elements together, thus achieving a kind of greyish-white mist with varied nuances, Velázquez adheres firmly to the optical canons of the 17th century and to his own technique, which is quite innocent of any such attempt. He makes clear distinctions between the form of objects and space, air or atmospheric circumstance. In his painting he takes everything into account, but he does not blend his elements; he superimposes them,

with exquisite grace and skill. What brings his work close to the formulas of Impressionism is the fact that the local colour is very noticeably affected by the general light of the place and the moment, which is what produces the tone of both these paintings, one more carefully constructed than the other but the two equally admirable. They are important milestones in the history of painting, works as revolutionary in character as El Greco's *View of Toledo*. There is real genius, too, in the way in which Velázquez suggests the human figure in the characters to be seen in these views of the Villa Medici.

I agree with absolute conviction with Longhi's attribution to Velázquez of the little oil-painting on board entitled *The Brawl*, which shows soldiers quarrelling over a gambling dispute *(Figs. 97 & 98 - Cat. 63)*. I believe that it is an important document in determining the course of the process leading to certain technical results developed in the larger works studied above. We may be surprised by the remarkable anecdotal dynamism of the action, so different from what we are accustomed to seeing in the master's works; but we cannot deny that this little *divertissement* remains faithful to his formula of horizontal arrangement of his compositions, paying little or no attention to the oblique axes, a characteristic I have mentioned as a constant in Velázquez's work from the beginning. The atmosphere is captured with impressive force, clarity and verisimilitude, which makes it sound like a snapshot; but there is nothing of the snapshot in its pictorial values.

Modern historians – again, I believe, rightly – tend to accept the identification of a little canvas in the Academy of San Fernando in Madrid as the copy made by Velázquez, according to Palomino, of Tintoretto's *Communion of the Apostles,* one of the compositions in the incomparable Scuola di San Rocco in Venice *(Fig. 100 - Cat. 65)*. It must be admitted that it is very difficult to come to a decision in this matter, considering the small size of the work and the fact that it is an exact copy of a composition by another artist. The execution and overall tone are very typical of Velázquez, however hard he may have tried to imitate Tintoretto's forms and even his technique, together with the spectacular chiaroscuro effects that appealed so strongly to the Venetian.

Fig. 88. JOSEPH'S COAT. 1630. Madrid: Monastery of the Escorial. Cat. No. 58.

Figs. 89 & 90. JOSEPH'S COAT. Details of figure 88.

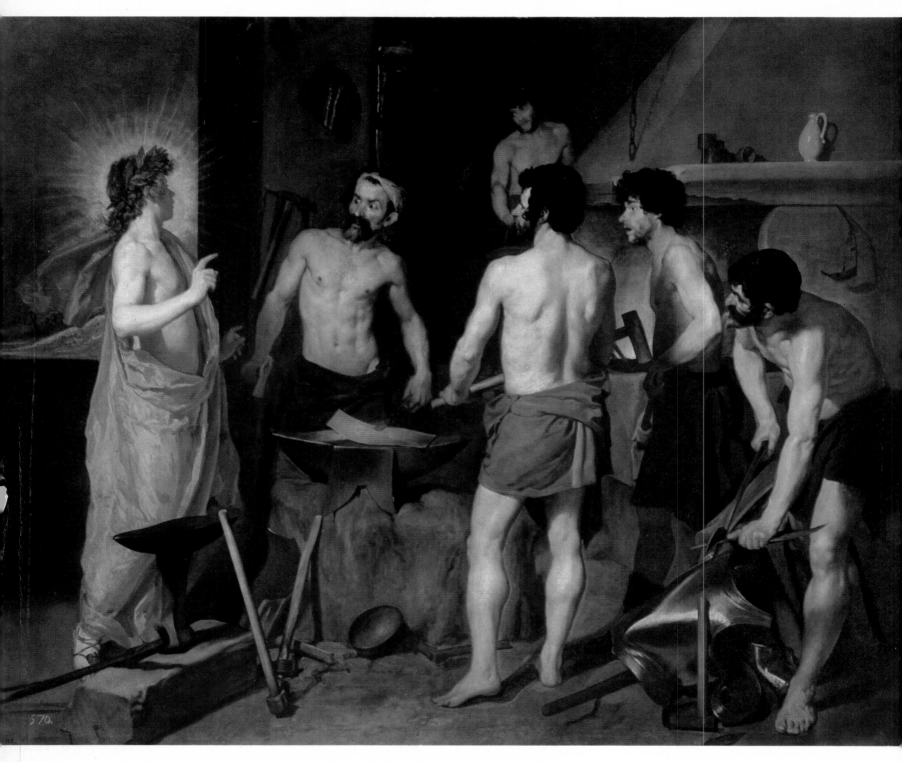

Figs. 91, 92 & 93. THE FORGE OF VULCAN. 1630. Madrid: Prado Museum. Cat. No. 59.

Fig. 94.
HEAD OF APOLLO.
1630. New York: Private
collection. Cat. No. 60.

Figs. 95 & 96.
GARDEN OF THE
VILLA MEDICI. 1630.
Madrid: Prado Museum.
Cat. Nos. 61 & 62.

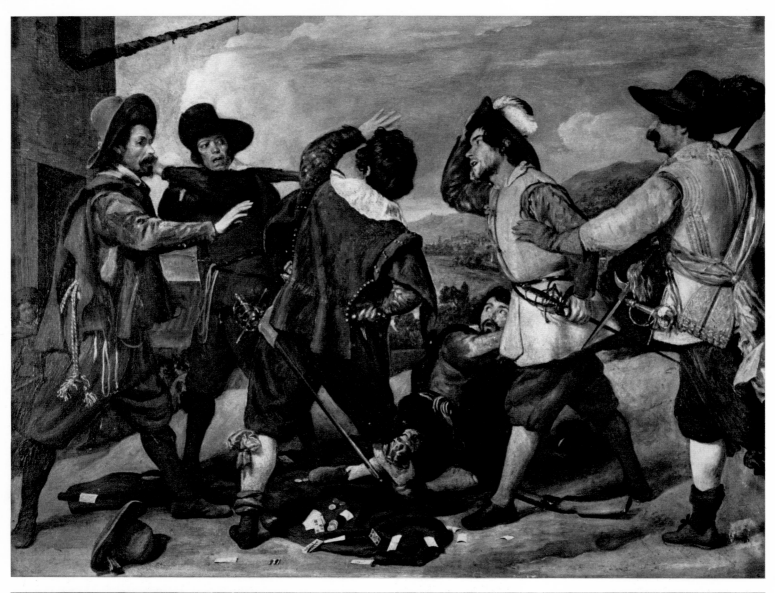

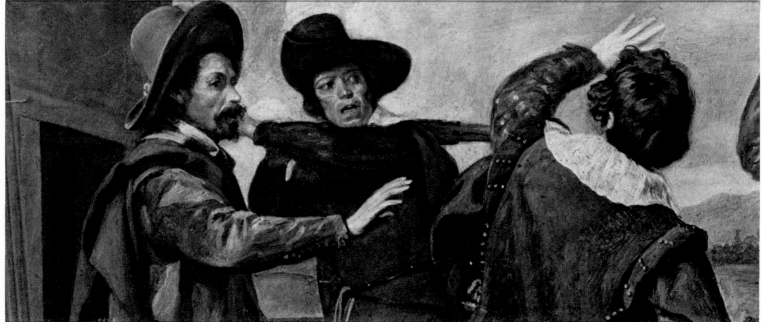

Figs. 97 & 98. THE BRAWL. 1630. Rome: Palazzo Pallavicini-Rospigliosi. Cat. No. 63.

Fig. 99. SELF-PORTRAIT. C. 1630. Florence: Galleria degli Uffizi. Cat. No. 64.

Fig. 100. THE COMMUNION OF THE APOSTLES. 1630. Madrid: Academy of San Fernando. Cat. No. 65.

IV

THE "SALON DE REINOS"

1631-1635

END OF PACHECO'S CHRONICLE AND DOCUMENTARY DATA. – THE PALACE OF EL BUEN RETIRO. – MAZO ENTERS VELAZQUEZ'S WORKSHOP. – WORKS DATED IN 1631. – MORE COMMISSIONS FROM DOÑA ANTONIA DE IPEÑARRIETA. – BEGINNING OF A NEW TECHNIQUE. – EQUESTRIAN PORTRAITS OF THE COUNT-DUKE. – VELAZQUEZ'S WORK IN THE "SALON DE REINOS". – *THE SURRENDER OF BREDA*. – THE EQUESTRIAN PORTRAITS. – WORKS ATTRIBUTED TO THE PERIOD 1631-1635. – PORTRAITS. – PORTRAITS PAINTED IN VELAZQUEZ'S WORKSHOP. – PAINTINGS ON RELIGIOUS SUBJECTS.

In this chapter, which begins in January of 1631 with Velázquez's return from his first visit to Italy, we shall study the following works: an important group of portraits, the painter's participation in the decoration of the new Palace of El Buen Retiro and a series of canvases which for various reasons are considered to have been painted during the five-year period under consideration.

Pacheco's text goes on to refer to the following years and even provides us with some interesting data; but from this point on it grows increasingly vaguer and is even mistaken as to the date on which the painter was appointed Gentleman of the Chamber: "The liberality and kindness with which he is treated by so great a monarch are incredible. To have a studio in his gallery (the one they call the North Gallery, in the Alcázar), to which his Majesty has a key, with a chair to sit on while he watches him paint, which he does almost every day. But what goes beyond everything is that, when he painted him on horseback, he kept him sitting for three hours at a stretch, all that power and grandeur in abeyance. And since the royal heart puts no limit to all these favours, the King has given his father three secretary's posts in this city, each of which brings him a thousand ducats a year. And to himself, in less than two years,

the office of Gentleman of the Wardrobe, and that of Gentleman of the Chamber in this present year of 1638, honouring him with the key, which is something sought after by many gentlemen of the Knightly Orders. And through the care and punctuality with which he endeavours to surpass himself every day in his services to His Majesty, we hope for increases and betterments in art for him who has deserved them, and in the favours and rewards earned by his great skill, which if employed in some other profession would surely never raise him to the high position he occupies today; and I, who have shared in so much of his happiness, will now put an end to this chapter."

And this is the last reference to Velázquez in Pacheco's book "The Art of Painting", which was not published until 1649, five years after his death. The original holograph manuscript is in the Institute of Valencia de Don Juan, in Madrid.

The documents regarding Velázquez's life during this period are few in number and not particularly revealing. I shall merely refer to them briefly here.

On September 24th 1632 he was paid 1,100 reales for priming the canvases for some royal portraits to be sent to the Austrian court.

On May 8th 1633 the King granted him the "right

to the staff of a sergeant of the court", a sinecure which he hastened to make over to his colleague Angelo Nardi for the sum of 4,000 ducats.

In October of the same year Velázquez and Carducho were appointed to assess the artistic worth of a series of portraits of the King and Queen done by other painters.

In 1634 there is a note of payment from the protonotary of Aragon: "More than a thousand ducats of eleven reales, which were paid in various entries to Diego Velázquez ..., being the price of eighteen pictures, which were Susannah by Luqueto (Lucas Cambiasi), an original by Bassano, the Danae by Titian, the picture of Joseph, the picture of Vulcan, five flower pieces, four little landscapes, two *bodegones*, a portrait of His Highness the Prince and another of Her Majesty the Queen. Assessed by Francisco de Rioja at 11,000 reales". In Cruzada Villamil's opinion, with which I agree, the "picture of Joseph" must refer to the *Joseph's Coat* that Velázquez painted in Rome, together with the *Vulcan* (*Figs. 88 & 91*). Two of the "little landscapes" might be the two pictures of the *Garden of the Villa Medici* (*Figs. 95 & 96*). In this case the sum mentioned as having been paid to Velázquez must have been the price of these original paintings plus the costs of transport for those acquired in Italy. This document gives us further evidence of the incredible delays in the royal accounting system.

The Palace of El Buen Retiro

In about 1631 construction began on a new royal residence, which was given the name of "Palacio del Buen Retiro". The Count-Duke gave some land not far from Madrid for the purpose, close to the monastery of the Hieronymite Friars. Work at first went forward so quickly that two years later some parts of the buildings were already in use. The architects were Alonso Carbonell, Gómez de Mora and Crescenzi. After a long delay in 1636, however, the work was resumed at a much slower pace and the palace was not finally completed until 1640.

Of this palace, which was built with very poor materials, all that is left is one of the main blocks, which is now the Army Museum. It is a simple structure, in a style deriving from the canons obtaining in the 16th century. This palace had immense gardens, dotted with little follies and pavilions, part of which now forms the beautiful Retiro Park of Madrid.

The block still standing contains the "Salón Grande del Buen Retiro", which, since it was used for assemblies of the Parliament, later came to be known as the "Salón de Reinos" (Salon of the Kingdoms). It was decorated between 1634 and 1635 by the principal painters to the Court – supervised, according to Elías Tormo, by Velázquez himself. The notes of payment for the twelve battle scenes that hung on its walls, published by María Luisa Caturla, reveal that between March 6th 1634 and June 14th 1635 Velázquez received the sum of two thousand five hundred ducats for "the paintings... by other hands, as well as those delivered by his own... for the Salon and Royal House of El Buen Retiro".

The whole ensemble, the arrangement of which is known to us through the description made of it by Antonio Ponz in his *Viaje por España*, included works by Zurbarán, Eugenio Caxés, Antonio Pereda, Juan Bautista Mayno, José Leonardo, Vicente Carducho, Juan de la Corte and Pedro Orrente, as well as five large canvases by Velázquez. Most of these paintings are now in the Prado and together make up one of the most important groups of works for the study of 17th-century Spanish art.

Mazo enters Velázquez's workshop

Towards the beginning of this period, at some unknown date in 1631, an event occurred that was to be extremely important in the life of the great painter: the engagement in his workshop of a young assistant from Cuenca aged twenty, called Juan Bautista Martínez del Mazo. Nothing is known of his earlier training. Velázquez must have grown very fond of him, for on August 21st 1633 he permitted him to marry his daughter Francisca, then fifteen years old, while in 1634 he transferred to the young man his office of Usher of the Chamber, with the corresponding emoluments. Mazo, indeed, was a very efficient assistant and endowed with undoubted skill;

but his works, almost always copies or adaptations, are only held up by the "velazqueño" structure under the surface.

Works dated in 1631

The first work of certain date after the journey to Italy is the portrait of *Prince Baltasar Carlos with a Dwarf* in the Boston Museum of Fine Arts (*Fig. 101 - Cat. 66*). The prince's age given in an inscription — a year and four months — tells us that this portrait of Philip IV's first son, born in October of 1629, was finished in March of 1631. This confirms what Pacheco wrote: that the King waited for Velázquez to return to paint the first portrait of his heir. In it we see the Infante standing, in his brocade suit, with officer's baton, sword, sash and a broad steel gorget, beside an unidentified dwarf. A great crimson curtain gives the dominant accent to the work, which is rich in black, white and golden tones. What with this and the richly-patterned carpet, the grey backgrounds that characterized the earlier court portraits have gone for ever. This picture reflects Velázquez's experiences in Italy, with its more impasted technique, softer contrasts and more varied palette. The stiff bearing of the child and the deformed little creature in the foreground create a strange contrast, especially since they are standing so near each other and are of the same height, though placed at different levels. Since this portrait, being painted by the Court painter Velázquez, cannot have been intended to be either allegorical or satirical, its realism seems even more confusing to the mind of the modern viewer. The predominant elements are the wealth of pictorial material and the beauty of the colour harmonies. The execution is careful and draughtsmanlike to some extent; in the brocade trimmings of the prince's suit, for instance. Velázquez does not make any "allusions" with the lighting, but depicts all the ornaments one by one and delineates every last detail with meticulous care and clarity, though he does give a certain looseness to such details as lend themselves to it, like the tassel of the cushion in the right foreground.

The influence of Velázquez's journey to Italy is evident in the little *Christ Crucified*, signed "Dº Velázquez fecit 1631", which was found a few years ago in the Convent of the Order of St. Bernard of the Holy Sacrament, in Madrid (*Fig. 102 - Cat. 67*). In the head there is something of the typology of Guido Reni, but the general ensemble of the image follows the scheme of the model repeated by Pacheco on several occasions (*Fig. 1*). In the anatomy there is a tendency to a contrasting modelling of lights and shadows. The execution is remarkably meticulous, from the skull at the foot of the cross to the sarcastic inscription crowning the upper part of the canvas. As a study from life it is superb, projected against a rather summary landscape background, in which the light outlines the horizon, giving a certain expressiveness to the buildings in the middle distance and creating a suitable gradation of planes. This canvas might be the one that figures in the inventory of Velázquez's estate drawn up after his death, as "a Christ crucified, one rod and a quarter high by three-quarters wide".

More commissions from Doña Antonia de Ipeñarrieta

I find myself in agreement with most of Velázquez's biographers in giving a date very soon after his return from Italy to a pair of full-length portraits in the Prado, representing *Don Diego del Corral y Arellano* (d. 1632) and his wife *Doña Antonia de Ipeñarrieta y Galdós,* who is portrayed with her son (*Figs. 103 & 104 - Cat. 68 & 69*). It will be recalled that this was the lady who paid Velázquez in the year 1624 for the portraits, which we have already studied, of *Philip IV* (*Fig. 54*), *The Count-Duke of Olivares* (*Fig. 58*) and García Pérez Araciel, her first husband. And she must have been a lady of no small influence, to have had no fewer than five large portraits painted by the great artist. Doña Antonia was married to Diego del Corral in 1627 and they had six children. She died herself in 1635.

The predominant feature of these two paintings is their frank spontaneity, in combination with Ve-

lázquez's characteristic simplicity. Don Diego, who was a Professor of Salamanca University and Chancellor of Aragon, is represented wearing a long black gown and standing beside a table covered with a red velvet cloth. The papers he has in both hands are notes of white that enliven this symphony of greys and dark tones, together with the cuffs and the little smooth collar that sets off the head, which is treated with impressive realism. This is the portrait of a person perfectly sure of himself and everything he undertakes, one to whom life has already given all he wanted. The painter pays close attention to the clothing, to which he gives a richness of texture very similar to that to be seen in the royal portraits he painted before going to Italy. The expression is caught with instantaneous rightness and demonstrates his mastery of a technique that was now reaching its highest point.

The portrait of Doña Antonia is that of a woman of character, painted with a realism that admits a certain sensation of hardness deriving from the sitter's psychology. The clothing is rich and stiff, but austere. There are several details – the complicated open collar, for instance, or the chain hanging on the lady's bosom – that reveal the painter's infallible simplicity of touch. Everything in the gradation of blacks and greys is done to highlight the face, which is given a magnificently blended modelling, with some superimposition of white strokes in the more brightly-lit areas. The rather pursed mouth and the straightforward, intelligent look are caught with great verisimilitude. This, in short, is one of the best portraits in this phase of Velázquez's career. The figure of the child, on the other hand, though evidently painted at the same time as that of his mother – by which I mean that it was not added later, as has been proved by X-ray – does not seem to be by Velázquez. It might well have been done by Mazo, the young painter recently admitted to the master's workshop.

Beginning of a new technique

A second portrait of *Prince Baltasar Carlos*, now in the Wallace Collection, London (*Fig. 107 - Cat. 70*),

was most probably painted in 1632. Camón Aznar suggests that the magnificent suit was possibly the one the prince wore at the ceremony of his Investiture as Heir to the Throne, which took place at the Monastery of the Hieronymites on March 7th of that year. By and large, this work is in the same spirit as the portrait painted the year before. The simplification of the foreground, with smooth flooring instead of the rich carpet, and the lack of movement in the plane against which the figure is projected make the latter stand out more brightly.

It is important to point out that this work is a starting-point for a new phase in Velázquez's technique. The execution is softer and more rapid than in earlier works. Thus begins the long evolution that was to lead to the paintings of his last period, which for this reason have been called – quite wrongly – "impressionistic". It is true, however, that from 1632 onwards, but not with absolute consistency, Velázquez abandoned modelling form actually as it was in order to paint according to a purely visual impression. That is, having passed successfully through an analytical period during which he constructed his works as if they were reliefs, he changed course into a phase in which, though his drawing remained just as precise, his treatment of form was dematerialized, and in this portrait of Prince Baltasar Carlos he moved towards forms which were hazier and more in conformity with the laws which in practice govern true optical reactions. Look, for instance, at the hand which rests on the hilt of the sword; it is a soft hand, without any real lines in it, yet a hand which the mind "reconstructs" perfectly, since the most exact drawing is within the form, although outwardly this appears, and in fact actually is, half dissolved. The same thing happens with the details of the setting. The rich dress, different in its decoration though of the same shape, compared with the earlier portrait of the prince, is treated more as a complex of vivid visual impressions which are combined and picked out with varying degrees of intensity and precision, than with the faithful linearism of the earlier work.

This transformation is a most important one. On the one hand it marks a transition from a way of looking at things still tied to a Renaissance type of vision to a truly Baroque vision. On the other hand,

it resulted in a simplification of the actual labour of painting, of that labour which was demanded by close attention to detail, though it presupposed, first a complete certainty of creating the desired effect, and secondly an infallible instinct for choosing those major and dominating elements which would give the spectator the impression that even the smallest details had been exactly represented. It is these qualities which are best served by analysis and study, rather than by mere observation.

It goes without saying that this whole technique also presupposes an absolute control of chiaroscuro so as to create the impression of volume. In its softness and its evanescent treatment of the values, this portrait displays the tactile qualities of the materials, effects of relief and of shadow, almost as powerful as those he used in the days of his "hardest" technique, as for instance in the *St. John on Patmos,* which we have already discussed *(Figs. 37 & 38).* Probably the chief quality of really great artistic geniuses is that they never abandon any conquest once made, but go on incorporating new elements while relegating earlier ones to the background and making them serve in a modified way in the achievements of later phases.

That is why that strength which was one of the young Velázquez's predominant characteristics was never lost, though it was gradually softened and expressed in other ways, according to period, subject and other factors. The variety of his colour range was also to increase, progressively but with caution. In his interiors nuance and chiaroscuro were to prevail; in exteriors aerial effects, which he treated with unrivalled lightness, softness and perfection. I must repeat that Velázquez, however realistic and uninterested in the imaginative or visionary, never falls into the fleshly naturalism of Rubens.

The pictorial formula we have seen hinted at in the second portrait of Prince Baltasar Carlos becomes more evident in the portrait of *Philip IV* in the National Gallery, London *(Fig. 108 - Cat. 71).* The colour range shows a return to the simplicity of the first works done in Madrid, but the general tone is more luminous. The predominant colours are brown, red and grey, supported by white and black,

the flesh-tints and some touches of gleaming metal. The King, who is shown standing, wears a sumptuously embroidered suit. With brilliant technique, Velázquez has achieved the visual effects of 16th-century court portraits, creating an amazing divergence between method and result. Seen as a whole, not only does the King's figure seem to be meticulously depicted in all its details, but these very details give the impression of having been drawn, one by one, with absolute precision. I have included a reproduction of a detail of the suit, in order to show the astonishing freedom of the execution and the irregularity of arrangement of the light touches suggesting the embroideries *(Fig. 109).*

Possibly intended as a pair to the preceding portrait is that of *Queen Elizabeth of Bourbon,* already mentioned in Chapter II, which was formerly in the collection of King Louis-Philippe of France *(Fig. 106 - Cat. 72).* Of all the portraits still extant of Philip IV's first wife, this is the one that most suggests the hand of Velázquez, providing further evidence, moreover, of the reworkings and variations gradually undergone by the royal portraits, to show the physical aspect of the passing years. In his interesting analysis of this canvas Crombie reveals that under the painting as it is today there is an earlier portrait of the Queen which coincides, as far as can be deduced from an X-ray, with the youthful model we know from the versions in Copenhagen and in a Florentine collection that we have already studied *(Figs. 67 & 68).* As the painting was originally in the Spanish royal collection – as is evidenced by the inventory numbers still on the canvas – the hidden portrait may be the one mentioned in the letter sent by the ambassador Striggi to the Duke of Mantua, from which I have quoted in Chapter III. Some date in 1632 or 1633 would seem to be indicated by the appearance of the Queen as she is in the present state of this work, to judge by the equestrian portrait we shall be studying later among the works decorating the Grand Salon of the Palace of El Buen Retiro *(Fig. 123).* The head is certainly the work of Velázquez, but some of the painters in the royal workshops undoubtedly had their part in the execution of the clothing and the setting.

Equestrian portraits of the Count-Duke

Some date in or about 1633 may be given to the *Equestrian Portrait of the Count-Duke of Olivares* in the Prado (*Figs. 110 & 111 - Cat. 73*), since it was copied by José Leonardo in his *Taking of Brisac*, painted in 1634-35 for the "Salón de Reinos", and there is an engraving of it in a book entitled "Origin and dignity of the chase", by Juan Mateos (1634). It belonged to Olivares himself and was sold to Carlos III by the Marqués de la Ensenada in 1769. This work is eminently baroque, in the unification – relative but pictorially real – of space, figure and background, the oblique arrangement of the sitter, the open execution and the wealth of atmospheric nuances and values. There is also a remarkable effect of movement. The black and gold armour and the horse's glossy crupper are possibly the most precisely modelled features of this painting.

The face is painted in a rather looser technique and the execution of the details follows the method already described in dealing with the clothing in the portrait of Philip IV (*Fig. 108*). Any analysis of this excellent work will lead to disappointment, for analysis necessarily entails the successive break-down and description of details and areas, whereas perhaps the most outstanding quality of the portrait is the vigorous unity of the whole, though this does not exclude an immense wealth of aesthetic, psychological and technical nuances. The painting is also of great interest from the "story-telling" point of view, as is the case with *The Surrender of Breda*.

In the Metropolitan Museum of Art in New York there is a replica of this portrait with variations (*Fig. 112 - Cat. 74*). I should declare right away that, as a result of my analysis of the execution and by the quality of the work, I am absolutely convinced that this replica is as genuine a Velázquez as the canvas in the Prado. In this second version the horse is white and the Count-Duke's sash is redder. There is some variation in the landscape, though the arrangement of the sitter is the same, as are his proportions in relation to the setting. In this version the clouds of smoke on the left, indicating the key points of a battle, are rather denser. This picture has a more sensuous quality than the one in the Prado, but the overall unification is perhaps not quite so successful.

Among the more recent discoveries in the Spanish Patrimonio Real is a canvas with a large white horse which is supposed to be the one that figures in the inventory of the belongings of Velázquez that were in the Alcázar at the time of his death, in the following terms: "Another large canvas showing a white horse, without any human figure" (*Fig. 135 - Cat. 75*). This inventory also included two canvases with "a chestnut horse" and "a grey hack". It may be supposed that these pictures, without any specific destination, were painted by Velázquez to be used in his workshop as models for equestrian portraits. The white horse in question, practically identical with the one ridden by the Count-Duke in the equestrian portrait in the Metropolitan, was repainted by some mediocre painter who turned the picture into a representation of St. James at the Battle of Clavijo.

Velázquez's work in the "Salón de Reinos"

Velázquez, as I said above, apart from supervising the decoration of this important room in the Palace of El Buen Retiro, made a personal contribution of five large canvases: *The Surrender of Breda* (*Figs. 113 to 117 - Cat. 76*) and the *Equestrian Portrait of Prince Baltasar Carlos* (*Figs. 118 & 119 - Cat. 77*), which were both painted expressly for the great ensemble, the *Equestrian Portrait of Philip IV*, an enlargement, brought up to date by total repainting, of an earlier portrait by Velázquez himself (*Fig. 120 - Cat. 78*), and the portraits, also on horseback, of *Elizabeth of Bourbon, Philip III* and *Margarita of Austria*, canvases brought from the Alcázar and fitted into their new positions after drastic modifications (*Figs. 121 to 124 - Cat. 79 to 81*).

The Surrender of Breda

This picture represents the end of one of the episodes of the war in the Netherlands: Justin of Nassau, Governor of Breda, delivering the keys of the city to Ambrogio Spinola. Velázquez, who had become acquainted with this Italian general on his voyage from Barcelona to Genoa, presents us with a

superb portrait of the man, simple and human. Historians do not agree as to the identification of other figures in the picture. I will just mention the fact that it has been suggested that the soldier in grey with a white plume in his hat on the extreme right is intended to be a self-portrait.

The work is divided into two almost exactly symmetrical parts; the two masses of men in the foreground – not very large masses, but enough to suggest the idea of multitudes – are arranged to left and right of the principal figures, while the hand delivering the key marks the centre of the foreground. But there is nothing hieratic about the comparative symmetry of the masses, for the painter counter-balances it with an asymmetry that is, as it were, in juxtaposition: the group on the right is made up of Spanish soldiers, under the line of lances that have given this picture its more popular name of *The Lances*. In the middle distance, through the space between the two generals, we can see another mass of soldiers. Behind these, moving further back but always parallel to the foreground, there are groups still fighting, patches of landscape, houses, villages and forts, the whole wrapped in a bluish grey mist that is one of the most beautiful elements in this picture. The conception and execution of this work certainly represent one of the very highest points in Velázquez's career.

In an analytical commentary like this we cannot fail to speak of something which, though a commonplace, should not be forgotten: the psychological factor, particularly in the frequently mentioned detail of the chivalrous way in which Spinola receives Justin of Nassau. In the most visible part of the Spanish group we see the faces of men of very different ages, men who were probably adventurers as much as soldiers. An interesting detail is the almost compassionate expression on the face of the soldier just behind and to the right of Spinola. The other faces express mere indifference, as is also the case with the Dutch group. Apart from the principal actors in the scene, nobody seems to feel either animosity or enthusiasm. The battle is over and the ceremony now taking place is a purely symbolic one which is carried out mechanically – except, as I have said, on the part of the two most important figures.

The strength of this picture comes from the solidity of its compact masses of opposed and balanced forms, from the intensity of the tones in the foreground and from the way in which this harmonizes with the bluish distance. Aerial perspective has seldom been treated with so much effectiveness, virtuosity and beauty.

The Surrender of Breda is at the same time a classical and a baroque picture. It is baroque in the freedom of the technique, in the daring and skilful management of the chiaroscuro – especially successful in the group on the left – and in the grandeur of the whole. Its classicism lies in the almost total absence of diagonal axes, the complete elimination of any turbulent movements – for even the big horse in the foreground, though shown as if moving, gives a sensation of calm rather than restlessness – and the serenity that emanates from the work as a whole.

I must say once more that Velázquez, rather than just a baroque, classical or realistic artist (though he was all three), was a painter, and a very painterly painter to boot. That is why this is not simply an historical painting. It is not only a question of skilful execution or the quality of the result, but of one man's concept and viewpoint. The groups of men in *The Lances*, or even the historic event it represents, are simply pretexts for the artist – like the figure of a king or that of a dwarf. A really great painter, a painter who loves his trade better than his iconography, never minds working to commission, nor does he care what subject he deals with, for they all permit him to do the same thing: paint. And so in all Velázquez's works we must conclude with what is the principle of each: the technique and the use the artist makes of it to create beauty, independently of representation though never failing to bear it in mind, since it is through representation that he must find the plastic values he seeks.

Despite the colour interest here, we again see in this work that Velázquez cares much more for tone and form than for chromatic sensuousness. His colour is always idealized and, as it were, slightly neutralized, though he knows how to use it to produce very important effects. In this connection I should like to come back once more to the question of the general contrast between the comparatively complicated

145

foreground and the bluish distance. There is remarkable daring in the way in which the depth of the Dutch group is constructed on a basis of tones, stressing light on dark and dark on light, from the large figure dressed in ochre to the elegant young man in white framed by a spirited horse's head and a human profile. The very vagueness of the cloud of smoke rising behind these figures accentuates the draughtsmanlike tonal precision of all the elements of the group. Similarly, thanks to the contrasts of tone – achieved by the use of dark or sallow flesh-tints – and the foreshortenings, the serried rows of heads on the right completely escape monotony. The black and gold of Spinola's armour and the gold and russet suit worn by the defeated general form an exquisitely beautiful harmony, which is heightened by the pink silk sash worn by the Spanish general and the white ruffs.

Representing a head almost in shadow in order to separate it from a figure placed more to the front, or finishing a face more precisely so as to justify its more forward placing in respect of those behind it, are procedures used constantly by the painter in this picture for the purpose of constructing the groups of figures. The constants are long, simple brushstrokes, touches of intense white, precise shadows to create foreshortenings and modellings that are not based on a uniform treatment of the surface but on the instinctive use of varied textures. Precision of line is intentionally darkened – mannerist concepts have long since gone by the board – and the mass of colour determines the form, the outline being its necessary consequence rather than its origin.

Velázquez's serene, classical and even temperament, his sense of elegance of the spirit and his love for aristocratic forms of behaviour are all reflected in this picture. There may very probably be some influence from Rubens; the influence is not a very specific one, however, since it is no more than the impulse that brought about the transition from the artist's first Madrid phase to his second, which was considerably freer and airier, as well as more open in form. But he still kept his taste for cool effects and greyish lights, in this case as the background to a more vividly coloured composition.

But all of this, though important, is secondary to the essential achievements of the work: the symmetrical composition based on horizontals and the way in which the painter articulates figure with figure, form with form, tone with tone, by means of constant oppositions, realistic, pictorial and at times almost arbitrary, but perfectly justified in every case. The result of all this is a masterpiece, in the presence of which it is not necessary to make any reference to the constant perfection of the drawing or the exact delimiting of each area.

The Surrender of Breda was valued at 500 doubloons in an inventory carried out in the year 1700; Goya and Bayeu assessed the canvas at 120,000 reales in the 1794 inventory. In the first official appraisal of the pictures in the Prado (i.e., after Fernando VII presented the royal collections to this museum) the picture was valued at two million reales, being considered Velázquez's greatest painting and the most important work of all Spanish painting. This opinion may not be valid today, for the general tendency is to prefer *The Maids of Honour* and *The Spinners,* but we should not forget that this may be due to the peculiar character of modern taste, which tends to prefer the artist's last works because of their greater dematerialization and the predominance of technique over content. This modern view may change with time; whether it does or not, however, *The Surrender of Breda* remains one of the essential milestones in the aesthetic evolution of Velázquez and, consequently, of the whole history of art.

The equestrian portraits

The *Equestrian Portrait of Prince Baltasar Carlos* is another of the canvases specially painted by Velázquez for the Grand Salon of the Palace of El Buen Retiro *(Figs. 118 & 119 - Cat. 77).* This magnificent portrait of the five-year-old prince, already entirely conscious of his elevated rank, marks an important step in the painter's advance towards the supreme freedom of *The Maids of Honour*. The landscape is a fleeting but very well-observed impression of the hills of the Pardo, with the Sierra de Guadarra-

ma in the distance, under a sky rich in shades that range from a pale greenish blue to a violet-tinged grey. The placing of the figure in the space is admirably balanced and this, despite the diagonal position, is an unmistakable sign of classicism. The freedom of execution, when it serves to produce strange, non-naturalistic effects, is quite comprehensible, but it is not easy to understand when it is used to achieve such intense and sublimated – by which I mean anti-expressionistic – realism as that reached by Velázquez using this kind of method so far removed from painted drawing. I insist that this is only possible when the artist has an exact perception of the essence of a form or texture and is also capable of shaping it, no matter how, without thereby failing to produce a faithful and substantial likeness. This is exactly what happens in this equestrian portrait of the little crown prince who did not live to be king.

Ever since they were installed in the Prado, the two pairs of equestrian portraits – those of Philip III and Margarita of Austria, Elizabeth of Bourbon and Philip IV – that flanked the doors in the end walls of the "Salón de Reinos" have been a subject of speculation among historians *(Figs. 120 to 124 - Cat. 78 to 81)*. The documents published by Azcárate, from which I have quoted in the historical part of the second chapter, have shed new light on this problem. In my opinion the following solution, advanced by Camón Aznar in his great work on Velázquez, is very probably the right one. The equestrian portrait of Philip IV is the one painted in 1625, exhibited in public to general applause and "very elegant verses", which the King paid for by granting Velázquez a sinecure for which a papal dispensation was required. The other portraits are the three canvases referred to in the aforesaid 1625 document as being "the same size as the portrait of His Majesty on horseback in the new salon", which were painted by Vicente Carducho, Eugenio Caxés and Bartolomé González. These four portraits were considerably enlarged by the addition of strips of canvas, that of Philip IV being totally repainted by Velázquez and transformed into a new masterpiece, as we have already seen. As in the equestrian portrait of the Count-Duke, form, colour and tone are perfectly balanced in this work. The

arrangement is more serene, less baroque, for the figure is placed on a plane parallel to that of the viewer. There is complete harmony between the rider and his mount, between the pink sash across the King's chest and the blues and greys of the sky and the landscape details. The horse, an admirable piece of painting (particularly the head, full of life), is the same one that appears in such a conspicuous position in *The Surrender of Breda*. As on other occasions, the King adopts that impersonal air that was deemed a fitting attribute of His "Serene" Majesty, by which I mean that his face tends to show no expression whatsoever.

In the remaining canvases Velázquez made radical alterations to the horses, transforming what were most probably (as Soria has suggested) adaptations from the engravings of Ioannes Stradenns into the most superb representations of horses in all Spanish painting, above all in the vigour of the brushwork and its relationship to the feeling of the form. The addition of strips at the sides also obliged him to modify the landscapes in the background. Unfortunately he was too deferential to make any great changes in the figures and clothing of the royal personages. He did, however, slightly change the appearance of the Queen to one more in keeping with her actual age. Certainly this portrait is extraordinarily like the one already studied *(Fig. 106)*. Although these paintings lack the quality inherent in those painted entirely by Velázquez, they are fairly impressive portraits, monumental in character and with a certain pictorial dignity. The voluminous cloaks and trappings permit us to see only the front part of the horses. Unfortunately the paint on the side additions has altered with time, possibly because of deficient priming, and the differences in tone between these and the main parts are very apparent. Undoubtedly, the most important of these portraits is that of Queen Elizabeth, whose face is absolutely typical of Velázquez's work, as I have said, and the same is true of the superb head of her white horse *(Fig. 121)*.

The landscape in this portrait, though rather summarily done and with the line of the horizon placed very low, shows great skill in the sinuous gradation of the grounds and the use of aerial perspective.

Works attributed to the period 1631-1635

Palomino mentions among the pictures in the palace of the Marqués de Eliche a canvas "very richly painted with the portrait of Prince Baltasar Carlos, who was being taught to ride his horse by Don Gaspar de Guzmán, his Master of the Horse". This is obviously an allusion to the two portraits now in England (in the Wallace Collection and that of the Duke of Westminster), which do in fact represent the crown prince taking a riding lesson in the riding school of the Alcázar of Madrid. In the first, which would appear to be a preparatory study, the young horseman stands out against a great crowd of figures that are simply sketched in, though with great skill, in a very fluid grey and black wash *(Fig. 125 - Cat. 82).* The second canvas *(Fig. 126 - Cat. 83)* is much more realistic and better constructed. Here horse and rider reappear in the foreground, without any remarkable variation from the other painting, but with a tonal contrast of greater intensity. The unknown personage and the dwarf who appear in the middle distance, on either side of the pony, are made more precise in this version. To the left, and slightly to the front, we see the impressive figure of the Count-Duke being handed a small training lance by an unidentified gentleman. Brilliantly sketched – in a foreshadowing of the famous heads reflected in the looking-glass in *The Maids of Honour* – we can make out the figures of King Philip and Queen Elizabeth looking on from one of the balconies of the Alcázar. This canvas, which is in all probability the one mentioned by Palomino, may also be the one measuring two rods and a half high that appears in the inventory of the estate of the Marquesa del Carpio, mother of the Marqués de Eliche, which was drawn up in 1648.

The elimination of strictly linear factors and the perfect placing and balance of each element in the whole pictorial ensemble speak very eloquently of the brilliant talents of the painter of these two pictures. The colour range shows a deliberate return to the asceticism of the works done before the Italian interlude, possibly as a reaction to the brilliant effects demanded for the decoration of the "Salón de Reinos". From the psychological point of view, the prince seems less impressive here, closer and more human, than in the great picture intended for the Salón, which was done at exactly the same time. It is surprising that doubts should have arisen regarding the attribution to Velázquez of two such notable paintings as these.

Portraits

To judge by its technique, the little bust-length portrait of a woman seen in profile *(Fig. 127 - Cat. 84),* which is entitled *Sibyl* in the Prado catalogue, was probably painted about 1631. In the execution, which still retains much of the closed technique of Velázquez's early days in Madrid, and in the colour range, which shows a slight tendency to use warmer tones, there are strong affinities with the two great works painted in Rome, particularly with *Joseph's Coat.* This little work, so classical and yet at the same time vividly realistic, may be the one that figures in the 1746 and 1786 inventories of paintings in the Palace of La Granja, in which it is described as being "by the hand of Velázquez, representing his own wife with a tablet in her hand". Indeed, though we have not enough evidence to make any categorical assertion possible, this beautiful work may well be a portrait of Juana Pacheco. It is composed with a great sense of construction and perfect balance between the figure and the background space. Features worth noticing are the firmness with which the lady rests the tablet against her breast and the delicate, simplified structure of the hand holding it.

The portrait of *Juan Mateos* in the Dresden Museum *(Fig. 128 - Cat. 85)* was identified by Justi thanks to the engraving by Perret on the title page of Mateos' work, "Origin and dignity of the chase", published in 1634. Velázquez's canvas was probably painted shortly before that date. This personage was Master of the Royal Hunt and Philip IV's mentor and inseparable companion on the great shoots the King loved to organize. He is also portrayed in the great canvas entitled *The Boar Hunt*, which we shall be studying in the next chapter *(Fig. 151).* This is a superb portrait, constructed with all the incomparable rightness of structure of Velázquez's finest paint-

ings. The unusually careful detailing of the clothing contrasts with the simplicity of the hands, which are little more than sketched in. This painting was already catalogued as a Velázquez in the 1685 inventory of works in the Galleria Ducale of Modena.

Similar to the preceding work, though psychologically somewhat less intense, is the portrait of the Sevillian sculptor *Juan Martínez Montañés (Fig. 129-Cat. 86)*. This artist was summoned to Madrid, where he remained between June 1635 and January 1636, to model a head of Philip IV for the use of Pietro Tacca, the Florentine sculptor commissioned to make a bronze statue of the King – the elegant equestrian monument that was first placed in front of the Palace of El Buen Retiro and now stands in the centre of the great square beside the Royal Palace of Madrid. Velázquez, who was a friend of the old Andalusian sculptor, represented him tool in hand, beside the gigantic head of Philip IV that he was modelling, which is shown unfinished in the painting, being summarily but very skilfully indicated by a few strokes in black against the grey tone of the priming of the canvas. This would seem to indicate that Velázquez painted this portrait during the summer of 1635 and left it uncompleted because he was waiting for the sculptor to finish his work. And this circumstance reveals something that is confirmed by other works: that the painter blocked in his canvases with a simple line-sketch done with the brush in a very fluid blackish tone on the priming. The execution of this austere portrait is the same as we have seen in other works of this period, though with a rather more robust and strongly-contrasted modelling, in keeping with the character of the old sculptor, and without any noticeable audacity or "experimentation", apart from the supreme simplicity with which the painter treats some of the details.

A work of capital importance among the portraits painted by Velázquez during the period we are now studying is undoubtedly the portrait of *Don Pedro de Barberana y Aparregui,* identified by an inscription on the stretcher of the canvas *(Figs. 130 & 131 - Cat. 87)*. This personage was born in 1579 and died in 1649, in the town of Briones, where he was the permanent

governor of the fortress. It was probably his long service in different posts and his work on the auditing of the royal accounts that won him the favour of being portrayed by the King's own painter. This canvas can be dated by the apparent age of the subject and also by the technique, in which the comparative dissolution of form that characterizes the works done after 1635 is not yet apparent. It is a straightforward painting, in which the translucency of the top layer reveals some retouching in the definition of the silhouette and, in the background, some impulsive strokes dashed in by the painter to get rid of excess colour on his brush. This is a work of incomparable realism; so much so, indeed, that an almost disturbing sensation of life emanates from the figure, which occupies almost the whole of the canvas without any accessory elements.

Paintings like this one are the proof that realism can produce – and indeed has produced – great masterpieces, and that idealization is not always indispensable. I might even add that that audacity of Velázquez's which contributes so much to the beauty of other works – *The Boar Hunt*, for instance, or even *The Maids of Honour* – was not really essential to placing the painter among the greatest artists of his age; an age, we should remember, that faced the greatest problems and demands in painting. In this portrait he achieves strictly pictorial qualities by means of rigorously representational elements. And that is the merit of this canvas, undoubtedly one of the finest painted by Velázquez at this more realistic than pictorial stage in his career and one in which he succeeds in giving an absolute effect of life and truth. The pains he took in painting it can be seen in every one of the elements that go to make it up and in the scrupulous defining of the textures. The brushwork is surprisingly limpid, assured and daring in the sober clothing, enlivened only by the vivid red of the great cross worn by knights of the military Order of Calatrava. The solidity of the figure (in a technique we might describe as a synthesis half-way between the thick impasto of his earlier works and the open form that he began to use after his return from Italy), though a predominant feature of the work, is almost forgotten when we look at the perfection of the hands and, above all, the strength and real life of the

head. This portrait of Don Pedro de Barberana is an example of exquisite harmony in greys and ochres against dark or black masses. Undoubtedly, the red of the knight's cross plays an essential role in balancing the colours, apart from the linear purity of its drawing and its ornamental value. Clearly, too, the pink and reddish tones of the flesh-tints help to produce this harmony. If there is any one factor, however, that really stands out in this picture and gives it particular significance, it is the triumph of the truth of catching a living likeness over the truth of "art for art's sake".

Another work possibly painted during this period is the *Portrait of a Lady* in the Staatliche Museen of Berlin *(Fig. 132 - Cat. 88)*, which was formerly supposed, on no grounds at all, to be a portrait of Inés de Zúñiga y Velasco, the wife of the Count-Duke of Olivares. Despite the opinions to the contrary expressed by Beruete and others, I am quite convinced that this work is by Velázquez, though perhaps with some collaboration from Mazo in the details of the elaborate clothing and in the hands. The perfectly simple head, with its subtle modelling, retains the precision of the preceding stage in the painter's career, with all the qualities of his style, particularly his almost superhuman skill in eliminating line and showing the taut structure of the drawing through the delicately blended modelling in colour, enlivened only by a look that is admirably caught and a beautifully drawn mouth.

The *Portrait of a Young Man* in the National Gallery in Washington *(Fig. 133 - Cat. 89)* was bought by Count Harrach in 1678 as a work by "Velasco". The draughtsmanlike construction is more evident in this canvas than in others of the period we are now studying; this is probably due to the rapidity of its execution, which induces me to consider it one of the very few preparatory studies to be found among the extant works of Velázquez. It is neither a very profoundly conceived portrait nor one of deliberately virtuoso effects, but it is a vivid image and one that is sufficiently beautiful and rich in quality to be unhesitatingly admitted as an authentic Velázquez. The technique, moreover, is that of the works just studied, with some variations but essentially always the same,

since it is based above all on the unwavering sureness of the modelling and the absolute precision of the form. The painter deliberately created a range of colours very close to one another, making the young man's clothing – except for the bluish-grey sleeves – almost the same as the smooth background, in which there are variations of intensity so slight as to be hardly visible to the casual glance. The man's face reveals audacity and a certain hardness, while the flesh-tints are of a rather dark pink hue, denoting a sanguine temperament.

Velázquez painted two portraits of Fernando Valdés, Archbishop of Granada and President of the Council of Castile from October 1633 until his death in Madrid in December 1639. Of the one that was probably painted soon after the first of these dates all that remains is a fragment which, though admirable, is so small that it only shows the sitter's hand with part of his forearm *(Fig. 134 - Cat. 90)*. The hand is holding a paper with Velázquez's signature and the canvas is now in the Royal Palace of Madrid. In this fragment we can see the characteristics of the technique initiated in 1631: softer modelling, elimination of the line and effects achieved with apparently arbitrary loose brush-strokes. It is really a pity that one of Velázquez's few signed works should have come down to us in so mutilated a form. The second portrait of the Archbishop has been rather luckier, for at least the head and bust of the sitter in the original full-length portrait are still preserved in this fragment, which is in the National Gallery in London *(Fig. 136 - Cat. 91)*. The drawing is evidently that of Velázquez, though the fluid technique suggests that it was painted at a later date than the other portrait. Ainaud de Lasarte provided the key to the problem of these two fragments by proving that a large canvas in the collection of the Duchess de la Peña in Madrid and another very similar one in the Archbishop's Palace in Granada are really contemporary copies of the two mutilated works. The hand with the signature is faithfully reproduced in the first of these copies, while the London portrait is undoubtedly the original of the canvas in Granada. The two portraits, which are perfectly identified by their inscriptions, employ the same typology: a seated personage, looking to the viewer's left, with a crimson curtain in the back-

ground. From the physical appearance of the sitter it may be asserted that the portrait in London was probably painted shortly before the Archbishop's death.

I think it logical to include among the works of this period the portrait of the court jester *Juan de Calabazas,* also known as *Calabacillas,* which is in the Cleveland Museum of Art *(Fig. 140 - Cat. 95).* The sitter is easily identified by the undeniable physical likeness to the *Juan de Calabazas* in the Prado, which is studied in the following chapter *(Fig. 159 - Cat. 104).* Thanks to the researches of Moreno Villa we know that this pathetic-looking figure was, at least from 1630 on, in the service of the Cardinal-Infante Don Fernando, and in that of the King from 1632 until his death in 1639. The austere technique of this work reveals its affinities with the portraits of the early years of the decade 1630-1640. Velázquez's tendency to simplify his colour range, moreover, reaches its highest point in this picture. An interesting feature is the scheme of the composition, which, without abandoning the usual construction in parallel planes, opposes the simple geometry of the architecture, the attitude of the little jester and the foreshortening of the folding stool.

Portraits painted in Velázquez's workshop

Though not considering them to be absolutely authentic works, entirely by Velázquez's own hand, I do not wish to leave out a number of portraits which are undoubtedly copies from originals by the painter that are now lost. Chief among them are two royal portraits in the Kunsthistorisches Museum of Vienna *(Figs. 137 & 138 - Cat. 92 & 93).* In their original format they were probably full-length portraits. Cruzada Villamil suggested that these were the paintings mentioned in a document in the royal archives in Madrid, in which Velázquez is instructed to carry out some "portraits of Their Majesties, to be sent to Germany". This order is dated September 24th 1632 and the painter was paid eleven hundred reales for the commission. The portrait of Philip IV coincides with the King's physical appearance at this time,

while Elizabeth of Bourbon seems rather older than in the equestrian portrait repainted by Velázquez in 1634 *(Fig. 123).* Camón Aznar, in my opinion rightly, considers this portrait of the Queen to have been painted in or about 1637 or 1638. Contemporary copies of both canvases still exist.

Among the works of Velázquez described by Palomino there appears the portrait of *Francisco de Quevedo,* "wearing spectacles as was his wont". There are several versions of this image of the poet which are undoubtedly reminiscent of Velázquez's style, though none of them possesses the quality of the great painter's own work. I reproduce here the version in the Wellington Museum *(Fig. 139 - Cat. 94),* since it is the one that seems to come closest to what the original by Velázquez would have been. Another copy of excellent quality is the one in the Institute of Valencia de Don Juan, in Madrid. The physical appearance of this implacable castigator of the court of Philip IV, and the circumstances of his eventful life, lead me to think that the original portrait was probably painted in the period we are studying.

Paintings of religious subjects

To round off this chapter dealing with the years 1631-1635, I should like to present three canvases on religious subjects now in the Prado, all three justly famous and universally familiar thanks to the vivid medium of cheap reproduction. *The Coronation of the Virgin* was painted for the Queen's oratory in the Alcázar of Madrid *(Figs. 141 & 142 - Cat. 96).* The fairly symmetrical composition is painted in the straightforward, naturalistic style the painter used for sacred themes, in representing which he hardly ever attempted to give the image a mystical or supernatural significance. Angels in flight appear in the lower part of the picture, amidst the clouds demanded by the conventions of the theme. The Virgin, full of grace and serenity, recalls the Greek ideal of beauty and the search for a sense of the divine through strict representation of perfection in the human form. This picture has none of the mystical raptures of El Greco or the theatrical move-

ments of Rubens. On the contrary, indeed, everything in it is grave and static. The free space almost disappears, the little there is left of it – between the figures in the upper part – being used for the lighting effects proper to the theme. Of great pictorial interest is the part centring on the crown held by the hands of God the Father and God the Son.

This picture presents a very successful synthesis of the methods used up to now in the different periods of the artist's career, though this in no way detracts from the unity of the work; what most strikes us about this canvas, indeed, is its majesty and its unity, the essential elements of which are the composition, the grouping of the figures and the arrangement of triangles on which the scheme is based. This geometrical scheme was probably a chance discovery for, unlike the Italians, Spanish artists did not go out of their way to seek canons of proportion and geometry concealed under the forms of the characters depicted.

Returning to the technique, we may find evident reminiscences of the procedures Velázquez had followed in the previous decade, and even of certain concepts popular in the Sevillian school at the beginning of the century. The figure of the Virgin, in particular, though softer and lighter, recalls the figures of Velázquez's first great period, above all in the treatment of the draperies – light, intense and with a force that comes as much from the perfect drawing as from the exact representation of the quality, thickness and degree of tension of the different stuffs. In the upper part – particularly in the heads of God the Father and God the Son, but also in the luminous patches near the centre and in the crown – there are some areas of more dissolved form and what seems to be an attempt at a "divisionist" technique. Though there is very little free space around the figures (above all to the right and left of the greater part of the central area), this space is so beautifully painted that it suggests bottomless depth.

Another religious composition, one of Velázquez's finest, is the one which represents – in the fashion of a medieval altar-piece, but within a unified space – various scenes from the legend of St. Anthony Abbot and St. Paul the Hermit (*Figs. 143 & 144 - Cat. 97*). According to Palomino, this canvas was painted for the hermitage of St. Paul in the grounds of the Palace of El Buen Retiro. Originally semi-circular at the top, later additions gave it its present rectangular format. In Camón Aznar's opinion, it was more probably painted for the hermitage of St. Anthony, also in the Retiro grounds, for it was there that the picture was discovered in 1701. As I said above, the iconography comes from medieval formulas and represents the saintly abbot four times: twice during his temptations by the devil, who appears to him in the guise of a centaur and a satyr successively, later praying over the corpse of St. Paul the Hermit and while the lions are digging the grave. The principal figures are those of the two saints, sitting under a tree and receiving the food brought to them by a raven. The whole is unified by one of the most beautiful landscapes Velázquez ever painted.

The predominant colours belong to a very beautiful range of transparent blues and greys. The technique is rapid and spontaneous, very similar to what we have seen in the heads of God the Father and God the Son in *The Coronation of the Virgin*.

The masterly *Dead Christ* in the Prado (*Fig. 145 - Cat. 98*), which formerly hung in the Church of San Plácido in Madrid, retains much of the dense execution of the works painted in Italy. Palomino tells us it was painted in 1638 but, as the information in the "Museo Pictórico" is not always to be trusted, I still think that it cannot have been painted much later than the *Christ Crucified* from the Convent of the Order of St. Bernard, which is dated 1631 (*Fig. 102*). The anatomy here is less naturalistic, the figure more majestic; like all great masterpieces, it possesses those touches of genius that are at once definable and, paradoxically, inexpressible.

On account of its provenance, this work is popularly known as the *Christ of San Plácido* and this name, though really one of place, certainly expresses the absolute serenity that emanates from this noble image, in which the painter has refused to include the slightest touch of expressionism, in order to represent Christ's majesty rather than his suffering.

Fig. 101. PRINCE BALTASAR CARLOS WITH A DWARF. 1631. Boston: Museum of Fine Arts. Cat. No. 66.

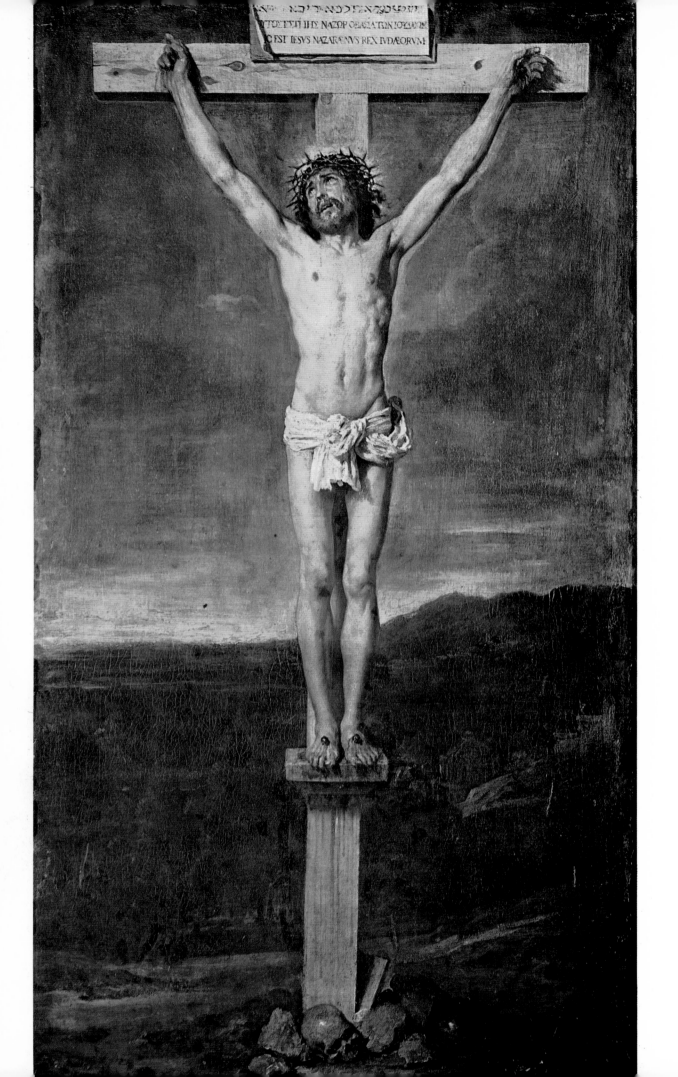

Fig. 102.
CHRIST CRUCIFIED. 1631.
Madrid: Prado Museum.
Cat. No. 67.

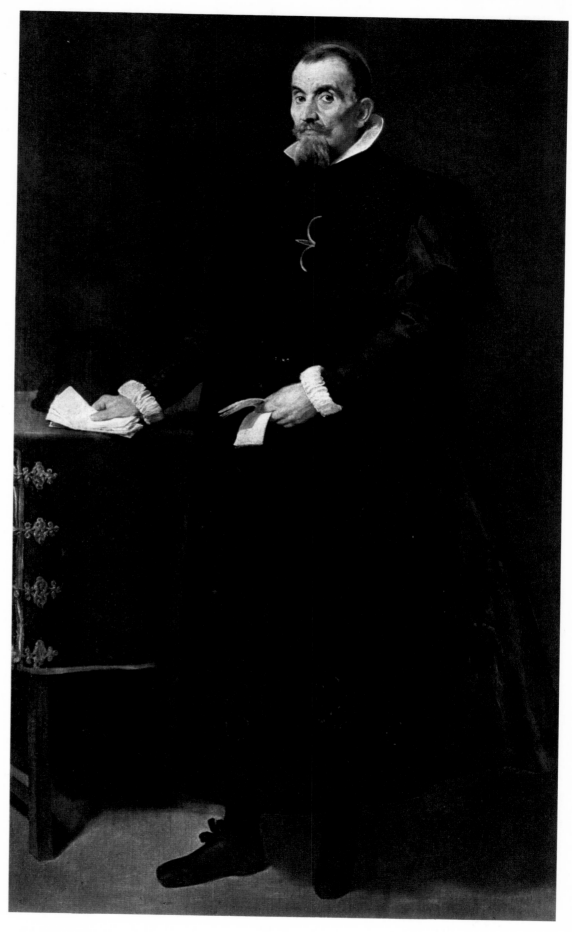

Fig. 103. DON DIEGO DEL CORRAL Y ARELLANO. C. 1631-1632. Madrid: Prado Museum.
Cat. No. 68.

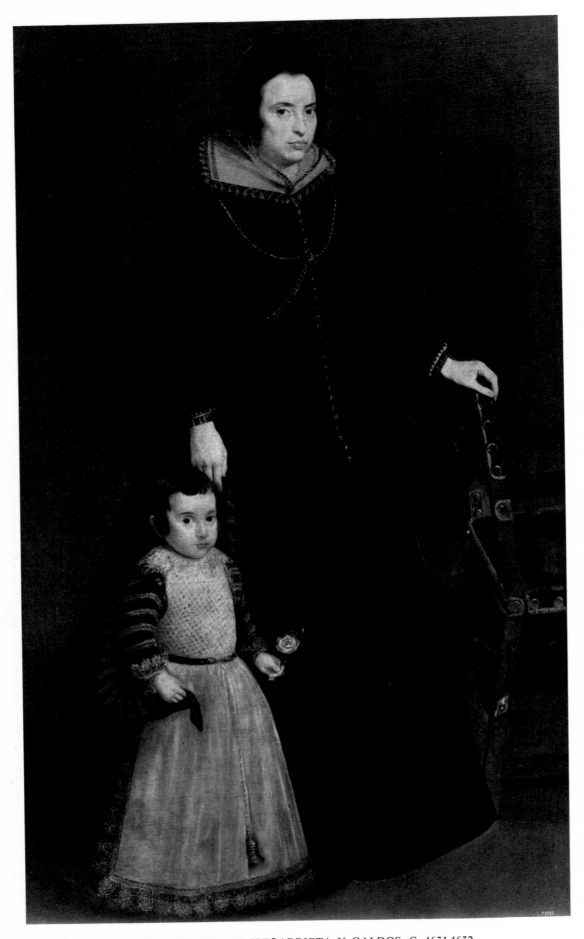

Figs. 104 & 105. DOÑA ANTONIA DE IPEÑARRIETA Y GALDOS. C. 1631-1632.
Madrid: Prado Museum. Cat. No. 69.

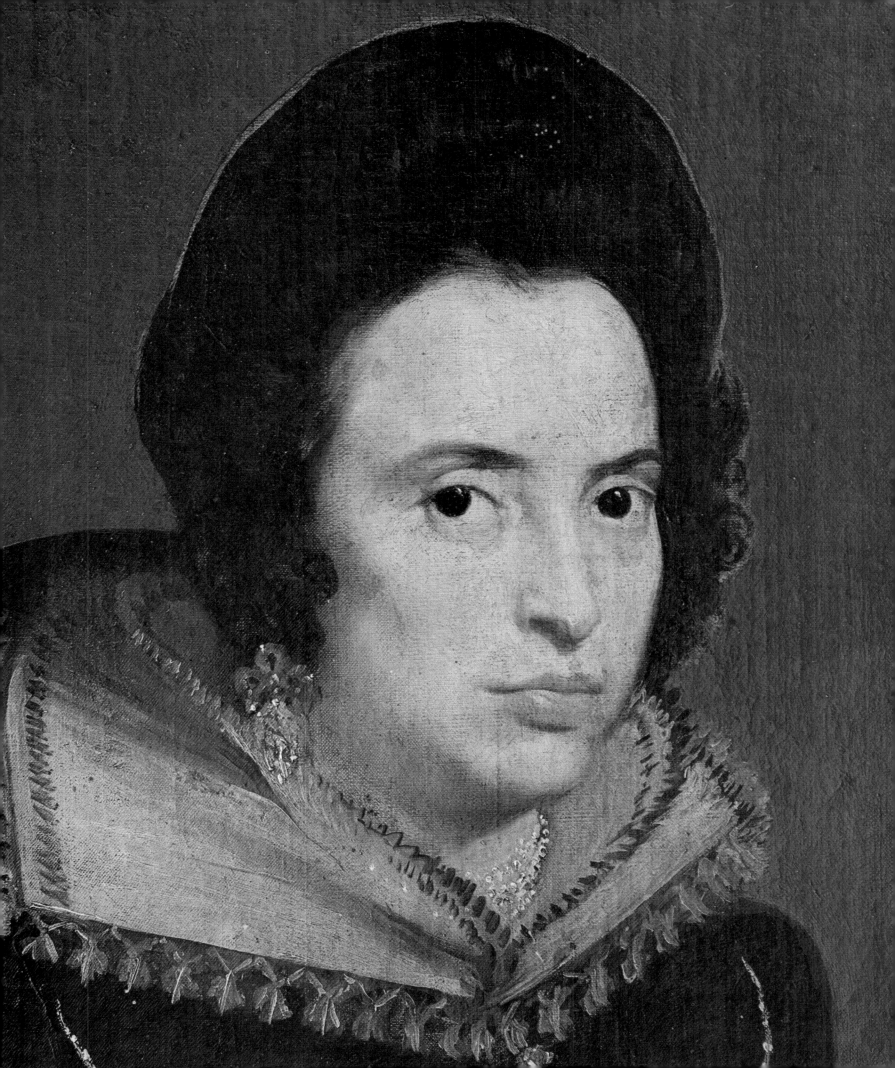

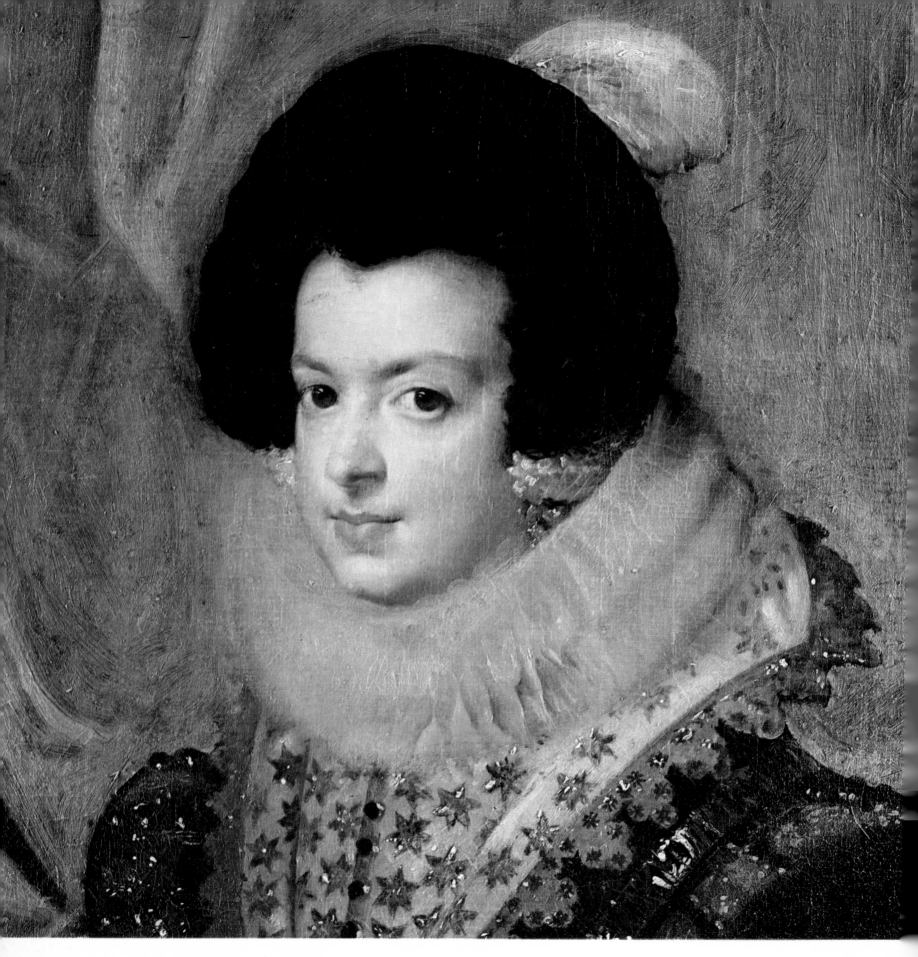

Fig. 106. QUEEN ELIZABETH OF BOURBON. Detail. C. 1632-1633. Private collection. Cat. No. 72.
Fig. 107. PRINCE BALTASAR CARLOS. C. 1632. London: Wallace Collection. Cat. No. 70.

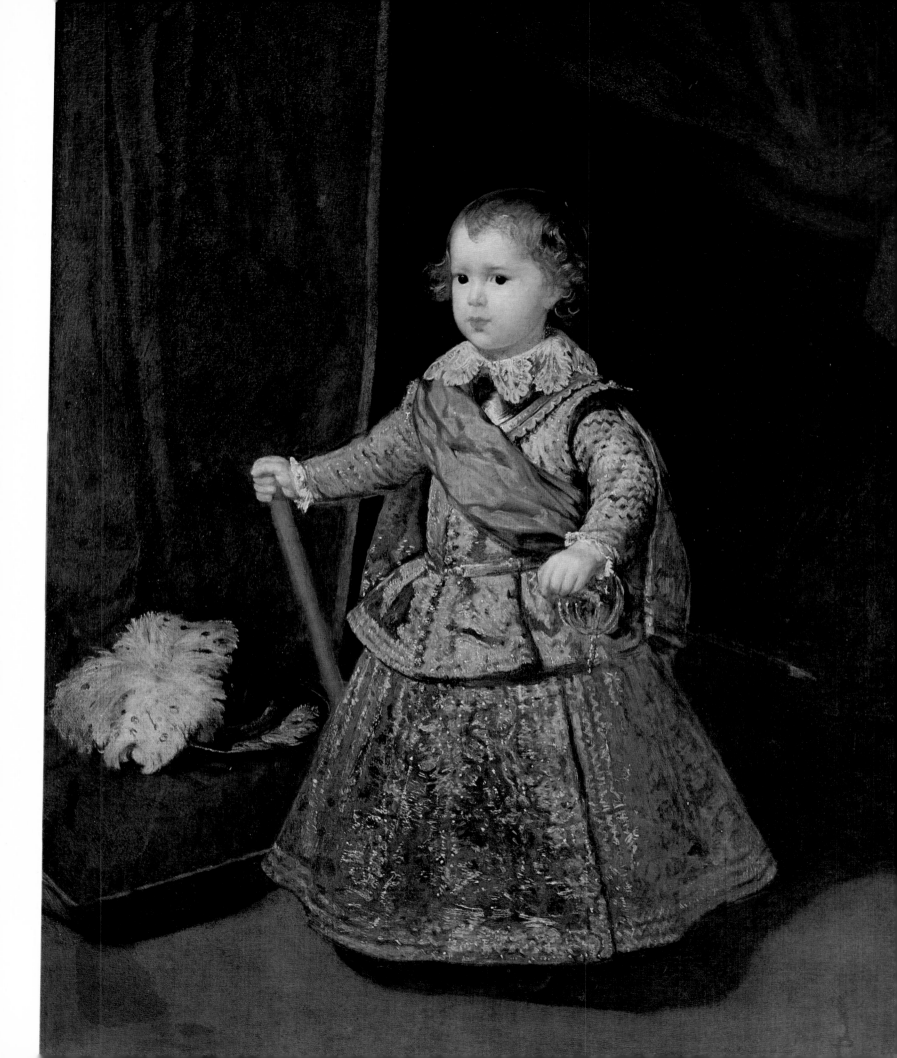

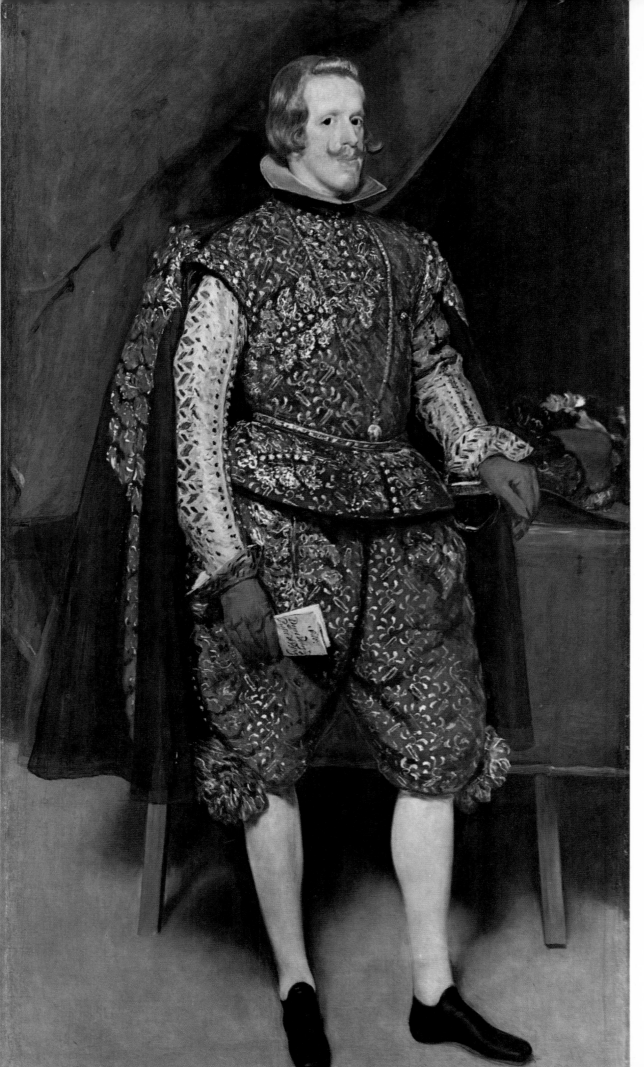

Figs. 108 & 109.
PHILIP IV. C. 1632-1633.
London: National Gallery.
Cat. No. 71.

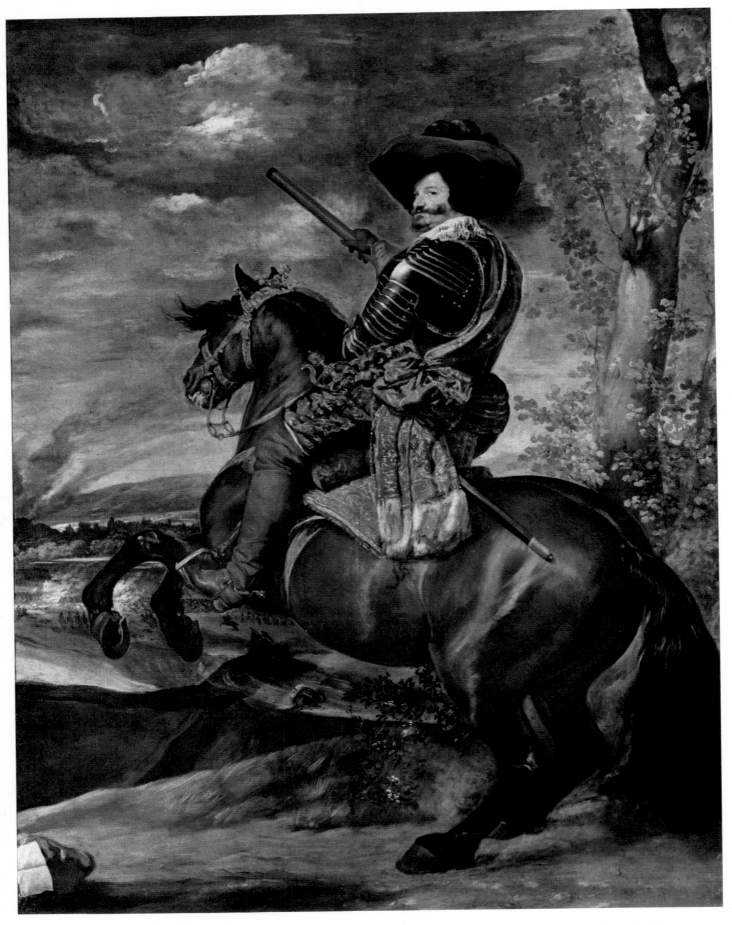

Figs. 110 & 111. EQUESTRIAN PORTRAIT OF THE COUNT-DUKE OF OLIVARES. C. 1632-1633. Madrid: Prado Museum.
Cat. No. 73.

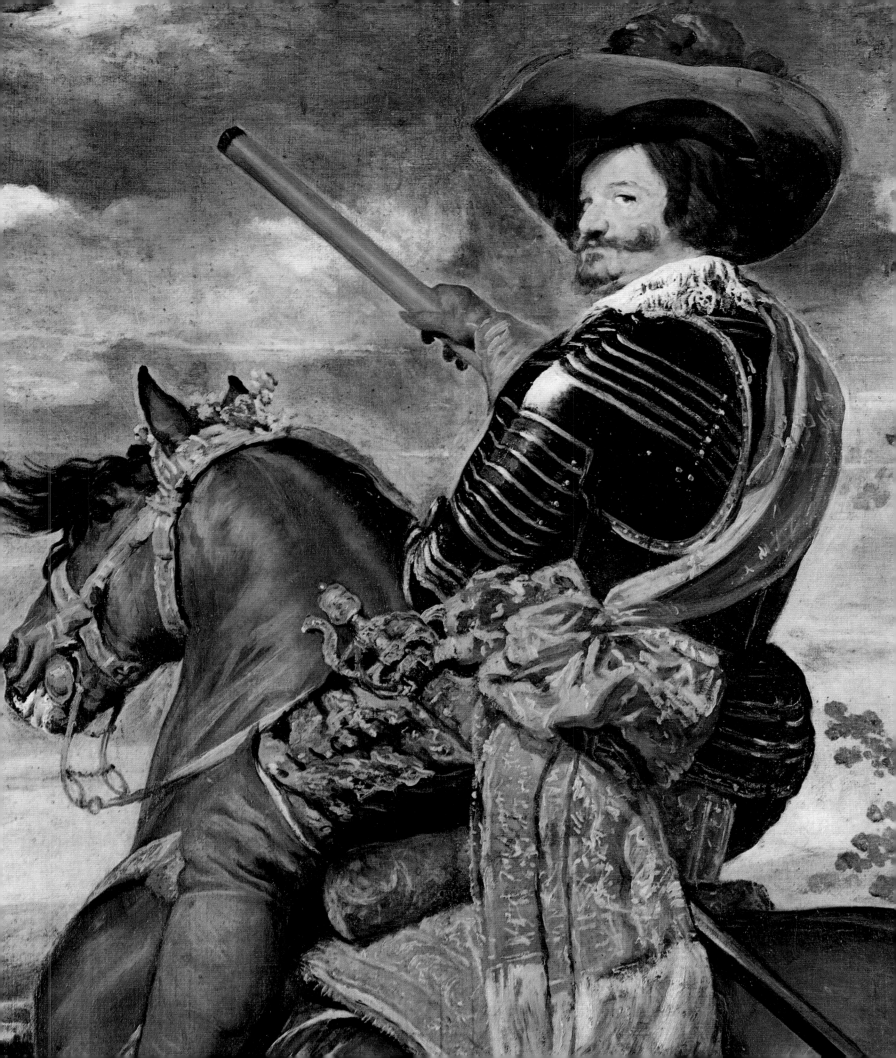

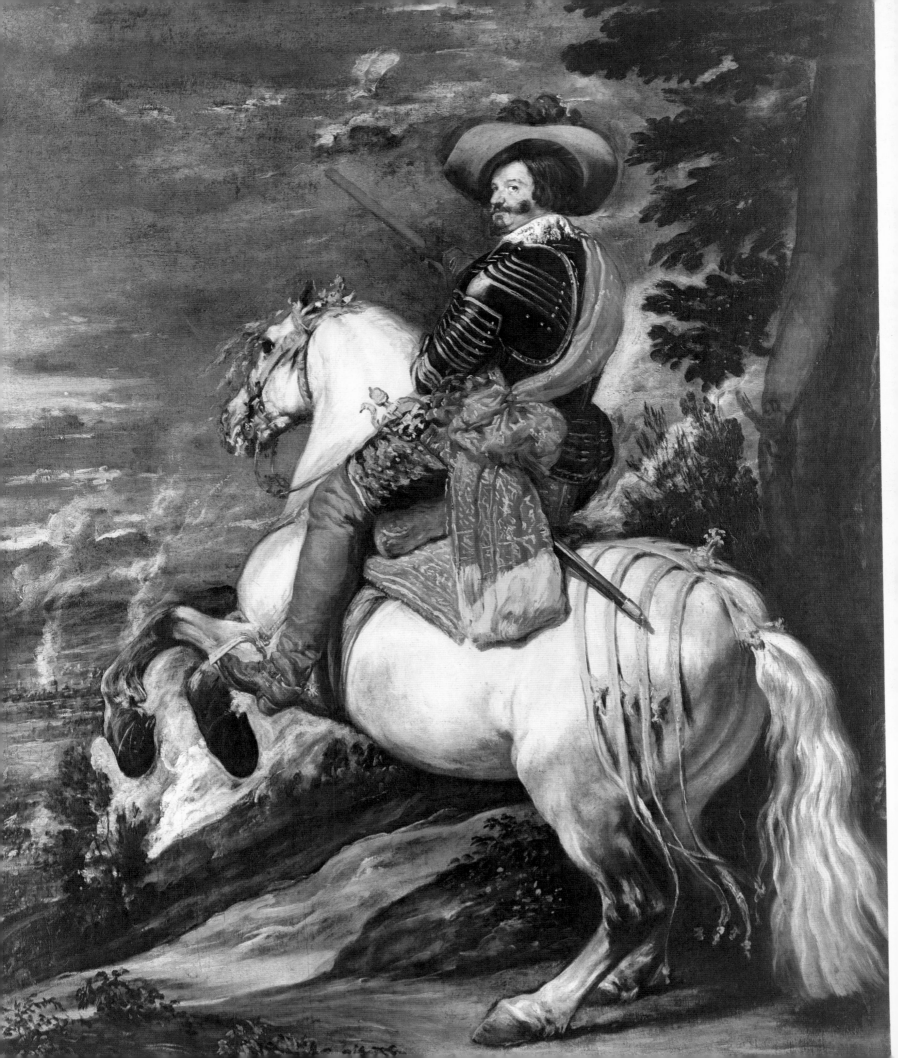

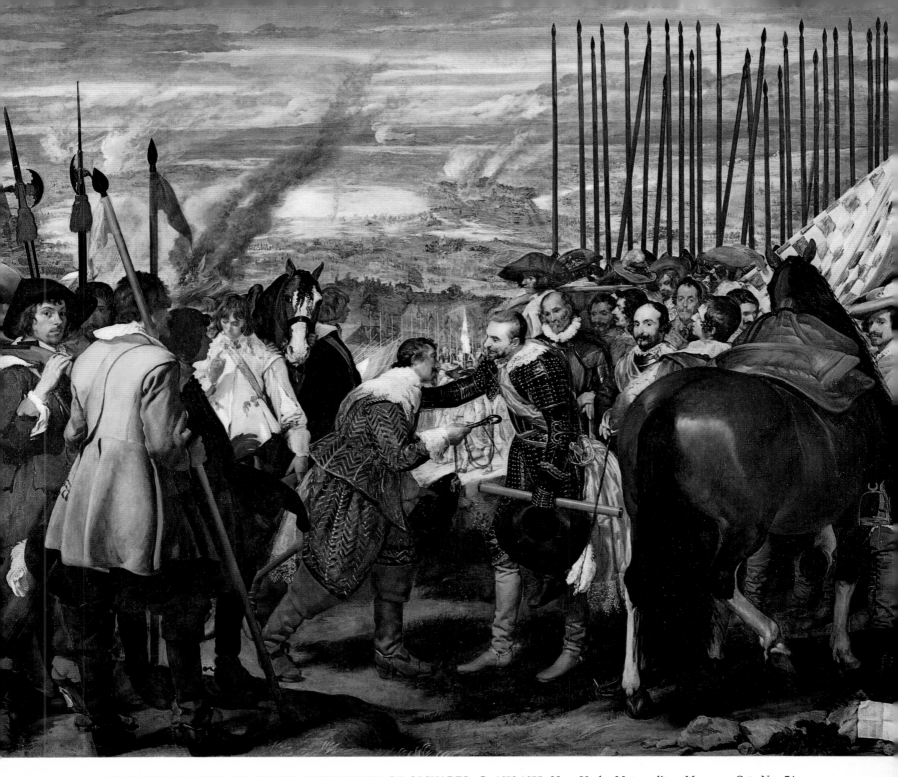

Fig. 112. EQUESTRIAN PORTRAIT OF THE COUNT-DUKE OF OLIVARES. C. 1632-1633. New York: Metropolitan Museum. Cat. No. 74.
Fig. 113. THE SURRENDER OF BREDA. 1634-1635. Madrid: Prado Museum. Cat. No. 76.

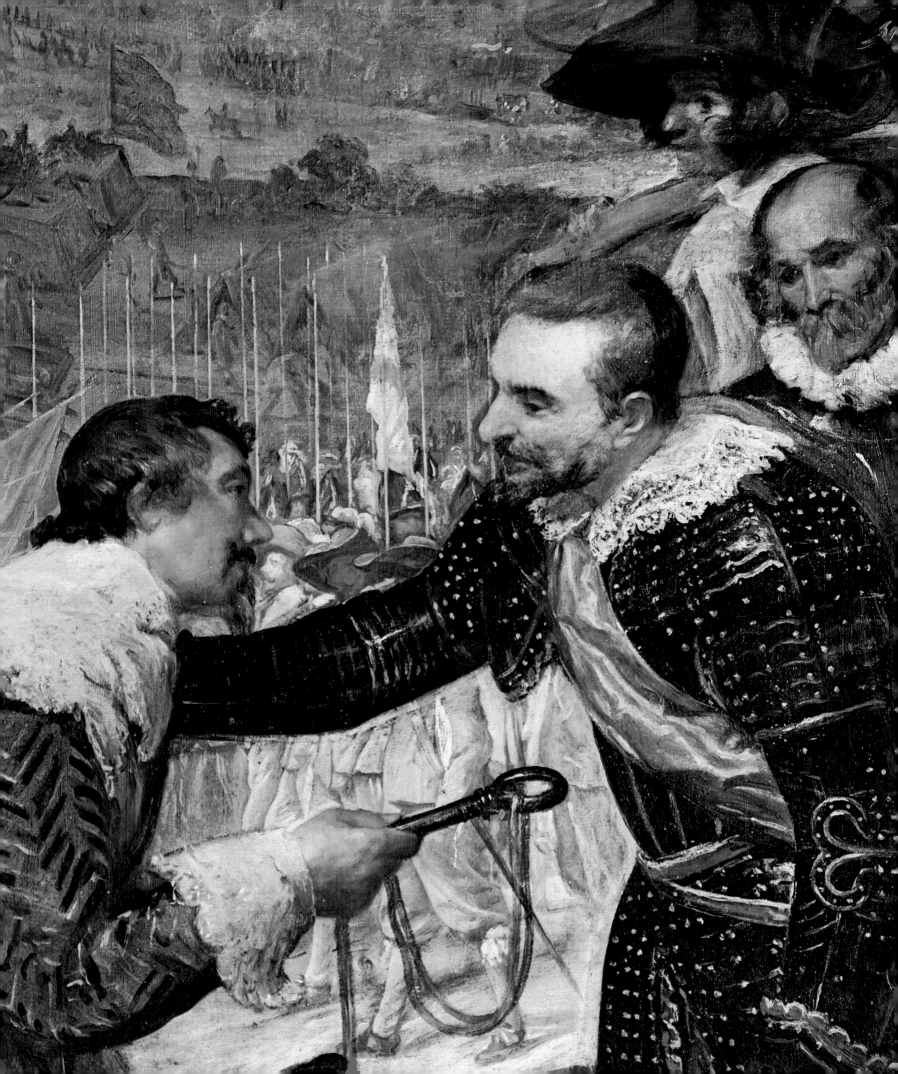

Figs. 114 & 115. THE SURRENDER OF BREDA. Details of figure 113.

Figs. 116 & 117. THE SURRENDER OF BREDA. Details of figure 113.

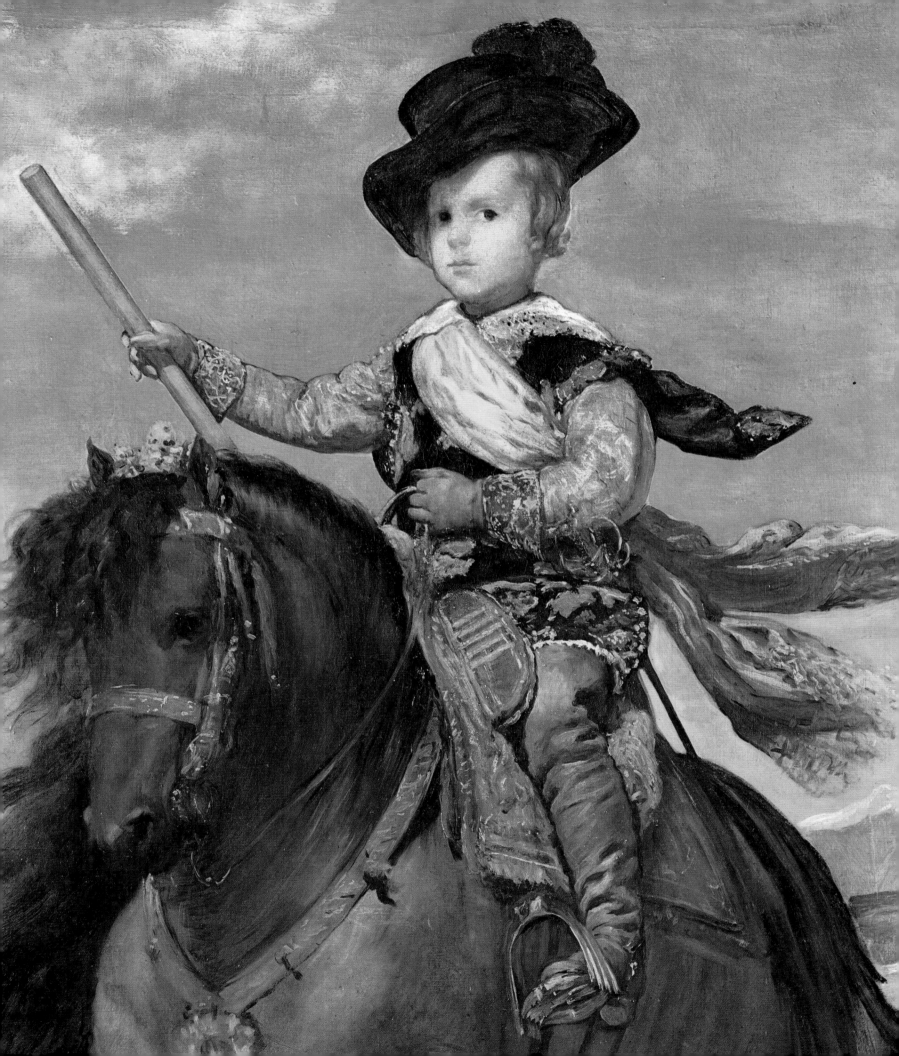

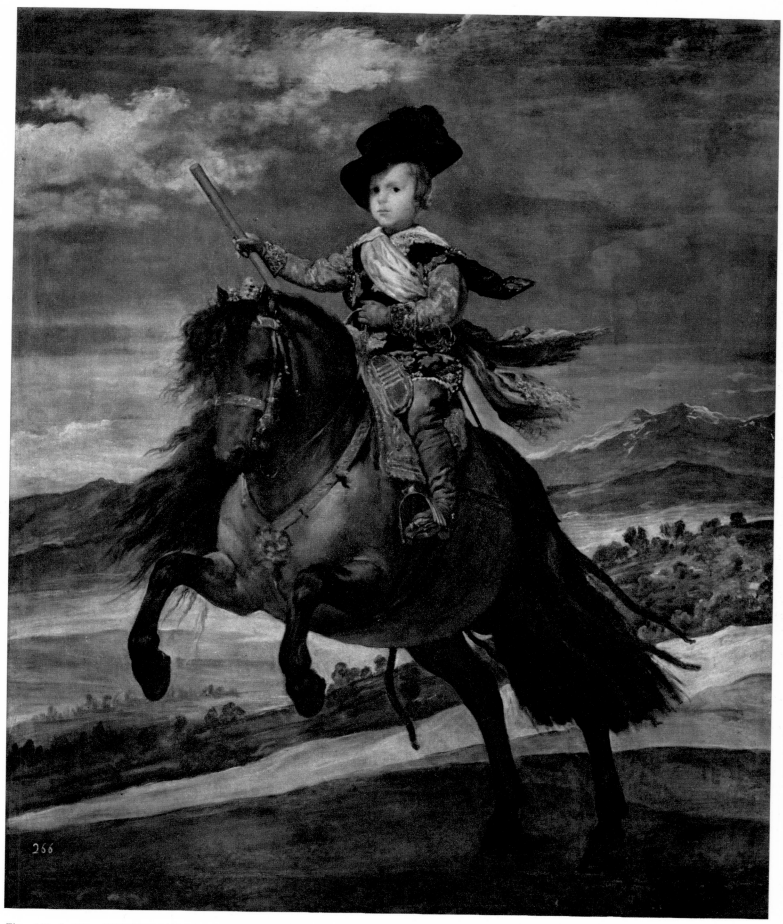

Figs. 118 & 119. EQUESTRIAN PORTRAIT OF PRINCE BALTASAR CARLOS. 1634-1635. Madrid: Prado Museum. Cat. No. 77.

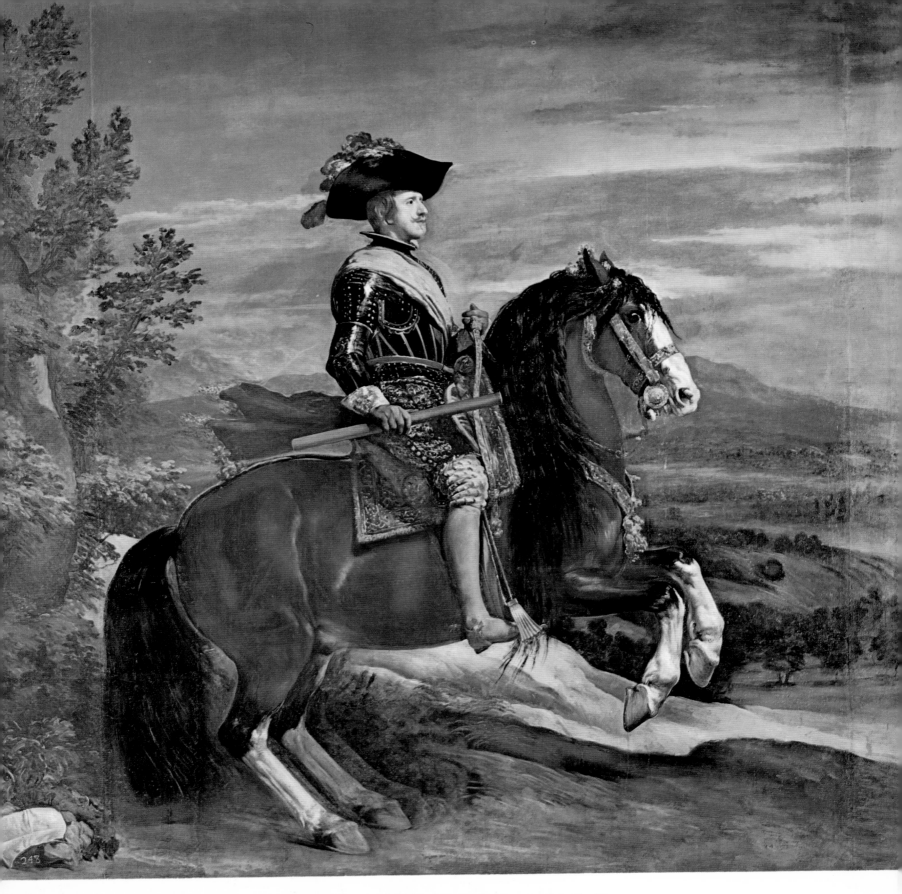

Fig. 120. EQUESTRIAN PORTRAIT OF PHILIP IV. 1634-1635. Madrid: Prado Museum. Cat. No. 78.
Fig. 121. EQUESTRIAN PORTRAIT OF ELIZABETH OF BOURBON. Detail of figure 123.

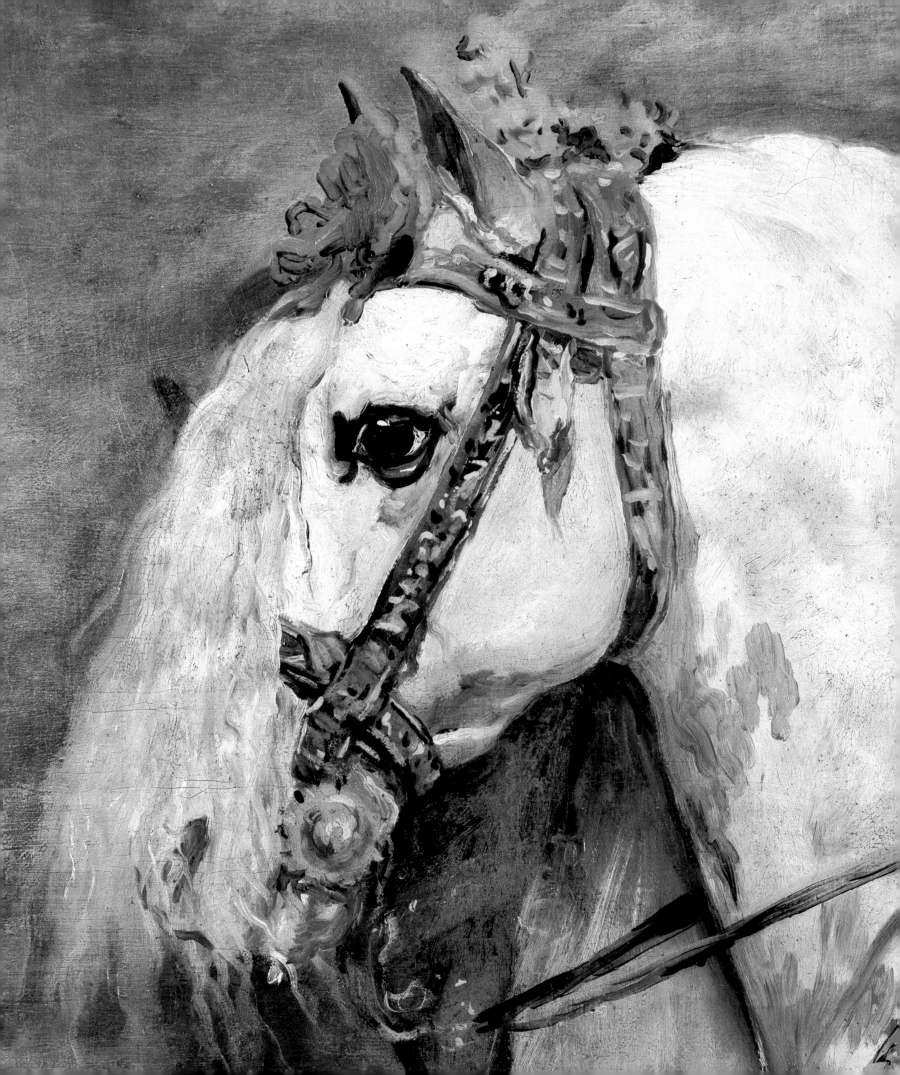

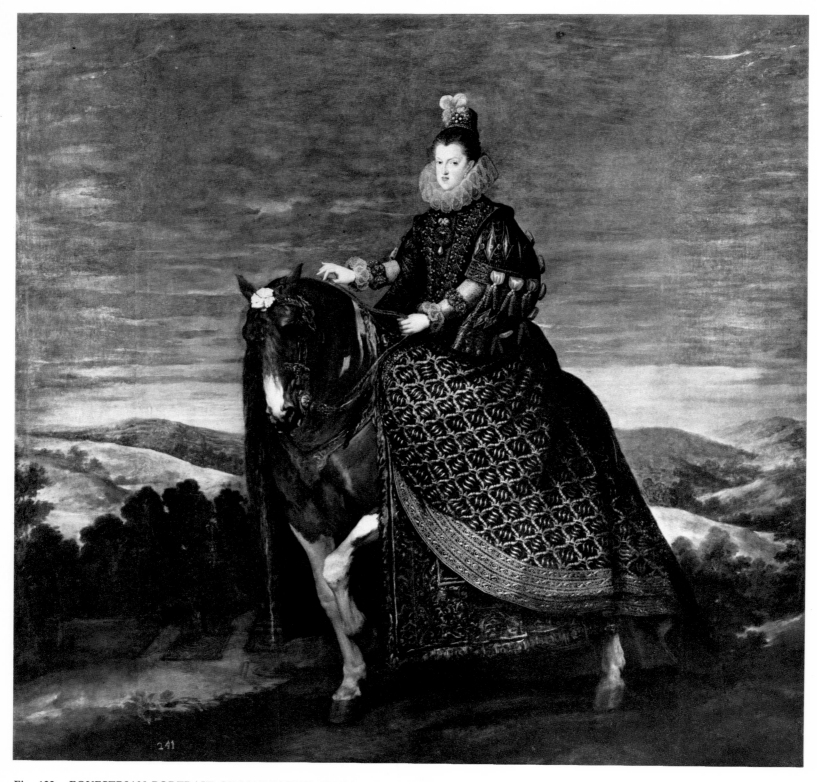

Fig. 122. EQUESTRIAN PORTRAIT OF MARGARITA OF AUSTRIA. 1634-1635. Madrid: Prado Museum. Cat. No. 79.

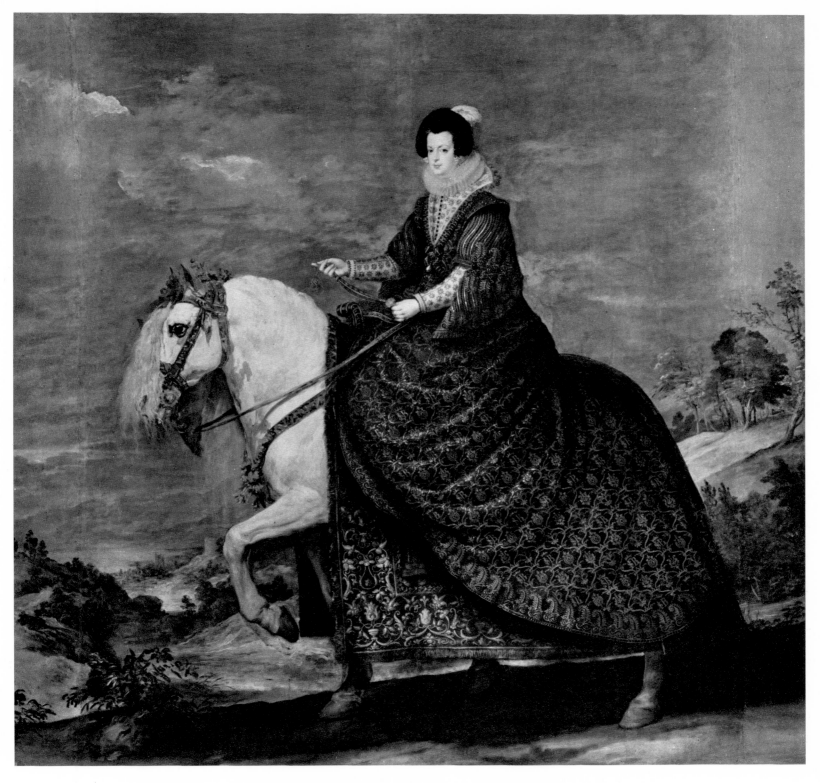

Fig. 123. EQUESTRIAN PORTRAIT OF ELIZABETH OF BOURBON. 1634-1635. Madrid: Prado Museum. Cat. No. 80.

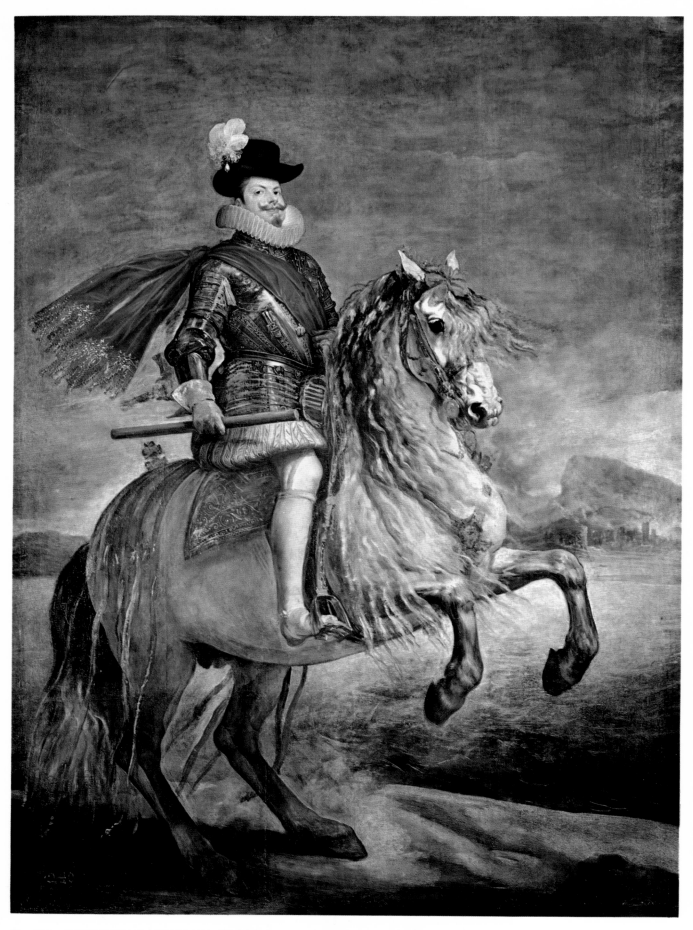

Fig. 124. EQUESTRIAN PORTRAIT OF PHILIP III. 1634-1635. Madrid: Prado Museum. Cat. No. 81.

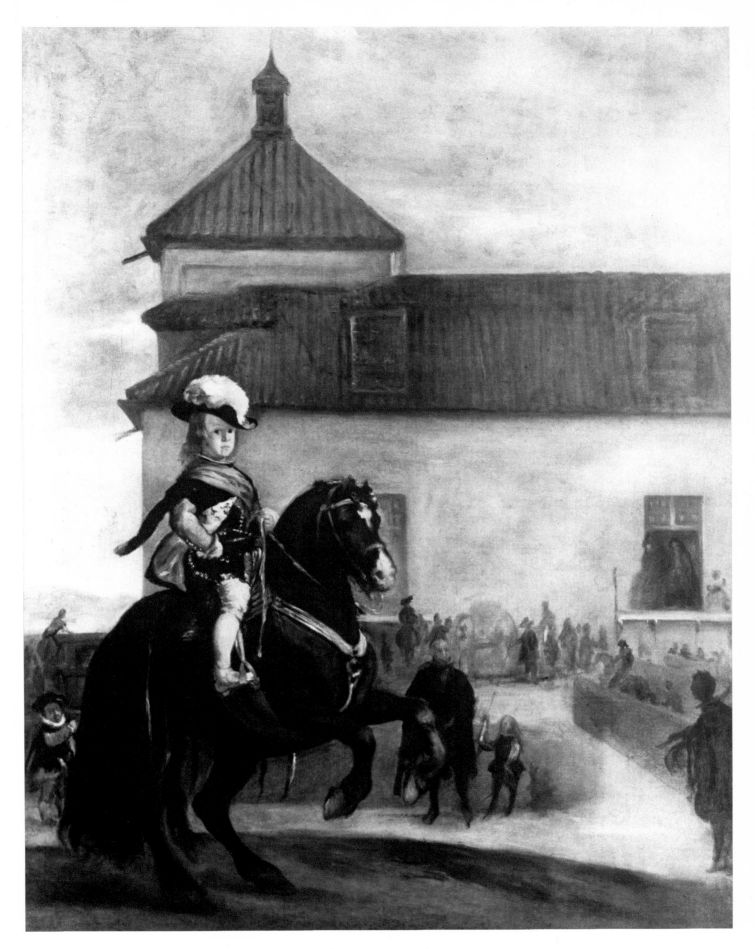

Fig. 125. PRINCE BALTASAR CARLOS ON HORSEBACK. C. 1635. London: Wallace Collection. Cat. No. 82.

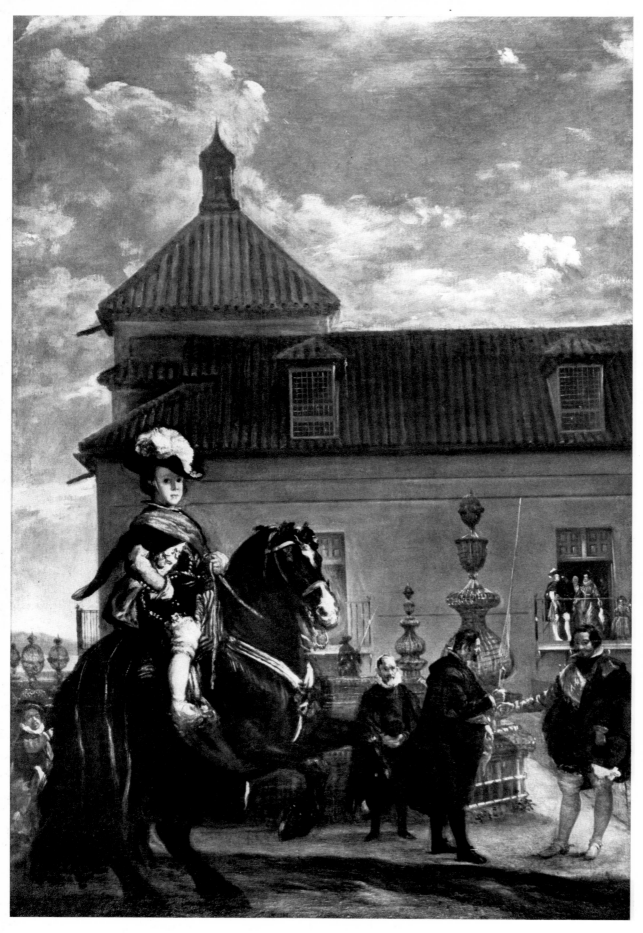

Fig. 126. PRINCE BALTASAR CARLOS ON HORSEBACK. C. 1635. Eccleston, England: Duke of Westminster. Cat. No. 83.

Fig. 127. SIBYL. C. 1631-1632. Madrid: Prado Museum. Cat. No. 84.

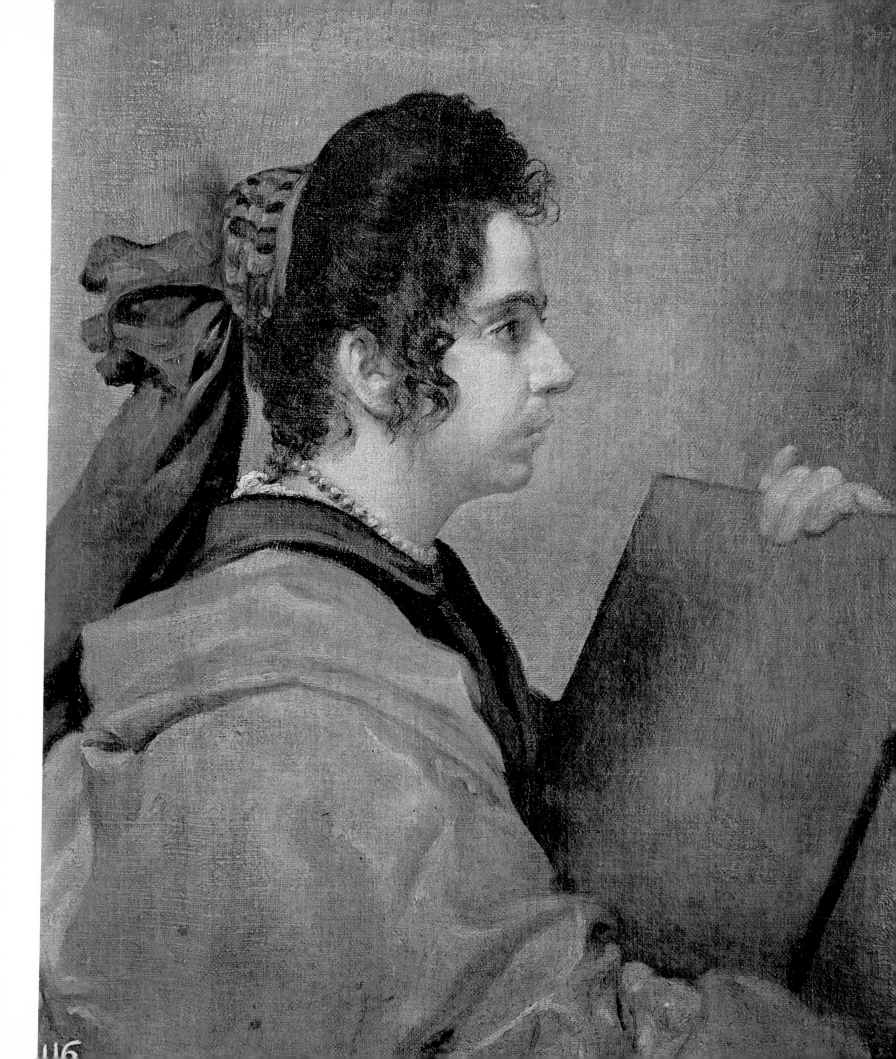

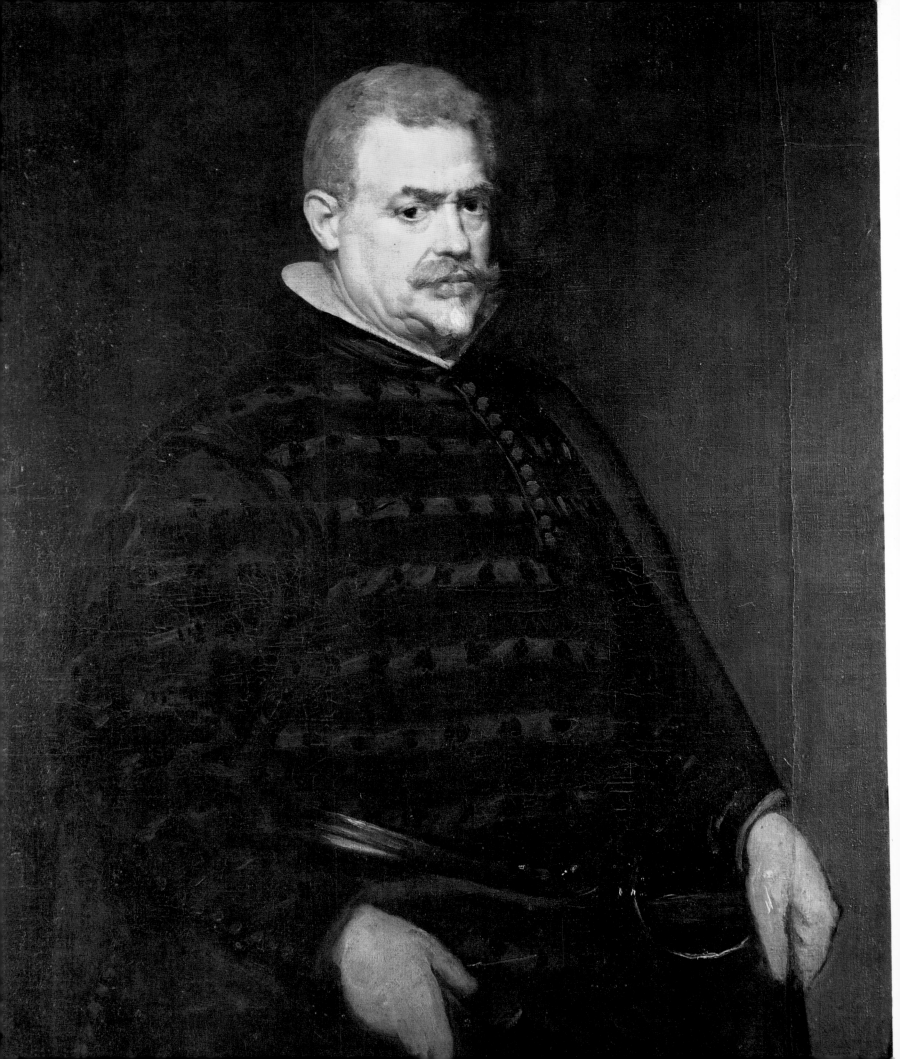

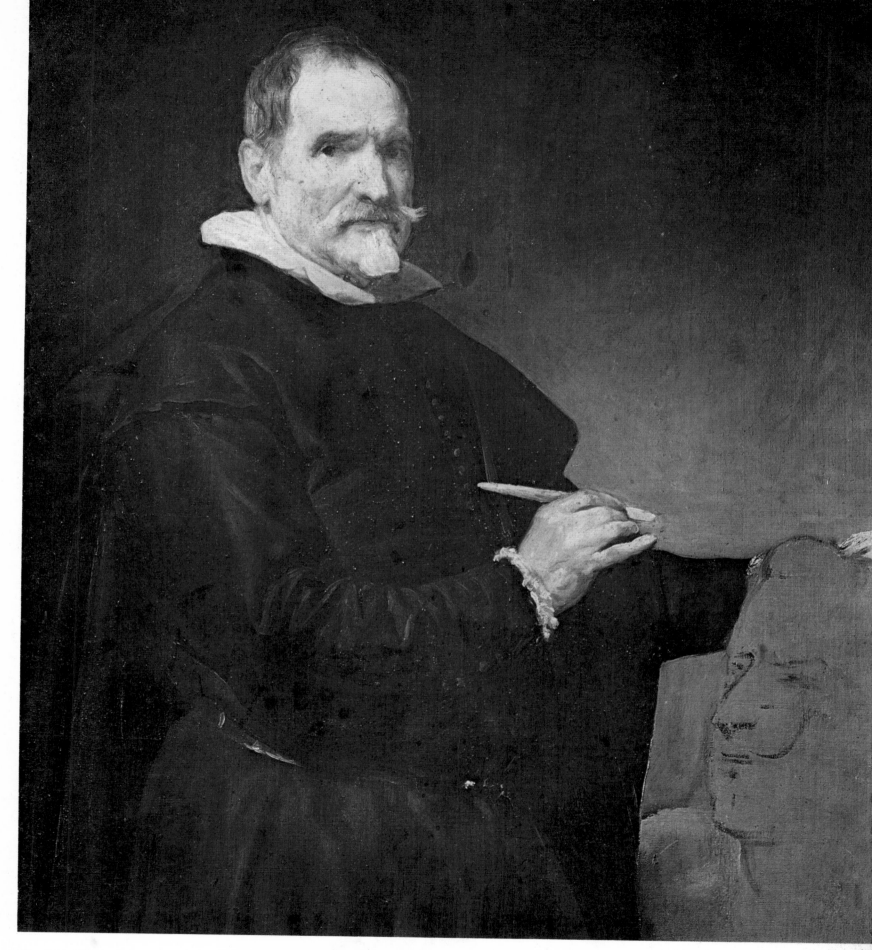

Fig. 128. JUAN MATEOS. C. 1631-1632. Dresden: Staatliche Gemäldesammlung. Cat. No. 85.
Fig. 129. THE SCULPTOR MARTINEZ MONTAÑES. 1635. Madrid: Prado Museum. Cat. No. 86.

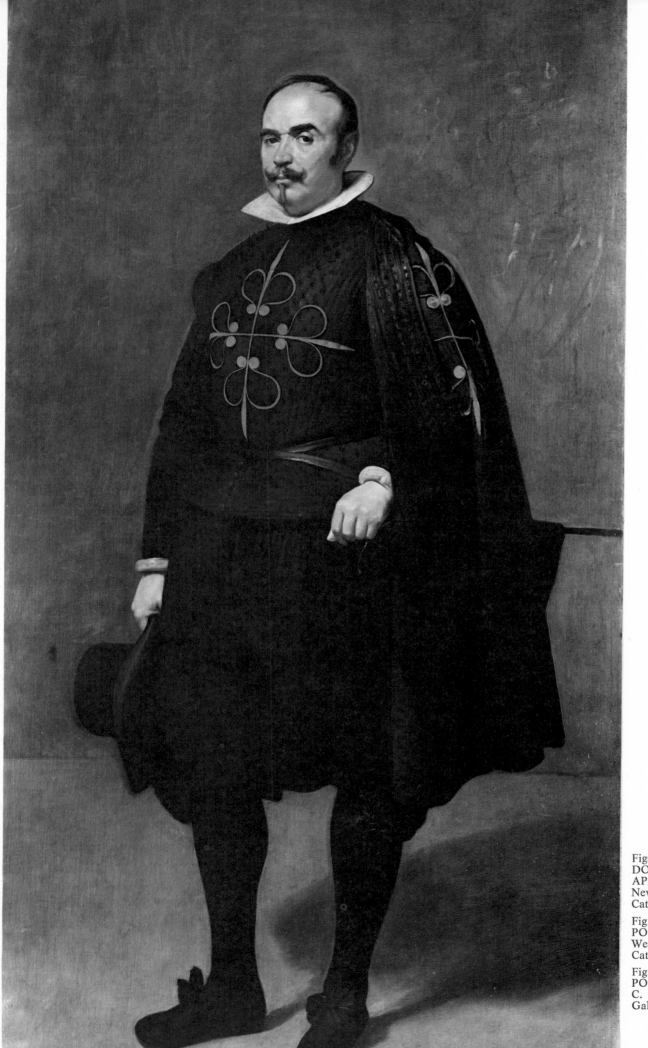

Figs. 130 & 131.
DON PEDRO DE BARBERANA Y
APARREGUI. C. 1635.
New York: Private collection.
Cat. No. 87.

Fig. 132.
PORTRAIT OF A LADY. C. 1635.
West Berlin: Staatliche Museen.
Cat. No. 88.

Fig. 133.
PORTRAIT OF A YOUNG MAN.
C. 1635. Washington, D.C.: National
Gallery of Art. Cat. No. 89.

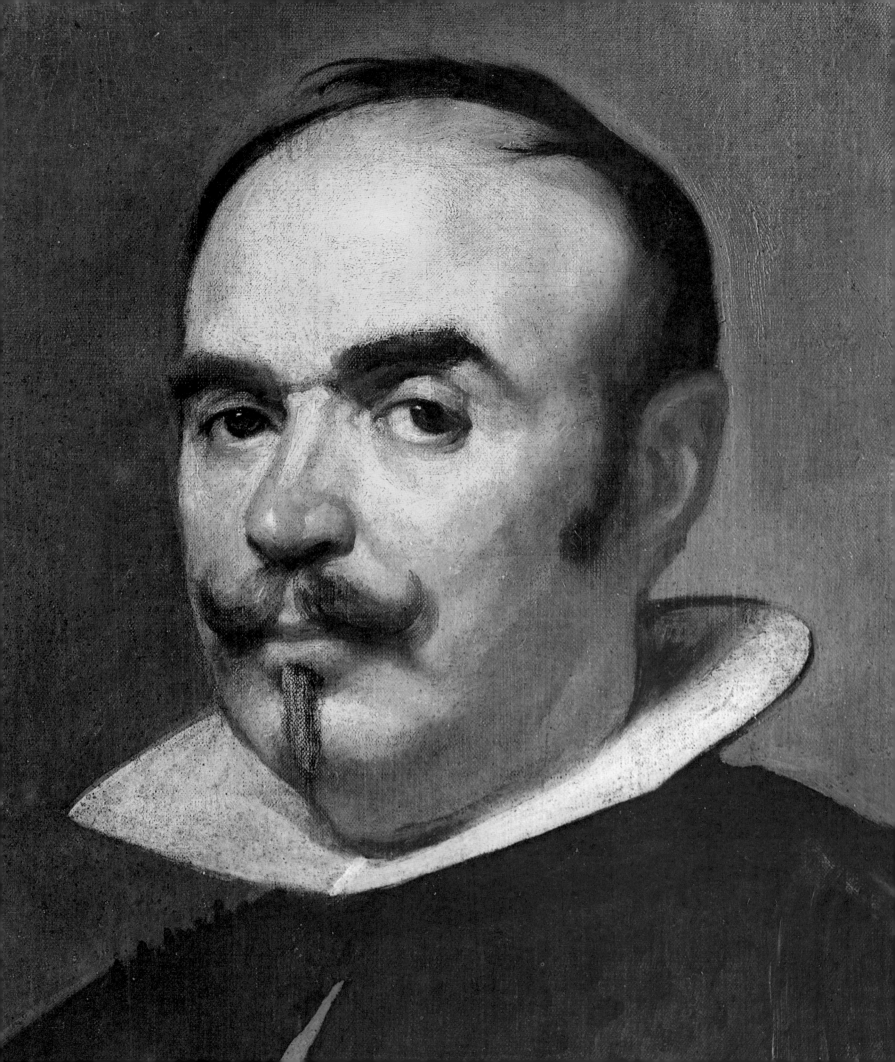

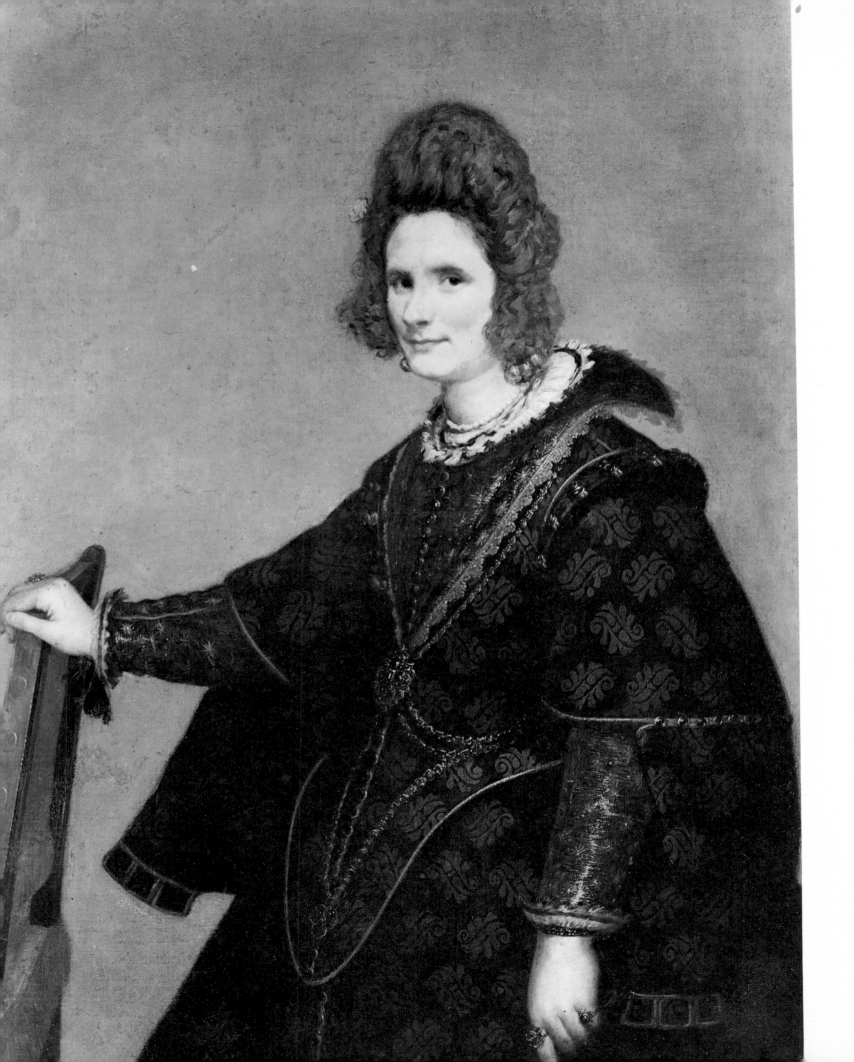

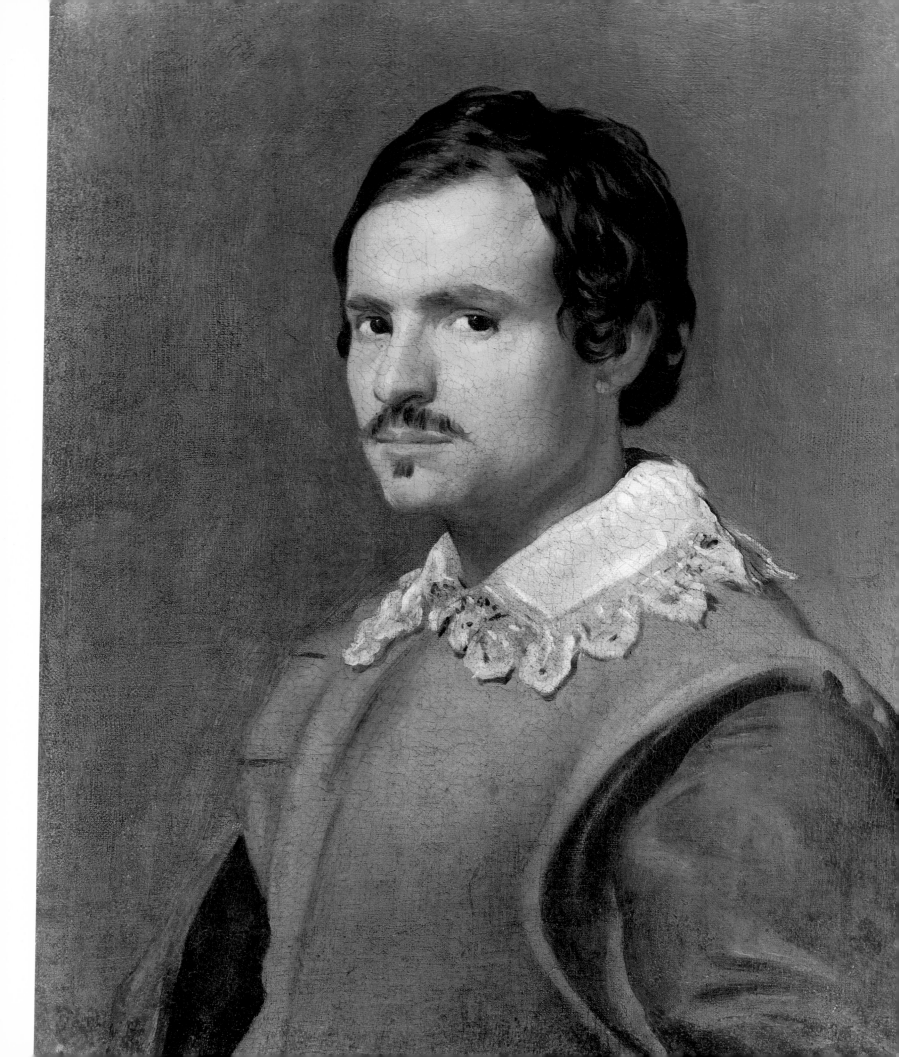

Fig. 134. A HAND FROM THE PORTRAIT OF ARCHBISHOP FERNANDO VALDES. C. 1633. Madrid: Royal Palace. Cat. No. 90.

Fig. 135. WHITE HORSE. C. 1632. Madrid: Royal Palace. Cat. No. 75.

Fig. 136. ARCHBISHOP FERNANDO VALDES. C. 1639. London: National Gallery. Cat. No. 91.

Fig. 137. PHILIP IV. C. 1632. Vienna: Kunsthistorisches Museum. Cat. No. 92.

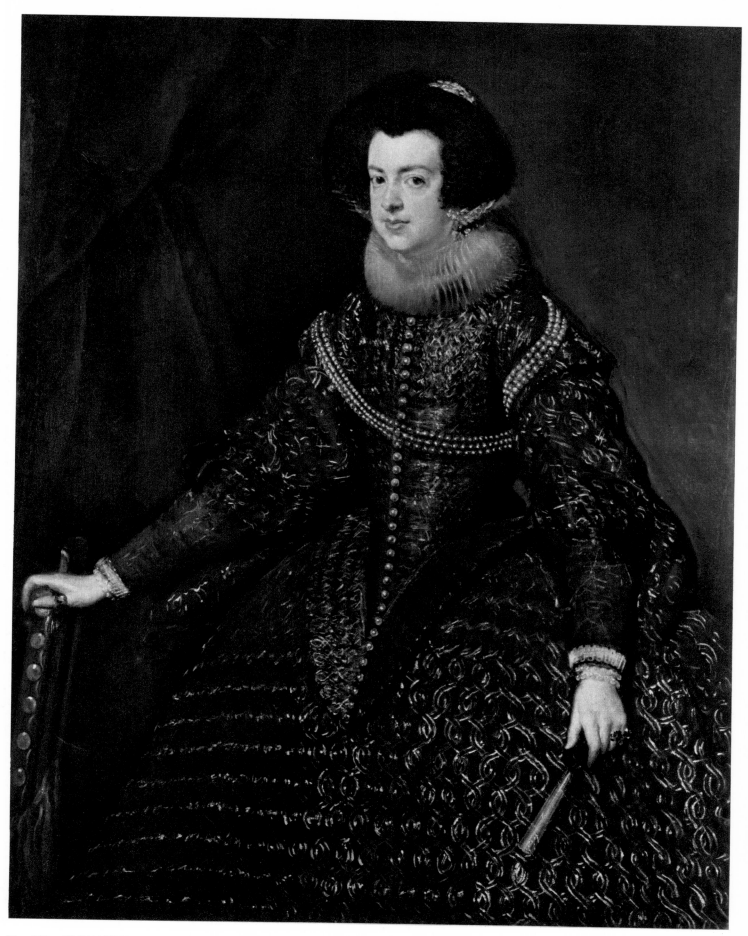

Fig. 138. ELIZABETH OF BOURBON. C. 1637-1638. Vienna: Kunsthistorisches Museum. Cat. No. 93.

Fig. 139. FRANCISCO DE QUEVEDO. C. 1635. London: Wellington Museum. Cat. No. 94.

Fig. 140. JUAN DE CALABAZAS (CALABACILLAS). C. 1635. Cleveland: Museum of Art. Cat. No. 95.

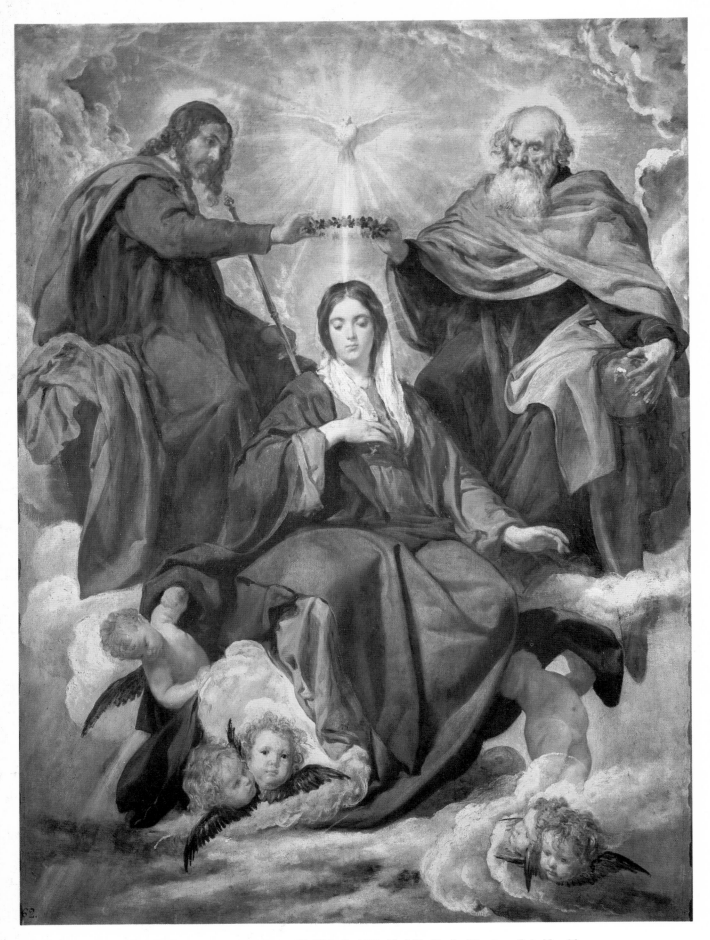

Figs. 141 & 142. **THE CORONATION OF THE VIRGIN. C. 1635. Madrid: Prado Museum. Cat. No. 96.**

Figs. 143 & 144. SAINT ANTHONY ABBOT AND SAINT PAUL THE HERMIT. C. 1635-1640. Madrid: Prado Museum. Cat. No. 97.

V

THE TORRE DE LA PARADA
1636-1648

1643. FALL OF THE COUNT-DUKE. – 1644. DEATH OF PACHECO. – THE DECORATION OF THE TORRE DE LA PARADA. – THE THREE PORTRAITS OF ROYALTY IN SHOOTING DRESS. – *THE BOAR HUNT*. – GALLERY OF DWARFS AND JESTERS. – PORTRAITS PAINTED BEFORE 1640. – COPIES OF LOST ORIGINALS. – THE PORTRAITS OF TWO LADIES AND A LITTLE GIRL. – WORKS DONE BETWEEN 1640 AND 1650. – THE PORTRAIT OF PHILIP IV AT FRAGA. – THE *VIEW OF ZARAGOZA* AND OTHER CANVASES THAT SHOW SIGNS OF VELAZQUEZ'S INTERVENTION. – *THE ROKEBY VENUS*. – *THE SPINNERS*.

Though twelve years are a long enough period, comparatively few of the works painted by Velázquez at this time are still extant. With the end of the rich store of information in Pacheco's text, moreover, Palomino's biography of the painter becomes much poorer as regards historical fact, though still rich in anecdote. Recently discovered documents have cleared up some of the uncertainties, but it must be admitted that the life of Velázquez is still full of lacunae. Throughout this period, so disastrous for the history of Spain, he was living in a house that belonged to the King in the Calle de la Concepción Jerónima. As in the foregoing chapters, I will first give a year-by-year continuation of my chronicle.

1636

On July 28th of this year Velázquez was appointed a Gentleman of the Wardrobe, a fact referred to in an anonymous manuscript of the time. "They have made Diego Velázquez a gentleman of the wardrobe to His Majesty, which looks as if he were aspiring to be one day a gentleman of the bedchamber and don a [knight's] habit like Titian"; a mordant commentary, but prophetic. On October 24th the painter petitioned to be paid "11,483 reales of his emoluments owing to him up to the end of 1634" and "3,960

reales for clothes over four years"; he declares, besides, that he is owed other sums for paintings he has done, "of which he is greatly in need". The purpose of his request, he says, is "that he may better serve Your Majesty on the occasion of the paintings commissioned for the Torre de la Parada as part of the great restoration".

Work was indeed in progress on the considerable extensions to the "Torre de la Parada", a shooting-box that stood on a slight eminence in the woods of the Pardo, about nine or ten miles from Madrid. It was originally a sturdily-built square tower of very simple structure, which had been built by Philip II before he became king. The restoration in question, begun in 1633 under the supervision of Juan Gómez de Mora, consisted of surrounding this building with an additional two-storey structure, thus transforming what had been a mere watchtower and resting-place into a luxurious royal shooting-box, the decoration of which was planned with particular care. In a letter dated in November of 1636 the Cardinal-Infante Don Fernando, then Governor of the Low Countries, speaks of having commissioned Rubens to paint a series of sixty canvases with illustrations of passages from Ovid's *Metamorphoses,* shooting scenes and pictures of animals. This was the great Flemish

Fig. 145. CHRIST OF SAN PLACIDO. C. 1632.
Madrid: Prado Museum. Cat. No. 98.

197

painter's last undertaking. Some of the sketches by his own hand, intended for the decoration of this building, are still preserved in various museums and collections, but most of the definitive works – painted by Cornelius and Paul de Vos, Pieter Snayers, Erasmus Quellin, J.P. Gowy, Jacob Jordaens and others – are in the Prado. In December of 1638 the last payment for this great series of paintings was made and the Torre de la Parada was ready to receive them.

As we have seen from his petition of October 24th, quoted above, Velázquez contributed several works to the decoration of this new mansion of Philip IV, though such information as we have regarding these works is not very precise and of much later date. Eleven canvases by Velázquez figure in the inventories carried out in the Torre de la Parada in 1701 and 1703: the portraits of the King, the Cardinal-Infante and Prince Baltasar Carlos in shooting dress; "four original portraits by Velázquez of dwarfs and other individuals"; the canvases entitled *Aesop, Menippus, Mars* and *The Boar Hunt.* This last work, and the royal portraits, were hung in the "King's Gallery", which was the principal room of the Torre. It should be remembered, however, that by the time these inventories were taken the location of paintings in the various royal residences had undergone great changes. In 1710 the Torre de la Parada was sacked and the paintings and tapestries removed to other palaces, but some of the works were lost.

1637

In a memorandum referring to a general reduction in the cost of uniforms for the staff of the royal establishments we read: "The suits for the barbers and for Diego Velázquez could be reduced to 80 ducats"; a pathetic piece of evidence of the measures taken by the administration to mitigate the fatal effects of the reckless disorder and extravagance practised by both Court and State in this period of political disasters.

Marie de Rohan, Duchess of Chevreuse, arrived in Madrid towards the end of 1673 and made her official visit to the King and Queen on December 8th. In a contemporary manuscript entitled *Noticias de Madrid,* which describes the solemn reception, we are told that the Duchess asked for a portrait of Queen Elizabeth to give to the Queen of England; the manuscript adds that the Queen of Spain "was usually reluctant to have her portrait painted". This would explain to some extent the surprising contrast between the many and excellent portraits Velázquez painted of Philip IV and his mysteriously infrequent participation in the few portraits that exist of Elizabeth of Bourbon. The same manuscript, which is dated January 16th 1638, tells us that the Duchess "is now being painted by Diego Velázquez in the French style and in French dress".

1638

Another illustrious visitor to the Court was Francesco II, Duke of Modena, who landed in Barcelona on August 16th of this year. This charming and ambitious ruler, who was later to betray Spain, was received by Philip IV with the most flattering attentions. Among other honours he was granted that of standing godfather to the King's daughter, the Infanta María Teresa, who was born on September 20th. Among the presents received by the Duke his Ambassador in Madrid, Fulvio Testi, mentions a jewel with a "piccolissimo" portrait of the King painted by Velázquez, "tanto simile e tanto bello che certo è una cosa di stupire". In a letter dated March 1639, by which time the Duke had returned to Modena, Testi writes to his master that "Velázquez is painting the portrait of Your Highness, which will be admirable", adding that it will cost 100 doubloons. "It is dear, but he works well and, to tell the truth, I do not consider his portraits inferior to those of any renowned painter, ancient or modern." This portrait has been lost, but we still have Velázquez's marvellous study for the head of this Machiavellian Duke *(Fig. 179).*

On October 16th Mazo's daughter (and Velázquez's granddaughter) was christened in the Church of Santa Cruz, receiving the name of Inés Manuela de Silva. Her godfather was Alonso Cano. The "de Silva" is evidently now beginning to be used as a family name.

1639

On May 10th Francisco Pacheco executed his will in Seville. He asked that he should be buried in

the Church of San Miguel and left all his property to his wife, with a special legacy to Velázquez's wife. He also ordered all his books, sketches, models, canvases, panels, landscapes, portraits (by himself or others) and prints to be sold to the highest bidder, along with the "Book of Portraits", to which he had devoted so much of his life, though he expressed his desire that it should be kept together, in memory of the important personages that figured in it.

The Cardinal-Infante Don Fernando wrote to Philip IV on June 26th, thanking him for sending a portrait of the Crown Prince: "It is a fine painting and makes me quite mad with delight... Mine is now finished, but the painters of this country are not so quick of spirit as Señor Velázquez."

A letter from a Tuscan envoy, written in Madrid on December 31st 1639, mentions a portrait of the Crown Prince "armed and in ceremonial dress", which had been sent to the English Court. This is almost certainly the one now in Hampton Court Palace, probably the work of Mazo.

1640

In this year Velázquez's first grandson was born; he was christened on March 18th and given the name of José, the godfather being once more the painter Alonso Cano.

On the 30th of the same month the King gave orders that Velázquez should be paid what he was owed for paintings done; but the painter's life was still dogged by delays and complications in his accounts with the administration. It was then decided that he should receive 500 ducats a year, in monthly sums, in payment for paintings already done and for those he was to paint in the future, an arrangement which entailed the drawing up of a statement of accounts. This document bears Velázquez's signature, with the surname "de Silva" being placed before it for the first time.

This year, too, a terrible fire destroyed one wing of the Palace of El Buen Retiro, pictures and tapestries being torn from the walls to save them and suffering great damage in the process. Alonso Cano was given the task of restoring a hundred and sixty damaged canvases. It is possible that one or more works by Velázquez were destroyed in this fire.

At the important annual bullfights of San Isidro (May 15th), Velázquez was assigned, as usual, to a place beside the royal barbers.

1641

In this year we have evidence that Velázquez received the annual sum agreed upon in settlement of his arrears of payment. In this year, too, he was entrusted with the appraisal of a *History of Scipio* painted by Vicente Carducho, who had died shortly before.

1642

Another son of Mazo's, Diego Jacinto, was christened on June 19th; this time the godfather was Velázquez himself.

In the month of April Philip IV began a journey through Aragonese territory, with "the purpose of pacifying the principality of Catalonia" (Palomino). In Zaragoza Velázquez, who was in the royal entourage, met Jusepe Martínez, an Aragonese painter and author of a book entitled *Discursos practicables del nobilísimo arte de la pintura*, which includes a biography of Velázquez. The King returned to Madrid on December 6th.

1643. Fall of the Count-Duke.

On January 6th of this year Velázquez was sworn into his new post as Gentleman of the Bedchamber to His Majesty, "in the way which he held that of the wardrobe", i.e., receiving the salary without having to perform the duties; in fact it was a way of adjusting accounts. This was the title Velázquez adopted in the signature on the portrait he was to paint of Pope Innocent X in 1650. In appointing him to this post, the King granted him a single lump sum of 2,000 ducats.

Only a few days later the Count-Duke of Olivares, overwhelmed by the tragic outcome of his policies, worn out and almost on the brink of madness, finally lost the confidence of Philip IV. He retired to Loeches (Madrid) and later to Toro (Zamora), where he died in 1645. Velázquez, mindful of favours received, was one of a group of friends who went to pay their

199

respects and take their leave of the fallen favourite when he stopped at Pozuelo de Alarcón on his journey from Madrid. Olivares was succeeded in the King's favour by his nephew, Luis Méndez de Haro, the son of a sister who had married Diego López de Haro, fifth Marqués del Carpio. The new favourite was a very rich man, modest, affable and mediocre. There is no record of any portrait of him by Velázquez, though the painter's salary was increased under the new régime.

Velázquez very probably painted other portraits of Olivares after the equestrian one, already studied, which is supposed to have been painted about 1633 *(Fig. 110)*. There are certainly several portraits of the Count-Duke based on the one done in 1625 *(Fig. 60)*, but they show him physically much changed and older. The best example is the half-length portrait in the Hermitage *(Fig. 178)*, which in turn seems to be the original of an engraving by Hermann Paneels, published in Madrid in 1638 with the annotation "Ex Archetypo Velázquez".

On June 12th Velázquez was paid 14,000 silver reales, as a first instalment of the 2,000 ducats the King had granted him while in Zaragoza. On the 9th of the following month he was instructed to present himself at the royal office of works, for works to be commissioned by the King, for which he would be paid 60 ducats a month. A few days later the board of works reported to the King that it was impossible to pay so much, bearing in mind "the small amount provided for these works". But the King replied ordering the payments to be made.

1644. Death of Pacheco

Towards the middle of January the King set out on the "Jornada de Aragón", a journey undertaken in order to see for himself how matters were going forward in the prolonged warfare caused by the constant risings of the Catalans. In Zaragoza on February 27th Velázquez, who was again a member of the expedition, was given the post of superintendent of the private works of the crown. The King set up his headquarters in Fraga. Among the expenses recorded by the royal quartermaster, in a manuscript now in the archives of the Royal Palace of Madrid, we find the following: On June 1st "His Majesty ordered repairs to be effected in the room in which he was posing for his portrait, for it was in a very bad state, without proper floors and with the walls falling, so that the whole room was like the funnel of a chimney ... Six reales were paid for the making of an easel for Diego Velázquez to use in painting a portrait of His Majesty ... The painting took three days to do, in various sittings ... A wooden box was made for carrying His Majesty's portrait to the Queen ... His Majesty ordered a wooden box to be made for transporting a portrait of the dwarf "El Primo", which had been painted by Diego Velázquez".

In Pellicer y Tovar's *Avisos* (Chronicles), with reference to August 16th, we are told that "The King had sent to the Queen a portrait showing him in his campaigning clothes... full-length, in a red and silver suit and with a staff. The Catalan nation borrowed it fron the King for this day... (August 10th, when the taking of Lérida by the Spanish army was celebrated). This canvas was hung in the church, under a gold-embroidered canopy, where many people went to see it and copies of it are being made". This text undoubtedly refers to one of Velázquez's finest portraits of the King, the one in the Frick Collection in New York *(Fig. 185)*, of which there are, indeed, several good contemporary copies.

On October 6th Queen Elizabeth, the gentle daughter of Henri IV of France and Marie de Medici, died at the age of forty-one, leaving two children: the Crown Prince, Baltasar Carlos, who was not destined to survive her long, and the Infanta Teresa, born in 1638, the future wife of Louis XIV.

Pacheco also died in this year, being buried on November 27th in the Church of San Miguel in Seville.

1645

The chronicle of this year begins with the birth of another grandson for Velázquez. He was christened on January 9th, being given the name of Baltasar, and Prince Baltasar Carlos was his godfather by proxy.

In March difficulties arose between Velázquez and the architect Juan Gómez de Mora over the royal works. In July the King gave orders that Velázquez

should be paid the salary corresponding to the services he had rendered in the said works, "which has been owing to him for two years".

1646

At the San Isidro bullfights this year Velázquez was finally removed from the vicinity of the royal barbers and given a place next to the Palace Steward and the chief officer for War. This is the only information we have concerning the painter for this year, which was another year of misfortune for the King, for October 9th brought the death in Zaragoza of his only son, Baltasar Carlos, that affable seventeen-year-old prince who had been the hope of all Spaniards and whose survival would have avoided one of the worst internecine wars in the country's history. Since 1643 his official painter had been Juan Bautista del Mazo, who would have been in Zaragoza when the ill-fated prince died. It seems certain that it was as a consequence of this journey that Mazo painted the much-disputed *View of Zaragoza* in the Prado *(Fig. 193)*, which he probably finished in Madrid in 1647, with his father-in-law's assistance.

1647

With an incredible lack of consideration, the King and his officials continued to overburden Velázquez with employments and duties that had nothing to do with painting. On January 22nd he was appointed supervisor of the works in the octagonal building then being erected on the site of the old tower of the Alcázar. Shortly afterwards his duties were extended to include those of accountant for the said works. And Velázquez still had to address petitions to the King asking to be paid the arrears of his salaries (May 11th and 17th).

1648

Another grandchild of Velázquez was born; this time a girl, María Teresa, who was christened on January 13th.

In a royal order dated May 18th 1648, the King admitted that Velázquez was owed 34,000 reales — for paintings done between 1628 and 1640 and other salaries from 1630 to 1639 — and gave instructions for the payment of this amount, which the painter received four months later.

Our chronicle of Velázquez's life in this year ends with a royal order, dated November 25th, with instructions that the painter be furnished with a carriage — and "a sumpter-mule for carrying some paintings" — to take him to Málaga, where he was to join the Duke of Nájera's expedition to Italy. Velázquez left Madrid accompanied by his servant and assistant Juan de Pareja, that modest painter who was to achieve immortality thanks to the magnificent portrait Velázquez painted of him in Rome.

During these years, in short, we can see that Velázquez's postion at Court grew steadily, though slowly, stronger and that the fall of the Count-Duke did nothing to check his progress. But we can also see that this position was not only as ambiguous as in earlier years but even more so if possible, for evidently either the King did not consider himself rich enough to maintain a Court painter solely as such with proper dignity or, with a mistaken idea of patronage and of the terms of familiarity on which he stood with Velázquez, he overwhelmed him with functions ranging from those of an usher to those of an architect and decorator.

* * *

The decoration of the Torre de la Parada

The group of paintings that give this chapter its title, most of them directly or indirectly connected with the decoration of the Torre de la Parada, provides us with extremely useful evidence for our study of the evolution of Velázquez's whole approach to painting. This evolution is not the result of a progressive increase in the painter's technical skill, though evidently this also took place. The spectacular advance to be observed in these paintings derives rather from another quality: exactitude in capturing forms in themselves and situating them in space, in their third dimension. This is a concept that needs some explanation, since it is not a question of an aesthetically perfect system of drawing — though it was also this — but of a method which succeeded in placing every element, however insignificant, in just the right place.

This innate, infallible quality gradually led him to the discovery that he could suppress elements in the compactness of the whole representation, without affecting its accuracy.

It is usual to speak of two kinds of realism: intellectual realism, which draws or paints everything as the artist knows it to be, and visual realism, which draws or paints as the eye dictates. Velázquez gradually advanced from the first to the second – and then surpassed the latter by achieving qualities that are almost magical. He discovered that the image represented on the canvas by apparently arbitrary but schematically exact procedures was "reconstructed" by the eye to a point at which it was impossible, without meticulously analysing the details, to realize how free the execution was. To put it in mathematical terms, we might say that Velázquez found a logarithmic system for the representation of form in space. By abandoning compact surfaces in favour of pigments so light that they barely cover the canvas — though with brushstrokes of thick impasto here and there — he took the first step in this direction. This was immediately followed by the elimination of the linear factor in his modelling, which was replaced by differences in tone and by contrasts of light and comparative shade. The third step consisted of that apparently arbitrary tracing of the elements to which I have already referred. With all this he achieved a definitive advance, a more daring breaking down of the form: the beginning of the dissolution of local colours into colour-light, which permits us to speak of "pre-Impressionism". This whole process was progressively to lead him to the prodigious inventiveness of *The Maids of Honour,* a picture painted with an art of visual suggestion that gives the viewer only some elementary — but miraculously exact — *points d'appui* and then obliges him to complete the forms suggested in his own mind. Apart from schematic precision, this requires a carefully-nuanced gradation of planes and a perfect representation of space and light.

The three portraits of royalty in shooting dress

Velázquez was just at the beginning of this fundamental process when he painted three key pictures:
the portraits of Philip IV, the Cardinal-Infante Don Fernando and Prince Baltasar Carlos, all in shooting dress and all shown as they were in 1635 or 1636. This is undeniable in the case of Baltasar Carlos, since he was born on October 17th 1629 and the canvas bears the inscription "Anno aetatis suae VI" *(Fig. 146 – Cat. 99)*. But each of the other two portraits, painted with the same technique as that of the Crown Prince, presents us with a problem. The portrait of *Philip IV (Fig. 147 – Cat. 100)* was altered shortly after being painted. In the original version the King was shown bare-headed, with his cap in his hand; a copy (now in the Goya Museum of Castres) was made of the work as it was then, probably by Mazo. Later a cap was painted on the King's head and the one in his hand effaced, to unify the three portraits. The traces are very perceptible, under the greyish mountain in the landscape.

The Infante Don Fernando, who was born in May of 1609, would have been about twenty-seven at this time, but in his portrait in shooting dress he looks much younger *(Figs. 148 to 150 – Cat. 101)*. It should be remembered that this prince had left Madrid in April of 1632, that he died in Brussels while Governor of the Low Countries in 1641 and that in those eleven years he did not once return to Spain. It is only natural that this portrait should really represent the prince as he had looked when he left Madrid, that is to say at the age of twenty-three. I believe that we have here yet another case of the adaptation of an old portrait, which would have been done at some time between 1630 and 1632 and of which all that remains on the canvas as it is now is the head. Velázquez totally repainted this portrait after increasing its height by adding ten centimetres of extra canvas — which, apart from giving it the same height as those of the Infante's brother and nephew, enabled the painter to complete the clothing with the same kind of cap as is worn by the other two royal sportsmen. The landscape, the Infante's costume and the dog are all in the same technique and pictorial concept as the other two portraits. But in the face *(Fig. 149)* we can see the emphatic execution and more blended modelling of the works done immediately after Velázquez's return from Italy.

The Boar Hunt

We now come to that much-disputed canvas in the National Gallery in London *(Figs. 151 to 155 - Cat. 102),* painted to record for posterity one of Philip IV's costly and extravagant hunting parties. The inventories of the Patrimonio Real include two original Velázquez's on the subject of boar-hunting and the work we are about to consider is very probably the one mentioned in the 1701 inventory of pictures in the Torre de la Parada. Among the diminutive horsemen inside the canvas enclosure that has been set up in the middle of the clearing called the Hoyo del Pardo, we can see the King, the Count-Duke and Juan Mateos. In one of the carriages the Queen can be seen. The background is a superb landscape, showing the dense masses of the famous holm oaks of the Pardo.

In the foreground, and outside the enclosure, there are groups of huntsmen, minor members of the entourage and people lying on the ground. Looking at the work as a whole, everything seems perfectly defined, specific and clear. Without being bucolic in tone, the feeling of nature does seem to predominate over the human or at least to equal it.

The figures are more or less detailed in treatment according to their distance from the viewer, but all can be seen to possess the same vividness, reality and lightness; the technique has benefited by all Velázquez's most recent discoveries. The sureness of his drawing enables him to place his figures with vigorous effect, to define forms with incomparable mastery and to dash in details with free, broken strokes, so as to emphasize points and lines of light, elements that reflect the sun's light more vividly or, on the contrary, cast a deeper shadow. Every fragment of this painting is a masterpiece and an analysis of its details would only serve to confirm the presence of Velázquez's typical procedures. But the picture also possesses other important features: the narrative sense, the variety of movements, the representation of the human figures and the great wealth of different effects, unified in the overall effect. The animals (hounds, horses, etc.) prove once more the painter's skill in this field. The attitudes are as varied as the complexity of the scene demands and the unerring perfection of the result justifies the bold freedom of the execution. The figures that can be identified are defined with incredible simplicity. Perhaps the most impressive features are the group of three gentlemen standing and talking and the hounds in the foreground. It is difficult to understand why some critics have expunged this painting from the catalogue of Velázquez's works. In my opinion this is not only one of the master's greatest works but also an important proof of the infinite store of knowledge of his craft accumulated by his genius before he had reached the age of forty.

Gallery of dwarfs and jesters

Four "original portraits by Velázquez of dwarfs and other individuals" are included along with *Menippus, Aesop* and *Mars* in the 1701 inventory of the works in the Torre de la Parada. This brief reference seems to indicate that the luxurious shooting-box, built between 1635 and 1638, had a sort of gallery of these court monsters. Such a gallery would very probably have included some of the canvases we are now about to study. These fabulous portraits are among the finest Velázquez painted in his whole career, but they also pose problems that are as intriguing as they are difficult to solve. Certainly these unfortunate creatures, deformed and more or less paranoiac, were an important feature of court life in Spain. Officially classed as "men of pleasure" (viz. entertainers), taken from the most widely-varying backgrounds — sometimes even sent from foreign countries — and with some females in their ranks, they were given diverse positions in the recklessly extravagant court of the House of Austria. Velázquez painted them as independent individuals or sometimes included them, in surprisingly conspicuous positions, in portraits of the royal family. Examples of this are the monstrous creature in the foreground of the portrait of Prince Baltasar Carlos *(Fig. 101),* the bearded dwarf in the two portraits of the same prince having a riding lesson *(Figs. 125 & 126)* and, finally, the uncouth presence of the monstrous Mari-Bárbola in *The Maids of Honour.* Though Velázquez painted hardly any portraits of the gentle Queen and

was seldom persuaded to immortalize the courtiers of Philip IV, he has left us quite a few portraits of these unhappy creatures, who swarmed all over the rambling, disorganized royal mansions, were included in official pay rolls and sometimes even had their own servants.

This fantastic aspect of the picaresque nature of court life is transformed into vivid images in no fewer than fifteen of the great painter's works, some of which I have already dealt with. According to inventories and literary references, however, an even greater number of such works have been lost. Some of these little creatures were portrayed in different versions and these would have been multiplied in the replicas and copies to be found in great numbers in the inventories of various private collections formed during the reign of Philip IV.

The four "dwarfs and other individuals" of the Torre de la Parada may be the portraits, all the same size, of the following personages: Francisco Lezcano, Juan de Calabazas, Diego de Acedo and Sebastián de Morra. The first, also known as "Niño de Vallecas", was buffoon to Prince Baltasar Carlos and died in 1649, still comparatively young to judge by the age he appears to be in his portrait (Figs. 156 & 157 - Cat. 103). He has a flat paintbrush in his hand, possibly lent by the painter to keep him amused while posing. There is a disquieting rhythm in the tumultuous juxtaposition of the masses of almost phosphorescent texture that make up the background and the rumpled clothing, but the expressive intensity of the image is admirably concentrated in the dwarf's face. The half-closed eyelids accentuate the vagueness of a strange kind of foolishness that does not exclude occasional flashes of shrewdness, as suggested by the pathetic twist of the mouth. The tendency to dissolution of line is still further accentuated in this work, in which the light and shadow, the changes of tone and a calculated variety of intensity in the treatment of areas and details produce a fascinating effect. The restrained palette is subordinated to the tone in order to give interest to the pathetic expressiveness of the face rather than to the form. The evanescent quality of the execution also helps to express the mists darkening the mind of this character – whom

Moreno Villa, in my opinion rightly, has identified as the dwarf who appears, looking a few years younger, in the foreground of the portrait of Prince Baltasar Carlos painted in 1631 (Fig. 101).

Another of the portraits in this little group is that of Juan de Calabazas, alias "Calabacillas" (Figs. 158 & 159 - Cat. 104). The fool whom we saw in the picture studied in the preceding chapter (Fig. 140) has here changed into a trembling figure. The expression – so seldom a feature of importance for Velázquez, enamoured as he was of serenity and, we might almost say (despite his humanism), of pure painting – dominates this canvas in a way that is at once astonishing and pathetic. Behind the little creature's grin we can detect a latent sadness. Sitting on the floor with his hands joined on one knee, he is surrounded by the attributes of his nickname "Calabacillas" (little pumpkins). The abrupt and at the same time sketchy modelling drastically destroys any linear duality. Other features worth mentioning are the very free rendering of the lace trimming on the dwarf's suit and the rough brushstrokes that create the structure of the twisted fingers; the figure is shown huddling in a corner of a bare room, behind the eerie ambiguity of his face. This dwarf, who had been in the service of the Infante Don Fernando before being chosen to wait upon Prince Baltasar Carlos, died in October of 1639.

Diego de Acedo, who figures in the palace pay rolls from 1635 to 1660, was an intelligent and audacious dwarf who was employed as an assistant in La Estampa, the office which printed documents with facsimiles of the King's signature. His diminutive stature was no hindrance to his love affairs; we learn from contemporary chronicles, indeed, that jealousy of this individual drove one of the palace stewards to kill his own wife in 1643. He went by the nickname of "El Primo" (The Cousin), possibly because, as his mother's surname was Velázquez, he was supposed to be related to the great painter or to some other Velázquez in court circles. As we have seen in the chronicle of the year 1644, Velázquez painted a portrait of "El Primo" while at Fraga. If we accept Moreno Villa's hypothesis that this was the

portrait that now hangs in the Prado *(Figs. 160 & 171 - Cat. 105)*, we must suppose that it was a "late entry" in the gallery of dwarfs in the Torre de la Parada. But it is also possible that Velázquez had already painted him before the King's Aragonese expedition. Moreover, a portrait of this character appears as an original Velázquez in the inventory drawn up for the auction of the Marqués del Carpio's property in 1690, while another portrait, probably of the same dwarf, is mentioned in the appraisal of paintings belonging to the Marqués de Leganés.

The portrait of *Sebastián de Morra (Fig. 161 - Cat. 106)* was certainly painted after the Torre de la Parada had been completed, for this dwarf, who had previously been in the Court of the Infante Don Fernando, Governor of the Low Countries, did not enter the service of the Crown Prince until 1643. This picture is not so lively as the sharply-observed portrait of "El Primo", but it is much less lugubrious than the first two in this series of dwarfs. The free, summary technique of this canvas indicates a fairly late date in the decade between 1640 and 1650, probably not long before the death of Prince Baltasar Carlos in 1646. The warm tone of the background increases the dazzling effect of the explosion of crimson, green and gold in the clothing of this arrogant personage, while the expression of restrained protest to some extent cancels out the very notable physical deformation of his body. What was the exact position of this man, who had a servant of his own on the palace pay roll? The human interest aroused by this gallery of oddities—for today's viewer, at any rate—makes it almost inexcusable to ignore this and other similar questions. It is not my task, however, to make a psychological analysis of these creatures, nor yet to study the spirit of an age in which monarchs took pleasure in surrounding themselves with such unfortunates, listening to their jokes and ironies or using them as the targets of their own bad humour. History tells us that they were often not lacking in influence, thanks to their frequent nearness to the rulers of the land.

To give some coherence to our study of this gallery of official figures of fun, we shall have to rely

on documents, since stylistic analysis, though so useful in determining the chronology of works painted in accordance with a methodical evolution, is an unreliable guide to Velázquez's more imaginative moments. The closest parallels to these works are the figures of *Menippus, Aesop* and *Mars,* which appear in the inventory of the Torre de la Parada, along with the portraits of the jesters Pablo de Valladolid, Don Juan de Austria and Barbarroja. They are united by their vertical format, the concept of their representation and, paradoxically enough, the disparity of the techniques used in painting them. If we look at them closely, some of these canvases give the impression of being unfinished; looking at them from the proper distance, however, we shall see that nothing is lacking, nothing left incomplete. In some of them, as will be seen, the painter has used different techniques, which makes their dating, even approximately, a complicated business.

The portrait of the jester *Pablo de Valladolid* seems to be the representation of an actor *(Figs. 162 & 170 - Cat. 107)*. We know that he was granted lodgings in the Alcázar in 1633, but when he died in 1648 he was living in the same house as the royal painter Juan Carreño de Miranda, who was his executor. The simplicity of colour and general sobriety of this canvas makes one think of the works Velázquez painted immediately after his return from Italy, but the abrupt, daring modelling of the face shows a freedom in the brushwork that is utterly unlike the documented works of that period. In the eyes there are no lines suggesting the end of the eyelids, while the nose is suggested by tone contrasts, points of light and the invisible sequence of the lines whose path is hinted at by certain rhythms.

The arbitrary – and fundamentally satirical – representation of the god *Mars,* a work as unpleasant as it is well painted, seems to have been done expressly to discourage, not only any (evidently non-existent) worshippers of the Roman deity, but also those who still exalted him, at least as an allegory of war. This "Mars" is simply a very commonplace man, almost naked and with an enormous moustache, pensively watching over his arms from under his superb helmet *(Fig. 163 - Cat. 108)*. This picture and

the celebrated allegory of Bacchus in *The Topers (Fig. 77)* have been widely quoted as examples of the anti-mythological character of Spanish iconography. As everybody knows by now, Renaissance themes had a very limited impact on Spanish iconography and, though Spanish painters of the 16th century accepted innovations in technique and composition, they rejected the paganization of art that prevailed in Italy and in the school of Fontainebleau, to mention two of the most characteristic centres: the first broad and diffuse, the second more concentrated. Their successors in the 17th century accepted the inheritance of the preceding age and, while they continued to assimilate technical novelties or to discover new methods for themselves, they showed a similar lack of interest in the themes made fashionable by Renaissance ideology: mythology, nudes and frivolous themes. Velázquez's *Mars* is certainly one of the mythological representations furthest removed from the classical tradition, but technically it is a masterpiece. The colour harmony between the pallid skin of this strapping figure, with no signs of exposure to the sun, and the crimson and violet of his rudimentary draperies is a daring novelty which is to some extent prefigured in the *Temptation of St. Thomas Aquinas* in Orihuela *(Fig. 85)* and is itself the immediate forerunner of *The Rokeby Venus (Fig. 195)*.

The identity of the model for *Mars* is unknown to us; it has been likewise impossible to identify, among the ranks of the jesters at the court of Philip IV listed in Moreno Villa's important study of the subject, the individuals who posed for *Aesop* and *Menippus*. In these two canvases there is a considerable disparity of technique, which is at odds with the apparent similarity of their realistic representation. They are straightforward portraits of two human types, without the least effort being made to achieve a convincing representation of two historical personages; their realism is all they have in common. The *Aesop (Figs. 164 & 166 - Cat. 109)* is painted with a dense pigment that allows us to see the thick superimposition of the brushstrokes on a face utterly devoid of lines except in the tracing of the upper lip, which defines one of those mouths characteristic of Velázquez, full of strength and expressiveness despite the summary treatment they are given. The features are irregular, with asymmetries bordering on deformation but acquiring remarkable interest when we analyse the magnificent execution. It is as if the painter wished to define the spirit of his personage through the brutal bareness of the paint. The clothing is treated with a rather less abrupt technique, though one that is very similar to that used in the clothing of *Francisco Lezcano (Fig. 156)*.

In his *Menippus (Figs. 165 & 167 - Cat. 110)*, who is represented as a sarcastic old man not entirely devoid of a certain impersonal benevolence, Velázquez reaches one of the heights of his art as a creator of processes of expression. If we analyse this old man's face, we shall find an accentuation of the methods the painter began to use after his Italian journey, methods which led him to the suggestion of reality – though depicting its visual quality, not its material substance – rather than to true delineation of his models. By this I mean that not only are there no lines defining the features in this aged countenance (much foreshortened), but the pictorial and tonal elements one would think he needed to make the old man's features perfectly visible are also absent. The mouth is suggested by a touch of red, while the eyes, one might almost say, are simply the look. The whole is reconstructed as if by a miracle and the form is reconstituted to define not just a generic type but a personage who undoubtedly possesses the characterization of the portrait, despite its title. The painter did not use his models as lay-figures in the construction of his "theme"; he painted them as themselves and gave the result whatever title occurred to him or whatever he had been asked to do. This way of doing things does not seem to square with the idea of a Velázquez attached to the aristocracy and the great magnates, himself endowed with an innate sense of superiority. On the contrary, it seems to betray a desire to manifest, through the direct human truth that he painted, some kind of protest and silent rebellion. The problem of his "experimentalism", moreover, still awaits elucidation. We may never know to what extent the painter was conscious of the value of his technical discoveries in themselves or the extent to which he was particularly interested in this facet of his work. It is just as likely

that he invented quite spontaneously, without the slightest previous concept, as that he tried to prove to himself to what extent he could achieve all this, by whatever means.

In these paintings, which really form a coherent group with the portraits of the dwarfs and jesters, Velázquez can be seen to be the forerunner of Goya in the attraction the latter felt for the unpleasant aspect of life. Velázquez never went so far as Goya in his choice of subject, nor is it likely that he would have been permitted to do so in his time, but in facing this suffering, deformed aspect of humanity he shows the feeling of protest that Goya, in very different ways, was to make one of the principal signs of his art.

Cristóbal de Castañeda y Pernia, otherwise known as "Barbarroja", figures in official documents between 1633 and 1649 *(Figs. 168 & 172 - Cat. 111)*. The clothes in which Velázquez painted him are vaguely reminiscent of Turkish costume, which might be an allusion to the famous Algerian pirate from whom he got his nickname. He was a bullfighter and one of the most celebrated royal jesters. This canvas appears for the first time in a royal inventory drawn up in 1701, which includes it among the works in the Palace of El Buen Retiro and mentions that it seems to be an unfinished work. It is true that a large part of the figure is left in the state of a mere initial sketch, with monochrome sections through which the priming of the canvas can be seen, giving the impression that the work was done very hurriedly in the space of a very few hours. The cloak and the hands are more carefully worked than the rest of the figure, including the head, which is a miracle of synthesis. But the balance is perfect and I suspect that Velázquez considered it a finished work. It is possible that with models like those of the series we are now studying he was emboldened to carry out experiments of this kind, experiments which in *The Spinners* and *The Maids of Honour* – and to some extent in *The Rokeby Venus,* which we shall be studying at the end of this chapter – can be considered finished works. Another portrait of "Barbarroja" was in the collection of the Marqués de Leganés in 1655.

Little is known of the last in this series of jesters

(Figs. 169 & 173 - Cat. 112), known as *Don Juan de Austria* after the name of the great admiral of the Battle of Lepanto; it was probably his nickname that led Velázquez to pose him in the midst of weapons, projectiles and armour, the whole arranged with the ascetic schematism of a Sánchez Cotán, in front of a large canvas with a sketch of a naval battle partly covered by another canvas still at the priming stage, in which we can make out the shadow of a large central oval. Recalling what was hinted at above in connection with the unequal finish of different sections, observe the contrast here between the construction of the form of the man's head, so similar to those of certain figures in *The Surrender of Breda (Fig. 113),* and the brilliant sketch that suggests the Battle of Lepanto. This portrait and the preceding one are fundamental works in studying the painter's technique, on account of the very visible retouchings and the sections left with hardly more than the preliminary brushstrokes.

I should like to repeat once more that Velázquez's humanism – or perhaps his supreme indifference? – always led him to treat the portraits of these figures of fun with as much objectivity, and even dignity, as if they were ordinary normal people or even important personages. In not one of these pictures can we find the slightest trace of irony or of an attempt to ridicule the sitter.

Portraits painted before 1640

The evolution of Velázquez's method of representation is very complex, for to each field of his art he brought a different approach and a different technique. In an age in which the word "experimentation" had very little meaning in the art of painting, in Spain at any rate, it is clear that he struggled feverishly to discover new directions and new techniques. But he did not on this account despise old discoveries or traditional formulas, which always reappear in his commissioned works, especially portraits.

A good example of this is the portrait of Gaspar de Borja, born in 1611, the son of St. Francis Borja of Gandía. He was Philip IV's representative at the Vatican; in 1643 he was appointed Archbishop of

Toledo and Primate of Spain, and two years later he died. In my opinion the canvas with a head and shoulders of this cardinal in the Museum of Ponce (Puerto Rico) *(Fig. 175 - Cat. 113)* is really all that remains of a full-length portrait painted by Velázquez about 1637, when this cleric was appointed President of the Council of Aragon. We can get an idea of what the complete canvas would have been like from a contemporary copy in the J.O. Flatter Collection in London, which repeats the scheme of the portrait of Archbishop Valdés studied in the preceding chapter *(Fig. 136)*. The painting in Ponce has been rejected as a copy by many critics, but for my part I still consider it an authentic Velázquez. The modelling of the face is sharp and powerful, even after its mutilation and successive "restorations". It is reminiscent in some ways of the geometrizing forms favoured by Velázquez a few years earlier. The technique of the biretta is also based on a strict geometric composition that is very characteristic of Velázquez.

In the Academy of San Fernando (Madrid) there is a preparatory sketch for this portrait *(Fig. 174 - Cat. 113a)*, a real work of genius and one of the extremely few original drawings by Velázquez still extant; the only one, in fact, of which we can be absolutely sure. It is a work of extraordinary intensity and truth, in which the use of line, which Velázquez so successfully eschews in his painting, is brilliantly managed.

Among the more notable events in Madrid in 1638, as we have seen, was the visit paid to the Spanish Court by Francesco II, Duke of Modena, in connection with which there are contemporary references to an equestrian portrait commissioned from, and apparently painted by, Velázquez. The present whereabouts of this canvas is unknown, but in the Galleria Estense of Modena there is what was probably the preliminary sketch for it *(Fig. 179 - Cat. 117)*. Painted very spontaneously from the living model, it is nevertheless by no means in the "sketch style" and it provides us with fresh proof of the eclecticism of the painter's technique at this stage in his career. Palomino tells us that the Duke became very friendly with Velázquez, which is confirmed by the cordial welcome he extended to him on his second journey to Italy, ten years later.

The most impressive features of this little canvas are the sobriety and piercing beauty of the colour harmonies: the blue-black of the armour with the crimson sash and the dark hair. As in most of the painter's works of this period, line is almost entirely eliminated; when it does appear, as in the sash, it is thanks to the brushwork.

It will be recalled that the Count-Duke of Olivares fell from favour in 1643, whereupon he retired first to his mansion at Loeches and later to Toro, where he died in July of 1645. I have already mentioned his portrait in the Hermitage, which seems to be at least partially by Velázquez *(Fig. 178 - Cat. 116)*. It is a half-length portrait, of which Beruete says that it is "painted with breadth, unblended colours and a full brush". The head was reproduced in an engraving done by Hermann Paneels in 1638, which would seem to place the original canvas shortly before this date. In the Royal Palace of Madrid there is a miniature on copper which is a replica or copy of this work. There are also several full-length portraits, not by Velázquez but based on this portrait. Unlike the portrait in the São Paulo Museum of Art *(Fig. 57)*, which clearly shows Olivares' arrogant aggressiveness, or the splendid equestrian portraits studied in the preceding chapter, here we can see that the great favourite has passed the zenith of his political career; not yet defeated or even fatigued, but certainly rather more subdued and as if indifferent at bottom.

Copies of lost originals

I think it is worth mentioning here, as an appendix to our study of the works done by Velázquez in the years 1630-1640, a group of portraits of Prince Baltasar Carlos and others which are reproductions of originals that have been lost or cannot be located. Two of these represent the Crown Prince: in one he is in court dress, in the other he wears armour and carries a marshal's baton, and of both there are several versions in existence, only some of which were evidently painted in Velázquez's workshop. I have chosen for reproduction the canvas in Vienna's Kunst-

historisches Museum *(Fig. 176 - Cat. 114)* and the one in the Mauritshuis in The Hague *(Fig. 177 - Cat. 115)*, both very beautiful works. Let us recall the Infante Don Fernando's letter in 1639, thanking Philip IV for sending him a portrait of Baltasar Carlos, and the slightly later letter written by a Tuscan envoy and mentioning that another portrait of the little prince, "armed and in ceremonial dress", had been sent to the English Court. It would appear probable that this latter portrait was the rather inferior painting that now hangs in Hampton Court Palace, a similar version to the one in The Hague. Similarly the portrait of *Admiral Adrián Pulido Pareja* in the National Gallery in London *(Fig. 187 - Cat. 123)*, which is unanimously attributed to Mazo, must be a copy of an original by Velázquez painted about 1638. And having gone thus far, we might as well mention the lost portrait of "Doorkeeper" Ochoa (a court jester who died between 1636 and 1638), which was reproduced by Goya in a very fine etching. Another copy of what may well have been an original Velázquez is in the possession of Queen Fabiola of Belgium.

The portraits of two ladies and a little girl

We now come to three important portraits of female figures by Velázquez: the *Lady with Fan* in the Wallace Collection *(Figs. 181 & 183 - Cat. 118)*, the *Young Lady* in the collection of the Duke of Devonshire *(Figs. 180 & 182 - Cat. 119)* and the *Head of a Girl* in the Hispanic Society *(Fig. 184 - Cat. 120)*.

There is a pronounced physical resemblance between the ladies in the first two portraits, a resemblance that is considerably lessened (perhaps on account of differences in age), but not altogether lost, in the third. The technique, very similar in all three, seems to date them in 1640 or thereabouts; and this is sufficient incentive for us to consider certain facts about the painter's family which help us to group these three portraits together and establish a fairly probable hypothesis.

It will be remembered that Juana Pacheco, Velázquez's wife, was born towards the end of May 1602. Francisca, their first daughter, who was born in 1619, married Mazo in 1634 and Inés, Velázquez's

first granddaughter, was born in January 1635. We cannot be too far out in considering the *Lady with Fan* to be between 38 and 40 years old, the *Young Lady* between 21 and 23 and the little girl between 5 and 7. These were the ages of the three females closest to the great painter in the period 1640-1642. All of this strengthens the slightly sentimental hypothesis which, encouraged by the evident charm of these works, identifies the three figures portrayed here by Velázquez as the great artist's wife, daughter and granddaughter. It should be remembered that it was Beruete who first suggested that the *Lady with Fan* might be Juana Pacheco.

Be that as it may, we are faced here with three portraits of a very intimate character, all of them to some extent marginal to Velázquez's technical experimentalism. By this I do not wish to imply that there is any return to the pictorial concept of twenty years before, though it is true that the use of line is more important here. The features are more definitely outlined and there seems to be an attempt to give the figures greater interest and reveal their whole personalities, in which the eyes play a fundamental role.

The *Lady with Fan*, which is the most famous and most widely reproduced of these three canvases, is truly one of the greatest portraits in the history of painting and one of those portraits of women in which it is not just an individual that is represented but a race, an age and the spirit of both.

It is hard to say just why the lady's very natural attitude and the fairly warm range of colours find in the asymmetry of the composition a factor of subtle compensation that endows the image with a latent dynamism and a certain reserve. This observation of mine may be mere hindsight, but the fact is that in perfect portraits like this one every element has its meaning and its function, whether it be a tonal relationship or a rather unusual method of composition. Undoubtedly the outstanding feature of this painting is the paint itself, as is always the case with Velázquez. He shares with the greatest artists the gift of being able to use paint both to represent something specific and to create qualities of its own. It is also undeniable that, though the fundamental ingredients are technique, concept and execution, when the sub-

ject is beautiful in itself, this can only increase the beauty of the pictorial merits.

This canvas, in short, is one of those that one does not forget, and the lady's face is in itself an admirable achievement. Before going on to the second portrait, we should observe how Velázquez uses slight variations of tone in the background – making it more luminous — in order to give greater emphasis to the fan, the sticks of which also receive reflections of light.

The portrait of the *Young Lady,* whose features are so similar to those of the *Lady with Fan,* is like a reflection of the preceding work. The foreground is largely taken up by the curve of the left arm, while the broad collar of white lace combines with the black mantilla to act as a catalyst between the tone of the flesh-tints and the exquisite quality of the colour and texture of the dress. The position, and even the expression, of the eyes are very like those in the *Lady with Fan,* so much so that it really seems impossible to doubt the hypothetical relationship for an instant. The similarity of concept and technique, moreover, seems to show quite clearly that the two paintings cannot have been separated by more than a few weeks, or a very few months at most. The format of the second portrait is more noticeably vertical and the space around the figure is much smaller. This may, of course, be a canvas that has been cut, or perhaps the preparatory sketch for a larger portrait, which would explain the abrupt treatment of the two hands. The interest is concentrated in the face in this portrait more than in its predecessor, though the treatment of the dress is among the artist's finest achievements; when examined in detail it reveals a boldness of execution that vanishes when the canvas is viewed from a distance.

The *Head of a Girl* is less precise, reaching only as far as the bust of the child, whose thick hair appears to be cut at the level of the chin. The dress is left as a mere sketch, even the background being more carefully painted, but the effect of volume is miraculously suggested by random transparencies and contrasts of light. An interesting characteristic of the work is the static quality of the expression. But it is the regularity of the features, the big

black eyes, the subtlety of the chiaroscuro and the purity of the modelling that produce the principal effect of this picture, which completes our hypothetical family group. In the features, too, as I have already pointed out, there is less resemblance to the other two portraits. The form of the nose, however, is very similar, as is that of the mouth. The cheeks are plumper and the use of shadow in the face is reduced to a minimum. The more one contemplates this canvas, the more one marvels at the result achieved by the painter with so few elements.

These very feminine portraits, with their soft technique and serene conception, seem rather at odds with the experimentalism of pictures like *Menippus* and *Aesop.* Little by little one begins to suspect that it was only because of the richness of his pictorial instinct that Velázquez at certain moments sought to use techniques that seemed to him to suit the character of his subject-matter.

Works done between 1640 and 1650

Few indeed are the works of Velázquez that can be dated, for various reasons, within the period of eight years preceding the painter's second visit to Italy (November 1648). The only one that can be thus dated with certainty is the portrait of Philip IV at Fraga. Another, the portrait of the Conde de Benavente, can be dated circumstantially and all that remains is a very limited number of canvases, the dates of which are lost in a welter of doubts.

It must be admitted that the period in question hardly lent itself to the normal triumphal expansion of the empire, an expansion always reflected in the works of court painters. Political events were far from favourable to Spain and the King himself had to bear the additional misfortune of losing both his wife, the gentle Queen Elizabeth, and his only son, Prince Baltasar Carlos, heir to the throne of Spain and the hope of his subjects, whose childhood and adolescence are recorded in successive portraits by Velázquez.

The portrait of Philip IV at Fraga

It is now universally admitted that the splendid canvas in the Frick Collection in New York *(Fig.*

185 - Cat. 121) is the portrait of Philip IV painted by Velázquez at Fraga in June of 1644. The King is shown wearing "red and silver, and with a staff", as recorded in Pellicer y Tovar's "Avisos" of August 16th. As we have seen, the royal quartermaster took the trouble to record that "the portrait took three days to finish, in several sessions", which reflects the amazement felt at such a feat by those who attended the King on this expedition into Aragon. Though perhaps a little over-theatrical, it is a very beautiful portrait and the technique used for the clothing is quite fantastic. The modelling of the face does not attain the strength and vitality that were essential elements in other portraits of the King, but few painters have achieved such a marvellous harmony of vermilion, crimson, white and black. The strokes I have mentioned before for removing excess paint from the brush — for that was their real reason for existing — can be discerned in nervous criss-crossings under the warm tone of the background, which further confirms the speed at which this work was painted.

According to López-Rey, the head in an allegorical portrait of Philip IV, now in the Palazzo Pitti (Fig. 186 - Cat. 122), is the work of Velázquez. The portrait itself is a copy of one painted by Rubens during his stay in Madrid in 1628 and 1629 and figures in an inventory of pictures in the collection of the Marqués de Eliche, drawn up in June 1651, with the following description: "A large picture of the King Our Lord, on a chestnut horse and His Majesty armed and with a staff in his hand and wearing his hat; and in the air some women carrying a sphere above his head, and behind the horse a Jew with the [King's] helmet in his hands, a copy from Rubens and the head by Diego Velázquez." A study of this portrait will show the accuracy of this description. Since the Marqués de Eliche was a nephew of the King's new minister and already owned several works by Velázquez, it seems fairly natural that the painter would not mind updating an old portrait of the King copied by somebody else. The similarity between this head and the one in the Fraga portrait tells us that this updating cannot have been carried out much later, or earlier, than 1644.

The bristling moustache that characterizes the two portraits of Philip IV that we have just studied reappears in the haughty *Portrait of an Unknown Gentleman* in the Wellington Museum, London (Fig. 189 - Cat. 125), another of the canvases included among the gifts lavished by Fernando VII on the British general. It has been variously identified over the years; one theory — worth mentioning for its very improbability — held that it was a portrait of Antonio Pérez, Philip II's rebellious secretary, and the work is thus described in the 1789 inventory of the Royal Palace of Madrid. In the inventory drawn up after Velázquez's death of the various belongings in his studio in the Alcázar there is a work described as "Another head, of a black-bearded man, unfinished", which might well be this portrait, for notaries' ideas of what constituted a finished work tended to vary widely. It is a wonderful study from life, possibly a preparatory sketch for an important portrait. Despite the firmness required by the character of the man portrayed, the modelling is soft and diffuse, though this does not alter the rigour of the form or the liveliness of the expression. The man in this portrait must have been a tough, daring character, to judge by the cast of his features, which are very typical of the idea most of us have — just because of portraits like this one — of 17th-century Spain.

Juan Francisco de Pimentel, Conde de Benavente, was born in 1584 and died in 1652. Velázquez probably painted the rather showy portrait now in the Prado (Fig. 190 - Cat. 126) about 1648, the year in which Pimentel was admitted to the Order of the Golden Fleece, for he is shown wearing its insignia over his blued and gilded steel armour. Besides, it was in November of that year that Velázquez left for Italy. This canvas has been cut, which suggests that it may originally have been a full-length portrait. It is one of those works in which the "official" tone is inevitably present, a painting that is to some extent cramped by the requirements of the costume and the rank of the man portrayed. Painting occasional or professional models, or even persons of the highest rank who were in the habit of posing for Velázquez, was not the same as dealing with a prominent figure with whom, presumably, he had had no previous contact.

I think this point should be admitted in extenuation of the softness of this portrait as a whole; for soft it is, despite the emphatic style in which it is painted — or possibly because of it.

Velázquez was always a very human painter and the personality of each sitter must undoubtedly have influenced the tone of his style and the quality of the result. Even from the point of view of objective representation, however, this is a good picture, particularly in the brilliant qualities of the armour, which some critics consider to have been inspired by that of the Conde de Orgaz in El Greco's great picture. But this is going too far. The fact is that in *The Burial of the Conde de Orgaz* El Greco was the first to break away from the conventions of the Quattrocento and give the metal of the armour a different quality and consistency, a practice continued and more profoundly developed by Velázquez in painting men in armour, as we have seen in his equestrian portraits of Philip IV and the Count-Duke of Olivares.

The portrait of a man with a white beard *(Fig. 188 - Cat. 124)* is accepted by Lafuente Ferrari and López-Rey as an authentic Velázquez, painted about 1648, and to judge by the reproduction it does indeed seem genuine. Its present whereabouts being unknown, however, I have been unable to study this work for myself. I will therefore complete the list of portraits painted during this period with two small canvases: the *Head of a Girl* in the Accademia Carrara in Bergamo *(Fig. 191 - Cat. 127)* and the bust of a middle-aged man, catalogued under the title of *Knight of the Order of St. James,* in the Staatliche Gemäldesammlung of Dresden *(Fig. 212 - Cat. 128).* The first is an unfinished work, which most historians have rejected; I think, however, that it deserves to be included among the authentic works, though I must admit that there are plenty of grounds for doubt regarding this beautiful sketch. Since it was probably done in a single sitting, we have little to go on in determining when it was painted. It maintains the initial approach of some portraits of the preceding period, but the form also shows an undeniable resemblance to that of the beautiful *Head of a Girl* in the Hispanic Society *(Fig. 184).*

The *Knight of the Order of St. James* in Dresden is a more important work and the man portrayed has been variously identified. Allende Salazar held that he was probably Fernando de Fonseca y Ruiz de Contreras, Marqués de Lapilla (d. 1660), whom Palomino mentions among personages painted by Velázquez. Von Loga suggested that the work might be a portrait of Gaspar de Fuensalida, the noble friend who let his own tomb be used for the painter's body. More recently Valverde has studied the possibility of this unknown gentleman's being the Marqués de Leganés, a distinguished soldier who married Spinola's daughter. There are no really telling arguments either for or against these hypotheses and, whoever the man was, his portrait was painted with the simplicity of a preparatory study. The brightness of a chain enlivens the form, which is not very strongly contrasted with the background. Nor did the painter make any real psychological study of the face, with its inexpressive look. Whenever Velázquez, for one reason or another, was not particularly attracted by the personality of his sitter, he resorted to mere physical objectiveness or to a broad, generic style, though never entirely neglecting the human factor.

As we shall see in the introduction to the next chapter, in the chronicle of Velázquez's second visit to Italy there is a final period with regard to which all we are told is that he spent some time in Modena in December of 1650. On the strength of this information — and the fact that the work is listed as a Velázquez in an inventory of the property of Prince Cesare Ignazio d'Este drawn up in 1685 — Mayer suggested that this picture was really one of the works Velázquez painted in Italy. From the technical point of view there is no reason why this should not be the case.

The View of Zaragoza *and other canvases that show signs of Velázquez's intervention*

The brevity required by a study like this one does not permit us to overlook certain problems to which no satisfactory solutions have yet been found, possibly on account of the plethora of different opinions regarding them. One of these problems is posed by

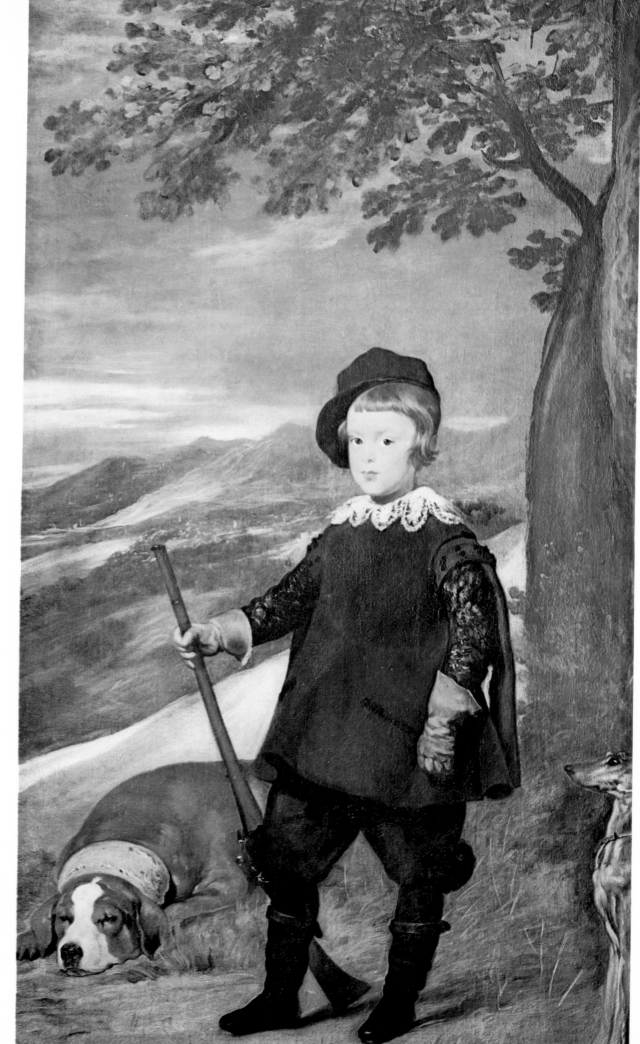

Fig. 146. PRINCE BALTASAR
CARLOS IN SHOOTING DRESS.
1635-1636. Madrid: Prado Museum.
Cat. No. 99.

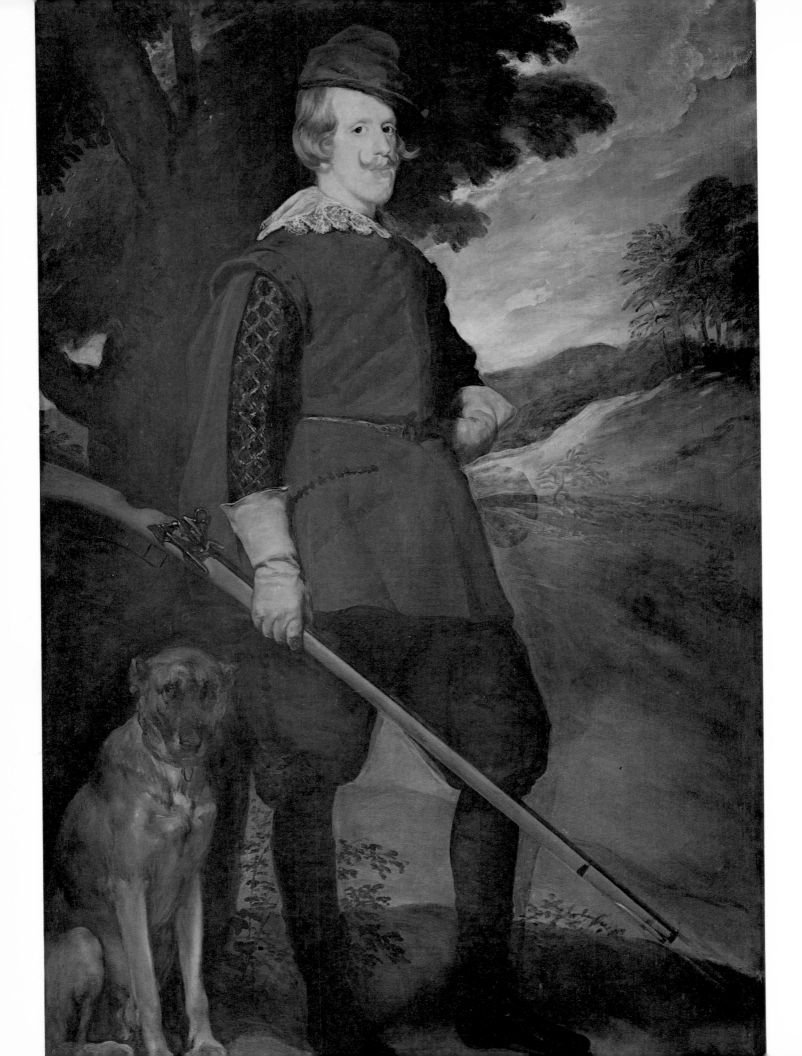

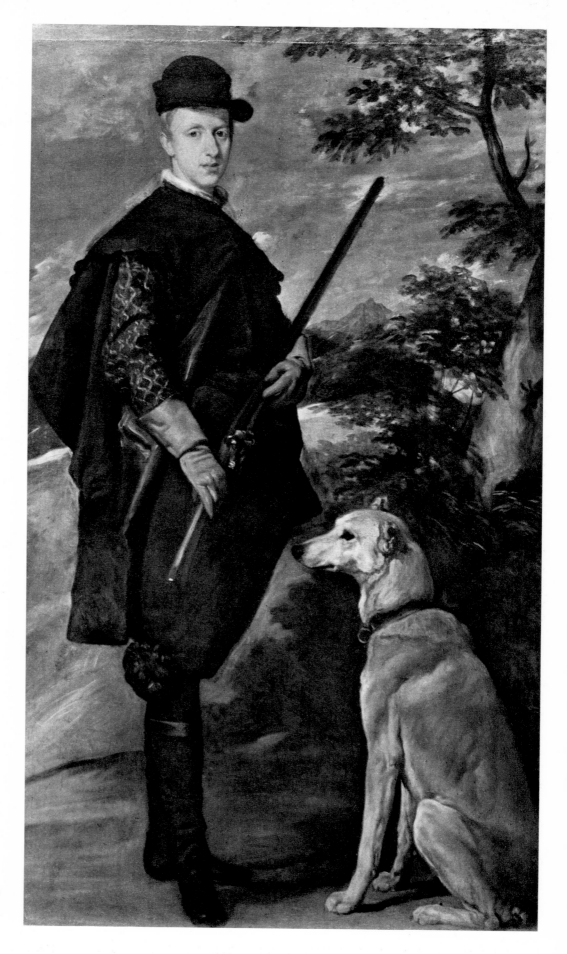

Fig. 147.
PHILIP IV IN SHOOTING DRESS.
C. 1635-1636. Madrid: Prado Museum.
Cat. No. 100.

Fig. 148.
THE INFANTE FERNANDO IN SHOOTING
DRESS. C. 1632-1636. Madrid: Prado Museum.
Cat. No. 101.

Figs. 149 & 150. THE INFANTE FERNANDO IN SHOOTING DRESS. Details of figure 148.

Figs. 151, 152 & 153. THE BOAR HUNT (LA TELA REAL). C. 1636-1637. London: National Gallery.
Cat. No. 102.

Figs. 154 & 155. THE BOAR HUNT. Details of figure 151.

Figs. 156 & 157. FRANCISCO LEZCANO (NIÑO DE VALLECAS). C. 1637. Madrid: Prado Museum. Cat. No. 103.

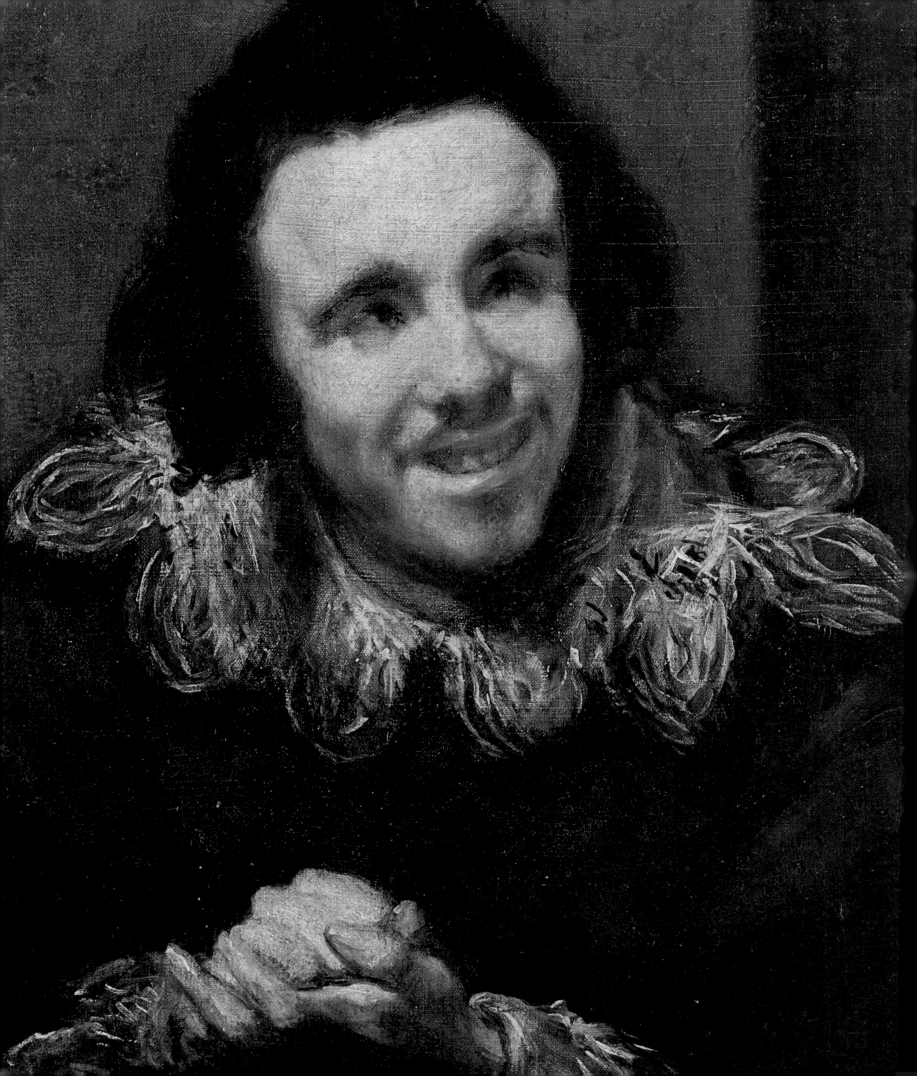

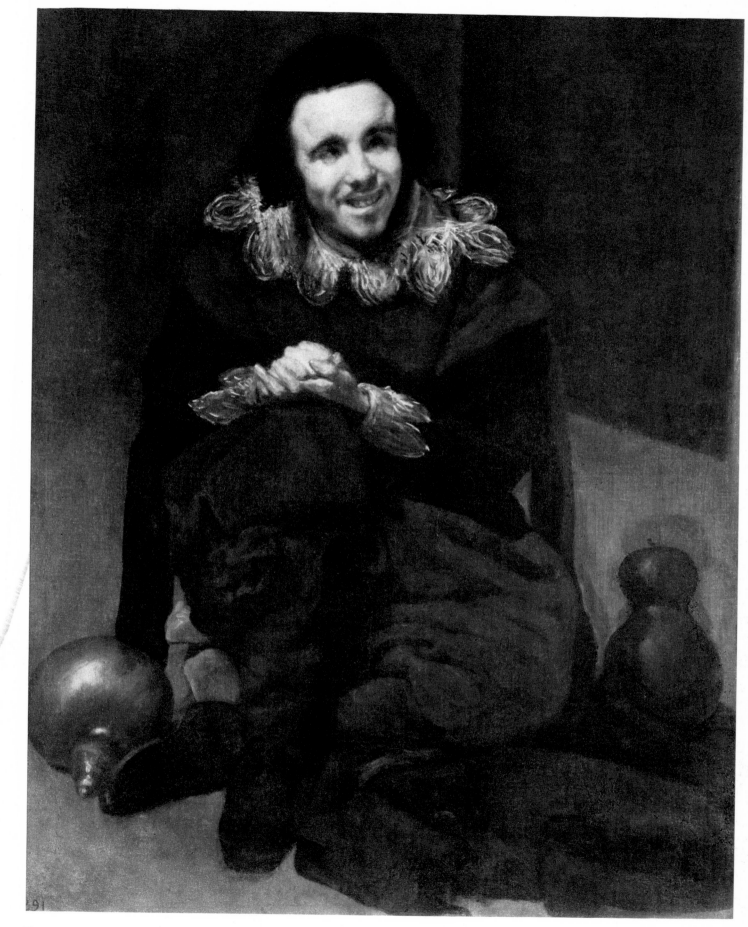

Figs. 158 & 159. JUAN DE CALABAZAS (CALABACILLAS). C. 1637. Madrid: Prado Museum. Cat. No. 104.

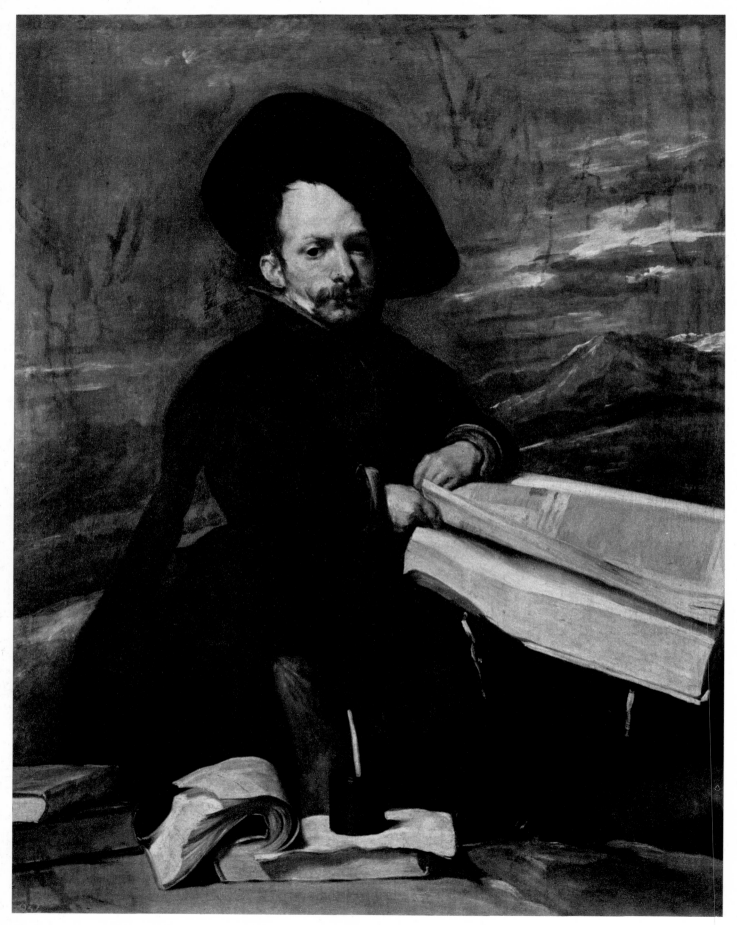

Fig. 160.　DIEGO DE ACEDO (EL PRIMO). C. 1637. Madrid: Prado Museum. Cat. No. 105.
Fig. 161.　SEBASTIAN DE MORRA. C. 1645. Madrid: Prado Museum. Cat. No. 106.

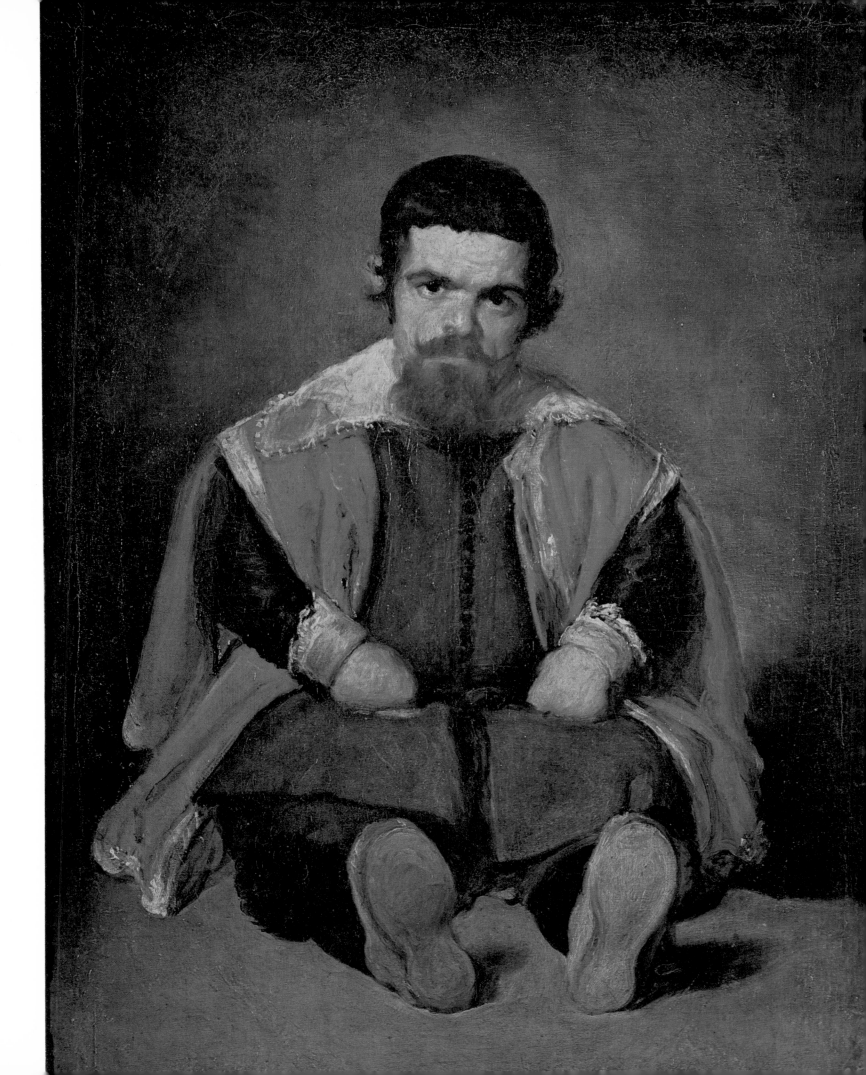

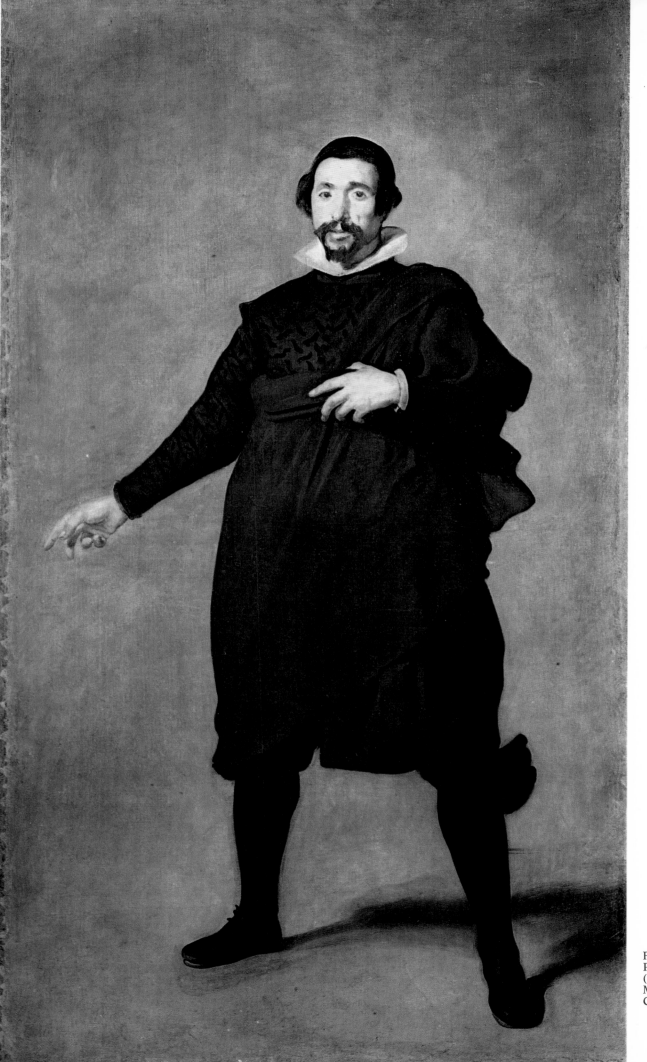

Fig. 162.
PABLO DE VALLADOLID
(PABLILLOS). C. 1637.
Madrid: Prado Museum.
Cat. No. 107.

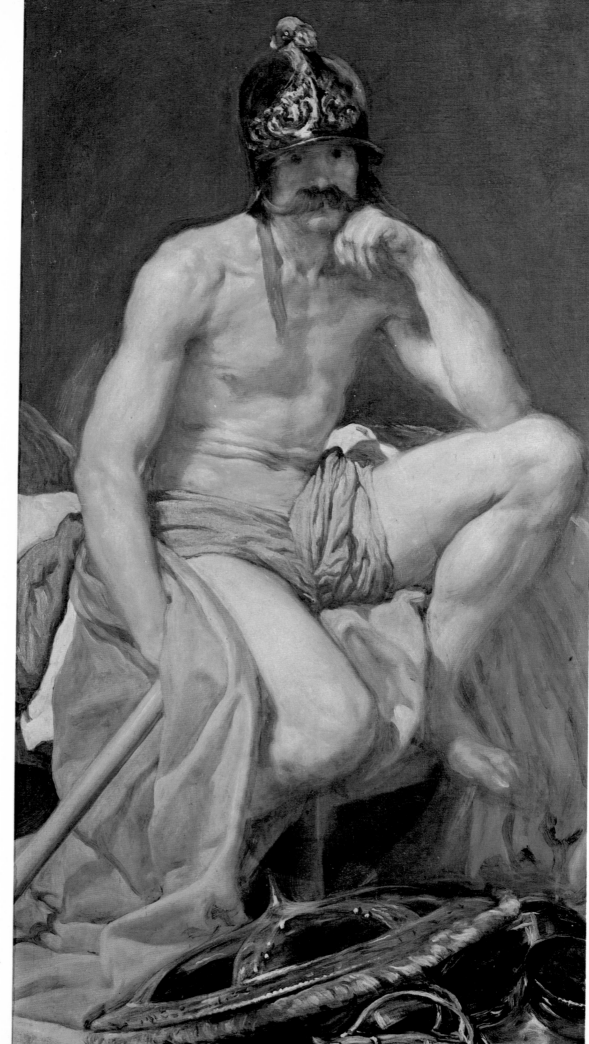

Fig. 163. MARS. C. 1637-1640.
Madrid: Prado Museum.
Cat. No. 108.

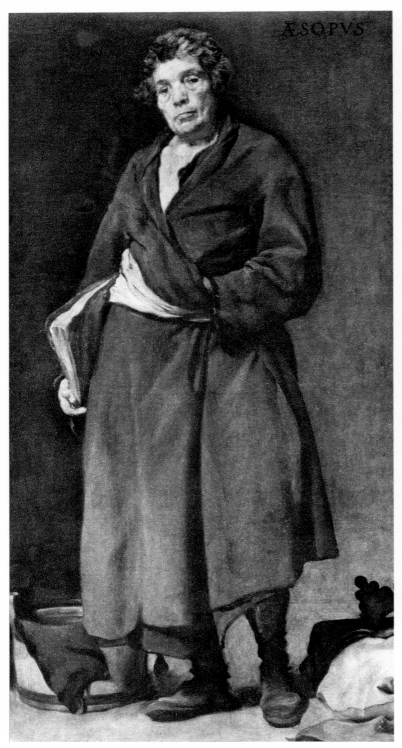

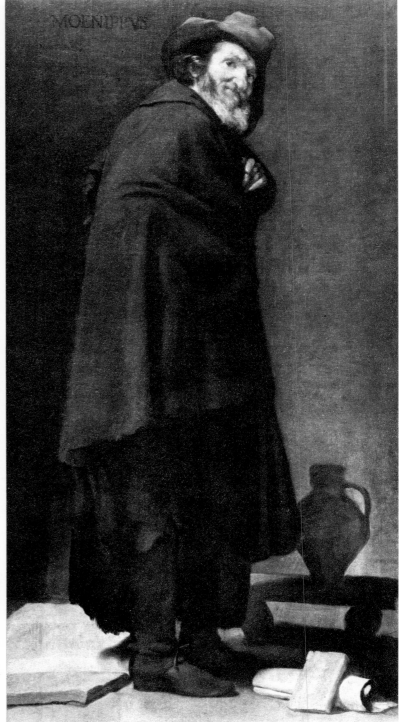

Fig. 164. AESOP. C. 1637-1640. Madrid: Prado Museum. Cat. No. 109.
Fig. 165. MENIPPUS. C. 1637-1640. Madrid: Prado Museum. Cat. No. 110.

Fig. 166. AESOP. Detail of figure 164.

Fig. 167.
MENIPPUS. Detail of figure 165.

Fig. 168.
CRISTOBAL DE CASTAÑEDA
Y PERNIA (BARBARROJA).
C. 1637-1640. Madrid: Prado
Museum. Cat. No. 111.

Fig. 169. DON JUAN DE
AUSTRIA. C. 1637-1640.
Madrid: Prado Museum.
Cat. No. 112.

Fig. 170. PABLO DE VALLADOLID. Detail of figure 162.
Fig. 171. DIEGO DE ACEDO. Detail of figure 160.
Fig. 172. CRISTOBAL DE CASTAÑEDA Y PERNIA. Detail of figure 168.
Fig. 173. DON JUAN DE AUSTRIA. Detail of figure 169.

Fig. 174. STUDY FOR THE PORTRAIT OF GASPAR DE BORJA. C. 1637. Madrid: Academy of San Fernando. Cat. No. 113a.

Fig. 175. ARCHBISHOP GASPAR DE BORJA. C. 1637. Ponce (Puerto Rico): Museo de Arte. Cat. No. 113.

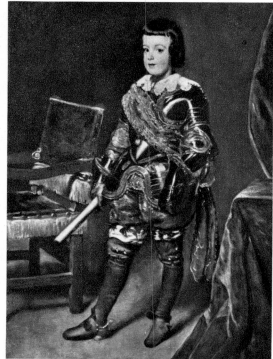
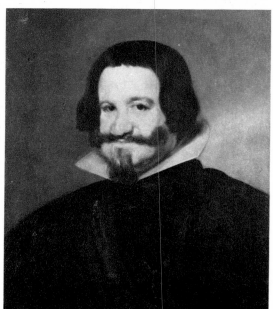

Fig. 176. PRINCE BALTASAR CARLOS. C. 1639. Vienna: Kunsthistorisches Museum. Cat. No. 114.
Fig. 177. PRINCE BALTASAR CARLOS. C. 1639-1640. The Hague: Mauritshuis Museum. Cat. No. 115.
Fig. 178. THE COUNT-DUKE OF OLIVARES. C. 1638. Leningrad: Hermitage Museum. Cat. No. 116.
Fig. 179. FRANCESCO II D'ESTE, DUKE OF MODENA. 1638. Modena: Pinacoteca di Modena. Cat. No. 117.

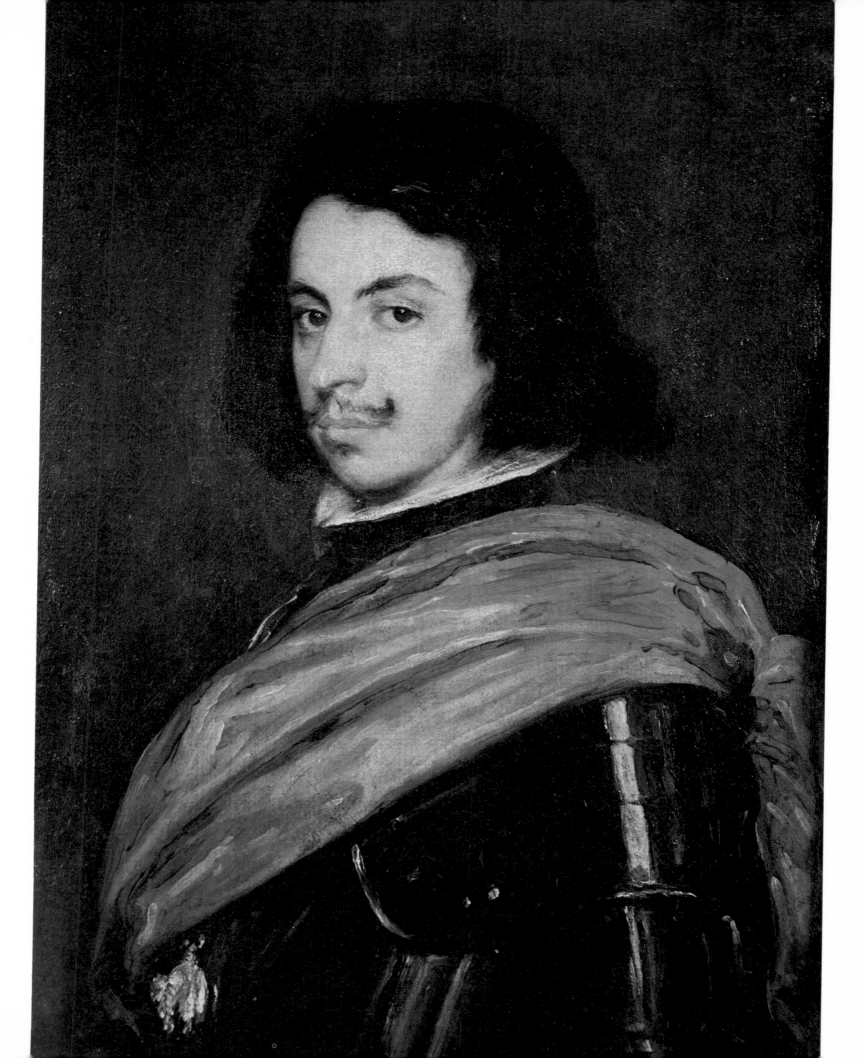

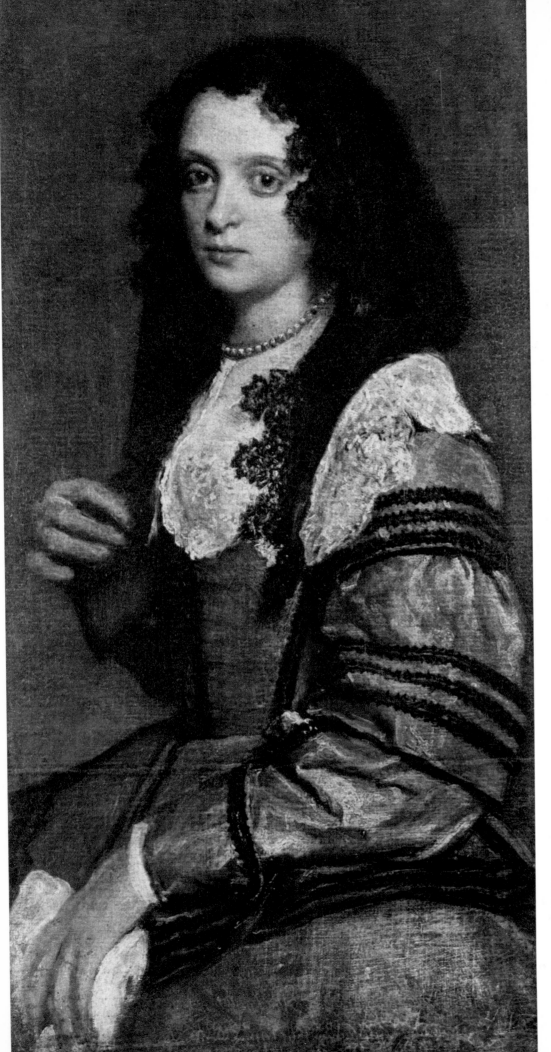

Fig. 180. YOUNG LADY. C. 1640-1642.
Chatsworth: Duke of Devonshire
Collection. Cat. No. 119.

Fig. 181.
LADY WITH FAN. C. 1640-1642. London:
Wallace Collection. Cat. No. 118.

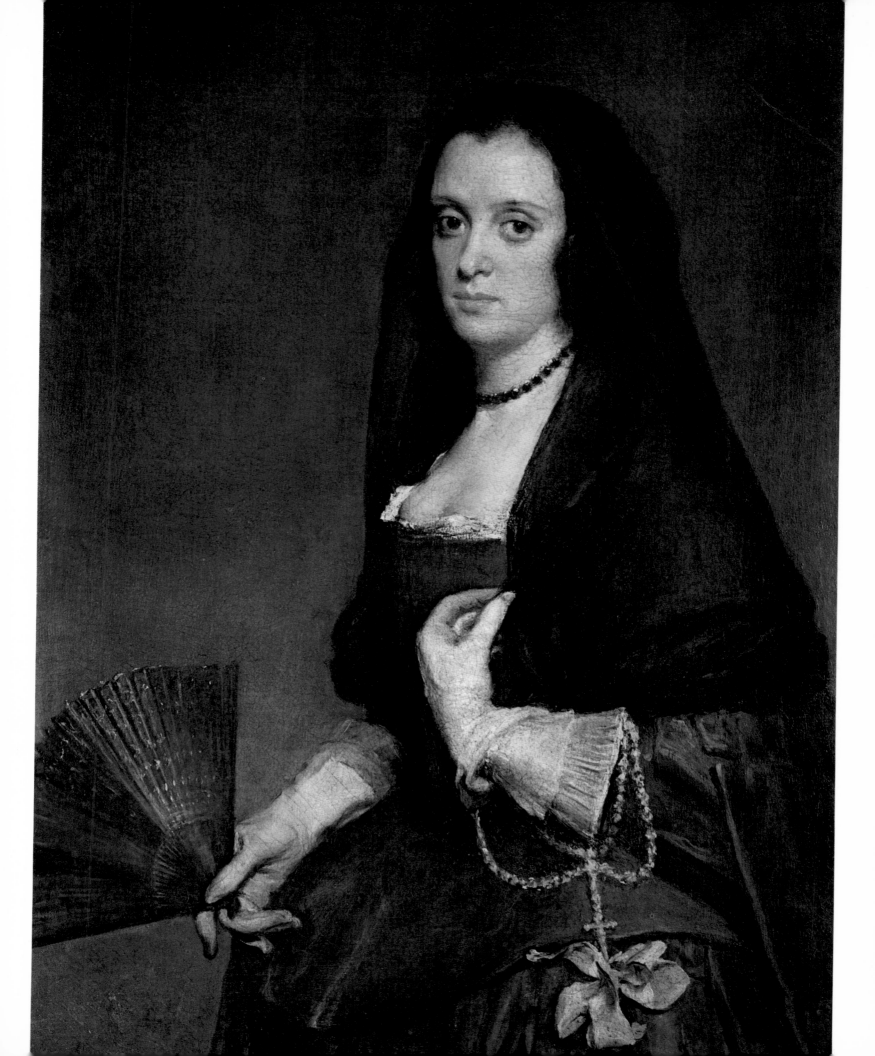

Fig. 182. YOUNG LADY. Detail of figure 180.

Fig. 183. LADY WITH FAN. Detail of figure 181.

Fig. 184. HEAD OF A GIRL. C. 1640-1642. New York: Hispanic Society of America. Cat. No. 120.
Fig. 185. PHILIP IV. 1644. New York: Frick Collection. Cat. No. 121.

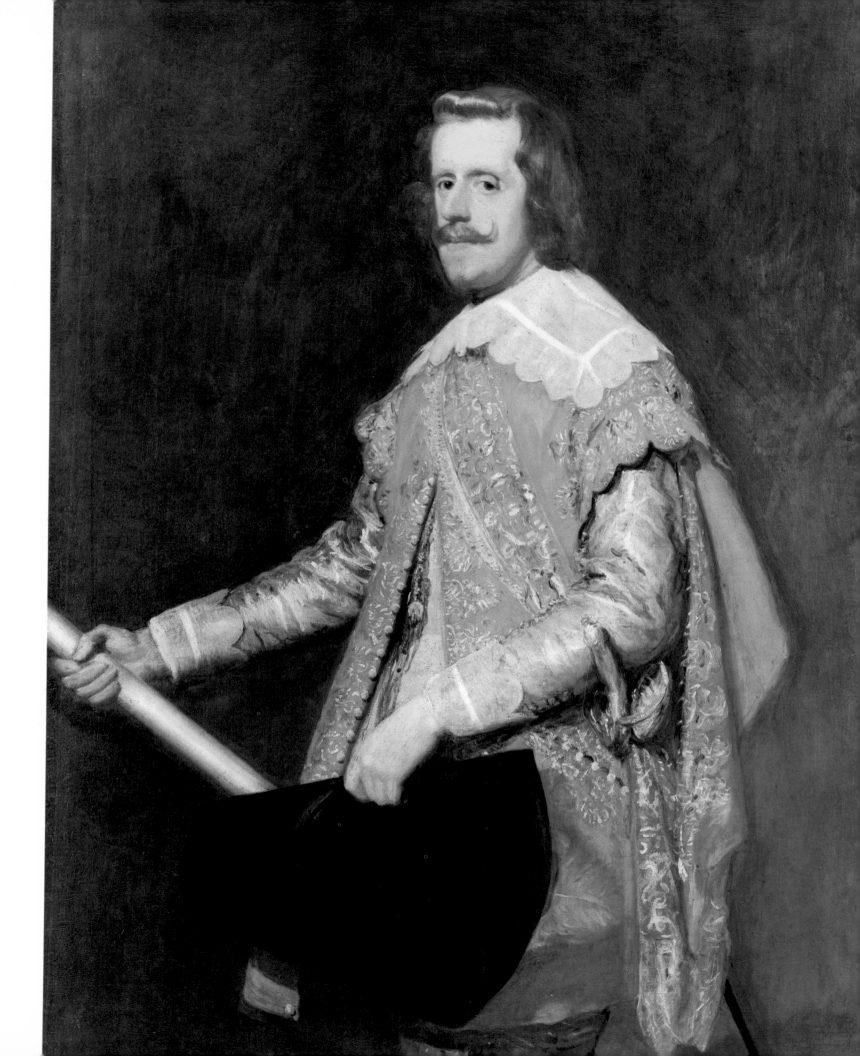

Fig. 186. PHILIP IV. C. 1644. Florence: Palazzo Pitti. Cat. No. 122.
Fig. 187. ADMIRAL ADRIAN PULIDO PAREJA. London: National Gallery. Cat. No. 123.
Fig. 188. PORTRAIT OF A MAN. C. 1645. Present whereabouts unknown. Cat. No. 124.

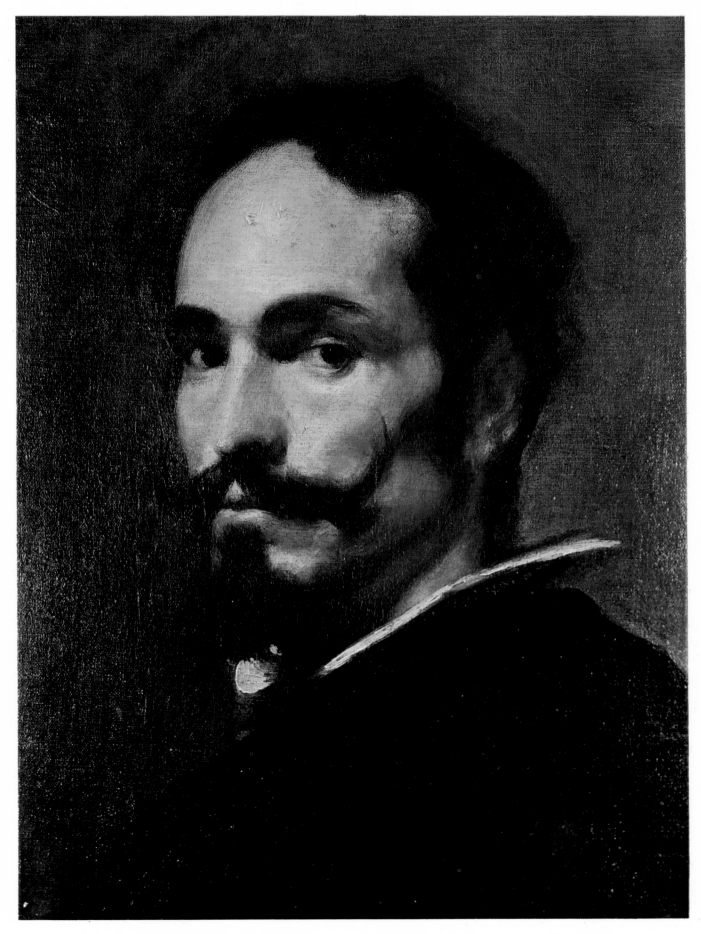

Fig. 189. PORTRAIT OF AN UNKNOWN GENTLEMAN. C. 1645. London: Wellington Museum. Cat. No. 125.
Fig. 190. JUAN FRANCISCO DE PIMENTEL, 10th CONDE DE BENAVENTE. C. 1648. Madrid: Prado Museum. Cat. No. 126.
Fig. 191. PORTRAIT OF A GIRL. C. 1648. Bergamo: Accademia Carrara delle Belle Arti. Cat. No. 127.

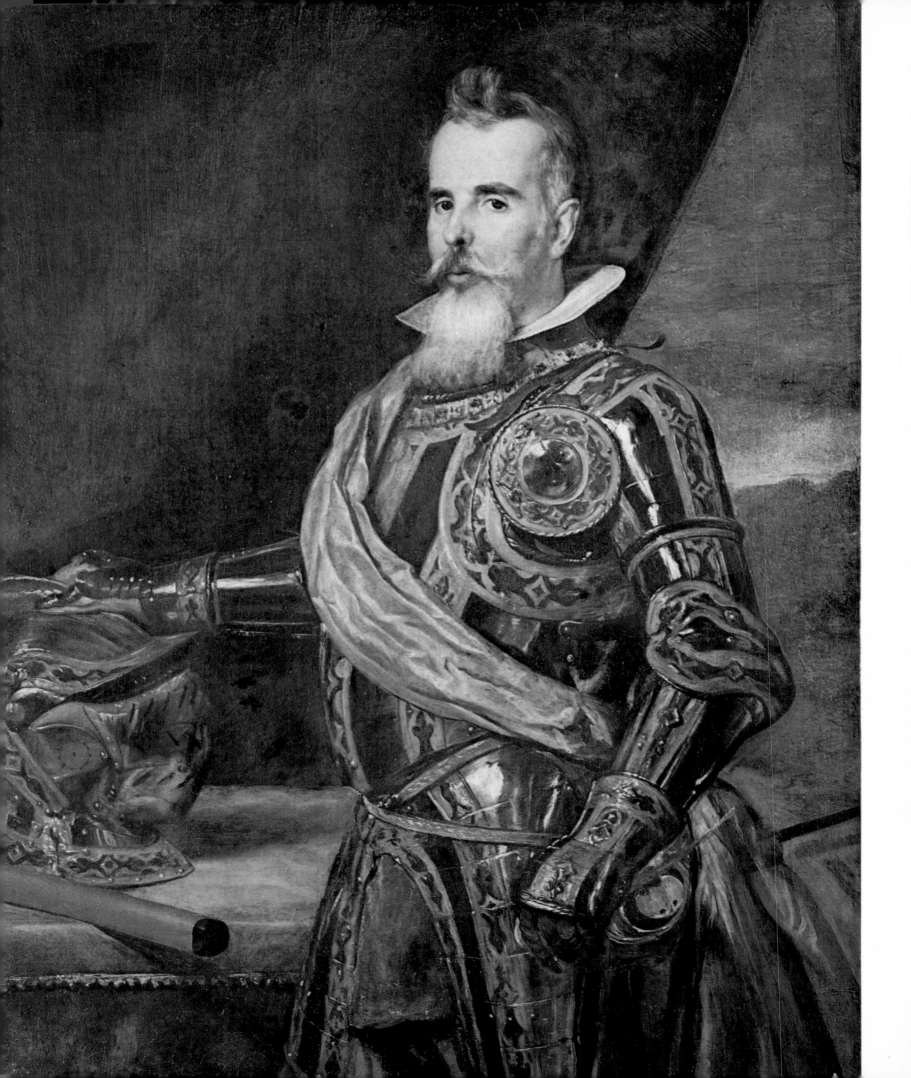

Fig. 192 (A & B). GROUPS OF FIGURES AGAINST A LANDSCAPE BACKGROUND. C. 1645-1648.
Bonn: Städtische Kunstsammlungen. Cat. No. 130.

Fig. 193. VIEW OF ZARAGOZA (DETAIL). Work signed by Mazo in 1647. Madrid: Prado Museum. Cat. No. 129.

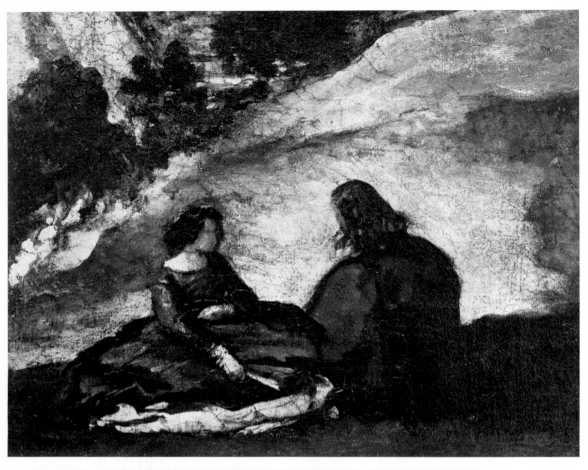

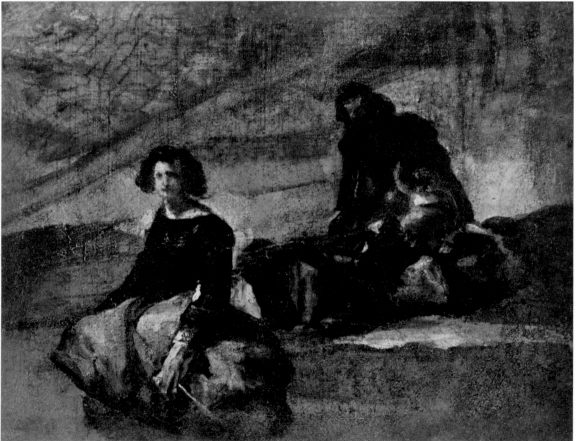

Fig. 194. GROUPS OF FIGURES AGAINST A LANDSCAPE BACKGROUND. C. 1645-1648. At dealer's.
Cat. No. 131.

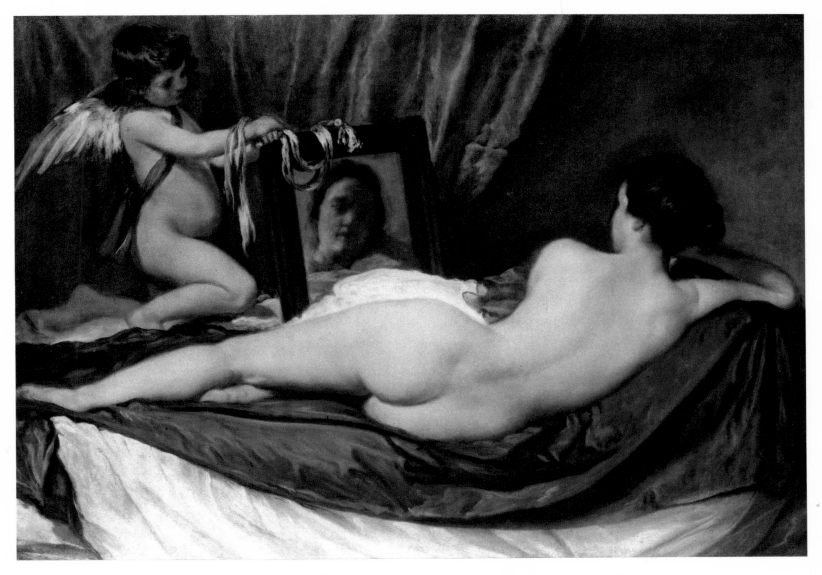

Fig. 195. THE TOILET OF VENUS (THE ROKEBY VENUS). C. 1645-1648. London: National Gallery. Cat. No. 132.

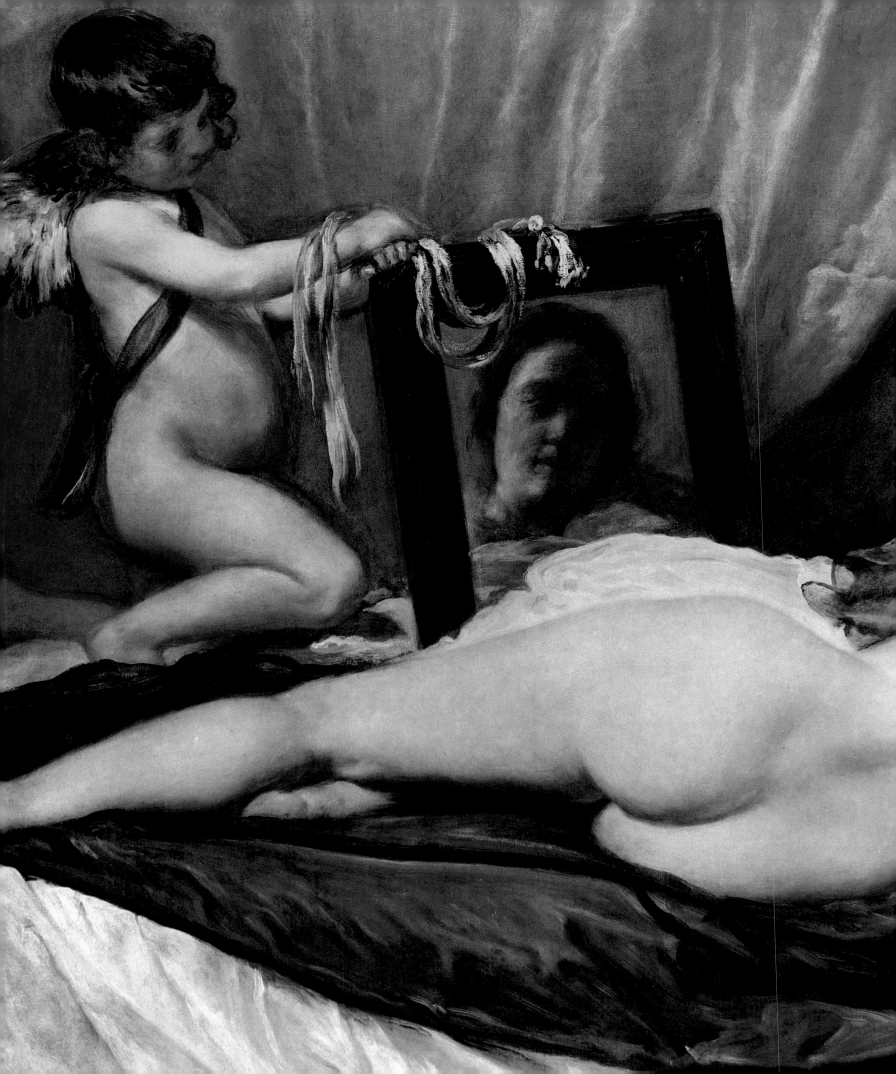

Figs. 196 & 197. THE TOILET OF VENUS. Details of figure 195.

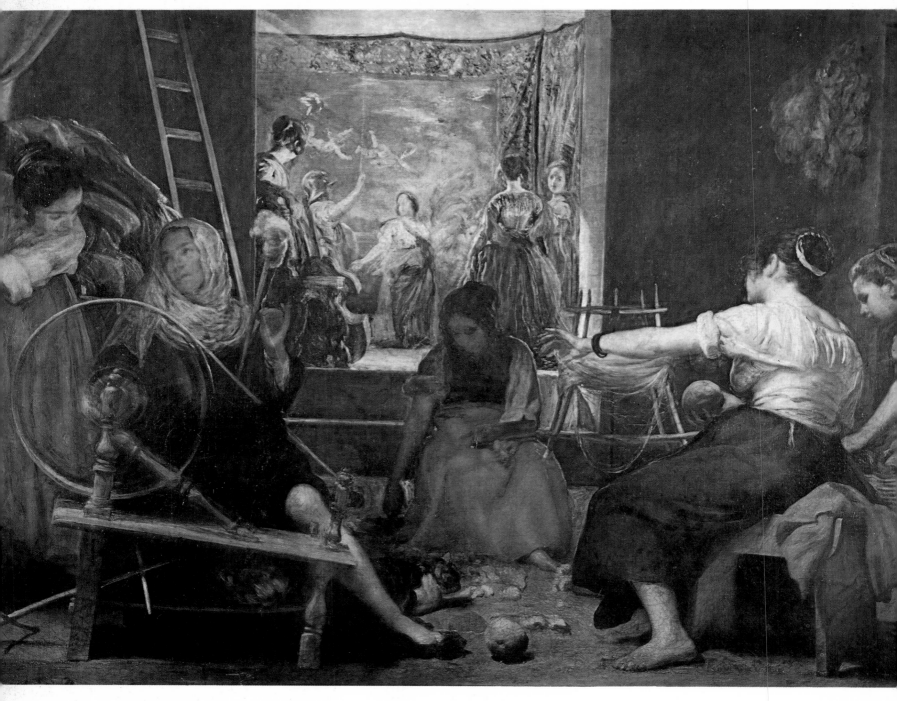

Figs. 198 & 199. THE FABLE OF ARACHNE (THE SPINNERS). C. 1645-1648. Madrid: Prado Museum. Cat. No. 133.

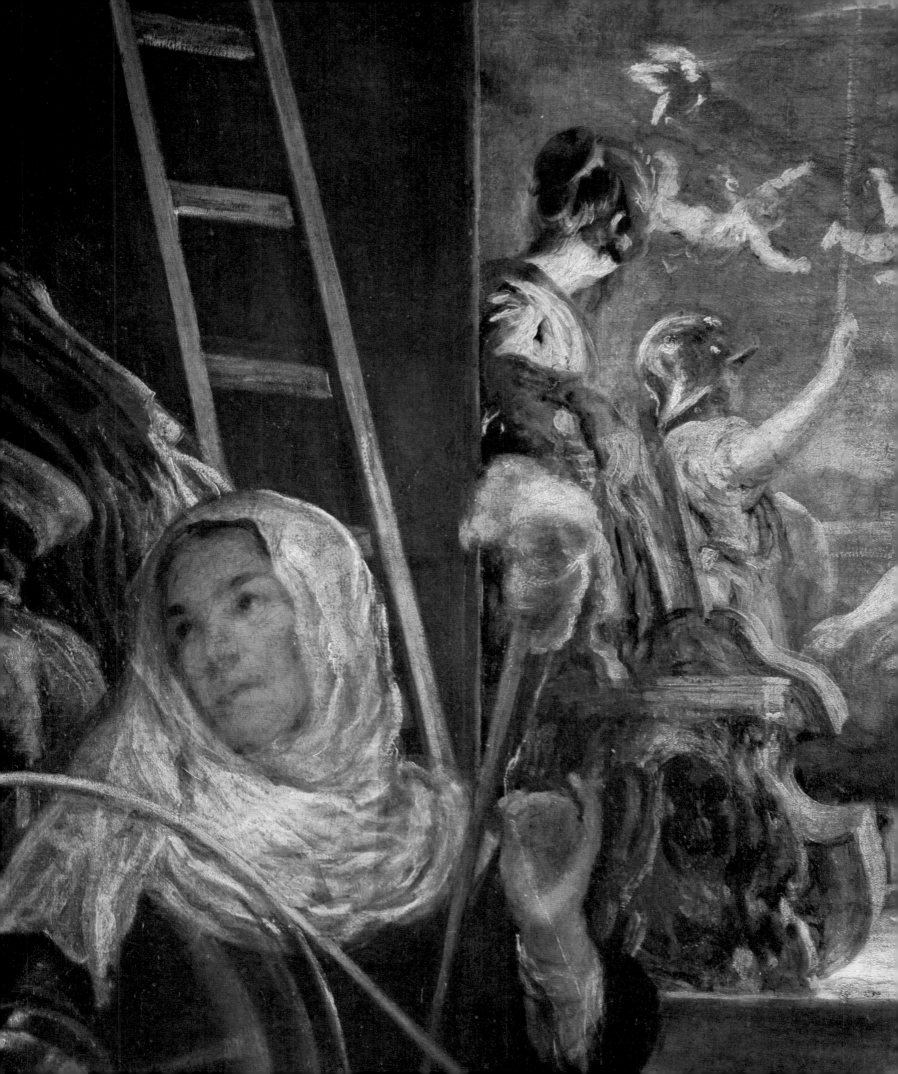

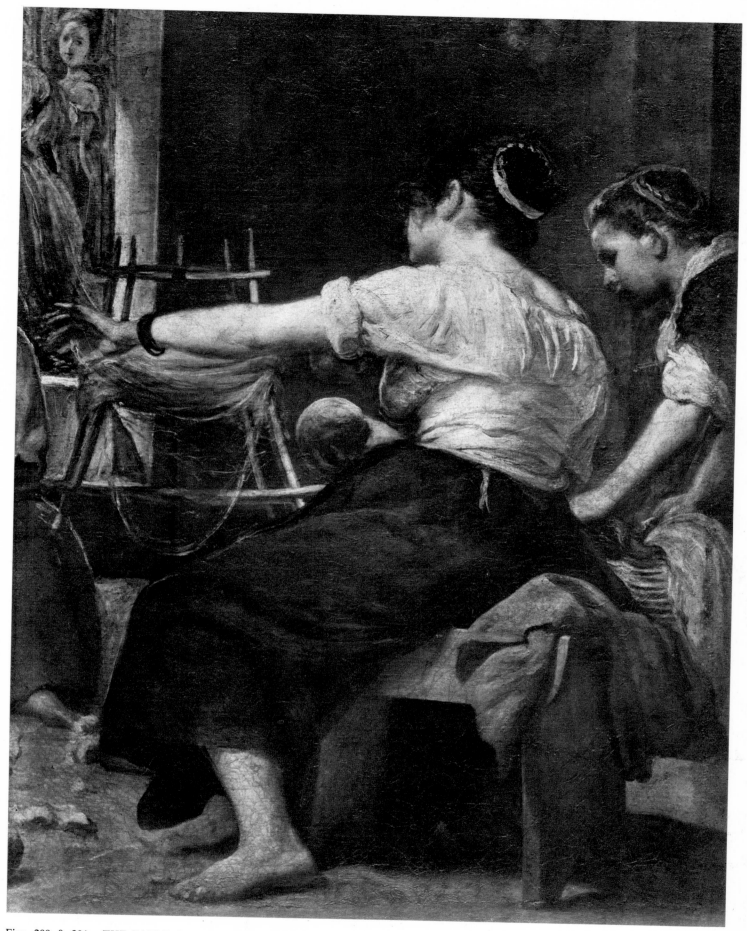

Figs. 200 & 201. THE FABLE OF ARACHNE. Details of figure 198.

Fig. 202. WOMAN IN PROFILE. C. 1644-1648. New York: Private collection. Cat. No. 134.

the analytical study of a group of works which have in common the smallness of the figures depicted in them, and with which the names of Velázquez and Mazo are both linked. Even the official catalogue of the Prado echoes the traditional doubts regarding Velázquez's participation in the *View of Zaragoza,* signed by Mazo in 1647. This work was certainly begun and carried out chiefly by the younger painter, but I must say I am quite convinced that some of the figures in the foreground *(Fig. 193 - Cat. 129)* were painted by Velázquez. And they are easily recognizable, for their liveliness and corporeality — so closely integrated — and the total absence of either over-insistence or hesitation are in marked contrast with the feeble structuring of most of the human figures that swarm over the vast panorama of this celebrated picture.

I am also in agreement with those who consider that Velázquez had a hand in the painting of some fragments of what were originally two large canvases dealing with rural themes. Two of these, now in the Städtische Kunstsammlungen of Bonn *(Figs. 192 A & B - Cat. 130),* are parts of what was evidently a hunting scene. The other two, which are much smaller, are mere scraps of distant landscape, with a few figures sitting on the grass *(Figs. 194 A & B - Cat. 131).* I should mention that these figures, so brilliantly sketched in here, are almost identically repeated — but in mediocre style — as more prominent characters in the *Fountain of the Tritons* in the Prado, a canvas which, after years of dispute, was finally attributed to Mazo.

The Rokeby Venus

In the inventory of the collection of Don Gaspar Méndez de Haro, Marqués de Eliche y del Carpio and grand-nephew of the Count-Duke's sister, which is dated June 1st 1651, we find the following entry: "A painting on canvas of a naked woman, reclining on a sheet and painted from behind... looking at herself in a glass held by a child, the work of Velázquez, two and a half rods in width and one and a half in height". This entry undoubtedly refers to that jewel of the National Gallery of London entitled *The Toilet of Venus,* though more usually known as *The Rokeby Venus (Figs. 195 to 197 - Cat. 132).*

It is a work that is impressive in its truth and simplicity — its basic realism idealized by the technique — and one which, like so many of Velázquez's works, presents the model without attempting to transform her into the deity that is the work's theme or pretext. The precise shading of the woman's naked body, in combination with the crimson hangings and the grey of the sheet, produces a colour harmony of rare beauty.

This is undoubtedly one of Velázquez's great works, with a new quality that gives wider scope to the dissolution of the form — to such an extent, indeed, that we may say that with this picture the artist is entering on his last period. Not only does he refrain from using tonal contrast in the areas in which it might be most effective; he even denies himself the use of this legitimate technique by placing a white cloth between the body and the looking-glass, so that the contrast is lessened at this point. The modelling is extremely sober, caressing the form just as the light might do and without forcing the impression of relief — that dense effect of Velázquez's younger days — but achieving it with the much more simplified methods of his final period. The face in the glass is reconstructed at a distance by the viewer's eye, for at close range one can see only nebulous forms. We are now but a step from the tour de force of the looking-glass in the background of *The Maids of Honour,* with its portraits of the King and Queen. This work, so astonishingly naturalistic in its colour and its tactile qualities, is undoubtedly the greatest Spanish nude of all time and one of the finest in the world.

One of this work's more felicitous features is the rhythm marked by the main guiding lines of the composition. The goddess's left foot is the starting-point for a series of sweeping yet delicate curves — the grey sheet, the line followed by the silhouette of the body and the contrast between the fullness of the left background — the figure of the little Cupid — and the void on the right. The ascending curve of the curtain, too, seems to derive from that network of lines on which the whole picture is planned. The naked body of the Cupid, moreover, serves as a counterbalance to the

centre and right-hand areas, in which Venus's flesh is more opulent. Needless to say, there is nothing sensual about this work, nor should there really be any need to mention this. But since I have commented on the psychological factor in the artist's approach to various other themes, I can hardly avoid doing so in this case – especially as the nude is such a very exceptional theme in Spanish painting.

The sobriety of the modelling imbues the woman's body with a delicacy that is more spiritual than sensuous – once more the painter shows his aristocratic sense of a proper moderation, refusing to be carried away by instinctive impulses. The depiction of feminine beauty is not the motif of this picture, but rather the reverse. Once again, what the artist is seeking is the pictorial, and he uses the beauty of a young woman's body, just as he used the deformities of the court jesters and dwarfs, to find in the process of painting his canvas the motifs that enable him to achieve that pure pictorialism which alone satisfied him. The contrasts of texture in some areas are amazing, examples being those of the pink ribbon, the frame of the looking-glass and the reflected face. It is in details like these that the master's astounding virtuosity can be appreciated.

A more careful analysis, however, reveals that the restraint and extreme simplicity of the face in the glass are also present in the body, realistically depicted with its back to the viewer. If we look closely at any area we shall see this simplicity of material and texture. In the head the qualities are at once tenuous and evanescent, and the outlines rather imprecise. The representation of the hair, though no more than a suggestion, is sufficient to give the impression of a whole head of hair in all its true physical reality. In the years that followed his visit to Italy Velázquez must gradually have realized that this was the course his work was to follow in the future. Though he may not have possessed that spirit of experimentation which only flourishes in an age marked by an excessively critical approach, whether on the part of artists themselves or of others (i.e., since the middle of the 19th century), his tendency to eliminate unnecessary detail has been more and more remarked upon, and he was well qualified to do this because he knew, better than any other painter before or since, exactly

what was meant by the word "necessary", those elements which could not be suppressed even in the most evanescent image without running the risk of dissolution.

This does not mean that Velázquez's technical advances, like those made by Greco before him (shadows created by colour rather than darkening the local colour of an area with black), should be considered "precedents" of 20th-century art. It is a great mistake to look upon Velázquez, even in his later years, as a forerunner of Impressionism. In the first place he was infinitely superior to all the Impressionists; in the second place, he worked within a style – the Baroque – that was totally different, optically and aesthetically, from that of the second half of the 19th century; and, finally, his technique could not be more different. Velázquez was only – and it was enough in all conscience – Velázquez. His last discoveries, moreover, did not foretell anything; they were merely the consequence of his basic principles and his miraculous gift for the art of painting.

The Fable of Arachne (The Spinners)

This famous canvas in the Prado (*Figs. 198 to 201 - Cat. 133*) was one of the paintings saved from the fire that destroyed the old Alcázar of Madrid in 1734. After its rescue it was subjected to a restoration from which it emerged with its dimensions considerably enlarged. The reproduction shows it without the strips of canvas then added to increase the space depicted. In the 1772 inventory of the new Royal Palace of Madrid it is mentioned as having come from the Palace of El Buen Retiro and described as "a tapestry factory, with women spinning and winding yarn". In a later inventory (1729) it is already given the title of *The Spinners,* the name under which it figures in the present catalogue of the Prado.

Mengs interpreted this picture as an allegorical representation of "The Fates"; Mayer thought it was intended to have a social significance; Ortega y Gasset said it represented the "marriage of Thetis and Peleus", thus placing the main interest in the background scene. Tolnay came a little nearer the right solution when he suggested an allegory of "Pallas

Athene", while Azcárate spoke rather more specifically of "Athene symbolizing government". It was Enriqueta Harris who first mentioned that the scene in the background might have something to do with Arachne. Angulo Iñíguez, finally, found the solution to the problem with his hypothesis that the painting represents the key dialogue of the Pallas-Arachne myth: Arachne, weaving a tapestry that represents the Rape of Europa, is struck by Pallas Athene and turned into a spider.

The above is certainly the likeliest explanation of the scene depicted in one of Velázquez's greatest paintings. In the foreground we see a workshop with five spinners and behind them a room, at a slightly higher level, in which a play is being acted or rehearsed before three ladies standing near a viola da gamba propped against a chair. The two characters "on stage", as it were, are Pallas Athene, in warlike attire with a lance and a shield, and Arachne, the gesticulating woman standing in the centre. The room is hung with two tapestries, one which is given a wrinkled appearance by foreshortening on the right and the other stretched across the wall at the back. This latter tapestry, which serves as the background to the dialogue between Pallas and Arachne, does indeed represent the Rape of Europa, which gives the key to the meaning of the whole composition. I should add that the tapestry reproduces a canvas by Titian, now in the Isabella Stewart Gardner Museum in Boston, which in Velázquez's time belonged to the Spanish royal collection.

It was María Luisa Caturla who discovered the following entry in an inventory of the estate of Pedro de Arce, Philip IV's steward and huntsman, drawn up on October 4th 1664: "another painting by Diego Velázquez, of the fable of Arachne, over 3 rods in width and 2 in height, valued at 500 ducats". The canvas in the Prado, if we discount the strips of canvas added later, measures approximately the same as Arce's picture. This latter, therefore, is probably the one we are now studying; the date on which it was added to the royal collections is unknown, but it was certainly before 1734.

As in *The Surrender of Breda*, the composition is vertically symmetrical, with stepped parallel planes. All diagonal axes or suggestions of movement are subordinated to that sort of static quality that is peculiar to Velázquez's aesthetic. The harmony of the picture as a whole is based on the mutually counterbalancing relationship of light, rhythm and colour. The artist uses blue, yellow, white and golden greys, enriched by a preponderance of reds that range from light vermilion to crimson. As we always find with Velázquez's palette, black plays a very important role. If the background were a blank wall or a flat wash, we should have a composition not so very different from those of the painter's early years. But with the opening up of the central area the concept has changed: we now have an all-embracing formula which combines the frieze-like character of the foreground with spatial depth and contrasts of tone and light. The open form, which uses widely-varying techniques in different areas, has a much more complex system of chiaroscuro than any to be found in previous works. Even the tapestry, with its brilliant colouring, is used to introduce some notion of the "exterior" into this world which, in its two distinct areas, opposes two different planes of reality: that of the reality of everyday tasks and that of the myth which is expressed by means of a theatrical performance or rehearsal and, what is more, projected on a work of art — the tapestry in the background.

The tendency to open form predominant in this work is strengthened by the way in which the painter expresses movement, whether alluding to it through gestures or really depicting it, as he does with the spinning-wheel by replacing the pattern of the spokes with a subtle effect of vibration, Everything in the picture obeys this principle and we may even say that nothing in the ensemble is left static, though each element is subject, as I said above, to the evident symmetry of the whole and the parallelism of planes in depth, more classical than baroque. But an analysis of each figure will show us that it is in movement and that the painter has made marvellous use of gesture to express, in all its intimacy, the workaday world of these spinners.

Other elements help to enliven what might have been dead areas: the red curtain on the left, for in-

stance, and the ladder, the light tones of which stand out very sharply. And the right-hand wall is animated by the lighter touch of the door-jamb and the effect of the bundle of wool hanging on the wall itself.

In this we have the culmination of the system that Velázquez employed between 1630 and 1650, the most characteristic feature of which is the change of technique according to area; that is to say, according to the relative importance of each element. He adapts the technique to the material represented, its importance in the overall scheme and its distance from the viewer. *The Spinners*, therefore, is a work painted in a great variety of impastos. Prolonged brushstrokes of rich, dense material in white are combined with masses of fluid colour. It is like a composition of nebulous stains, with vigorous strokes defining the essential forms, particularly those that reflect the light with any intensity. This is the method that achieved its first fullness in *The Surrender of Breda,* with the difference that in *The Spinners*, since it represents an interior and so has no distant backgrounds, the effects of aerial perspective are greatly reduced. The range of colours is quite a rich one: white, yellow, red, vermilion, crimson lake, sienna, green and blue. The natural earth colours — which played such an important role in Velázquez's early works — have practically disappeared. We find ourselves, therefore, in a chromatic world entirely opposed to that of the works painted before the visit to Italy.

The modelling of details is non-existent, if by modelling we mean the volumetric precision of closed form. The faces and hands are hardly more than mere suggestions. The painter has only to provide a minimum of visual data of the form and the viewer can reconstruct it spontaneously. Only Velázquez's incomparable ability to suggest the sensation of form and even the plasticity of detail by pure chromatic contrast could have achieved the miracle of making the effectiveness of this scene — in the foreground, in the background and even in the partially visible scene on the tapestry — stand out clearly amid so many distractions.

But the sad truth today is that this great picture, which is, quite rightly, one of the painter's most famous works, can no longer be appreciated in all its true original beauty. The canvas, unfortunately, is positively stiff with repaintings and in a dangerous state of disintegration. In fact it is quite possible that, if no remedy is found, the painting will slowly crumble away.

As a complement to the difficult problem of the "Fable of Arachne", recent *catalogues raisonnés* of Velázquez's work have included a small canvas discovered some years ago in an old collection in Milan. It is a half-length portrait of a *Woman in Profile,* who is pointing with the forefinger of her right hand at a tablet she is holding in the other hand *(Fig. 202 - Cat. 134),* and is evidently a copy of the *Sybil* in the Prado *(Fig. 127),* which was probably painted on the painter's return from his first visit to Italy. An elementary comparison between the two pictures, which are of similar size, is sufficient to show us what a long way Velázquez had come. The *Sibyl* is an example of serene classicism, objective judgment and the desire to achieve a strict order in space. The formal balance is obtained by means of the static arrangement of the forms themselves. The *Woman in Profile,* however, is a much more naturalistic painting, more direct, more spontaneous and chromatically richer. Even the clothing is less dense than in the *Sibyl,* while the woman's pose has the effect of a snapshot (as also occurs in *The Spinners*). The technique, too, is freer, with brushstrokes that are very perceptible as such; also worth mentioning is the delicate modelling of the right hand and forearm.

It was Mayer who first drew attention to the connection between the pictorial concept of this second version of the *Sybil* and that of *The Spinners*. He indicated at the same time the undeniable physical resemblance between the model for the *Woman in Profile* and one of the women in the group on the right of the larger work. López-Rey, moreover, has suggested, in my opinion rightly, that this woman may also have been the model for the *Rokeby Venus.* All of this goes to corroborate the belief that this group of pictures was painted at the same stage in Velázquez's development: the stage immediately preceding that group of his last paintings which is presided over by the incomparable *Maids of Honour.*

VI

THE SECOND VISIT TO ITALY

1649-1651

PALOMINO'S ACCOUNT. – DOCUMENTARY DATA. – WORKS DONE IN ROME. – THE LONG JOURNEY HOME. – *JUAN DE PAREJA*. – *POPE INNOCENT X*. – OTHER PORTRAITS PAINTED IN ITALY.

Velázquez set out for Italy for the second time on January 21st 1649, as a member of the retinue accompanying the Duke of Nájera, who was going to Trento to receive as the new Queen of Spain the Archduchess Mariana, daughter of Emperor Ferdinand III of Austria and Philip IV's sister, the Infanta María.

According to Palomino, Velázquez went to Italy "sent by His Majesty as ambassador extraordinary to Pope Innocent X and to buy original paintings and old statues, and to take casts of some of the more celebrated... by both Greek and Roman artists". He travelled by sea from Málaga to Genoa and then continued, by way of Milan, to Padua and Venice. "Here he found occasion to buy a ceiling painted with stories from the Old Testament, by Giacomo Tintoretto" and other canvases attributed to the same painter and to Veronese.

Stopping in Bologna, he had interviews with "Michele Colonna and Agostino Mitelli, noted fresco painters ..., to discuss the possibility of their coming to Spain". From Bologna the traveller went on to Florence and then to Modena, where the Duke showed him his palace and "the portrait Diego Velázquez painted of the Duke when [the latter] was in Madrid". In Parma, the next stage on his journey, he had the opportunity of admiring the works of Correggio. From Parma he went on to Rome, where he stayed only a few days, as he had "to go to Naples to meet the Conde

de Oñate, viceroy of that kingdom", who gave him 8,000 reales on the instructions of Philip IV. There he also visited Ribera, from whom he probably acquired the three paintings mentioned in the inventory of the effects found after Velázquez's death in his studio in the Alcázar.

Palomino goes on to say: "He returned to Rome, where he was most favourably received by the Cardinal Patron Astalli Pamphili, a Roman and a nephew of Pope Innocent the Tenth, and by Cardinal Antonio Barberino, Abbot Pereti, Prince Ludovisio, Monsignor Camillo Massimi and many other gentlemen: as also by the most illustrious painters, such as Matia Pretti (Knight of the Order of Malta), Pietro di Cortona and Monsieur Poussin, and by Alessandro Algardi of Bologna, and Gian Lorenzo Bernini, both very famous sculptors.

Without neglecting his business, he painted many things, the principal one being the portrait of His Holiness Pope Innocent the Tenth, from whom he received great and most notable favours. And since the Holy Father wished to honour him, in recognition of his great ability and merit, he sent him by way of remuneration a gold medal hanging from a chain, with the likeness of His Holiness in medium relief: he brought a copy of this portrait to Spain ... He painted portraits of Cardinal Pamphili, the illustrious lady Donna Olympia, Signor Camillo Massimi (a chamberlain to His Holiness and a noted painter),

Monsignor Abbot Hippolito (also a chamberlain to the Pope), Monsignore the chief steward to His Holiness and Monsignor Michel Angelo, the Pope's barber, Ferdinando Brandano, Chief Officer of the Pope's Secretariat, Geronimo Bibaldo and Flaminia Triunfi, a lady who was an excellent painter. And he did other portraits, of which I make no mention, since they were left as sketches, though they were not lacking in resemblance to their originals: all of these portraits he painted with long-handled brushes, in the brave fashion of the great Titian, and in no way inferior to his [Titian's] heads; which will not be doubted by anyone who has seen those by his hand in Madrid.

When it was decided to have a portrait of the Sovereign Pontiff painted, [Velázquez] wished to prepare himself previously with the exercise of painting a head from life; so he did the head of Juan de Pareja (his servant and a skilful painter), so faithfully and so vividly that, having sent it with Pareja himself to some friends for their appraisal, they looked from the painted portrait to the original in admiration and amazement, not knowing to whom they should speak or who would answer them. Regarding this portrait, Andreas Schmidt (a Flemish painter at this Court, who was in Rome at the time) has told us that, in accordance with the custom of adorning the cloister of the Rotonda (where Raphael is buried) with outstanding ancient and modern paintings on St. Joseph's Day, this portrait was placed there and won such universal acclaim that, in the opinion of all the painters of different nations, all the others looked like paintings but only this one looked like reality; as a result of which Velázquez was received as a member of the Roman Academy in the year 1650."

Palomino, who wrote his "Lives of the Spanish painters and sculptors" at the beginning of the 18th century, very probably had access to first-hand information or contemporary chronicles dealing with Velázquez's last period, since his account is almost always borne out by the evidence revealed by modern research.

Documentary data

Regarding Velázquez's stay in Venice, there is a very interesting letter to Philip IV from the Spanish Ambassador in that city, the Marqués de la Fuente, who mentions the painter's arrival and the object of his journey: "... he arrived on the 21st (of April) and without any loss of time I have arranged for him to see as many paintings as his stay in my house will permit". The Ambassador also hints at the difficulties awaiting Velázquez in his search for works of art to adorn the Alcázar. Italy, that inexhaustible mine of art which had by now become an international market, was already beginning to take precautions against the incipient collecting mania of the European rulers and magnates. Part of Velázquez's booty from his journeys is now in the Prado.

The painter's short visit to Rome and his second stay there on his return from Naples are confirmed in some letters written by Cardinal de la Cueva (Bishop of Málaga), then living at the Papal Court; letters which express with unusual harshness this prelate's opinion of Philip IV and do not spare Velázquez himself in their accusations. In the first letter, written to his brother on May 19th, he says:

"Here has come a fellow called Velázquez, one of the King's gentlemen of the bedchamber, who says he has been commissioned to travel around Italy, seeking out statues and paintings ... to adorn the palace of Madrid..." The letter goes on to criticize the King and Queen for spending money on "such insubstantial things", especially when they are "in such straits ...; they show little awareness, if any, of their difficult and dangerous situation". In another letter, sent on June 19th, the Cardinal writes: "There is much unedifying talk about the commission to plunder paintings and statues that was given to the gentleman of the bedchamber Velázquez". In a third letter, dated July 12th, he says: "The gentleman of the bedchamber Velázquez has returned here from Naples and is still at his raiding, but I do not know if he has secured any booty so far".

These letters provide evidence for part of Velázquez's journey, since they specify the date of his arrival in Rome. His stay there was long and productive, but there is very little information about it to add to Palomino's account. It is recorded that his election to the Academy of St. Luke took place in January of 1650 and that on February 15th he became a member of the "congregazione dei Virtuosi", a society of art-

ists who held an annual exhibition of their works in the portico of the Pantheon. As we have seen, Velázquez took part in this exhibition, on March 19th, with the portrait of Juan de Pareja, which he had done as a preparatory exercise before painting that of the Pope.

Works done in Rome

Palomino's text is equally reliable regarding the works painted by Velázquez in Rome. This time the good fairy that watches over old paintings has been generous, for of the portraits mentioned by Palomino we still have that of Juan de Pareja, two of Innocent X, those of Cardinal Astalli and Monsignor Camillo Massimi and that of Monsignor Michel Angelo, the Pope's barber.

As we have seen, Juan de Pareja made the journey to Italy as Velázquez's assistant. The son of Moorish slaves, he was born in Seville about 1610. In 1630, by now a freedman and a painter, he moved to Madrid and soon entered Velázquez's workshop. Pareja's self-portrait in his *Vocation of St. Matthew* in the Prado proves beyond a doubt that he was the sitter for the masterly portrait Velázquez painted in Rome.

Innocent X, elected Pope in 1644, had been in Madrid as Papal Nuncio, and as he arrived in the Spanish capital in 1626 he may have already known Velázquez. The great portrait in the Galleria Doria-Pamphili was probably painted between May and July of 1650. Palomino tells us that Velázquez "brought a copy to Spain", while in the inventory of the painter's estate drawn up after his death one of the items is "a portrait of Pope Innocent X". It seems reasonable enough, as a working hypothesis, to assume that both pieces of information refer to the small canvas formerly in the collection of Catherine II of Russia, which now hangs in the National Gallery in Washington.

It was Miss Trapier who identified another of the portraits painted by Velázquez in Rome, the one of Cardinal Camillo Astalli in the Hispanic Society *(Fig. 208)*. Palomino gives the Cardinal the additional surname of Pamphili, adopted by the young cleric when Innocent X adopted him as his nephew and made him a cardinal at the same time. This appointment took place on September 19th 1650, but four years later the Pope deprived him of his new name and revoked "everything decreed in his favour". In a manuscript preserved in the Escorial there is a list of paintings brought from Naples to Spain in 1686, in which we find "a portrait of Cardinal Astalli by the hand of Diego Velasco, eight-sided, measuring two spans". Judging by its shape and size, this cannot be the canvas in the Hispanic Society.

The magnificent Velázquez in the Ralph Bankes Collection *(Fig. 211)* was identified not long ago as the portrait of Monsignor Camillo Massimi. The early history of this canvas is rather better documented, for it figures in the inventory of the estate of this cleric, drawn up after his death in 1677, and it then passed into the collection of Gaspar Méndez de Haro, the Spanish Ambassador in Rome.

The portrait of a smiling cleric found in an English collection was pronounced by Mayer to be one of the canvases painted by Velázquez in Rome; Mayer suggested that it might well be the portrait of "Monsignor Michel Angelo, the Pope's barber". I think it logical to concur with this suggestion as a suitable title for a painting of such quality, which is undoubtedly the work of Velázquez *(Fig. 209)*.

Of the portrait of Cristoforo Segni, chief steward to the Pope, which is also mentioned by Palomino, there survives what may be a canvas that was left in the sketch stage by Velázquez and finished by Pietro Neri, unless it is an excellent copy of a lost original completely painted by Velázquez. The man portrayed *(Fig. 213 - Cat. 142)* is holding a letter in his hand with an inscription that reads as follows: "alla Santa. di Nro. Sigre. Inocencio X Monste. Maggiordomo ne parte a S. Sta. per Diego de Silva y Velaqz. e Pietro Martin Neri". Neri, who was the same age as Velázquez and the painter of some works of excellent quality, was a member of the Academy of St. Luke in Rome.

The long journey home

We do not know exactly how long Velázquez remained in Rome. A letter from the secretary of the Duke of Modena, dated December 12th 1650, an-

nounces his arrival in that city and tells us "that he comes from Rome, returning to Spain". It also adds that Velázquez had asked for permission to see the Duke's collection, a petition which the zealous secretary attempted to discourage.

From this date until his return to Spain in June of the following year the information we have about Velázquez's movements is both scanty and confused. Anything he may have done in such a long period is shrouded in mystery, nor have we any trace of works painted by him at this time. Palomino dismisses this stage in the painter's career by saying: "He decided to return to Spain on account of the repeated letters... in which His Majesty ordered him to return". And once again Palomino's information is borne out by documentary evidence. As early as February of 1650, in fact, Philip had written to the Duke of El Infantado, with instructions for the painter to return to Madrid. The King's anxious interest is revealed in fourteen urgent letters, containing such admonitions as that he should not make the journey overland, "on account of the length of time he would take (the more so considering his character)". These latters, however, tell us something of the enormous amount of work done by Velázquez on this journey: acquiring paintings, sculptures and decorative objects, having reproductions painted and casts of famous sculptures taken and making the difficult arrangements for the transport of the whole to Spain. Many of these pieces are still in Spanish museums and palaces. The last letter from the King referring to this journey is dated June 23rd 1651 and says: "Velázquez has arrived in Madrid and some cases containing part of the work he has brought with him have reached the Spanish coast in ships from Naples". The return voyage was made from Genoa to Valencia.

Velázquez's family was increased this year by another granddaughter, who was christened Jerónima on May 20th 1650. Also worth mentioning is a letter dated December 17th of the same year, from the cardinal who was then the Vatican Secretary of State to the Papal Nuncio in Spain, regarding Velázquez's admission to a Spanish military order.

If we analyse all the contemporary references to this second visit to Italy and compare them with those made to Velázquez's first journey, we shall see a very evident change. It is not that there is any lack of reservations and captious comments on this second occasion, but undoubtedly the rather contemptuous tone of the expressions used in 1630 has given way to one that betrays a certain cautious fear. This, of course, was partly due to the development of Velázquez's personality, the reputation he must have acquired by then in Italy and his higher rank among the royal officials. The demonstrations of his talent that he gave in Italy, moreover, were splendid enough to banish any doubts as to his importance.

* * *

Let us now consider the group of portraits Velázquez painted in Rome. Their analysis is of particular interest because they form a very precisely dated ensemble and are linked by various outstanding qualities that they have in common, among which are their veracity and vigour. But these works also display subtle differences of style; it could hardly be otherwise since, as we have seen, the artist's way of working depended on his reaction to his sitters but also obeyed the momentary dictates of his temperament, which naturally led to differences in treatment, execution and technical procedure.

Juan de Pareja

The technique of the portrait of Juan de Pareja is well adapted to what seems to emanate from the sitter's face: a certain brusque, instinctive force *(Figs. 203 & 204 - Cat. 135)*. It is a realistic baroque work which makes very telling use of tonal contrasts and also pays great attention to the texture of materials. In it we may see a sudden return to the sober palette of the painter's early days, with a preponderance of black. The vigorous modelling constructs by means of fairly thick impastos, especially in the more luminous areas, and is certainly intended to produce a work of great veracity. Here the painter was not seeking conventional beauty, but simply attempting to depict what he had in front of him. There are certain sim-

Fig. 203. JUAN DE PAREJA. 1649-1650.
New York: Metropolitan Museum. Cat. No. 135.

Fig. 204. JUAN DE PAREJA. Detail of figure 203.
Fig. 205. POPE INNOCENT X. 1650. Rome: Galleria Doria-Pamphili. Cat. No. 136.

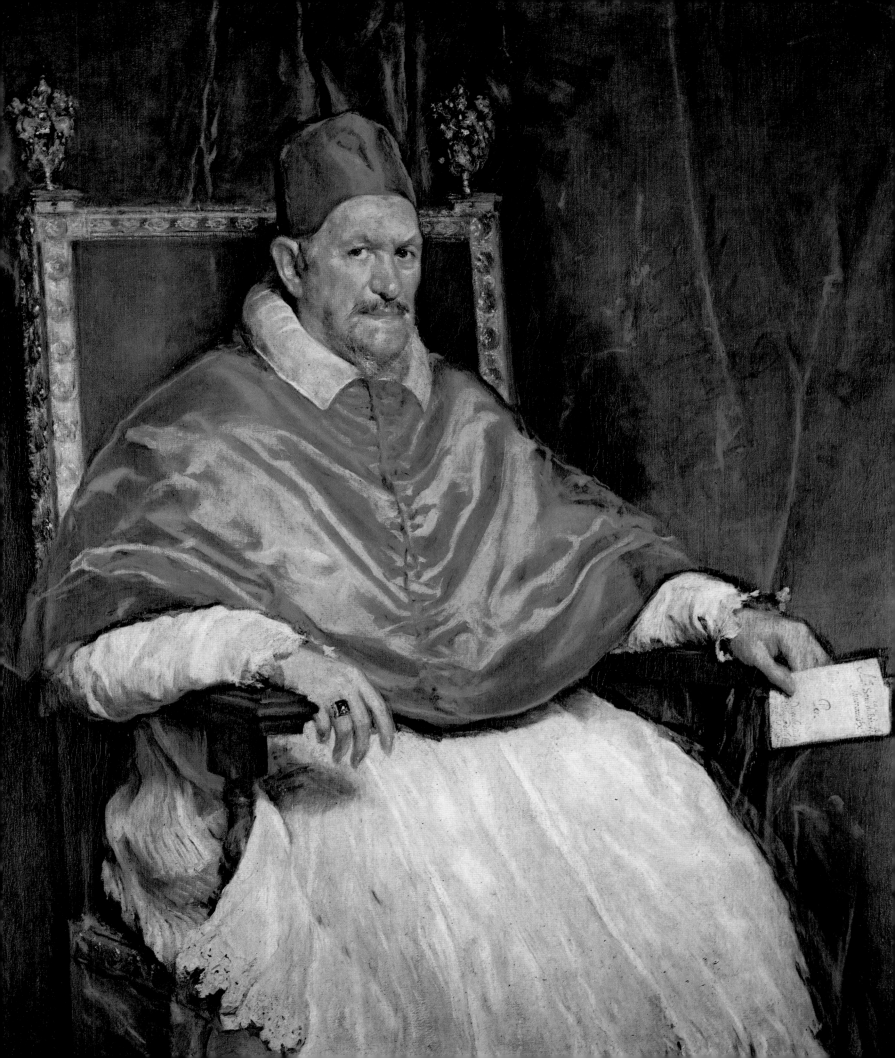

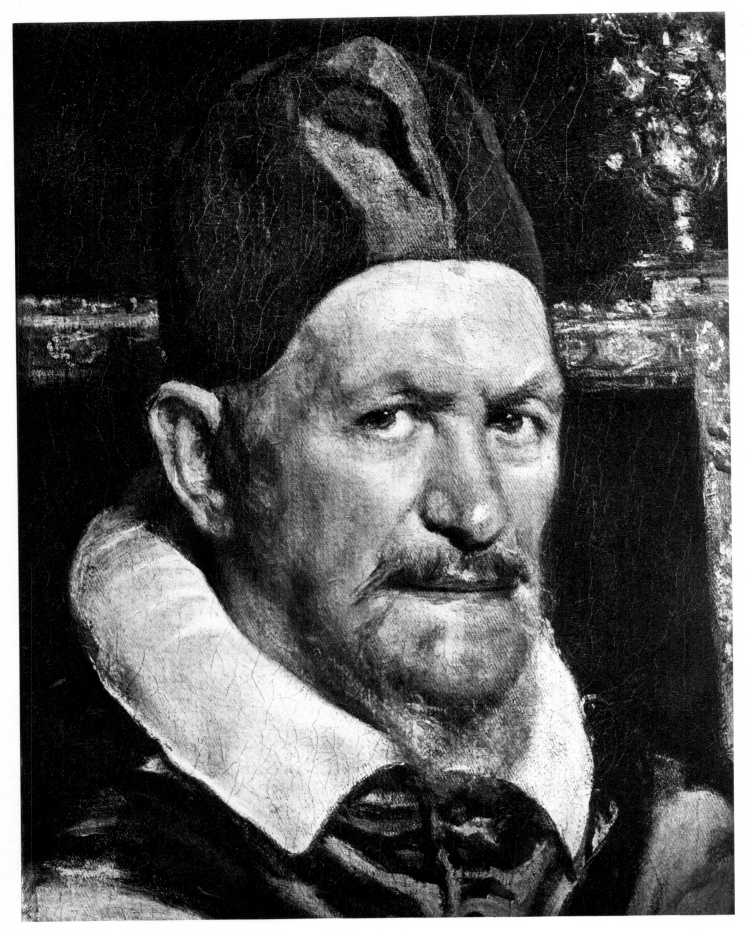

Fig. 206. POPE INNOCENT X. Detail of figure 205.
Fig. 207. POPE INNOCENT X. 1650. Washington, D.C.: National Gallery of Art. Cat. No. 137.

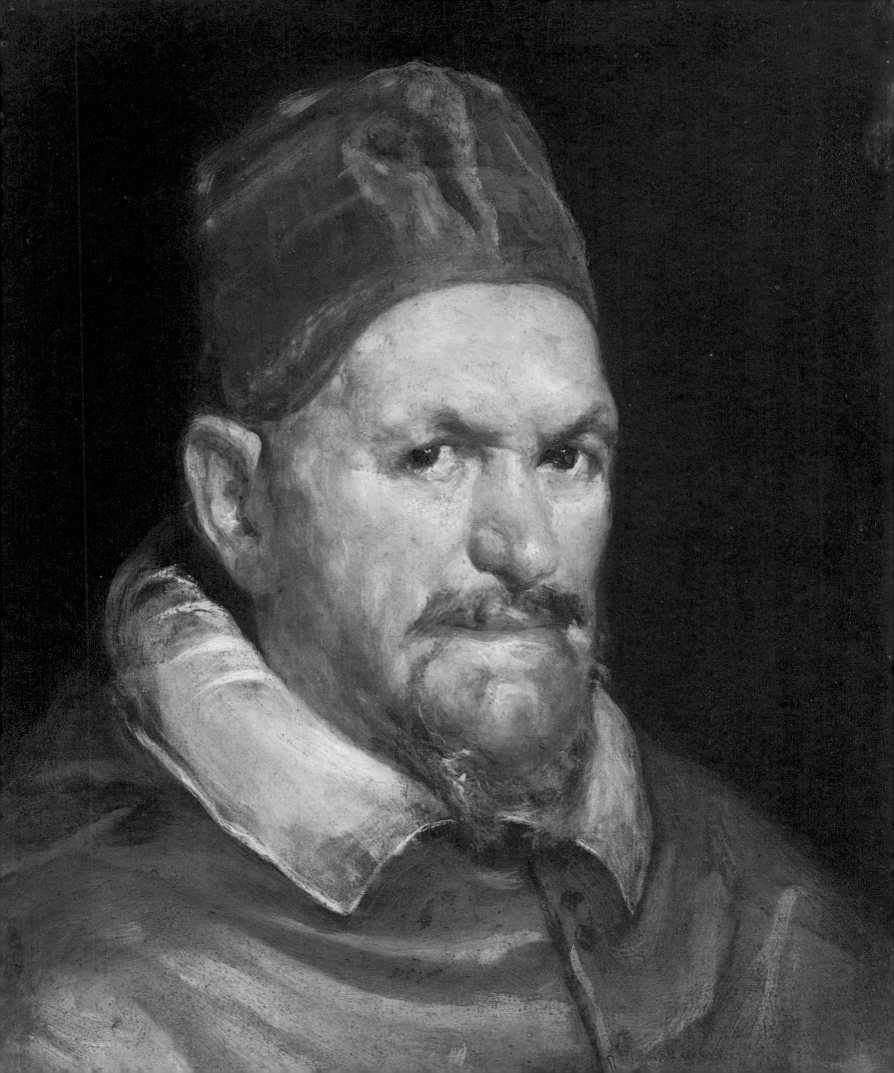

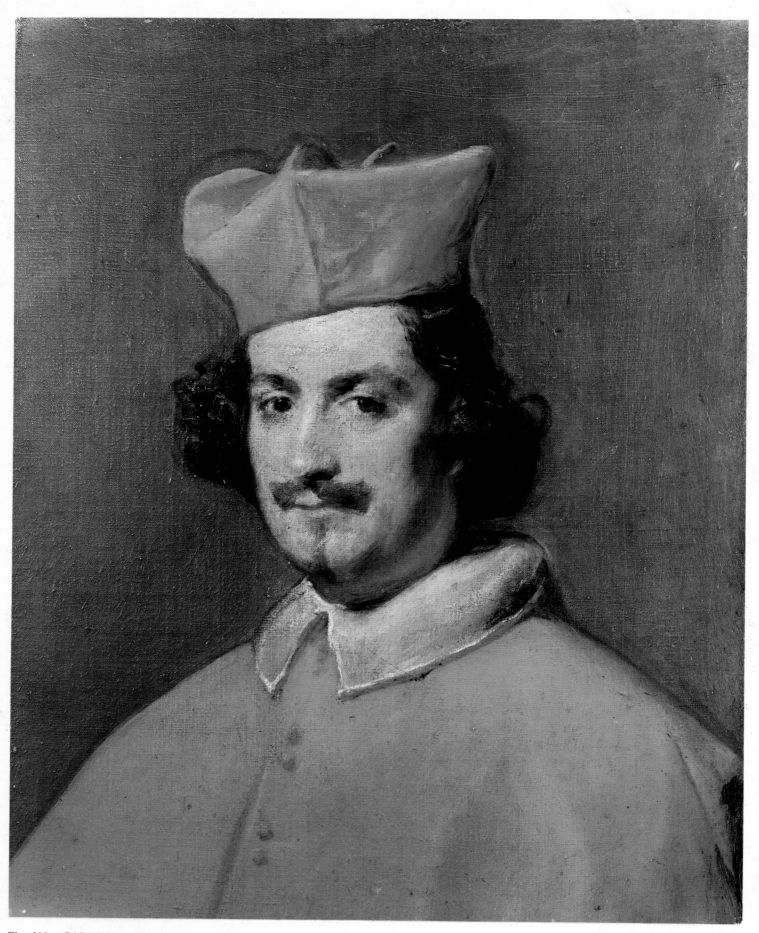

Fig. 208. CARDINAL CAMILLO ASTALLI. 1650. New York: Hispanic Society of America. Cat. No. 138.

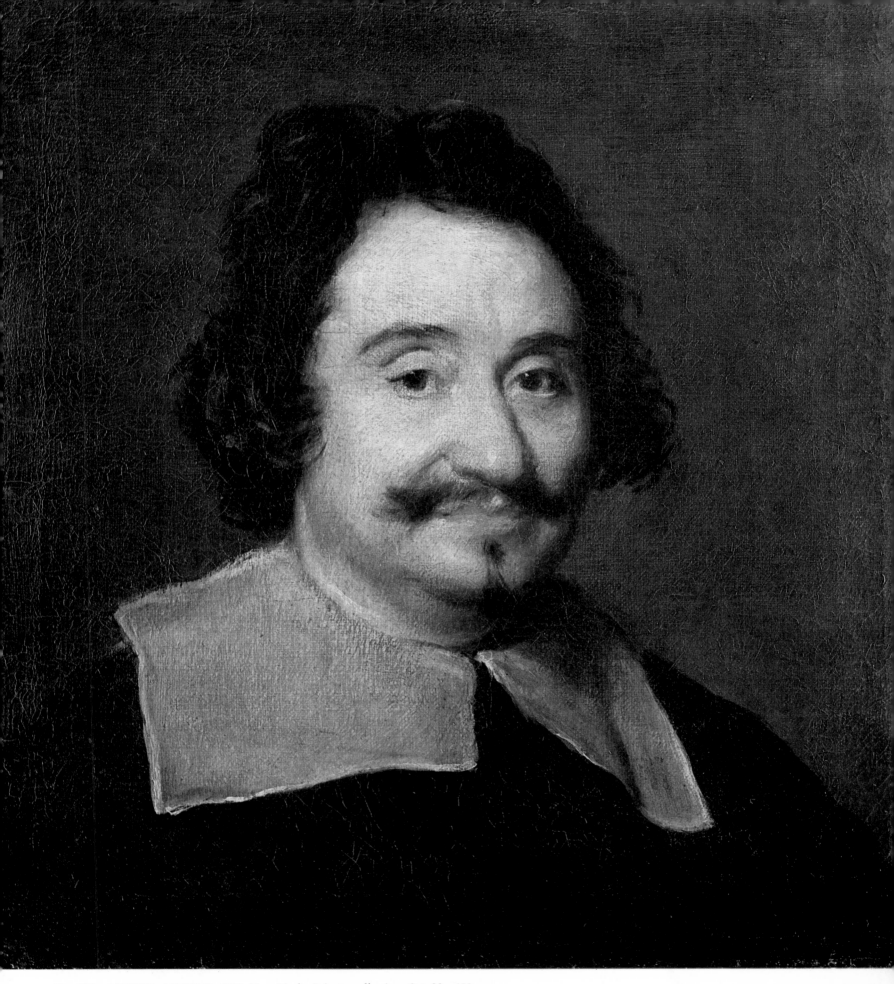

Fig. 209. MICHEL ANGELO. 1650. New York: Private collection. Cat. No. 139.

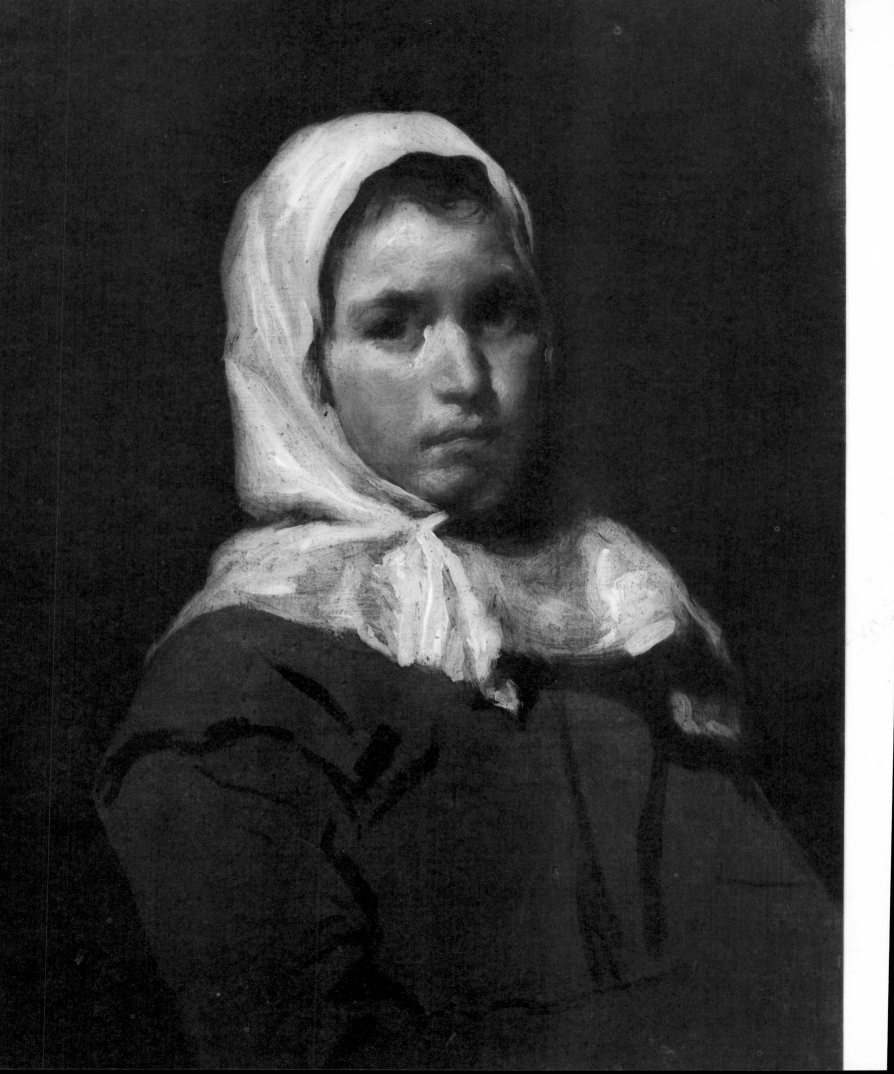

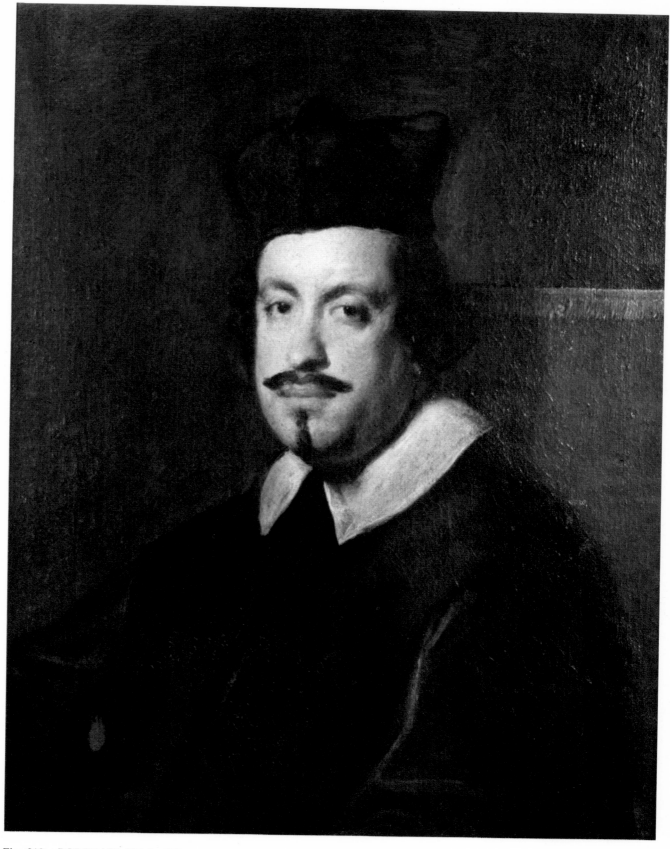

Fig. 210. PORTRAIT OF A GIRL. 1649-1650. New York: Private collection. Cat. No. 141.
Fig. 211. MONSIGNOR CAMILLO MASSIMI. 1650. Kingston Lacy, Wimborne, Dorset. Cat. No. 140.

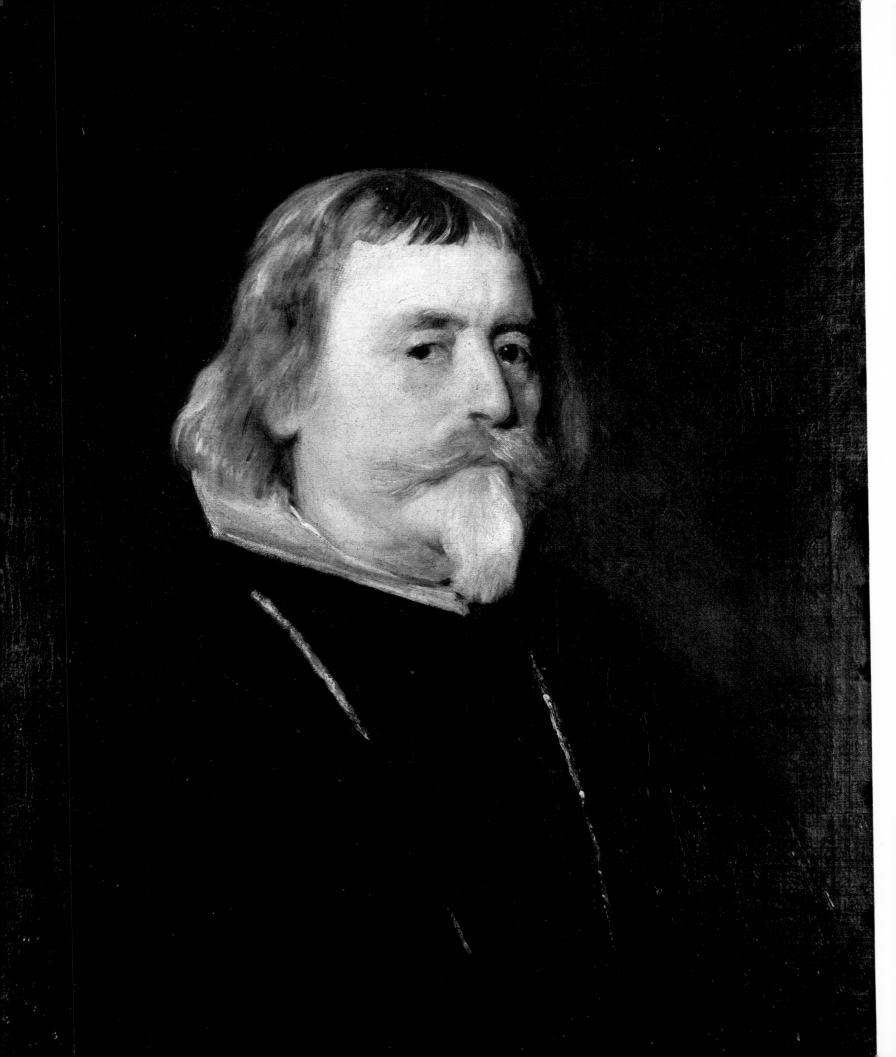

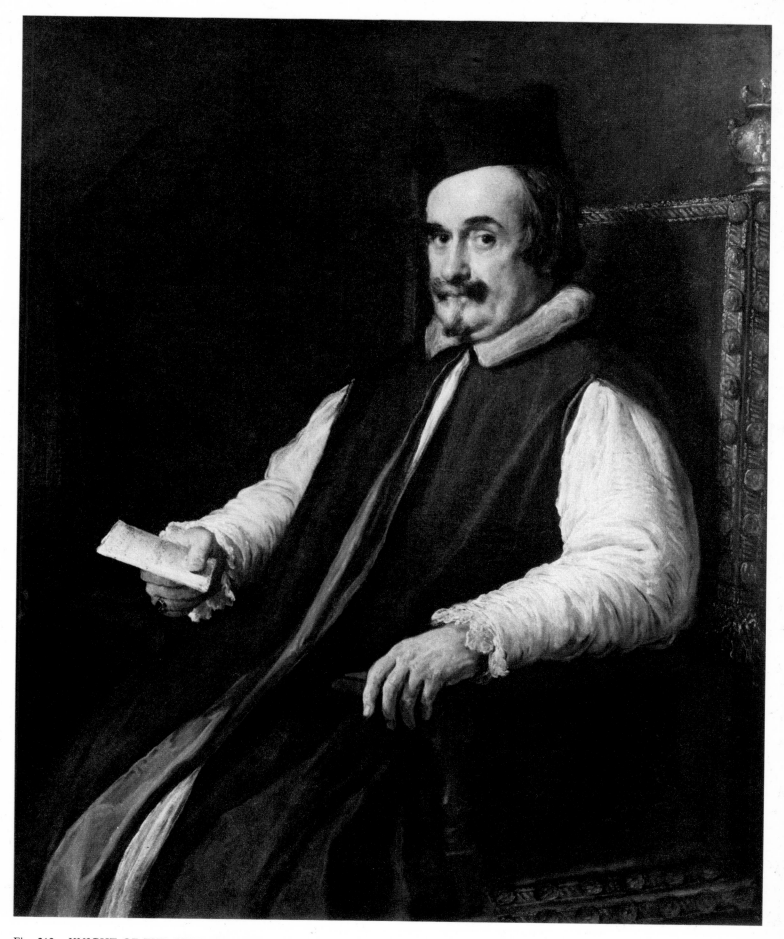

Fig. 212. KNIGHT OF THE ORDER OF ST. JAMES. C. 1650. Dresden: Staatliche Gemäldesammlung. Cat. No. 128.
Fig. 213. PORTRAIT OF CRISTOFORO SEGNI. C. 1650. Krentzligen (Switzerland): Heins Kister. Cat. No. 142.

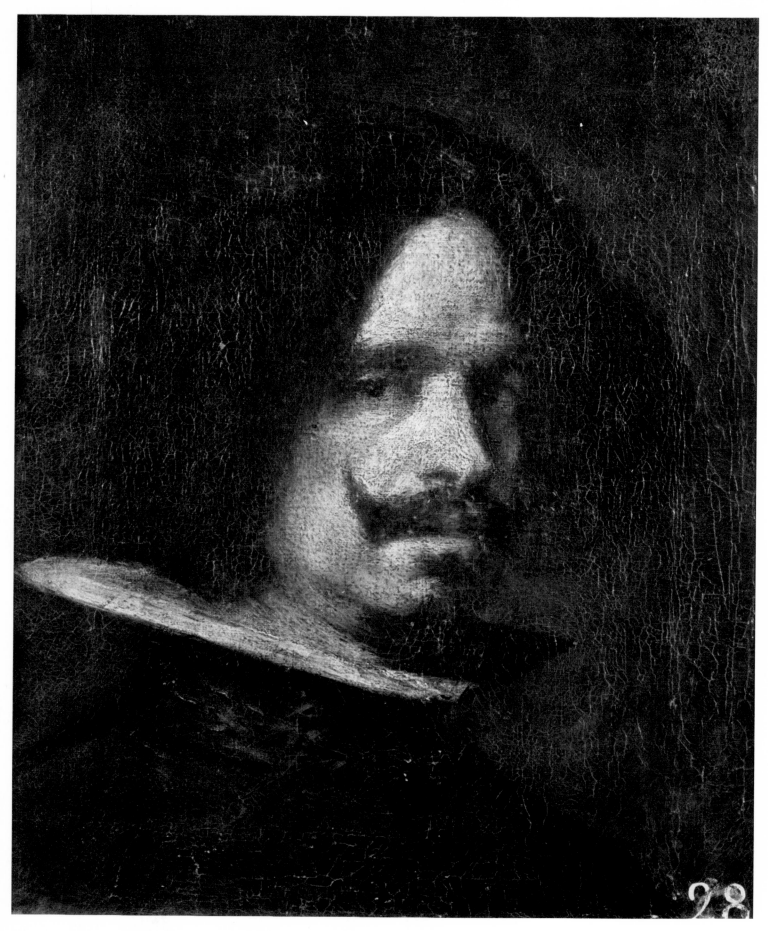

Fig. 214. SELF-PORTRAIT. C. 1645. Valencia: Provincial Museum. Cat. No. 143.

plifications in the treatment of the stuffs in the man's clothing and, as usual, the third dimension is very precisely suggested. This work fully justifies Veláz-quez's title of "Painter of truth".

It is amazing to see how the painter succeeded in giving such precision to a face with hardly any linear elements. Only by the handling of the colour and the way in which the paint is laid on with brilliantly skil-ful dragging of the brush (sometimes making use of slight roughnesses) are the sitter's features depicted. The same applies to the clothing, in which the out-standing feature, thanks to the brilliance of the ex-ecution, is the white collar, which gives a really impressive sensation of real material. The long white strokes so typical of Velázquez are perceptible here and help us to see how the soft "greyings" provide sufficient modelling to suggest both material and form.

This is a portrait that certainly deserves the uni-versal acclaim it was accorded when it was sold to the Metropolitan Museum recently, after being sold at auction for the highest price so far recorded for a 17th-century painting.

Pope Innocent X

It is hardly suprising that the Pope found this portrait "too truthful" *(Figs. 205 & 206 - Cat. 136)*, for it is an implacable analytical study both of the sitter's physical characteristics and of his psychology. His look is hard and unpleasant, the mouth slightly twisted in a contemptuous, self-satisfied sneer. The features, though not ugly, are not particularly har-monious either, with the prominent chin, the rugged area of the eyebrows and the rather fleshy nose. This face is dominated, however, by a sense of greatness, an expression of the power the sitter is obviously aware of possessing, though at the same time there is an indefinable suggestion of what might be called disquiet. In the smaller painting *(Fig. 207 - Cat. 137)*, which is supposed to be a preparatory study for the great portrait, these purely representational con-ditions are intensified; possibly some of the prodigious sensitivity of the modelling was lost in the transfer to a larger canvas. What is added, however, which is

almost the whole of the body, seated on a severely simple throne, more than makes up for this. Veláz-quez evidently took particular pains with the work as a whole and with every detail. The hands — very fine, regular and carefully tended — are beautifully drawn, as are the silky qualities of the sumptuous, purple-red cope and biretta and the frothy white of the surplice, the whole forming a very rich frame for the face of the sitter, who, though uneasy in front of such a faithful likeness, must also have felt some sat-isfaction with the image that was to immortalize him.

Baroque and realistic, dense and intense, this is one of the greatest portraits in the whole history of art. And it is impossible to give concrete, quantitative reasons for this opinion, which is shared by the vast majority of art historians and critics.

Other portraits painted in Italy

The portrait of Cardinal Astalli is a very differ-ent kind of work *(Fig. 208 - Cat. 138)*. In his portrait of the Pope Velázquez sought to stress the import-ance of his sitter with a dazzling display of pic-torial vigour, but here his work is freer and simpler. The modelling is less constrained and draughtsman-like, the differentiation of the features more sum-mary; it is, however, an excellent portrait, painted with great economy of means and almost certainly in a very short time. The execution is a synthesis, with no perceptible traces of the preparatory drawing – if there was any such drawing, even one done with the tip of the brush.

This young prince of the Church has a certain air of indifference, though he is clearly a man of decision, one who knows whom he serves and is aware of his own worth. But no part of his face denotes anything like the great personality or complex psychology of Innocent X. This may perhaps be one reason for the different treatment accorded to the two works.

The other two portraits of clerics are direct, realistic works; the men portrayed are of no particu-lar consequence, but the painter, true to his humanistic principles, has caught their characters with detached interest and sympathy. These members

of the Pope's household who ministered to his daily needs would naturally be kindly, peaceful men, always ready to please in their humble occupations and proud to be so close to the person of the Vicar of Christ. The first of these works is the bust-length portrait of *Monsignor Camillo Massimi* in the Bankes Collection *(Fig. 211 - Cat. 140),* which I have only been able to study in photographic reproduction. The "readiness to please" that I have just mentioned is absolutely personified, though in combination with a certain strange look of disillusionment, in the second portrait, which is supposed to be that of *Michel Angelo,* the Pope's barber *(Fig. 209 - Cat. 139).* This is also a bust-length portrait, against a dark background, closer in treatment to the portrait of Innocent X than to that of Cardinal Astalli. The features are strongly outlined by their own shadows, which produce a notable impression of relief. Apart from the more accentuated chiaroscuro, the technique is neither dramatic nor analytical, but simple, straightforward and unified. The variations of tone and the differences of touch in the working of the pigment also help to determine the areas of the face, from the darkness of the background – which acts as a foil to the qualities of the look – to the sheen of the skin on the forehead. This work, in short, is one in which everything is supplied by the painter. As frequently happens with Goya's portraits, in this one by Velázquez all that really matters is the portrayer, not the man portrayed.

Opinions like the foregoing may seem obvious to the point of naiveté, but they are not quite so obvious if we remember that the artist has two media at his disposal in producing beauty, which are the choice and imitation of beautiful models and interesting, attractive themes, and the result achieved through the execution. And so, while the convergence of these two media is quite common in the Italian school, in Spanish painting – and particularly in Velázquez's case, though still more in that of Goya – the artist is very often obliged to dispense with thematic beauty, so that his efforts are necessarily greater. The execution, rather than the modelling, is the source of beauty and aesthetic emotion.

A hitherto unpublished work by Velázquez, discovered not so long ago in the magic world of old, modest, forgotten collections, is the impressive *Portrait of a Girl,* in somewhat less than half-length, with the head wrapped in a white kerchief *(Fig. 210 - Cat. 141).* The attribution is made in an inscription painted directly in black on the back of the canvas, together with the initials D G H interlaced in the celebrated monogram with which Diego Gaspar de Haro marked the pictures in his collection. This prominent member of the Count-Duke's family died in 1689 while Viceroy of Naples, after having been Spanish Ambassador in Rome. This picture bears the number 1387, which has a corresponding entry in the last inventory of the Viceroy's estate, drawn up in Naples on December 18th 1687. It is an absolutely spontaneous painting, probably done in a single day. The dark greenish sienna of the priming plays a decisive role in the shadows of the face as a tone in depth. It also shows through the tenuous transparencies that create the chiaroscuro of the white kerchief and becomes the general tone of the girl's dress, the folds of which are simply sketched in with strokes of fluid black. The modelling of the features is based on a cursory initial colouring of vermilion and ochre, on top of which some incredibly precise brushstrokes of pure white create luminous nuances and reflections. The black has hardly anything to do but outline the figure by covering the whole of the background in flat wash. The texture of the modelling, which has undeniable affinities with the pictorial formula employed in the luminous areas of *The Spinners (Fig. 198),* reveals the very short space of time within which all three were painted. With these works begins a new concept of representation, that prodigious discovery of visual suggestion that was to attain perfection in Velázquez's last period.

I do not wish to end this chapter devoted to the works painted by Velázquez during his second visit to Italy without recalling once more the possibility suggested by Mayer that the portrait of the *Knight of the Order of St. James* in the Museum of Dresden, which we studied in the preceding chapter *(Fig. 212 - Cat. 128),* may also have been painted during this visit.

VII

VELAZQUEZ'S LAST YEARS

1651-1660

1652. "APOSENTADOR DE PALACIO". – 1658. THE NEGOTIATIONS FOR VELAZQUEZ'S ADMISSION TO THE ORDER OF ST. JAMES. – PORTRAITS. – THE FIRST PORTRAITS OF THE INFANTA MARGARITA. – *THE MAIDS OF HONOUR*. – LAST PORTRAITS OF THE INFANTA MARGARITA AND PRINCE PHILIP PROSPER. – LAST KNOWN WORKS. – AFTER VELAZQUEZ'S DEATH. – VELAZQUEZ'S DRAWINGS.

Velázquez was in Madrid, after his return from Italy, on June 23rd 1651. In the month of July the Infanta Margarita was born, that little princess destined to be the central figure of *The Maids of Honour* and of one of the most beautiful sequences in all child portraiture. It was probably at a somewhat later date that Velázquez painted the official portrait of Philip IV's second wife, Mariana of Austria *(Fig. 218)*, which was the first in a series of portraits of this Queen regarding which it is difficult to specify the exact degree of Mazo's assistance in his father-in-law's work. At about the same time Velázquez painted a new portrait of Philip IV, the preliminary study for which is now in the Prado *(Fig. 217)*.

On September 6th 1651 the painter was paid 260,000 maravedís, which represented his emoluments for 1650 and 1651, at the monthly salary of 69 ducats. This settlement of arrears continued, for in April and June of 1652 he received his salary as a royal painter for the period from June 1646 to December 1651 and was also paid 150 ducats for his work as supervisor of the King's private works during the same period.

1652. "Aposentador de Palacio"

In a letter dated October 2nd 1652 the Condesa de Monterrey, one of the late Count-Duke's sisters, writes of the arrangements made concerning her portrait by Velázquez and says: "... the Marqués de Leganés wants it for his house after my death, on account of the great fame it has won".

The Mazo-Velázquez family had yet another child before the year was out. This time it was a boy, who was christened Melchor Julián on November 6th, with Velázquez himself and his wife as godparents. This eighth child may well have been the cause of his mother's death; two years later, at all events, in the marriage articles of Inés, the couple's eldest daughter, Velázquez's son-in-law is described as a widower.

I have left for the end of the Velázquez chronicle for 1652, though it really took place at the beginning of the year, the painter's appointment to the post of "Aposentador de Palacio" or Chief Steward of the Palace. The *bureo,* a council of nobles responsible for the administration of the royal establishments, had presented a memorandum to the King suggesting various candidates for this important position, but Philip IV settled the question with a note in his own hand in the margin of this document: "I appoint Velázquez". And thus, with what the King intended as a favour, the most unfortunate period in the painter's life began. The obligations of his new post, which had little or nothing to do with art, weighed him down with unlooked-for and time-consuming

duties which left him little time for painting; his name, practically unknown to the official papers of earlier years, suddenly appeared on a considerable series of documents. Just when he had reached his zenith as an artist he found it materially impossible – or very nearly so – to practise his art.

Palomino, in one of the finest passages in his study of the painter, deplores the mistake the King made in "rewarding" Velázquez with a post so eagerly sought-after. He considers, rightly, that "rewards to men of talent should be approached in a different way from those granted for other merits... for if this [reward] is the result of a man's exercise of his talent, he can hardly develop this talent further if he has no occasion to practise it; and therefore rewards to artists, it seems, should be purely honorific and pecuniary... giving the artist more and more occasions on which to add to the honour won with the beauties of his work... for to suspend the use of his talent is a reward that is really a punishment in disguise". And that, in fact, was exactly what happened.

1655

In this year the King decreed that Velázquez should move his household to the "Treasury", a four-storey building with a garden near the Alcázar, where the artist would have plenty of room. There he was to spend the remaining years of his life, overburdened with all kinds of administrative business and red tape in general.

Is it possible that Velázquez, as a result of so many years at Court, the flattering attentions shown to him in Italy and the growing favour and friendship of his King, was becoming ever more ambitious? Whether he was or not, the truth is that he was in receipt of salaries from five different posts and, though always incredibly in arrears, the emoluments paid to him over the years came to a very considerable total.

1657

In 1657 Philip IV's first son by his second wife was born: Prince Philip Prosper, a sickly, epileptic child who lived just long enough to be immortalized by Velázquez in the marvellous portrait in the Vienna Kunsthistorisches Museum *(Fig. 231),* which was sent to the Emperor of Austria, along with the "blue" portrait of the Infanta Margarita, in 1659. The new heir to the throne of Spain died at the age of three. Palomino gives us a description of these two portraits, goes on to speak of a miniature of the Queen painted on silver – "round, with the diameter of a Segovian eight-real piece" – and finally says: "On very few occasions did Diego Velázquez take up his brushes after this; and thus we may say that these portraits were his last works, and the ultimate in perfection painted by his eminent hand."

1658. The negotiations for Velázquez's admission to the Order of St. James

The year 1658 is given in a text, printed in Rome, that purports to be a catalogue of the paintings sent by Philip IV to the Escorial, "described and placed in order by Diego de Silva Velázquez, knight of the Order of St. James..., the Apelles of this age. A work presented, dedicated and consecrated to posterity by Don Juan de Alfaro". Cruzada Villamil considered this text apocryphal and even today, indeed, it is hedged about by doubts and uncertainties. It is full of observations and opinions that might very well have been expressed by the great painter in personal conversations with the Cordovan painter Alfaro, a pupil of Castillo and a devoted friend of Velázquez himself, on whom he wrote a monograph, now lost, of which Palomino apparently made great use.

1658 and 1659 were the years of the long negotiations for Velázquez's admission to the Order of St. James. In the preceding chapter I have spoken of some steps taken to this end by the painter himself while in Rome, and he evidently did not lose sight of this idea on his return to Madrid. In a letter dated September 2nd 1651 the Papal Nuncio tells Cardinal Pamphili (or Astalli) that he will support the petition of "Don Diego de Silva Velázquez concerning his desire to obtain from His Majesty the King one of the three military habits". Philip IV did indeed grant the right to wear the "Habit of the Order of St. James to Don Diego de Silva Velázquez" on June 12th 1658 and ordered enquiries to be made "to know whether he possesses the required qualifications".

The drawing up of the ensuing report, which consisted of the painter's genealogy and the evidence of 148 witnesses, took a hundred and thirteen days. Then came other official notes, reports and declarations, after examining which the decision of the Council of the Orders was unequivocal: the proofs of untainted blood were accepted, but not those of nobility, so that a dispensation from His Holiness the Pope was essential. The King applied for this dispensation without delay.

Even when the papal dispensation had been received, however, the recalcitrant members of the Council of the Orders still had objections to make and the King found himself obliged to apply to Rome for another dispensation, which finally arrived in an Apostolic Brief from His Holiness Alexander VII, dated October 1st. Even then the Council insisted that the painter must first be granted the title of *Hidalgo*, which the King signed and ratified on November 28th. It is worth remarking that among the witnesses summoned to give evidence in the course of these prolonged negotiations were the painters Alonso Cano, Zurbarán, Carreño, Nardi and Sebastián Herrera Barnuevo. In Palomino's words Velázquez "in the Convent of Corpus Christi, and with the usual ceremonies duly performed, received the Habit from the hands of the Conde de Niebla".

1660

But tragedy now threatened the Empire. Since the position of the Spaniards in Flanders could no longer be maintained after the defeat at Niewpoort on June 4th 1658, Philip IV had no option but to sue for peace. Just a year earlier, in one of his letters to Sor María de Agreda, he had mentioned the idea of arranging a marriage between his daughter María Teresa and Louis XIV, "thinking that such a pledge would be a certain peacemaker". And this marriage, indeed, though in time it was to lead to the tragic War of the Spanish Succession on the death of Carlos II, at least put an end to the prolonged warfare with France and the Low Countries. The Treaty of the Pyrenees, by which Philip sacrificed part of the principality of Catalonia, was drawn up in Madrid on November 7th 1659 and signed on the Isle of Pheasants, in the middle of the River Bidasoa (which

forms part of the Franco-Spanish frontier), on June 6th 1660. The Infanta María Teresa was delivered up to Louis XIV the following day.

Velázquez's responsibilities in the arrangements for this historic event were really crushing. It all proved too much for his strength, indeed, for the journey of the vast royal entourage to San Sebastián and back to Madrid began on April 8th and did not finish until June 26th. In a letter dated July 3rd, to the Valladolid painter Diego Valentín Díaz, he writes: "I arrived in Madrid exhausted, from travelling all night and working all day". This was the beginning of that rendering of accounts that put a period to the life of the great painter. He died on August 4th, "delivering up his soul to Him who had created him to win such universal admiration" (Palomino). Six days later he was followed to the grave by Juana, that discreet and faithful woman who had been his wife and friend since his apprentice years in the workshop of the good Pacheco. Neither of them had made a will.

The great painter was buried in a tomb in the crypt of the parish church of St. John the Baptist, a tomb ceded for the purpose by Gaspar de Fuensalida. The epitaph on his tombstone was composed by the brothers Juan and Enrique de Alfaro.

* * *

Portraits

In these last years of his life Velázquez painted an admirable series of portraits of some of the highest in the land. The painter's maturity is reflected in the impressive unity to be found in this series, a unity of style and technique within a range of colours that was richer than ever. He had by now discovered how to eliminate once and for all the ceremonious stiffness of traditional court portraiture. Though fashions had become even more absurd and anti-natural, with still more enormous skirts and a greater proliferation of transparent lace, and coiffures were complicated affairs of plumes and ribbons, Velázquez succeeded in synthesizing this motley confusion of ornament and establishing a perfect balance between the cos-

tumes and the silky softness of the flesh-tints. The portraits that he painted in this period of agonizing overwork are really marvellous.

One of the first of these portraits was probably that of the Infanta María Teresa, the daughter of Philip IV and Elizabeth of Bourbon and future wife of Louis XIV. At any rate, the head and shoulders portrait in the Metropolitan Museum of New York *(Fig. 215 - Cat. 144)* appears to be an original, painted about 1651, in which the princess is depicted with a tulle flower in her hair. The most evanescent colour and technique are used in the clothing, suggesting the forms rather than representing them. The dark background is an excellent foil for the transparent tones of the fine stuffs and jewels and the delicate complexion of the young princess, then about fourteen years old. Shortly afterwards Velázquez was to paint another head-and-shoulders portrait of the Infanta, this time wearing an elaborate coiffure strewn with flowers that look like butterflies *(Fig. 216 - Cat. 145)*. In this portrait the face is rather more theatrically treated, with touches of light of a kind rarely used by Velázquez.

The portrait of Philip IV, originally in the royal collection *(Fig. 217 - Cat. 146)*, may well have been an original study by Velázquez for a new series of official portraits. It would seem natural that when the portrait of the new Queen of Spain was painted, to be sent to her family in Vienna, and to be hung in official institutions in the country, it should be accompanied by an updated portrait of her royal husband. A fair number of excellently painted canvases, reproducing with barely perceptible variations the rather bloated middle-aged face of the sketch in the Prado, confirm the existence of this new "edition" of the royal likeness, largely produced by Mazo, though possibly with some assistance from Carreño de Miranda. When studying this series of paintings, at all events, one frequently feels tempted to include some of them in the catalogue of authentic works by Velázquez. This is particularly so in the case of the picture in the Vienna Kunsthistorisches Museum, which, though now considerably cut down, may have originally been the full-length portrait sent to the

Archduke Leopold Wilhelm on February 22nd 1653. The date of what was to be Velázquez's penultimate likeness of Philip IV is also confirmed by a portrait signed by Pedro de Villafranca in 1655.

The official portrait of Queen Mariana could not be painted until the beginning of 1652, for when Velázquez returned from Italy the Queen was expecting her first child, the Infanta Margarita. In the Prado hangs what may be the original version of this elegant portrait *(Fig. 218 - Cat. 147)*. At any rate it is the best in the long sequence of replicas and copies that constitute another of the problems of analysis – still awaiting a satisfactory solution – posed by the works produced in Velázquez's workshop. As long ago as 1700 this portrait, which is a symphony in white, vermilion and black, welded together by the subtlest and widest range of greys, hung in the Escorial as the pair to a portrait of Philip IV, in armour and with a lion at his feet, probably painted by Mazo and now also in the Prado. But originally the two canvases were not the same size: the portrait of Mariana suffered later additions in the upper part of the hangings, as can be quite clearly seen in the reproduction in the present work. Special mention should also be made of two excellent replicas of the new queen's first official portrait, one in the Louvre *(Cat. 148)* and the other in the Kunsthistorisches Museum in Vienna *(Cat. 149)*. The latter would appear to be the one sent to the Archduke Leopold Wilhelm in February of 1653.

This sequence of pictures of the Spanish royal family continues with an extremely beautiful portrait of the Infanta María Teresa, the future Queen of France, now hanging in the Kunsthistorisches Museum in Vienna *(Fig. 220 - Cat. 150)*. This masterpiece, unfortunately, is now incomplete, for the lower part was cut away at some stage in its history. The Infanta's dress is in a greyish tone of cream, with trimmings in the same shade of red as the flowers arranged in her hair at the level of the mouth. As in the portrait of the Queen, María Teresa is holding a white handkerchief in her left hand, which rests on her enormous skirt; the figure stands out against a greenish background, which becomes gradually darker towards the upper

part. The face, though so young, is already hieratic in expression; here we have a human being confined in the prison of court protocol, a young girl already doomed to spend her life playing a role, without ever being asked whether she wants to or not. And yet it strikes us as the portrait of a fairly happy and kindly person. Even the air of tension produced by the almost armour-like farthingale cannot banish a latent tenderness from her lips or dim the youthful sparkle in her eyes. The technique of this work comes close to the astounding *tour de force* of *The Maids of Honour:* it has the same capacity for adaptation, dissolving the form in the details only to reconstruct it in the ensemble. The brushwork is adapted to what it depicts, ranging from the evanescent softness of an almost insubstantial modelling to the nervous strength of untidy, vivid movements, or performing miracles of draughtsmanship in certain details of the clothing, such as the red braiding round the neck. It is in the hands that we can best perceive this technique of Velázquez's last years, which consists of an expressive abstraction of forms that are later reconstructed by the eye of the viewer. It would appear that this was the portrait sent by Philip IV to Ferdinand III of Austria in 1653.

In the Boston Museum of Fine Arts there is a replica of this portrait *(Cat. 151)*, a work of impeccable technique and just as vigorously painted as the one I have just described. The two portraits are very similar and it is really difficult to detect whether any artist other than Velázquez had a hand in painting the one in Boston. The execution is somewhat similar, but still masterly – and the greater simplicity may be merely due to the fact that this work is a repetition. This was very probably the canvas sent to the Archduke Leopold Wilhelm, Governor General of Flanders, along with the portraits of Philip IV and Mariana of Austria. Another excellent replica of the same portrait hangs in the Louvre, but it has also been considerably cut down.

The first portraits of the Infanta Margarita

The most important group of portraits of women or girls in Velázquez's last period – in which such portraits easily outnumber those of men, unlike what we have seen to be the case in the painter's early years at Court – is the series devoted to the Infanta Margarita, a figure who surely deserves greater prominence in the legends and literary anecdotes of art, if only as the enchanting little girl at the centre of one of the world's greatest paintings: *The Maids of Honour.*

She was Philip IV's first child by his second wife, Mariana of Austria, and was born, as we have seen, in 1651. The earliest of the extant portraits of the princess must be the one in Vienna *(Fig. 221 - Cat. 152)*. Judging by the apparent age of the charming little figure, this was probably painted in 1653 and shows the Infanta standing in an attitude stereotyped over three generations – her left hand holding a furled fan and her right hand resting on a table covered with a blue cloth, on which stands the celebrated bunch of flowers in a glass vase that is one of Velázquez's most beautiful pieces of painting *(Fig. 222)*. An oriental carpet, predominantly red, and a curtain that is like a darker extension of the blue cloth on the table harmonize beautifully with the pink and grey of the Infanta's dress. The face, which, as we shall see, was in time to become more beautiful and expressive, is rather static in this portrait. The technique shows the incredible degree of facility that the painter had by now attained, a few strokes of the brush being enough to define qualities, colour and lights and the form and volume being given their exact significance in the space.

In the Duke of Alba's collection there is a very fine replica of this portrait *(Cat. 153)*, though without the vase of flowers; it already figures as belonging to this collection in an inventory drawn up in 1796. There are some differences of shading in the interpretation of the face and this creates different values, which have to be examined analytically to be properly perceived. Of rather later date is another portrait of this princess which is now in the Louvre *(Cat. 154)*. The figure is shown very much in the foreground and only slightly more than half-length, though both hands are visible, in the conventional positions of other court portraits. It is a copy of a lost original and was painted by Mazo, though with some assistance from Velázquez himself.

The next portrait of the Infanta Margarita, also in the Kunsthistorisches Museum *(Fig. 228 - Cat. 156)*, was painted at about the same time as *The Maids of Honour*, as we can tell, apart from the facial resemblance, by the fact that the little princess is portrayed in a dress very similar to the one she wears in the larger picture, though the lights give it reflections of an intenser gold and the setting gives rise to different tonal effects. Most of the pictorial space is filled by the childish figure, graceful and solemn at the same time, which stands out against the floor and dark background on the left and a red curtain on the right. In its genre this painting possesses the qualities of *The Maids of Honour*, though without the considerable problems resolved in that work. The softness of part of the modelling is offset by the skilful effects of tone and colour, which restore the integrity and clarity of the image. As in all the other portraits of this group, the Infanta's hands rest on the sides of her vast skirt and are a brilliant synthesis of form and colour.

The Maids of Honour ("Las Meninas")

This great picture *(Figs. 223 to 227 - Cat. 155)* makes its first appearance in the royal inventories of 1666, under the title "The family picture", which was retained in several subsequent inventories. In 1686 it hung in what was called the "Apollo Room, His Majesty's summer office". Though saved from the fire in the Alcázar in 1734, it suffered some damage on that occasion and had to be repaired by Juan García de Miranda. Ponz mentions it as hanging in the new Royal Palace. Finally, Fernando VII presented it to the Prado and it figures in the great gallery's first catalogue, published in 1819. It first received its present title in the 1843 catalogue, compiled by Pedro de Madrazo.

The work represents a group of people in a fairly large room, which grows gradually darker towards the ceiling. The principal figure is the Infanta Margarita, standing in the centre and being offered a little red vase on a tray by María Agustina Sarmiento. The girl on the right, slightly inclined towards the Infanta, is Isabel de Velasco. Both of these young ladies were *meninas* or maids of honour to the King's daughter. *Menina* (the word means "little girl" in Portuguese) was the name given to daughters of the nobility in attendance on the royal family. To the right of these three figures, and behind the dog lying in the foreground, we see Mari-Bárbola, a deformed (indeed almost monstrous) German, and the little Italian manikin, Nicolasito de Portusato, both dwarfs in the Queen's service. Behind them, to the right and at no great distance but seen in half-light, stand the Infanta's duenna, Marcela de Ulloa, wearing the nunlike headdress of widowhood, and a man talking to her who is supposed to be Diego Ruiz de Azcona, the *guardadamas* or gentleman in attendance on the royal ladies. These are the characters more or less compactly grouped together in some sort of continuity. But there are also others, whose positions in the canvas are more complex.

In the background, standing on the steps of a staircase and seen against the light, there is José Nieto Velázquez, former director of the royal tapestry factory and one of the palace stewards. Philip IV and Queen Mariana are seen reflected in a vertical rectangular looking-glass that hangs on the wall in the background. Slightly to the left in the middle distance we see Velázquez himself, at work on a huge canvas. On his breast he wears the red cross of a knight of St. James – which would have been a later addition to the picture, since he was not granted the habit of this order until 1659.

The surprising composition of *The Maids of Honour* has been interpreted in several different ways. Palomino's was probably the first of these explanations. After identifying all the figures, he writes: "The canvas on which [Velázquez] is painting is a large one and nothing can be seen of what has been painted, since we are looking at it from behind. Velázquez gave a proof of his great skill by describing what he was painting with an ingenious scheme, taking advantage of the crystalline light of a looking-glass, which he painted at the farthest end of the gallery, in front of the picture, and in which the reflection or repercussion shows us our Catholic Monarchs Philip and María Ana".

Palomino's explanation certainly lends itself to confusion and it is hardly surprising that it has been

misinterpreted by some art historians and critics, thus giving rise to the popular misconception that what we see in *The Maids of Honour* is what was seen by Philip IV and Mariana of Austria as they posed for Velázquez.

If we are to go by the rules of geometrical perspective, this cannot be the true explanation, as has been made clear in a recent study by Bartolomé Mestre Fiel, who is also responsible for the explanatory sketch I have included here. If what is represented in *The Maids of Honour* were the scene before the King and Queen as they posed for Velázquez – and the reflection in the looking-glass were that of the royal couple themselves – then the vanishing point of the composition would be in the centre of this glass. But since this point of the line of the horizon is, in fact, within the doorway in the background, the painter (or the viewer) must necessarily have been standing outside the room, at a little distance from the door leading into it. What we see in the looking-glass, therefore, is not the real image of the King and Queen, but that of the central part of the great portrait of them that Velázquez was painting. At a later stage the artist placed his own likeness in a suitable attitude in front of the big canvas. This, I think, is the correct interpretation of Palomino's text; and it gives logical significance to the title of "The Family" by which this great work was at one time known in the inventories of the royal collections.

Palomino tells us that this work was painted in 1656 and the little princess – born, as we know, in 1651 – does indeed look about five years old. The room in which the scene takes place appears to be what was called the "workshop of the royal painters", not the studio in which Velázquez usually worked.

On the background wall, above the looking-glass and the door, hang two large pictures, which have been identified by Sánchez Cantón as *Pallas and Arachne* by Rubens and *Apollo and Marsyas* by Jordaens.

In 1666 this work was valued by Mazo at 1,500 silver ducats. In 1686 Arredondo put its value at 10,000. About a century later it was appraised by Goya, who gave the figure of 60,000 reales, just half the value he attributed to *The Surrender of Breda*. Undoubtedly each age sees works of art with different eyes, according to the prevailing taste, and it also seems evident that any or all of these appraisers may well have been influenced by their awareness of the general popularity of this or that work – or, even more so, by that same awareness on the part of the powerful personages they were working for. Though *The Surrender of Breda* is one of Velázquez's most beautiful, balanced and even profound paintings, today it would certainly not be considered worth twice as much as *The Maids of Honour*, a work which is now looked upon as an almost mythical achievement, not only on account of its pictorial qualities but because of the spirit emanating from its theme.

Nor do I mean to say that the subject-matter is of no importance. Velázquez uses the King's little daughter as an archetype of refined, delicate beauty, just as he uses the attitudes of the Infanta's two attendants to represent his own innate feeling for courtesy, while the dwarfs on the right serve to display once more his profound humanity, for there is

certainly not the slightest hint of irony in the way in which they are depicted. His own relationship with the young noblewomen and with the Infanta herself is one of degree rather than of essence, for the superb self-portrait shows that, though aware of his own worth, he is neither haughty nor yet aloof or abstracted. As for the figures in the background (the man on the staircase and the figures reflected in the looking-glass), though not altogether devoid of the same human significance, the lesser clarity with which they are depicted (I do not mean clarity of essence but clarity of line and analysis) does rather tend to make us see them as pretexts for displaying the great artist's extraordinary pictorial skill. Though it may sound rather arbitrary, I must say I am convinced that this complex and grandiose canvas was painted in a very short space of time. Not even in his preparatory sketches for portraits or the miraculously swift transformation of the equestrian pictures in the "Salón de Reinos" had Velázquez ever used such a rapid technique or such economy of material. In this work he went further than ever before in his suppression of previous analysis, as we can see by the way in which he creates several effects at once by varying the quality of the brushwork.

The first thing that astonishes us about *The Maids of Honour*, apart from the wonderful harmonies of tone and colour, is the composition, the ordering of the whole. In the baroque of Velázquez, as I have said before, there was still a noticeable tinge of classicism, as is evidenced by his fondness for order and contempt for oblique axes. The lower part of this canvas is enlivened by the figures, while the upper part plunges gradually into semi-darkness. The pictures on the background wall, the looking-glass and the open door form an ordered series of rectangular shapes which are the best possible support for the subtle arabesques created by the attitudes of the figures. The luminous rectangle of the open door, so perfectly harmonized in tone, does not stand out too sharply or "advance" towards the viewer, but remains firmly set in the background wall, thus playing its proper part in the geometrical arrangement I have just mentioned. The differences of tone are perfectly natural in every area of the work. And this is because here the painter's sense of realism comes

to the fore again, lightened by a very peculiar kind of spirituality, which is difficult to explain because it is based purely and simply on the supreme tact with which the theme is treated, both in the overall effect and in each separate detail. We are now far indeed from violent chiaroscuros or any of the "lessons" that may have contributed to the development of the painter's personality. This work represents the highest point reached by an art that has gone its own way – a way which was mainly one of progressive elimination and an advance of visual over intellectual realism: elimination of density, of linear effects, of academic precision of draughtsmanship. Velázquez had not ceased to learn throughout his long middle period and had discovered that, whether he wanted to "see" a form with absolute precision or to represent it just as accurately, a very few brushstrokes were enough. The secret consists of knowing what sort of strokes to use and having the intuitive ability to put them in the proper place right from the start, without repetition, insistence or rectification. Simplicity, of course, is not necessarily the only sign of genius, as is proved by the complex technique used by Rembrandt. But it is the specific quality of Velázquez, and *The Maids of Honour* is the work which best exemplifies this talent.

It should be noticed that the only feature of the work that is comparatively strongly painted, with fairly dense modelling, is the dog lying in the right foreground. But immediately behind him the conjuring and legerdemain, the just-sufficient allusions, begin; and also the disintegration of the form, to a certain extent, into colour and tone. Let us observe, for instance, the Infanta's left hand, resting on her farthingale. Velázquez deliberately unified the shading, so that it is only the gleam of the lights indicating relief and an almost formless drawing that differentiate the hand from the fabric; apart from the lights, however, the ring and the black cuff are the factors that enable our eyes to reconstruct the form of the hand exactly.

The elimination of elements, or of almost the whole of their mass, reaches its limit in the two figures standing in half-light. If we isolate the figure of Ruiz de Azcona, it becomes a collection of shadows with a vaguely human shape. It is evident, therefore,

that the surrounding elements also play their part in our reconstruction of the image and help to produce the plastic miracle that this signifies. The figures in the looking-glass are also painted with incredible economy of material and almost unheard-of simplicity; but the images are there in the glass, as evident and as well characterized as any of the portraits in this book. A diffuse movement of the brush on the lower right-hand side of the glass is used by the painter to represent the reflection of the light in the glass and the shape of the King's body at the same time. Just one clear, curving line is enough to suggest the Queen's coiffure. Notice, too, the sureness of the long, broad, loose strokes suggesting a draped curtain in the upper right-hand corner, the red of these strokes being used to enliven the whole of this area in contrast with the black of the frame and the alternating brightness and dullness of the glass itself.

That intuitive knowledge of the indispensable minimum that had to be painted to enable the viewer to reconstruct the work for himself (a discovery of Baroque art later pursued by the Impressionists, though by other means and with nothing like the same success, towards the end of the 19th century) was systematically used by Velázquez. That is why he has sometimes been quite erroneously called – as if it were a great compliment – the "forerunner of Impressionism", when he was really the one artist above all others who knew most of all the secrets of the art of painting.

And this knowledge goes hand in hand with an absolute assurance in the matter of gradations, whether those intended to suggest differences of distance or those that establish the differences between the materials represented. To distinguish a satin from a velvet or a flesh-tint, Velázquez never had to labour the execution; he immediately achieved the desired effect by the way in which he applied the paint. And so we may conclude that the greater an artist's assurance is in the use of his means, the greater will be his possibilities of economy in that use. Velázquez's art was always ruled by this principle and more particularly so in his last years, though it was already quite noticeable in the long middle period.

The cliché phrase according to which Velázquez knew how to "paint the air" is based on the extra-ordinary exactitude of his tonal gradations and on his understanding of aerial perspective.

Velázquez's innate tendency to simplicity shows itself in his modelling, which is neither wholly blended nor abrupt. He likes to neutralize his shading by emphasizing only some of the elements, in order to avoid too great a predominance of the chromatic intensity, and he always demands a proper balance of all the factors. Sometimes, instead of the usual combination of complementaries he uses the harmony of a colour with a neutral tone close to the corresponding complementary. Thus in *The Maids of Honour*, for instance, the predominant harmony in the figure of the main group is one of yellowish and grey shades, supported by ochres against the dark greys of the background and the upper part of the picture. The effect of this harmony is completed by light, expressive touches of black and red and by the pink-tinged pallor of the flesh-tints. Shadows are skilfully and unhesitatingly created, sometimes with the use of black.

Velázquez does not wholly reject the psychological factor, but he never permits it to predominate either. He is not essentially a painter of characters, though the characters of his sitters are unerringly caught in most of his portraits. It cannot be denied that humanity in general always interested him more than the peculiarities of any one sitter, but he was certainly capable of differentiating to an incomparable degree the slightest nuances of physiognomy or expression.

This is possibly due to the fact that his ruling passion in life — and one that is perfectly realized in *The Maids of Honour,* among other works — was that of "painting paint". And once furnished with all the external data and in possession of his personal skills, while complying with the demands of his theme he luxuriated, as it were, in the very act of painting: the fluidity of the pigment, the sumptuousness of his material, the originality of the colour and the precision of an effect. This is the idea of painting that prevails in his art, the one that reaches its highest point in *The Maids of Honour,* whether defining the figure seen against the light in the background with a few unerring strokes of black, giving the true feel of the wood in the panelled door beside this figure, dappling the

Infanta's creamy skirt with little strokes of white or suggesting, without even attempting to draw it, her beautiful fair hair.

But all the perfections of detail in this canvas, though so important in their way, are of little significance in comparison with the degree of absolute unity achieved in the work as a whole. One of the most important qualities of *The Maids of Honour*, indeed, if not the most importhant of all, is this sense of all-embracing unity that binds all the elements together in one and the same representation.

This fact is all the more surprising when we realize that within its unitary character, which is based on the restraint and limitation of the impulse to model "objectively", the technique reveals considerable differences according to the element or detail defined, as we can see, for instance, in the restless zigzag strokes in the Infanta's sleeves, the brusque movements in a lighter tone in the sleeves of the *menina* on the right or the daring simplification of the painter's own right hand holding the brush. The elements painted with an abrupt technique always rest on a form that is given just the right fullness and with this balance of effects the artist achieves the desired result.

Even in audacity Velázquez is restrained, for though the examples I have just given could be taken as indicative of what he might have done if he had "let himself go" in this direction, as I have repeatedly said, he had no temperamental leaning to excess, even to an excess of artistic virtuosity. And this, in him, was the greatest paradox of all.

Last portraits of the Infanta Margarita and Prince Philip Prosper

In 1659 Philip IV sent the Emperor Leopold I of Austria one of the finest presents recorded in history: the "blue" portrait of the Infanta Margarita and the portrait of Prince Philip Prosper, both of which now hang in the Kunsthistorisches Museum in Vienna *(Figs. 229 & 231 - Cat. 157 & 158)*. These two paintings are so full of wonderful qualities that it is almost impossible to do justice to them in the imprecise language of criticism. I will merely say that all Velázquez's gifts are displayed in them to the fullest. From the point of view of colour, the first canvas is quite extraordinary, with the harmony of the blue dress (in which the close combination of tactile quality and shading is incomparable), the princess's fair hair and the wonderful tone of the setting. The painter concentrated all the light on the figure, leaving the background in the deepest of shadows. The modelling of the face is almost insubstantial. This canvas, which had been cut to fit into an oval frame, has been very well reconstructed with the aid of a copy in the Museum of Budapest, probably the work of Mazo.

Palomino gives a detailed description of the portrait of Prince Philip Prosper, which would seem to imply that in the Alcázar of Madrid there was a replica of the canvas we are now studying. Here Velázquez left a greater area of space round the figure than in other portraits and used the progressive darkening of this space to create a background against which the little figure stands out marvellously, as do the colour harmonies, in which the predominant tones are the carmine of the armchair on the left and the carpet, the vermilion and white of the prince's clothing and the luminous splash of white made by the little dog on the chair, a superb and incomparably truthful piece of painting *(Fig. 233)*. As in the portraits of the Infanta Margarita, the face and hands are depicted with incredible simplicity and a minimum of modelling.

In this art it is the interaction of effects between one form and another, between certain colours or textures and others, that makes the overall effect always seem that of a living work. The chiaroscuro in this work is closely allied to the colour, especially with the carmine, and it models the space in depth in an extremely natural way. As I said before, the armchair, the curtain and the chair behind the little prince are caught almost at random, as it were, and are arbitrarily cut off by the composition to let the figure of Prince Philip Prosper appear almost at the centre of the pictorial space.

Last known works

The fairly small group of portraits painted during Velázquez's last period is completed by the

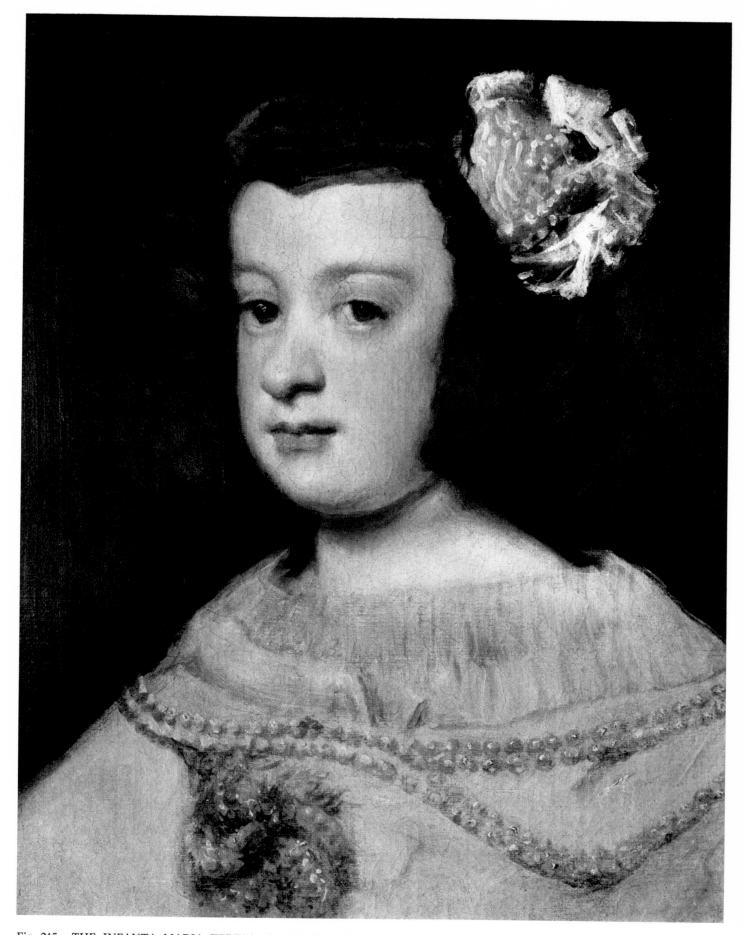

Fig. 215. THE INFANTA MARIA TERESA. C. 1651. New York: Metropolitan Museum. Cat. No. 144.

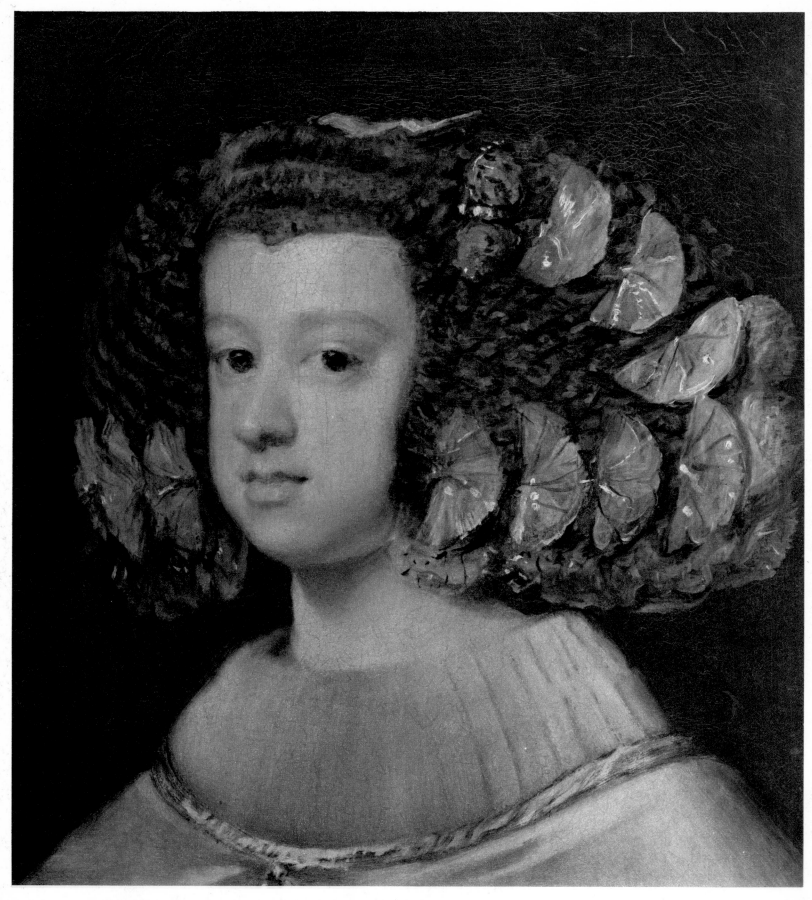

Fig. 216. THE INFANTA MARIA TERESA. C. 1651. New York: Metropolitan Museum. Cat. No. 145.
Fig. 217. PHILIP IV. C. 1651-1652. Madrid: Prado Museum. Cat. No. 146.

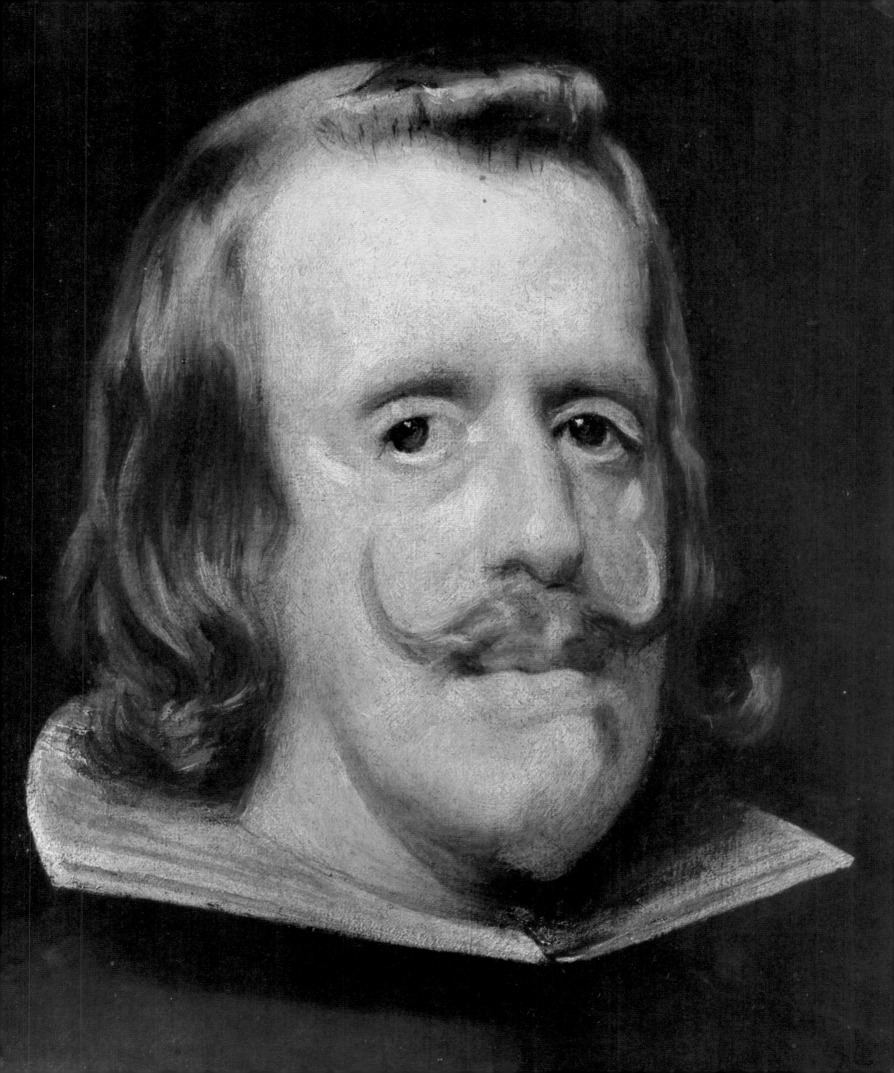

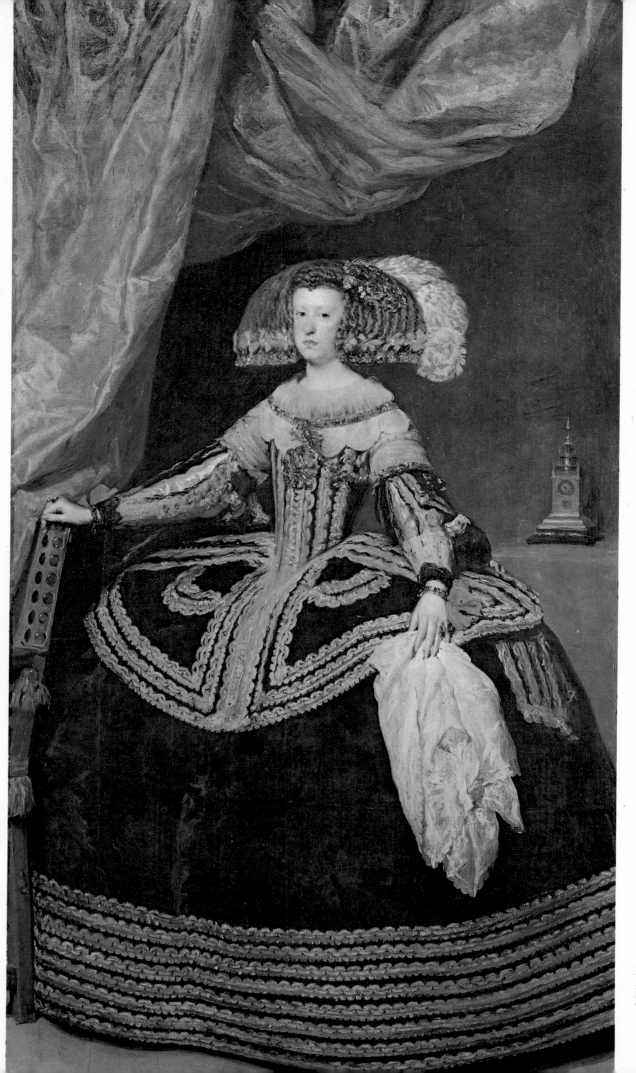

Figs. 218 & 219.
MARIANA OF AUSTRIA. 1652.
Madrid: Prado Museum.
Cat. No. 147.

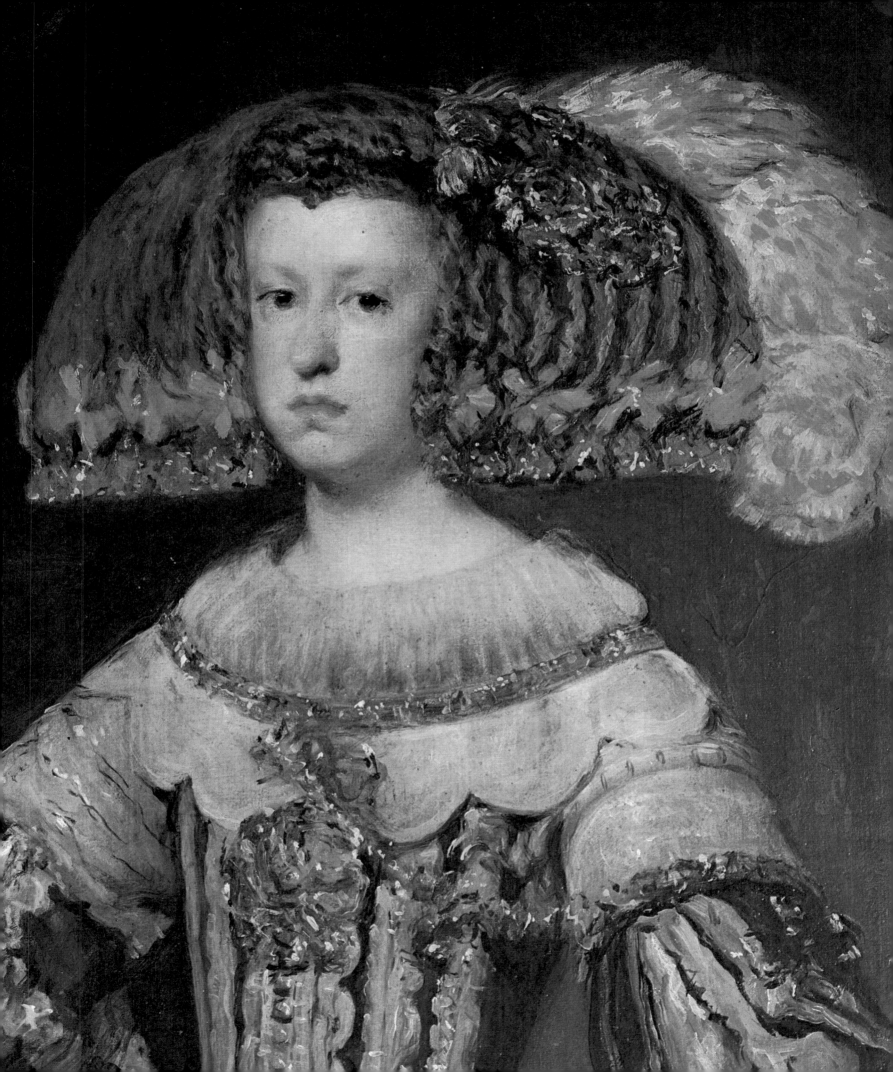

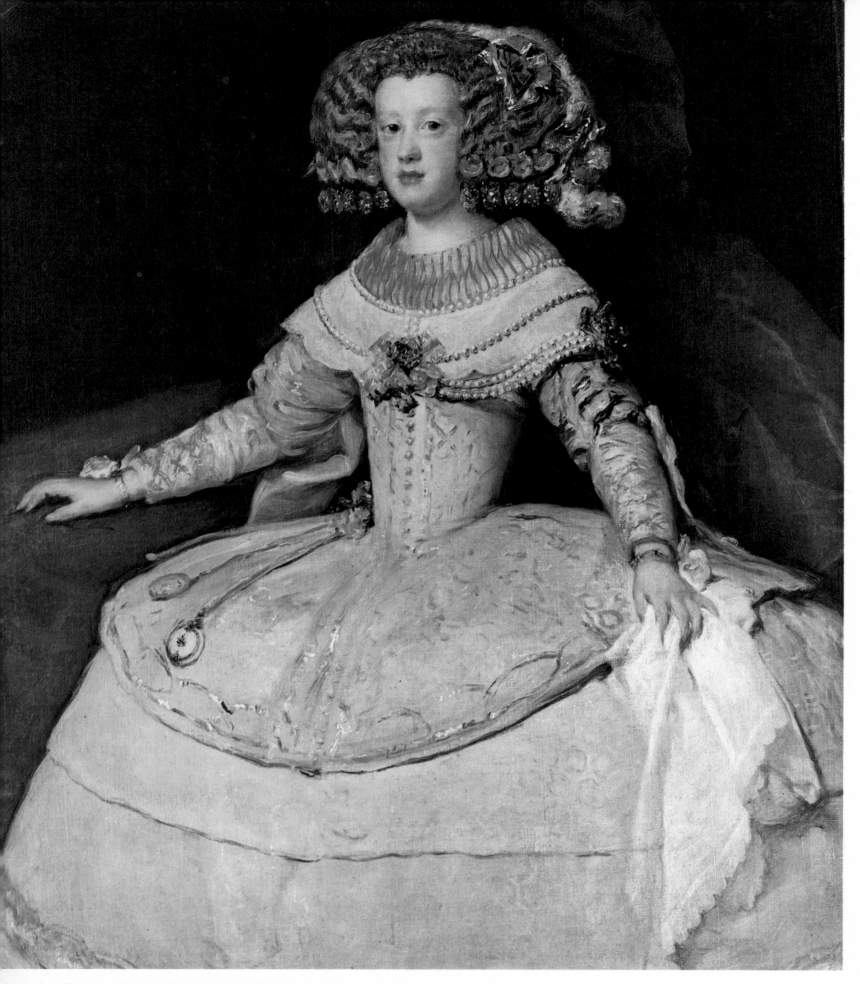

Fig. 220. THE INFANTA MARIA TERESA. C. 1652. Vienna: Kunsthistorisches Museum. Cat. No. 150.
Fig. 221. THE INFANTA MARGARITA. 1653. Vienna: Kunsthistorisches Museum. Cat. No. 152.

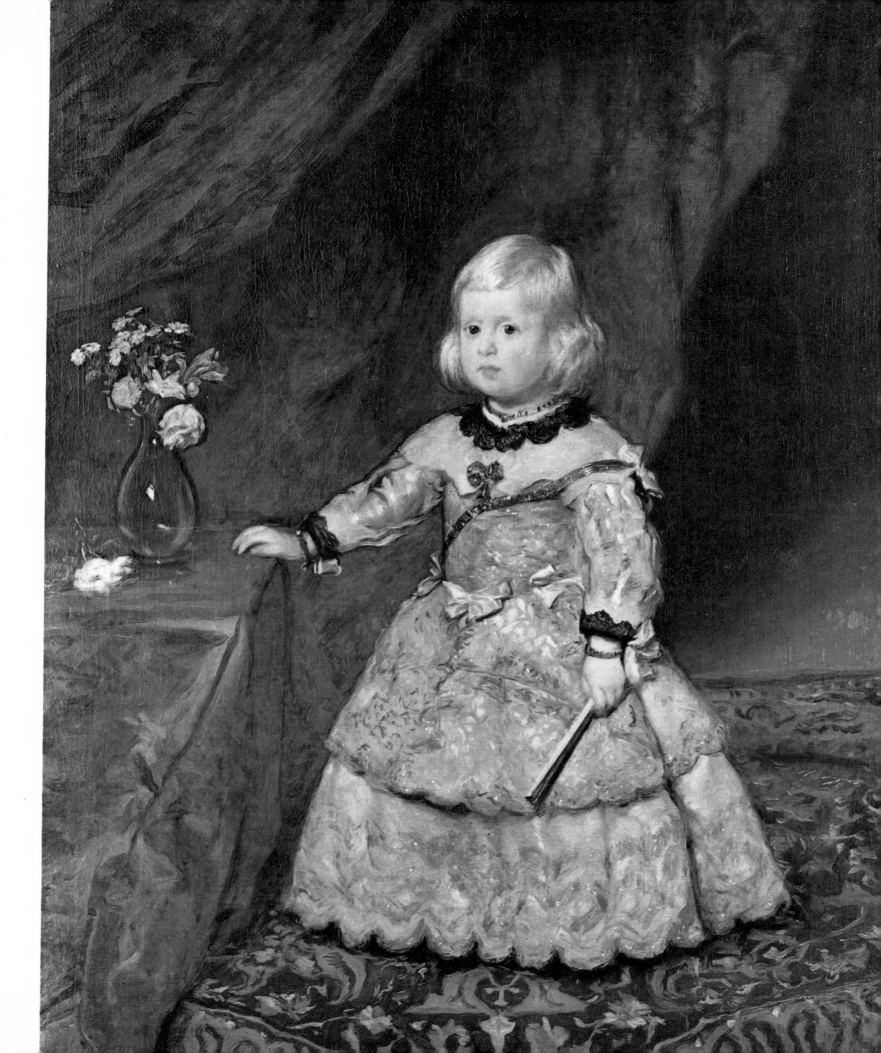

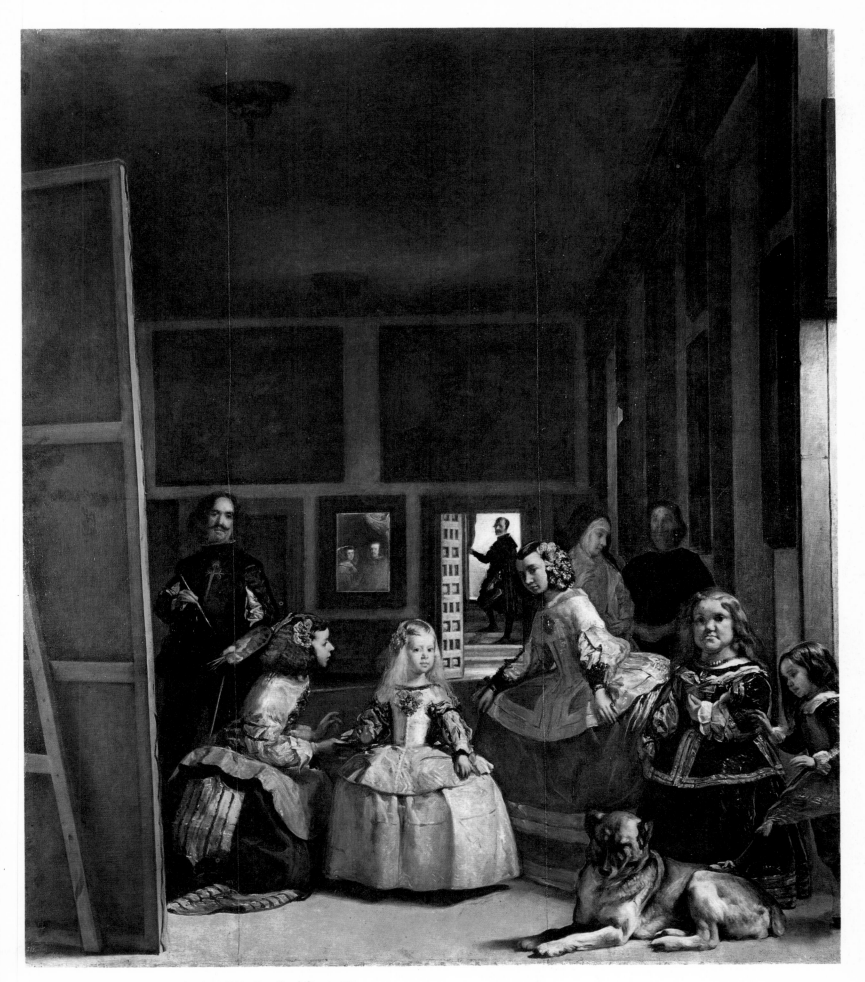

Fig. 222. THE INFANTA MARGARITA. Detail of figure 221.
Fig. 223. THE MAIDS OF HONOUR (LAS MENINAS). 1656. Madrid: Prado Museum. Cat. No. 155.

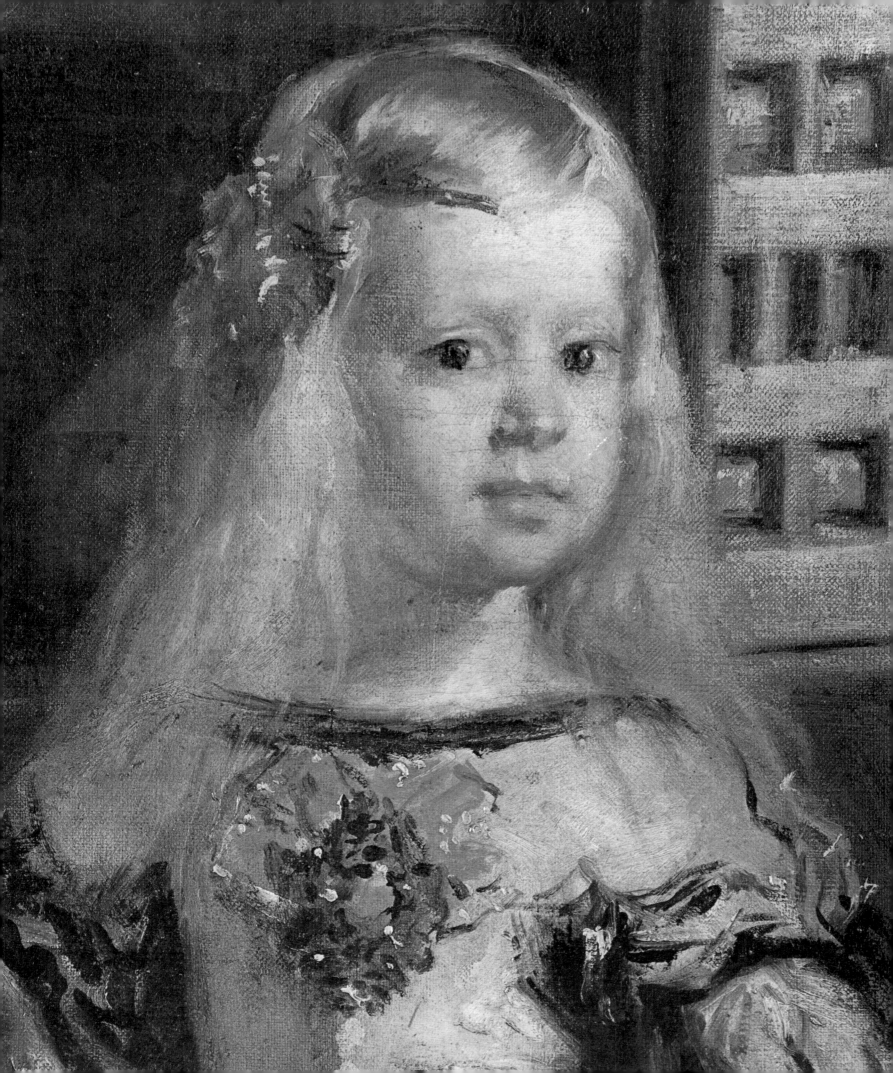

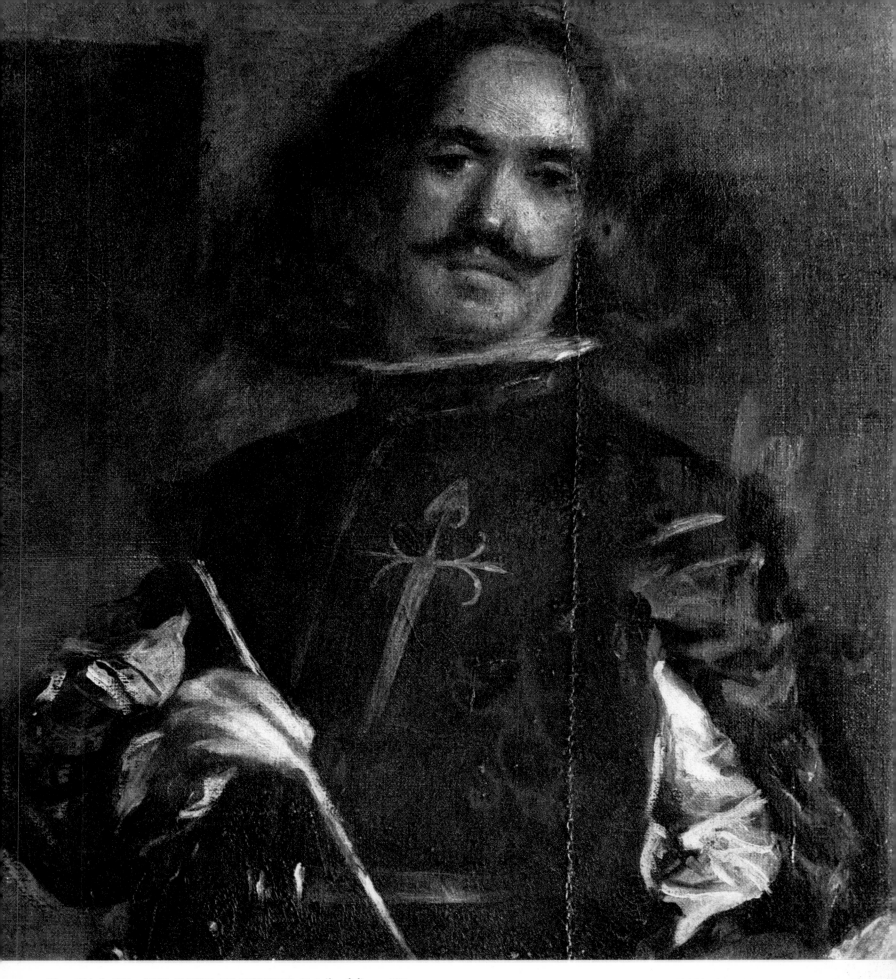

Figs. 224 & 225. THE MAIDS OF HONOUR. Details of figure 223.

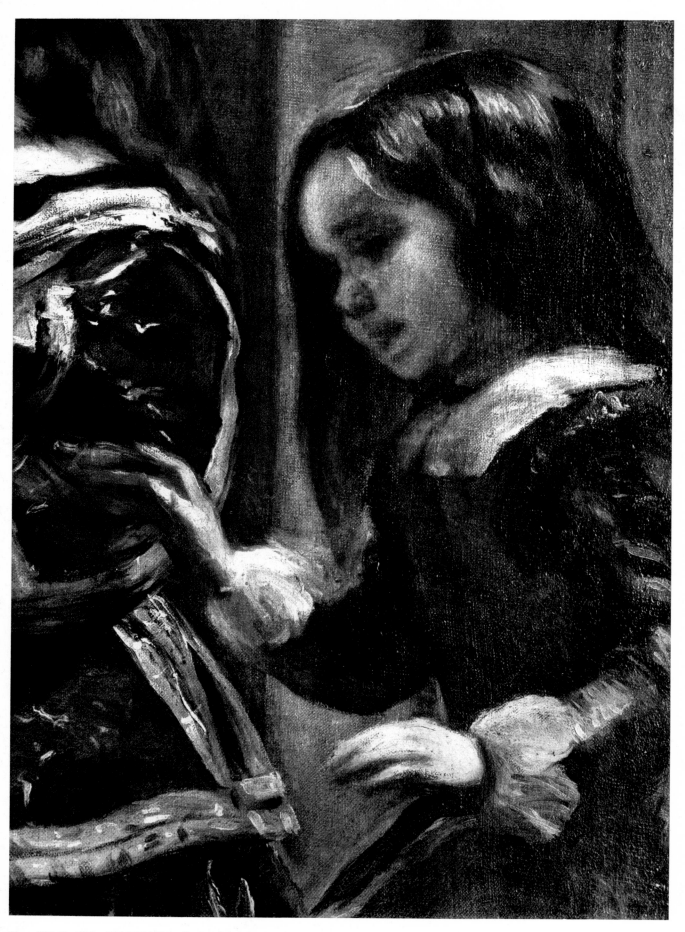

Figs. 226 & 227. THE MAIDS OF HONOUR. Details of figure 223.

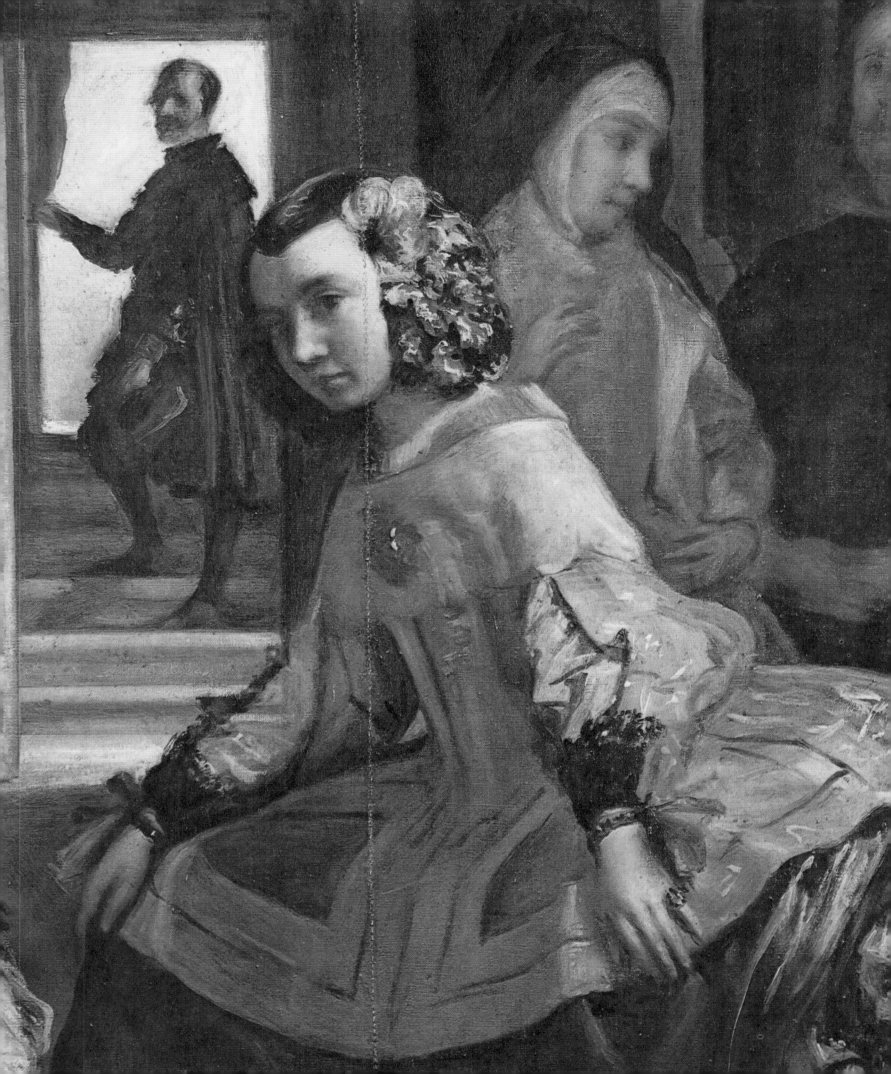

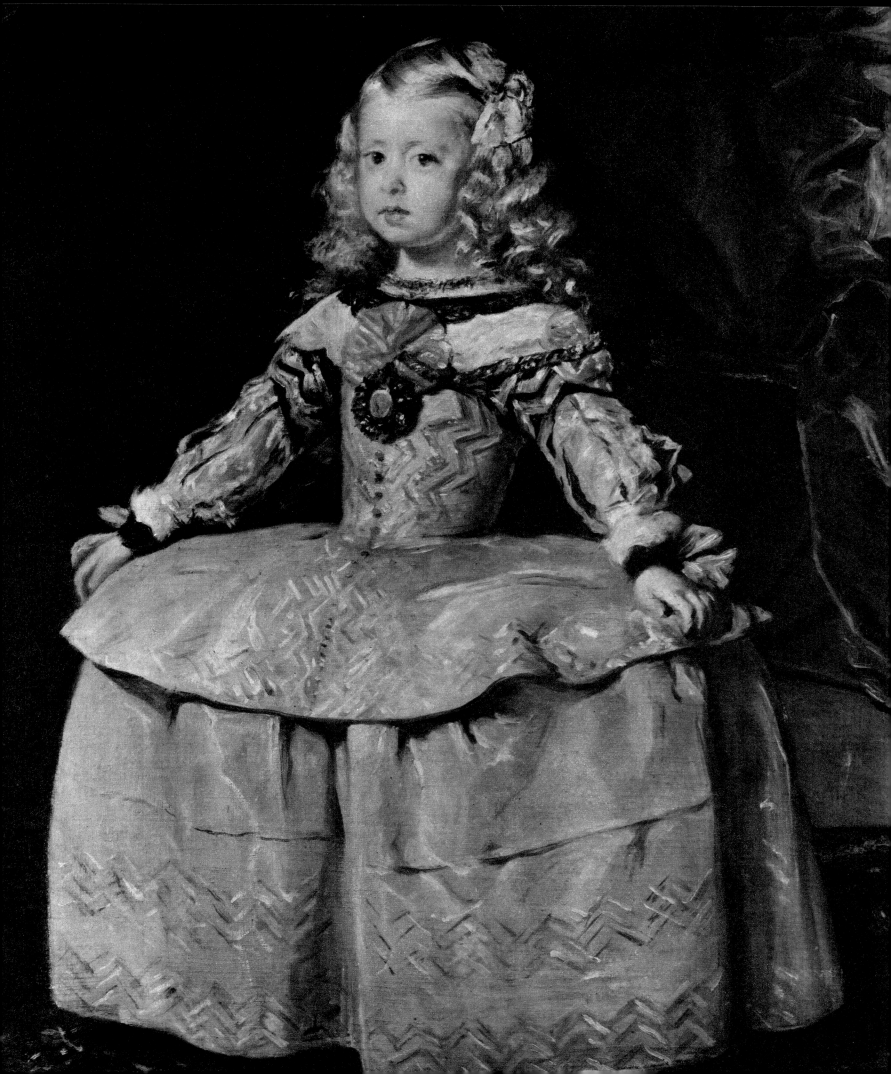

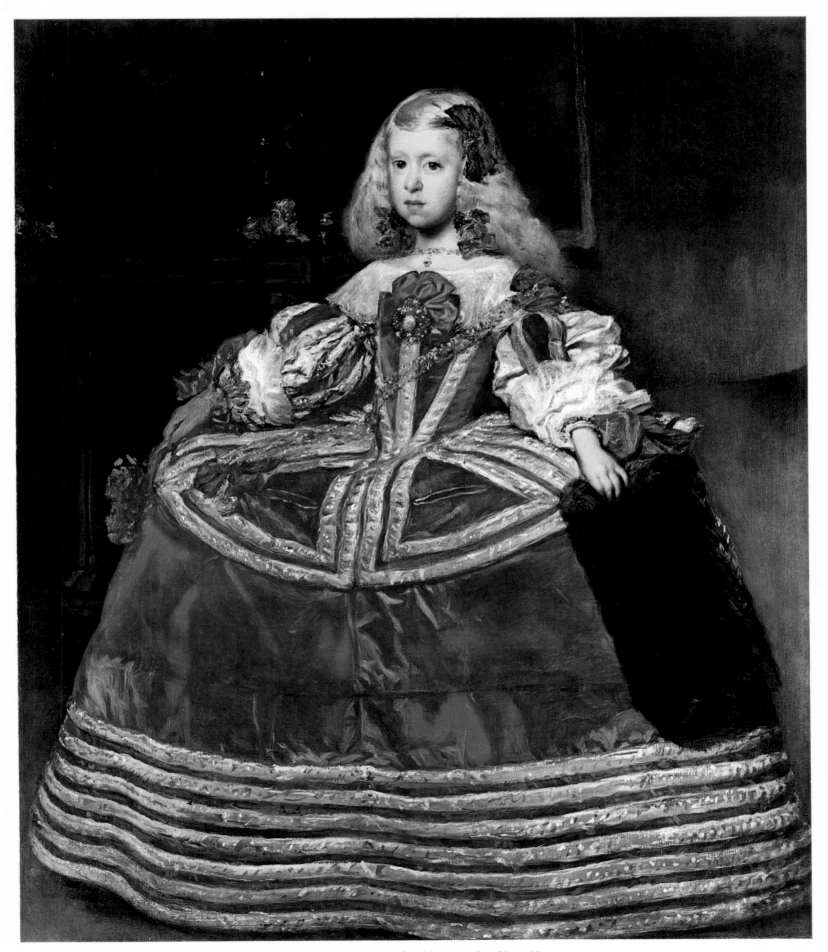

Fig. 228. THE INFANTA MARGARITA. 1656. Vienna: Kunsthistorisches Museum. Cat. No. 156.
Fig. 229. THE INFANTA MARGARITA. 1659. Vienna: Kunsthistorisches Museum. Cat. No. 157.

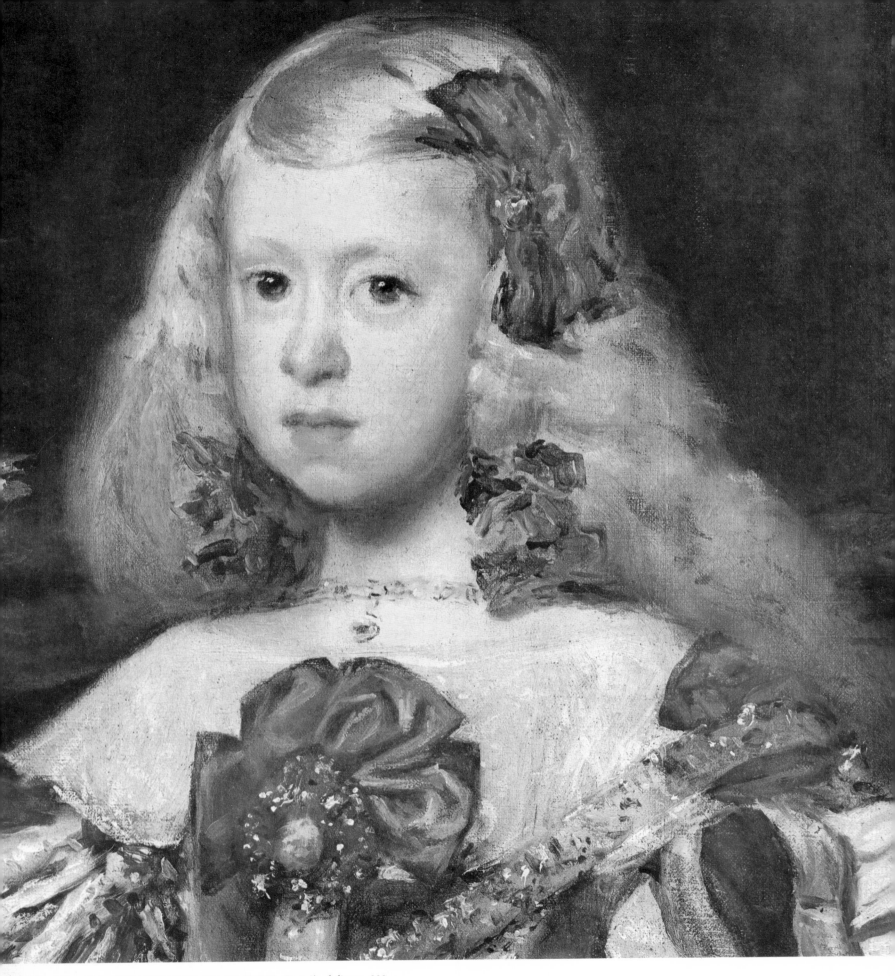

Fig. 230. THE INFANTA MARGARITA. Detail of figure 229.
Fig. 231. THE INFANTE PHILIP PROSPER. 1659. Vienna: Kunsthistorisches Museum. Cat. No. 158.

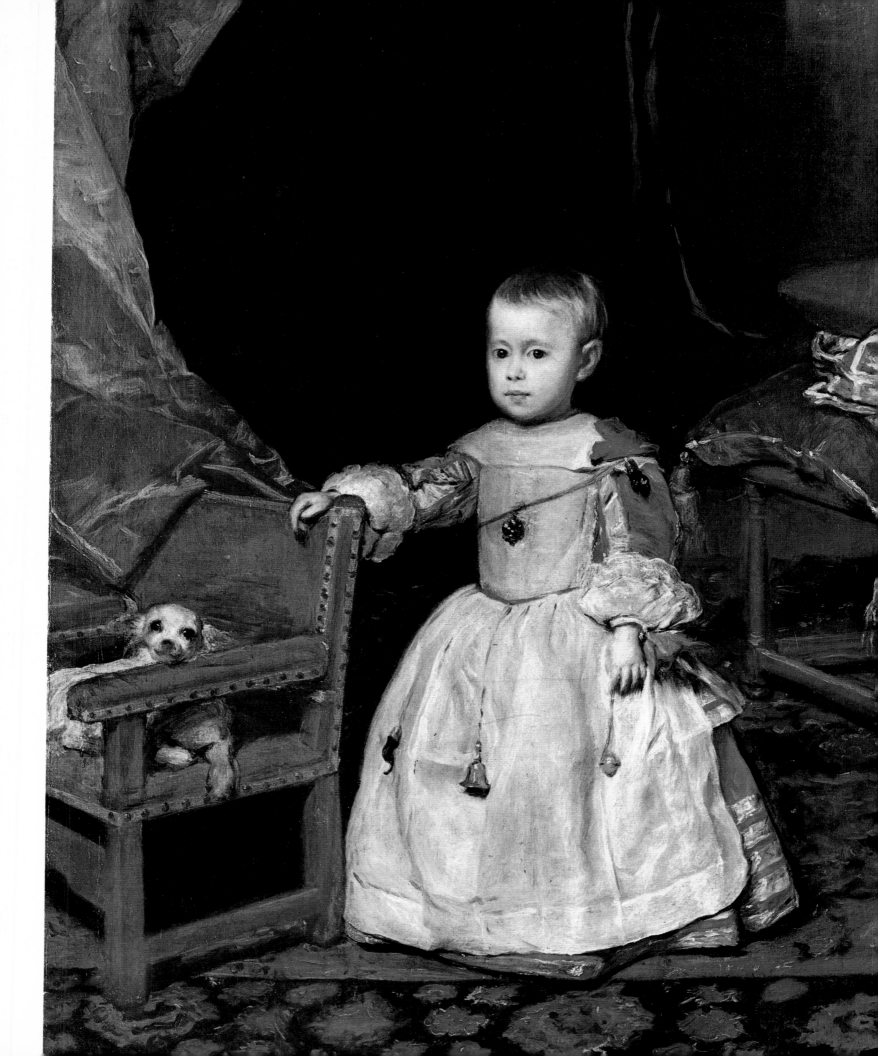

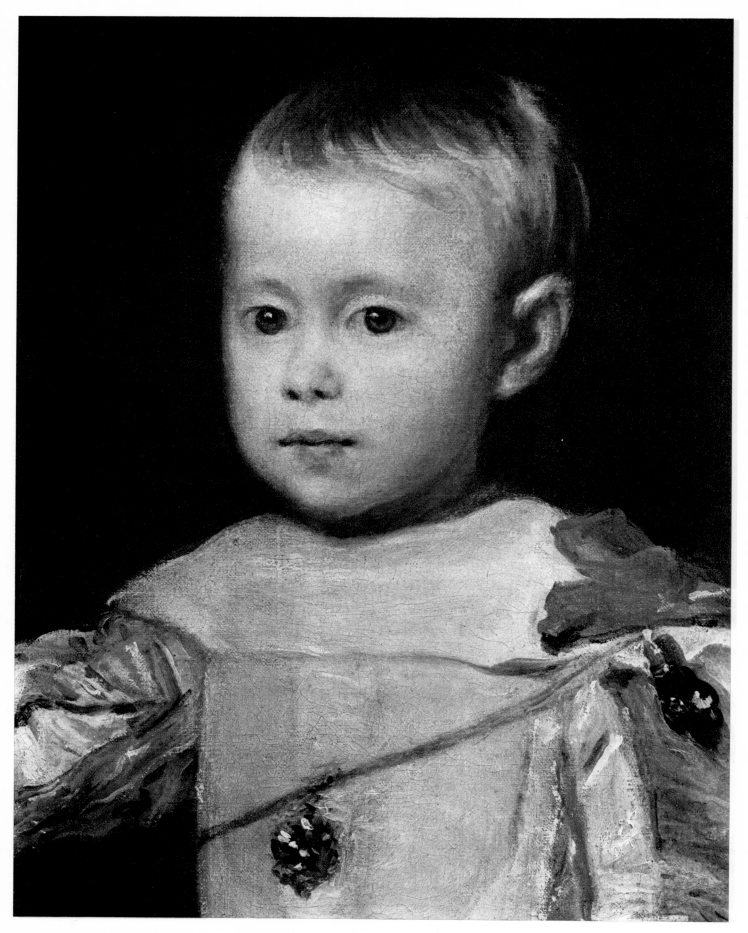

Figs. 232 & 233. THE INFANTE PHILIP PROSPER. Details of figure 231.
Fig. 234. MERCURY AND ARGOS. C. 1659. Madrid: Prado Museum. Cat. No. 159.

Fig. 235. MERCURY AND ARGOS. Detail of figure 234.
Fig. 236. WOMAN SEWING. C. 1650. Washington, D.C.: National Gallery of Art. Cat. No. 160.

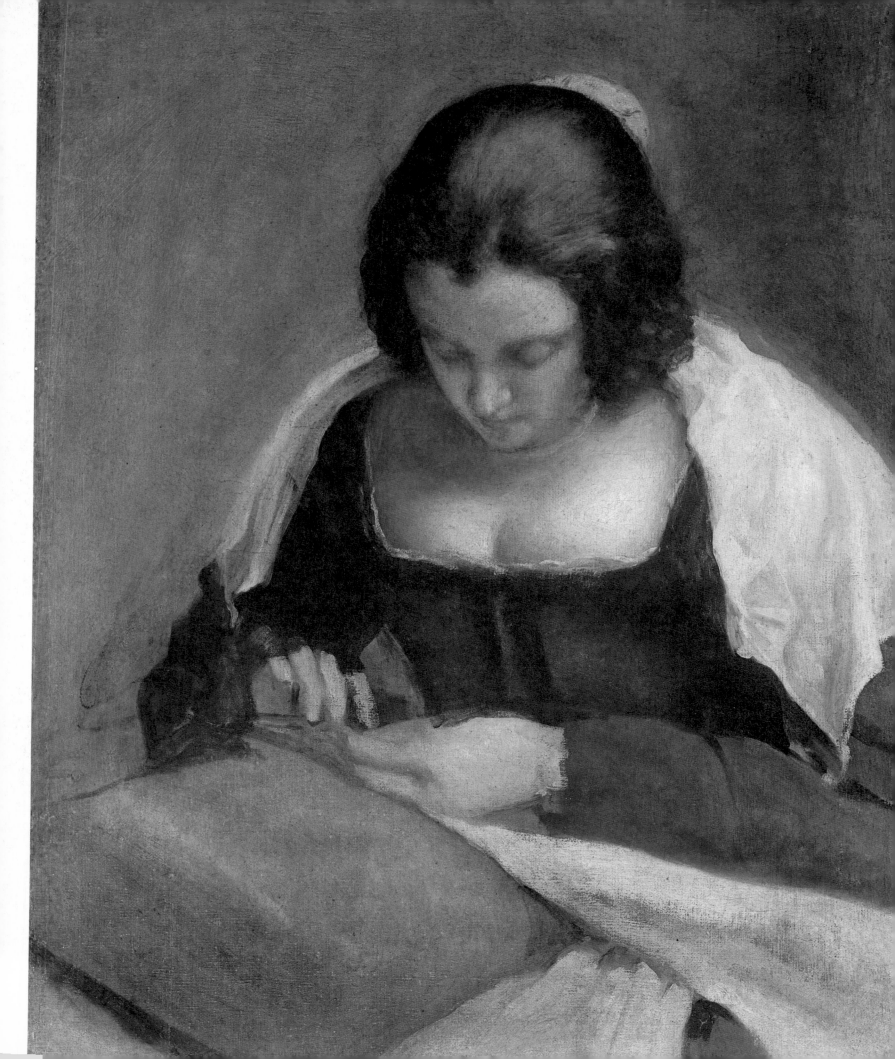

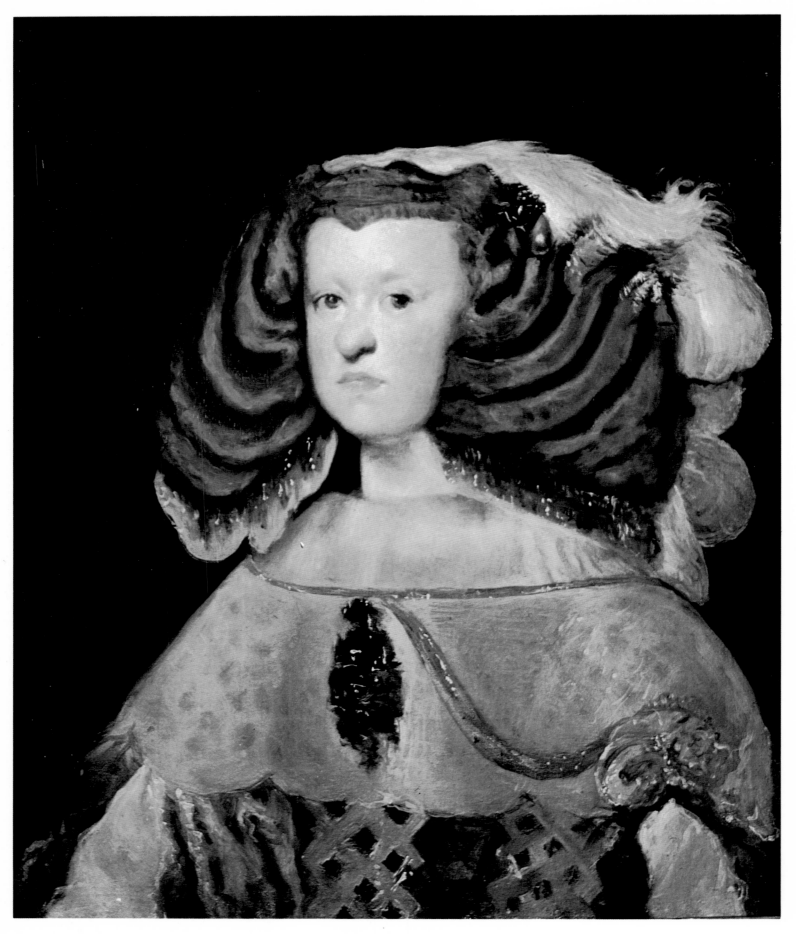

Fig. 237. MARIANA OF AUSTRIA. C. 1656. Lugano-Castagnola: Château de Rohoncz Foundation (Baron Henry Thyssen-Bornemisza).
Cat. No. 162.

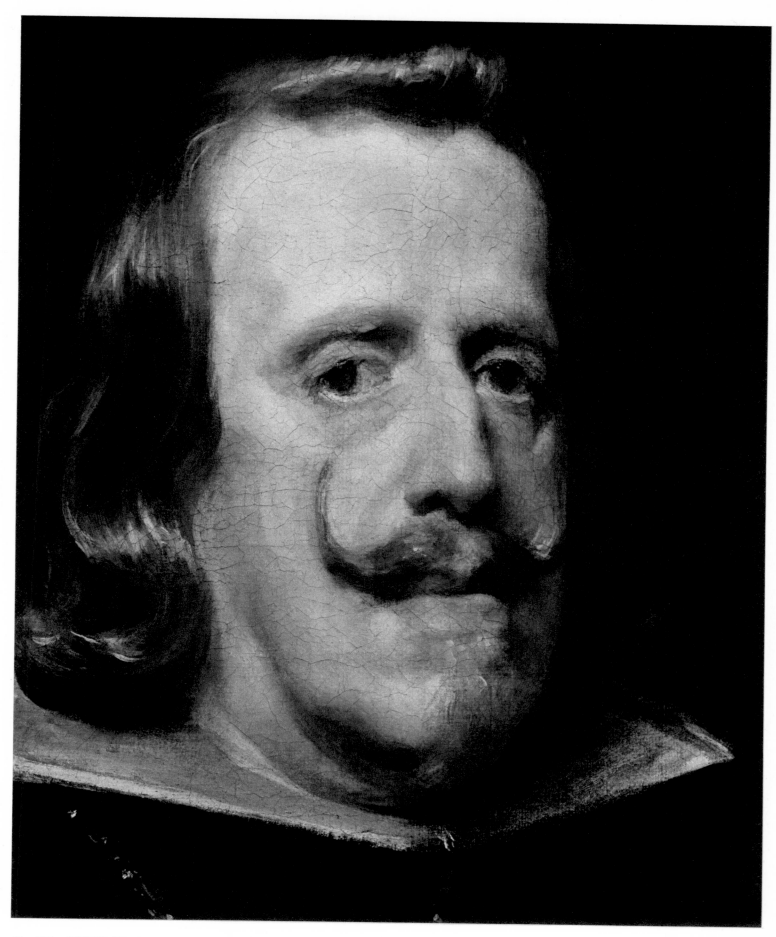

Fig. 238. PHILIP IV. C. 1657. London: National Gallery. Cat. No. 163.

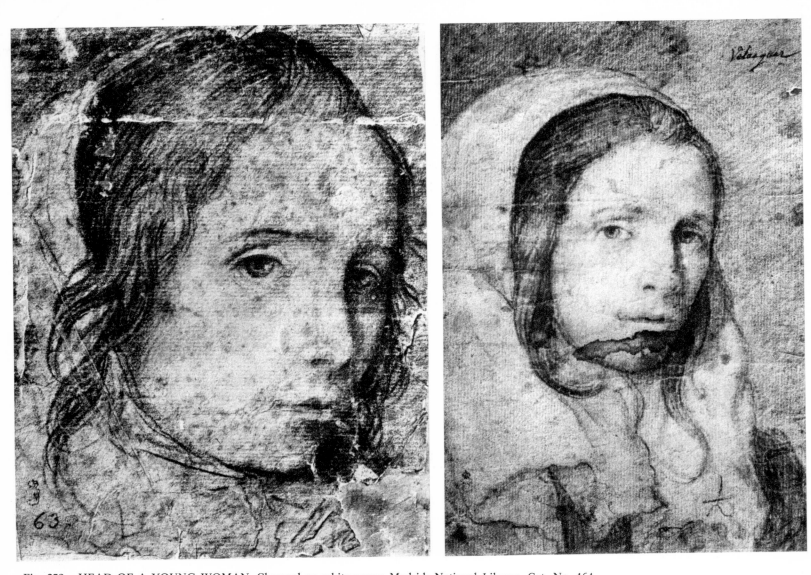

Fig. 239. HEAD OF A YOUNG WOMAN. Charcoal on white paper. Madrid: National Library. Cat. No. 164.
Fig. 240. BUST OF A YOUNG WOMAN. Charcoal on white paper. Madrid: National Library. Cat. No. 165.

Woman sewing in the National Gallery, Washington, the portrait of *Mariana of Austria* in the Thyssen-Bornemisza Collection and the *Philip IV* in the National Gallery in London. The first *(Fig. 236 - Cat. 160)* may be identified as the canvas found in Velázquez's studio after his death, since it figures in the inventory drawn up shortly afterwards as: "Another head, of a woman doing needlework". The model's physical resemblance to the *Lady with Fan* in the Wallace Collection *(Fig. 181)* makes it very probable that this work is a portrait of Juana Pacheco, thus completing the group studied in Chapter V. This diligent sempstress, painted at a moment of intimacy, of relaxation on the artist's part from his ever more burdensome court duties, may very well be that faithful wife who was to survive her husband by only six days.

Outstanding in this masterly work are the luminosity of the ample white shawl covering the lady's shoulders and the technical daring shown in the simplification of the hands, a simplification which, as in other late works by Velázquez, becomes a mere note of reference to essentials, i.e., to what suffices to enable the viewer's eye to reconstruct the total form of what has been painted.

I believe the *Philip IV* in London *(Fig. 238 - Cat. 163)* to be Velázquez's last portrait of his King. It is a pathetic face, reflecting the tragic closing years of Philip's life. In this respect it is interesting to compare the physical change in the sitter between this portrait and the one done in 1651-1652 as one of the series of official portraits painted on the occasion of the King's second marriage *(Fig. 217)*.

The pair to this last portrait of the King was probably a second likeness of Mariana of Austria, of which there would appear to be two versions extant, both painted with considerable participation by Velázquez himself: one in the Thyssen-Bornemisza Collection in Lugano *(Fig. 237 - Cat. 162)*, the other in the Rothschild Collection in Paris *(Cat. 161)*. The Queen, who has by now quite outgrown her formerly childish appearance, also seems to be affected by the sad evidence of the Empire's progressive decline. These are both versions, with slight variations, of the same model, which is particularly characterized by the baroque luxuriance of the coiffure, here rendered with masterly simplicity.

Another example of the way Velázquez painted in his very last period is the canvas in the Prado *(Figs. 234 & 235 - Cat. 159)*, representing the treacherous exploit of *Mercury and Argos*. This is one of two paintings that hung in the "Hall of Mirrors" of the Alcázar in Madrid, according to the 1686 inventory: "two other pictures of the same size, hanging between windows and measuring three rods in width by one in height, one of Apollo flaying a satyr and the other showing Mercury and Argos with a cow, both original works by Velázquez". The first of these two compositions was probably lost in the fire that ravaged the Alcázar in 1734. As for the one now before us, it had its height increased by the addition of two strips of canvas (24.5 centimetres at the top and 8 centimetres at the bottom) after its rescue from the fire, which did not in fact damage it very seriously, though it was left rather darker as a result of the scorching of the varnish. For my part I am convinced that proper cleaning would restore this canvas to its original aspect. And it certainly deserves it, being as it is probably one of Velázquez's last compositions and painted with a vigour and economy that are amazing in a man as weary and prematurely aged as Velázquez was by then. His mind, however, was clearer than ever.

After Velázquez's death

On August 10th, four days after the painter's death, the chief of the royal stewards drew up an inventory, in the presence of Gaspar de Fuensalida and Juan Bautista del Mazo, of the furniture and other effects found in the studio used by Velázquez in the Alcázar, which was in what was known as "the Prince's lower rooms", just beside the "Treasury", the painter's family residence. This "studio" is probably the room shown in the work entitled *Mazo's Family* in Vienna's Kunsthistorisches Museum. The inventory includes furniture, sculpture, jewels and various paintings attributed to Titian, Bassano and Ribera, three works by El Greco and two by Velázquez himself: a "head of an Englishwoman" and a "portrait of Her Highness the Infanta, Queen

of Hungary", which latter is probably the canvas in the Prado studied in Chapter II *(Fig. 69)*.

The inventory of the private property of Velázquez and his wife was drawn up by the witnesses to the foregoing document, both of whom had been appointed executors, between the 11th and the 29th of the same month. This is a document of great importance, which was published, with commentaries, by Sánchez Cantón in the "Archivo Español de Arte" in 1942. From his article I have taken the following description of the painter's home. "The residence in the treasury consisted of four floors: lower rooms, *bovedilla* (probably a mezzanine), *bóveda* and upper rooms. In the lower rooms were the vestibule or hall, the parlour (Doña Juana's domain) and a bedroom and, outside the house or perhaps in a semi-basement, the coach-house, in which a 'large old red coach' was kept, and the stable, with 'two old black mules'. In the *bovedilla* were the main bedroom, in which Velázquez and his wife died within a week of each other, and a kind of 'all-purposes' room, where the painter probably sometimes worked. In the *bóveda*, which we would call the main floor, were the drawing-room and the library. The upper rooms were used as lumber-rooms. The position of the kitchen is not mentioned, though there is a list of its utensils". This account of his abode reveals that Velázquez lived comfortably, in a spacious, well-furnished house which contained an excellent library, 28 tapestries, 44 pictures, curtains and carpets. The list of jewels and clothes is likewise an extensive one. Information about the paintings, unfortunately, is exceedingly meagre and only rarely are the artists' names given. Among the works by Velázquez himself we can very probably identify a "Portrait of Pope Innocent X" *(Fig. 207)*, a "Portrait of Don Luis de Góngora" *(Fig. 53)*, "Another head, of a woman doing needlework" *(Fig. 236)*, "Another large canvas showing a white horse, without any figure" *(Fig. 135)* and "a Christ crucified, a rod and a quarter high" *(Fig. 102)*; but the identification of "a reclining Venus, by Velázquez, two rods [in width]" as the *Rokeby Venus,* though tempting, is ruled out by the fact that the latter work appears in the inventory of the collection of Gaspar de Haro, drawn up in 1651, as we saw in Chapter V.

Nobody has yet proposed a satisfactory identification for other canvases in the inventory, which in Sánchez Cantón's opinion may have been by Velázquez: "A head of the Conde de Siruela", "Another head, of Don Tomás de Aguiar", "A head of Don Carlos Bodequín", "Another head, of a man with a black beard, unfinished", "A captain on horseback, drawn in paint", "A girl", a rather ill-written entry which might be "A head in profile with a helmet", "A portrait of Diego Velázquez, the suit unfinished", "A sketch of Prince Baltasar Carlos on horseback", "Landscapes of Italy", "Philip IV on a chestnut horse" and others less exactly described.

"Even after his death he was pursued by envy," writes Palomino. In effect, Velázquez's property was attached by the exchequer and until April 11th 1666 Mazo and his children were unable to recover it, together with 610, 385 maravedís, all that was left of the painter's unpaid salaries after such lengthy legal proceedings.

In the course of some town-planning developments decreed by Joseph Bonaparte the parish church of St. John the Baptist in Madrid was pulled down and with it vanished for ever the tomb and ashes of one of the greatest painters of all time.

Velázquez's drawings

Drawings attributed to Velázquez are very few in number. Art historians, too, are far from unanimous on this subject – logically enough, since the diversity of concepts and techniques that we find on analysing such drawings as are attributed to the painter counsels us to be very cautious and, indeed, to reject a great many of them. As I have said before, Pacheco and Palomino make but brief reference to Velázquez as a draughtsman: the first speaks of studies drawn from life during his son-in-law's apprenticeship, while the second mentions the drawings done by Velázquez in Italy, especially those of works by the great Venetians of the Renaissance.

To tell the truth, there is only one drawing extant of which we can be absolutely certain that it is

by Velázquez: the study for the portrait of Archbishop Borja *(Fig. 174)*, a formidable head which would be enough in itself to place Velázquez among the greatest draughtsmen of all time, for it is an example of just that synthesis of thematic and purely plastic values that is the essence of this branch of art. This pencil drawing, now in the Academy of San Fernando in Madrid, is carried out with great simplicity, but conveys precisely the right qualities of line, shading, surface and volume, with a noticeably realistic approach. It was done when Velázquez was about forty-five, so that it is roughly contemporary with the famous "red and silver" portrait of Philip IV at Fraga.

Of all the drawings supposed to be by the great painter on no other grounds than the personal opinion of this or that art historian, I can only accept with entire conviction the attribution to Velázquez of a girl's head and a head-and-shoulders drawing of a young woman in the National Library in Madrid *(Figs. 239 & 240 - Cat. 164 & 165)*, done with the same technique in charcoal on linen paper and identical as to quality. We have only to look at these drawings to realize that they are unquestionably by the same hand and probably even done at the same time. It has also been suggested that the model is the same in both and certainly the two faces are very similar, but there is not absolute identity. The beauty, perfection and softness of the technique of these works really makes them worthy products of the hand of the great painter. The second one has Velázquez's name inscribed in ink in the upper right-hand corner, but the inscription does not seem to be in Velázquez's writing. If we compare these drawings with that of the head of Archbishop Borja, the diversity of concept becomes evident; though their expressive intensity and precision of line are in no way inferior to those of the prelate's head, the concept of form is tighter and the tendency to blended modelling much more evident. These differences can be explained by accepting a comparatively early date for the two drawings in the National Library; they may have been done at some time between 1620 and 1625 – at the end of the painter's Sevillian period or during his early days in Madrid.

As I have already said in an earlier part of this book, I do not believe the sketch for the angel that appears in the *Christ after the Scourging* (National Gallery, London) is by Velázquez. Nor do I think we can attribute to him some slight pencil sketches deriving from *The Surrender of Breda*. Again, though the sketch of a man's head in the National Library in Madrid and the standing figure of a man wrapped in a cloak in the Academy of San Fernando are of undeniable artistic quality, I cannot bring myself to accept them as original works by the great artist. Nor do I agree with the attribution to Velázquez, by certain art historians of note, of the pen-and-ink sketch (with touches of water colour) of the apse of the Cathedral of Granada.

Such a notable dearth of drawings – even allowing for numerous losses and destructions – makes it seem probable that Velázquez frequently began his pictures by establishing the initial lines of the composition with the brush directly on the canvas; i.e., without any preparatory drawings at all. This hypothesis would appear to be confirmed by certain areas that he left unpainted in some of the portraits we have studied. We need only recall in this regard the vigorous brushstrokes, indicating the mass rather than the form, that define the hand in the *Portrait of a Young Gentleman* in Munich *(Fig. 73)*, the unbelievably simple sketch of the head of Philip IV in the portrait of Martínez Montañés *(Fig. 129)* or the representation of the dress of the young woman with the white kerchief painted in Rome *(Fig. 210)*, this last a quite exceptional achievement that consists simply of the superimposition of a few lines in transparent black on the dull tone of the priming.

I should add that even *The Maids of Honour* gives the impression of having been painted without any preparatory drawing other than the strokes in fluid pigment drawn directly with the brush as the composition advanced; this is not only apparent in the pictures on the wall in the background, but in the heads, completely devoid of detailed features, of the two figures in the middle distance on the right – and even in the slighter details of the more important figures.

Another work that gives this sensation of having been executed directly and without preparatory drawings is *The Spinners,* a real prodigy of illusion-

ism of form and colour, in which the basic drawing – which in fact probably never existed – provides a perfect skeleton for the living form.

Obviously this serious scarcity of drawings by a man who was not only the greatest of Spanish painters but also one of the world's greatest artists of all time is an aching void for all those who love the art of Velázquez, or who simply love art in general. It will always be a matter for regret that we do not possess a sequence of drawings by Velázquez that might enable us to follow the painter's evolution in this field as we can with his painting. But these are vain railings against the irrevocable decisions of fate.

Even admitting, however, that many of Velázquez's drawings may have been lost over the centuries, and accepting the fact of his preference for drawing directly in oil on canvas, what does this great dearth of drawings really signify? In all probability it simply confirms the fact that Velázquez was much more than merely a curious analyst of genres, methods, etc.; that he was a genius endowed with an extraordinary gift for painting, for the most pictorial of all kinds of painting.

CATALOGUE

Symbols used in the catalogue

C: Charles B. Curtis: *Velázquez and Murillo*. New York; London, 1883.

M: August L. Mayer: *Velázquez. A Catalogue Raisonné of the Pictures and Drawings*. London, 1936.

LR: José López-Rey: *Velázquez. A Catalogue Raisonné of his oeuvre*. London, 1963.

All the paintings in this catalogue are in oil on canvas unless otherwise stated.

1. THE VIRGIN MARY (MAGNIFICAT)
Inscribed: MAGNIFICAT ANIMA MEA DOMINUM
Signed with the monogram reproduced in the text (page 15).
C. 1615-1616.
Fig. 8.
1.20 x 0.99 m.
San Lúcar de Barrameda: Estate of José Colón.
Barcelona: Félix Millet; Raimond Maragall.
LR 24.
Gómez Moreno, Manuel: *Catálogo de la exposición de siete obras maestras del arte español del siglo XVII.* Barcelona, Edimar, S. A., 1949.

2. THE MUSICIANS
C. 1616-1617.
Fig. 9.
0.87 x 1.10 m.
Ireland: La Touche.
London: R. Langton Douglas.
West Berlin: Staatliche Museen.
M 115 LR 109.
By courtesy of the Staatliche Museen.

3. TWO MEN EATING
C. 1616-1617.
Fig. 10.
0.645 x 1.04 m.
Madrid: Marqués de la Ensenada Collection. Royal Palace until 1813.
(Presented to Wellington.)
London: Wellington Museum.
There is a probable sketch for this composition in a private collection in Rome.
C 85 M 109 LR 105.
Ada di Stefano: "Archivo Español de Arte", 1954, page 257.
Victoria and Albert Museum Copyright.

4. THE MAIDSERVANT
C. 1617-1618.
Fig. 11.
0.55 x 1.04 m.
Zurich: Private collection.
Chicago: Art Institute.
LR 99 M 105.
Mayer, August L.: *Das Original der Küchenmagd von Velázquez.* "Der Cicerone", September-December 1927, page 562.
By courtesy of the Art Institute of Chicago.

5. THE LUNCHEON
C. 1617-1618.
Fig. 12.
0.96 x 1.12 m.
Edinburgh: A. Sanderson Collection.
London: Langton Douglas (1908).
Budapest: Museum of Fine Arts of Hungary.
This work has been considerably repainted.
M 122 LR 120.
By courtesy of the Museum of Fine Arts of Hungary.

6. MAN'S HEAD
C. 1617-1618.
Fig. 14.
0.39 x 0.355 m.
Bought in Amsterdam by Alexander I of Russia in 1814.
Leningrad: Hermitage Museum.
Fragment of a composition.
M 128 LR 121.
By courtesy of the Hermitage Museum.

7. THE LUNCHEON
C. 1617-1618.
Figs. 13 & 15.
1.07 x 1.01 m.
Bought by Catherine II of Russia.
Leningrad: Hermitage Museum (1797).
M 121 LR 113.
By courtesy of the Hermitage Museum.

8. OLD WOMAN FRYING EGGS
C. 1618.
Figs. 16 & 17.
0.99 x 1.169 m.
London: Sir J. Charles Robinson.
Richmond: Sir Francis Cook, Bart.
Edinburgh: National Gallery of Scotland.
C 84 M 111 LR 108.
Baxandall, David: *A dated Velázquez bodegón.* "Burlington Magazine", XCIX, 1957, page 156.
By courtesy of the National Gallery of Scotland.

9. JESUS IN THE HOUSE OF MARTHA AND MARY
Remains of the date can still be seen (1618 ?).
Figs. 18, 20 & 21.
0.60 x 1.035 m.

Norfolk: Sir William M. Gregory (1881).
London: National Gallery.
M 9 LR 8.
Reproduced by courtesy of the Trustees, the National Gallery, London.

10. THE MAIDSERVANT
C. 1618.
Fig. 19.
0.315 x 0.34 m.
Monte Carlo: At dealer's.
Los Angeles: Boso N. Maric.
LR 102.
Soria, Martín S.: *An unknown early painting by Velázquez.* "Burlington Magazine", XCI, No. 554, 1949.

11. THE WATER-SELLER OF SEVILLE
C. 1622.
Figs. 22-24.
1.065 x 0.82 m.
Madrid: Inventory of the Palace of El Buen Retiro, 1701. Presented by Fernando VII to Lord Wellington in 1813.
London: Wellington Museum.
This may be the canvas that figures in the inventory of paintings belonging to Juan de Fonseca which were appraised by Velázquez in 1627 when they were bought by Gaspar de Bracamonte.
C 86 M 118 LR 124.
López Navío, José: *Velázquez tasa los cuadros de su protector D. Juan de Fonseca.* "Archivo Español de Arte", 1961, page 53.
Victoria and Albert Museum Copyright.

12. STILL LIFE
C. 1620.
Fig. 25.
1.08 x 0.87 m.
Seville: José de Cañaveral (1867).
Paris: Sedelmeyer (1913).
Amsterdam: Rijksmuseum.
M 161 LR 167.
Mayer, A. L.: "Belvedere", 1923, page 13.
By courtesy of the Rijksmuseum.

13. WOMAN'S HEAD
C. 1618.
Fig. 26.
0.25 x 0.18 m.
Madrid: Museo Lázaro Galdiano.
M 555 LR 594.
By courtesy of the Museo Lázaro Galdiano.

14. JOB
Inscribed: NOLI ME CONDENNARE.
C. 1618.
Fig. 30.
1.21 x 0.95 m.

London: A. L. Nicholson.
Sitges: Charles Deering.
Chicago: Art Institute.
M 3 LR 3.
Mayer, August L.: *Two unknown early works by Velázquez.* "Burlington Magazine", XL, January 1922.
R. M. F.: *Velázquez's 'Dying Seneca'.* "Bulletin of the Art Institute of Chicago", XIX, October 1925.
By courtesy of the Art Institute of Chicago.

15. SAINT FRANCIS
C. 1618-1619.
Fig. 34.
1.13 x 0.98 m.
Seville: At dealer's.
Madrid: Private collection.

16. EPIPHANY
1619.
Figs. 27-29.
2.04 x 1.25 m.
Seville: Novitiate of San Luis.
Madrid: Prado Museum.
C 9 M 7 LR 6.
Ainaud de Lasarte, Juan: *Pinturas de procedencia sevillana.* "Archivo Español de Arte", 1946, pages 54-63.
By courtesy of the Prado Museum.

17. JERONIMA DE LA FUENTE (1554-1630)
Signed: "Diego Velasquez f. 1620".
This work bears the following inscription: "This is the true portrait of Mother Jerónima de la Fuente, religious of the convent of Sancta Isabel de los Reyes de T., foundress and first abbess of the convent of S. Clara de la Concepción in the City of Manila in the Philippines. She left to occupy this position at the age of 66 years on Tuesday the twenty-eighth of April in the year 1620. With her from this convent went Mother Ana de Cristo and Mother Leonor de Sanct Francisco, religious, Sister Juana de Sanct Antonio, novice. All persons of great importance. For such a great work".
Fig. 31.
1.6 x 1.1 m.
Toledo: Convent of Santa Isabel de los Reyes.
Madrid: Prado Museum.
M 546 LR 577.
Caturla, María Luisa: *La madre Jerónima Yáñez, de Velázquez.* "Archivo Español de Arte", 1953, page 125.
By courtesy of the Prado Museum.

18. JERONIMA DE LA FUENTE
This is a replica, wholly done by the painter himself at about the same time, of the canvas in Cat. 17, and with an identical inscription. It retains the phylactery with the inscription: "Satiabor dum gloria... ficatus verit", which was erased from the picture in the Prado. It now

bears a signature and a date (1620), which may have been inscribed at some date subsequent to the execution of the work.
Fig. 32.
1.6 x 1.06 m.
Toledo: Convent of Santa Isabel de los Reyes.
Madrid: Fernández de Araoz Collection.
LR 578.

19. JERONIMA DE LA FUENTE
C. 1620.
0.762 x 0.635 m.
Similar version to the two preceding works (Cat. 17 & 18), but done in half length.
Work not studied.
Tissington Hall, Derbyshire: Sir William Fitzherbert.
M 547 LR 579.
Waterhouse, E. K.: "Burlington Magazine", No. 606, 1953.

20. CRISTOBAL SUAREZ DE RIBERA (1550-1618).
1620.
Signed with the monogram reproduced in the text (page 27).
Fig. 33.
1.97 x 1.42 m.
Seville: Church of San Hermenegildo. Museo de Pintura.
M 438 LR 475.
Gestoso y Pérez, José: *Un monograma y varias interpretaciones.*
"Boletín de la Sociedad Española de Excursiones", XVIII, 1910, page 129.
By courtesy of the Museo de Pintura, Seville.

21. SAINT THOMAS THE APOSTLE
C. 1619-1620.
Figs. 35 & 36.
0.94 x 0.73 m.
Orleans: Musée des Beaux-Arts (1843).
M 20 LR 37.
Un Velázquez en el Museo de Orleans. "Archivo Español de Arte y Arqueología", 1925, page 230.
Longhi, Roberto: *Un "Santo Tomás" de Velázquez y las conexiones italo-españolas entre los siglos XVI y XVII.* "Anales y Boletín de los Museos de Arte de Barcelona", 1951.
By courtesy of the Musée des Beaux-Arts, Orleans.

22. SAINT JOHN ON THE ISLAND OF PATMOS
C. 1619-1620.
Figs. 37 & 38.
1.358 x 1.023 m.
Companion picture to Cat. 23.
Seville: Chapterhouse of the Convent of the Shod Carmelites. Manuel López Cepero.
London: Bartholomew Frere (1809). National Gallery.
C 19 M 35 LR 29.
Reproduced by courtesy of the Trustees, the National Gallery, London.

23. IMMACULATE CONCEPTION
C. 1619-1620.

Figs. 39 & 40.
1.346 x 1.016 m.
Companion picture to Cat. 22.
Seville: Chapterhouse of the Convent of the Shod Carmelites. Manuel López Cepero.
London: Bartholomew Frere (1809). Mrs. Woodall and the Misses Frere. National Gallery (1974).
C 4 M 5 LR 21.
Angulo Iñíguez, Diego: *Velázquez y Pacheco.* "Archivo Español de Arte", 1950, page 354.
Reproduced by courtesy of the Trustees, the National Gallery, London.

24. SAINT JEROME
C. 1619-1620.
Figs. 41 & 42.
1.13 x 0.98 m.
Cadiz: At dealer's.
Madrid: Private collection.

25. SAINT JOHN THE BAPTIST
C. 1620-1622.
Figs. 43 & 44.
1.75 x 1.525 m.
Seville: Julian Williams.
London: Louis-Philippe sale, 1853.
Sitges: Charles Deering.
Croton, Mass.: Mr. and Mrs. Richard E. Danielson.
(On loan to the Art Institute of Chicago.)
C 18 M 34 LR 40.
C. M.: *An early Velázquez.* "Bulletin of the Art Institute of Chicago", XVIII, February 1924, page 14.
Mayer, August L.: *Two unknown early works by Velázquez.* "Burlington Magazine", XL, No. CCXXVI, January 1922.
By courtesy of the Art Institute of Chicago.

26. HEAD OF AN APOSTLE
C. 1620-1622.
Fig. 45.
0.38 x 0.29 m.
Fragment of a picture probably belonging to the same series as Cat. 27.
Madrid: Marqués de Casa-Torres. Condesa de Saltes.
M 19 LR 35.

27. SAINT PAUL
C. 1620-1622.
Fig. 46.
0.98 x 0.78 m.
This work probably belongs to the same series as Cat. 26.
Barcelona: Leopoldo Gil. Museo de Arte de Cataluña.
M 18 LR 34.
By courtesy of the Museo de Arte de Cataluña.

28. SAINT ILDEFONSO RECEIVING THE CHASUBLE
C. 1622-1623.

Figs. 47 & 49.
1.65 x 1.15 m.
Seville: Church of San Antonio. Museo de Pintura.
M 43 LR 47.
Angulo Iñíguez, Diego: *La imposición de la casulla a San Ildefonso, de Velázquez.* "Archivo Español de Arte", 1960, page 290.
Carriazo, Juan de Mata: *Correspondencia de don Antonio Ponz con el Conde del Aguila.* "Archivo Español de Arte y Arqueología", 1929, page 157.
By courtesy of the Museo de Pintura, Seville.

29. CHRIST AT EMMAUS
C. 1622-1623.
Figs. 48 & 50.
1.23 x 1.326 m.
Seville: José Cañaveral.
Zurich: Manuel de Sota.
New York: Altman Collection. Metropolitan Museum.
M 15 LR 19.
By courtesy of the Metropolitan Museum of Art. Bequest of Benjamin Altman, 1913.

30. KNIGHT OF MALTA WITH A SKULL
C. 1620.
Fig. 51.
0.53 x 0.48 m.
Naples: Duke of Casano.
Milan: Private collection.
There is another version of this portrait extant without the skull, which might be a replica, but it is difficult to judge until a proper cleaning has been carried out. Royal Palace, Madrid.
M 370 & 371 LR 537 & 538.

31. MAN WITH RUFF
C. 1621-1622.
Fig. 52.
0.4 x 0.36 m.
Madrid: Royal Palace. Prado Museum.
C 222 or 223 M 390 LR 549.
By courtesy of the Prado Museum.

32. LUIS DE GONGORA (1561-1627)
1622.
Fig. 53.
0.51 x 0.41 m.
Madrid: Marqués de la Vega Inclán.
Boston: Museum of Fine Arts.
Portrait originally crowned with a laurel wreath, which was painted out by Velázquez himself.
M 339 LR 496.
Borelius, Arón: *Velázquez's portrait of Góngora.* "Burlington Magazine", July 1938.
By courtesy of the Boston Museum of Fine Arts.

33. LUIS DE GONGORA (1561-1627)
0.6 x 0.48 m.
Replica of the canvas in Cat. 32.
Madrid: Museo Lázaro Galdiano.
M 340 LR 497.
Camón Aznar, José: *Temas de Velázquez.* "Goya", No. 36, May-June 1960, page 342.
By courtesy of the Museo Lázaro Galdiano.

34. LUIS DE GONGORA (1561-1627)
0.59 x 0.46 m.
Replica of the canvas in Cat. 32.
Madrid: Prado Museum.
C 161 M 341 LR 498.
By courtesy of the Prado Museum.

35. PHILIP IV (1605-1665)
Painted in 1624 for Antonia de Ipeñarrieta, widow of García Pérez. Velázquez's original receipt is preserved in the Metropolitan Museum.
Fig. 54.
2 x 1.028 m.
Zarauz: Palace of the Corral family.
Madrid: Duchess of Villahermosa.
New York: Metropolitan Museum.
C 106 M 199 LR 236.
Mélida, José Ramón: *Un recibo de Velázquez.* "Revista de Archivos, Bibliotecas y Museos", X, 1906, page 173.
By courtesy of the Metropolitan Museum of Art. Bequest of Benjamin Altman, 1913.

36. PHILIP IV (1605-1665)
C. 1624.
Fig. 55.
0.608 x 0.473 m.
New York: Herbert Straus Collection.
Dallas, Texas: The Meadows Museum.
M 183 LR 232.
By courtesy of the Meadows Museum, Southern Methodist University, Dallas, Texas.

37. PHILIP IV (1605-1665)
C. 1624.
Fig. 56.
2.09 x 1.1 m.
Madrid: Luis Navas.
Boston: Museum of Fine Arts (1904).
M 200 LR 237.
Gilman, B. I.: *Report of facts and opinions regarding the new Velázquez.* "Bulletin of the Museum of Fine Arts, Boston", 1905.
Lathrop, Francis: *The new Velázquez in the Boston Museum.* "Burlington Magazine", VII, No. XXV, April 1905.
By courtesy of the Boston Museum of Fine Arts.

38. THE COUNT-DUKE OF OLIVARES (1587-1645)
Painted in 1624 for Antonia de Ipeñarrieta, widow of García Pérez.

Velázquez's original receipt is preserved in the Metropolitan Museum.
Figs. 57 & 58.
2.012 x 1.111 m.
Zarauz: Palace of the Corral family.
Madrid: Duchess of Villahermosa.
São Paulo: Museo de Arte.
C 173 M 316 LR 506.
Mélida, José Ramón: *Un recibo de Velázquez.* "Revista de Archivos, Bibliotecas y Museos", Madrid, 1906.
Lafuente Ferrari, Enrique: *Velázquez y los retratos del Conde-Duque de Olivares.* "Goya", Nos. 37-38, July-October 1960, page 64.
Gudiol, José: *El Conde-Duque de Velázquez en el Museo de Arte de São Paulo.* "Coloquio 22", February 1963.
By courtesy of the Museo de Arte, São Paulo.

39. PHILIP IV (1605-1665)
C. 1625.
Radiography has revealed another portrait of the same personage with some variations. This may be Velázquez's first portrait of the King, painted in 1624.
Figs. 59 & 61.
2.01 x 1.02 m.
Madrid: Palace of El Buen Retiro (1701 inventory). Prado Museum.
C 105 M 205 LR 241.
By courtesy of the Prado Museum.

40. PHILIP IV (1605-1665)
C. 1625.
1.99 x 1.08 m.
Madrid: Marqués de Leganés.
London: Conde de Altamira sale (1827).
Boston: Isabella Stewart Gardner Museum.
C 116 M 201 LR 242.
By courtesy of the Isabella Stewart Gardner Museum.

41. THE COUNT-DUKE OF OLIVARES (1587-1645)
Dated with the anagram + A625 (1625).
Inscribed: "EL CONDE-DUQUE".
2.16 x 1.295 m.
Madrid: Conde de Altamira (?).
London: Colonel Hugh Baillie (1824). Sir G. L. Holford.
New York: The Hispanic Society of America.
C 171 M 318 LR 507.
Trapier, Elizabeth du Gué: "Notes Hispanic", 1944, Vol. IV.
Gillet, Louis: *Un portrait d'Olivares par Velázquez.* "La Revue de l'Art", July 1910, page 17.
Trapier, Elizabeth du Gué: *The cleaning of Velázquez's Count-Duke of Olivares.* "Varia Velazqueña", pages 320-322.
By courtesy of the Hispanic Society of America.

42. THE COUNT-DUKE OF OLIVARES (1587-1645)
C. 1625.
Figs. 60 & 62.
2.09 x 1.11 m.

Paris: Spanish Gallery, Louvre Museum.
London: Louis-Philippe sale (1853). Henry Farrer. Henry Huth.
Madrid: José Luis Várez Fisa.
C 170 M 319 LR 508.

43. PHILIP IV (1605-1665)
C. 1625.
Fig. 63.
0.57 x 0.44 m. (fragment).
Madrid: Prado Museum.
C 122 M 203 LR 239.
By courtesy of the Prado Museum.

44. THE INFANTE CARLOS (1607-1632)
Son of Philip III and Margarita of Austria.
C. 1627.
Figs. 64 & 65.
2.09 x 1.25 m.
Madrid: Prado Museum.
C 144 M 294 LR 326.
By courtesy of the Prado Museum.

45. PHILIP IV (1605-1665)
C. 1628.
Fig. 66.
2.07 x 1.21 m.
Brussels: Prince of Orange.
London: Dorchester House, R. S. Holford.
Sarasota, Florida: John and Mabel Ringling Museum of Art.
C 107 M 207 LR 243.
By courtesy of the John and Mabel Ringling Museum of Art.

46. THE INFANTA MARIA OF AUSTRIA (1606-1646)
Daughter of Philip III and Margarita of Austria. Married in 1631 to Ferdinand III of Hungary.
C. 1628.
Fig. 69.
0.58 x 0.44 m.
Madrid: Royal Collection (Quinta del Duque del Arco) 1794. Prado Museum.
C 244 M 507 LR 379.
By courtesy of the Prado Museum.

47. HEAD OF A YOUNG MAN
C. 1623-1625.
Fig. 70.
0.56 x 0.39 m.
Madrid: Prado Museum.
C 222 or 223 M 383 LR 565.
By courtesy of the Prado Museum.

48. BUST OF AN OLD MAN
C. 1623-1625.
Fig. 71.
0.521 x 0.4 m. (fragment).

Madrid: Count Koenneritz (1824-1828).
Munich: J. Boehler.
Detroit: Detroit Institute of Arts.
M 391 LR 556.
Mayer, August L.: Ein unbekanntes Männerbildnis von Velázquez.
"Pantheon", IV, July 1929, page 334.
Valentiner, William Reinhold: Portrait of a Nobleman by Diego Veláz-
quez. "Bulletin of the Detroit Institute of Arts", XI, 1929.
By courtesy of the Detroit Institute of Arts.

49. PORTRAIT OF A GENTLEMAN
C. 1625.
Fig. 72.
1.04 x 0.79 m. (fragment).
Milan: At dealer's.
Florence: Fondazione Contini-Bonacossi.
M 393 LR 557.

50. PORTRAIT OF A YOUNG MAN
C. 1628.
Fig. 73.
0.895 x 0.695 m.
Bought in Madrid by the Minister Wieser in 1694 for the Elector Johann
Wilhelm of Düsseldorf.
Munich: Alte Pinakothek.
C 229 bb M 388 LR 566.
By courtesy of the Alte Pinakothek, Munich.

51. DEMOCRITUS
C. 1624-1628.
Figs. 74 & 75.
0.98 x 0.8 m.
Rouen: Bureau de Finances (1789). Musée des Beaux-Arts.
In 1692 a canvas described as "a philosopher laughing, with a sphere,
an original painting by Diego Velázquez" was given by the Marqués de
Carpio along with some other paintings to his gardener, Pedro Rodrí-
guez, in lieu of his arrears of wages.
M 67 & 448 LR 76.
Gonse, Louis: Un tableau de Velázquez au Musée de Rouen. "Gazette
des Beaux-Arts", IX, 1893, page 125.
Pita, J. M.: "Archivo Español de Arte", 1952, page 236.
Lefort, Paul: El hombre del mapamundi de Velázquez. "Museum", 1912,
page 201.
By courtesy of the Musée des Beaux-Arts, Rouen.

52. COURT JESTER WITH A WINEGLASS
C. 1627-1628.
Fig. 76.
0.762 x 0.635 m.
Derriads, Chippenham, Wilts.: Sir G. Prior Goldney, Bart.
London: R. Langton Douglas (1914).
Toledo (Ohio): Toledo Museum of Art.
M 447 LR 441.

Mayer, August L.: The man with the wineglass by Diego Velázquez. "Art
in America", III, June 1915.
By courtesy of the Toledo Museum of Art.

53. BACCHUS (THE TOPERS)
Paid for in July 1629.
Figs. 77-80.
1.65 x 2.25 m.
Madrid: Real Alcázar. Prado Museum.
C 27 M 51 LR 57.
Borelius, Arón: En torno a los Borrachos. "Varia Velazqueña", page 245.
Cruzada Villamil, Gregorio: El cuadro de Los Borrachos, original de
Velázquez. "El Arte de España", VIII, 1869, page 61.
By courtesy of the Prado Museum.

54. STAG'S ANTLERS
C. 1626.
Fig. 81.
In a royal inventory of 1636 there is a description of "a Stag's Antlers
painted by Diego Velázquez with lettering that says 'killed by the King
our Ld. Phil. fourth in the year 1626".
Segovia: Palacio de Riofrío.
Angulo Iñiguez, Diego: "La Cuerna de venado", cuadro de Velázquez.
"Reales Sitios", No. 12, 1967.
By courtesy of the Patrimonio Nacional.

55. STAG'S HEAD
Fragment.
Fig. 82.
0.66 x 0.52 m.
Madrid: Marqués de Casa-Torres. Vizconde de Baïguer.
Casa-Torres, Marqués de: "Boletín de la Sociedad Española de Excur-
siones", 1922, page 48.
M 147 LR 150.

56. CHRIST AFTER THE FLAGELLATION CONTEMPLATED BY THE CHRISTIAN SOUL
C. 1628-1629.
Figs. 83 & 84.
1.65 x 2.06 m.
Bought in Madrid by Sir John Savile Lumley (1858).
London: National Gallery.
In the author's opinion a charcoal drawing for the figure of the angel
in this composition, which was destroyed in the fire at the Instituto
Jovellanos (Gijón), was apocryphal.
C 10 M 12 LR 12.
Hornedo, S. I., Rafael María de: Al hilo de la Exposición Velázquez y
lo velazqueño. "Razón y Fe", LX, No. 758, 1961, page 247.
Reproduced by courtesy of the Trustees, the National Gallery, London.

57. THE TEMPTATION OF SAINT THOMAS AQUINAS
C. 1628-1629.
Figs. 85-87.
2.44 x 2.03 m.

Orihuela: Santo Domingo. Museo Episcopal.
M 44 LR 54.
Camón Aznar, José: *El Velázquez de Orihuela*. "A.B.C.", August 30th
1953.
By courtesy of the Museo Episcopal, Orihuela.

58. JOSEPH'S COAT
Painted in Rome in 1630.
Figs. 88-90.
2.23 x 2.5 m.
Madrid: Palace of El Buen Retiro (1637). Monastery of the Escorial.
C 3 M 1 LR 1.
By courtesy of the Patrimonio Nacional.

59. THE FORGE OF VULCAN
Painted in Rome in 1630.
Figs. 91-93.
2.23 x 2.9 m.
Madrid: Palace of El Buen Retiro (1701). Prado Museum.
C 35 M 61 LR 68.
Angulo Iñíguez, Diego: *La fábula de Vulcano, Venus y Marte y 'La Fragua' de Velázquez*. "Archivo Español de Arte", 1960, page 149.
Soria, Martín S.: *La Fragua de Vulcano, de Velázquez*. "Archivo Español de Arte", 1955, page 142.
By courtesy of the Prado Museum.

60. HEAD OF APOLLO
Study for "The Forge of Vulcan".
Painted in Rome in 1630.
Fig. 94.
0.36 x 0.25 m.
Genoa: Isola Collection (1840).
London: Sold at Sotheby's in 1935.
New York: Private collection.
M 62 LR 69.
Mayer, A. L.: "Burlington Magazine", Vol. 50, 1927, page 332.

61. GARDEN OF THE VILLA MEDICI
Painted in Rome in 1630.
Fig. 95.
0.44 x 0.38 m.
Madrid: Real Alcázar (1666). Prado Museum.
C. 42 & 43 M 154 & 155 LR 157 & 158.
Lorente, Manuel: *Velázquez y la Villa Médicis*. "Varia Velázqueña",
page 257.
By courtesy of the Prado Museum.

62. GARDEN OF THE VILLA MEDICI
Painted in Rome in 1630.
Fig. 96.
0.48 x 0.42 m.
Madrid: Real Alcázar (1666). Prado Museum.
C 42 & 43 M 154 & 155 LR 157 & 158.

Lorente, Manuel: *Velázquez y la Villa Médicis*. "Varia Velazqueña",
page 257.
By courtesy of the Prado Museum.

63. THE BRAWL
Painted in Rome in 1630.
Oil on board.
Figs. 97 & 98.
0.281 x 0.396 m.
Rome: Palazzo Pallavicini-Rospigliosi.
LR 133.
Longhi, Roberto: "Paragone", No. 1, 1950.
Longhi, Roberto: *La riña ante la embajada de España*. "Varia Velazqueña", page 328.
By courtesy of the Pallavicini-Rospigliosi family.

64. SELF-PORTRAIT
C. 1630.
Fig. 99.
1.01 x 0.81 m.
Florence: Galleria degli Uffizi.
C 195 M 174 LR 178.
Brunetti, Estella: *Per il soggiorno fiorentino del Velázquez*. "Varia Velazqueña", page 293.
Becherucci, Luisa: *Per i ritratti del Velázquez agli Uffizi*. "Varia Velazqueña", page 293.
By courtesy of the Galleria degli Uffizi.

65. THE COMMUNION OF THE APOSTLES
1630.
Fig. 100.
0.65 x 0.52 m.
Madrid: Academy of San Fernando.
By courtesy of the Royal Academy of San Fernando.

66. PRINCE BALTASAR CARLOS WITH A DWARF (1629-1646)
1631 (This work bears the inscription AETATIS AN... MENS 4).
Fig. 101.
1.36 x 1.04 m.
Acquired in Italy by the Earl of Carlisle about the middle of the 18th
century.
Boston: Museum of Fine Arts.
C 149 M 269 LR 302.
By courtesy of the Museum of Fine Arts, Boston.
Purchased by the Henry Lillie Pierce Fund.

67. CHRIST CRUCIFIED
Signed: "Do. Velázquez fa. 1631".
Fig. 102.
1 x 0.57 m.
This may be the canvas that figures in the inventory of Velázquez's
estate drawn up after his death: *"Un Xpto crucificado, de bara y quarta
de alto y tres cuartas de ancho"* (A Christ crucified, a rod and a quarter
high by three-quarters wide) (1.05 x 0.63 m.).

Madrid: Convent of the Order of St. Bernard of the Holy Sacrament.
Prado Museum.
LR 15.
By courtesy of the Prado Museum.

68. DON DIEGO DEL CORRAL Y ARELLANO (1570-1632)
Married to Antonia de Ipeñarrieta y Galdós in 1627.
C. 1631-1632.
Fig. 103.
2.15 x 1.1 m.
Zarauz: Palace of the Corral family (1668 inventory).
Madrid: Duchess of Villahermosa. Prado Museum.
C 15 M 335 LR 494.
Ainaud de Lasarte, Juan: *Velázquez y Barcelona.* "Mundo Hispánico",
No. 155, 1961, page 40.
By courtesy of the Prado Museum.

69. DOÑA ANTONIA DE IPEÑARRIETA Y GALDOS (d. 1635)
First married to García Pérez Aracil (d. 1624), later to Diego del Corral
(Cat. 68). In 1624 she paid Velázquez for three portraits (Cat. 35 & 38).
It is not known which of her six children is the boy accompanying her
in this portrait; his figure is not the work of Velázquez.
C. 1631-1632.
Figs. 104 & 105.
2.15 x 1.1 m.
Zarauz: Palace of the Corral family (1668 inventory).
Madrid: Duchess of Villahermosa. Prado Museum.
C 259 M 548 LR 580.
Mélida, José Ramón: *Los Velázquez de la casa de Villahermosa.* "Revista
de Archivos, Bibliotecas y Museos", IX, 1905, page 89.
By courtesy of the Prado Museum.

70. PRINCE BALTASAR CARLOS (1629-1646)
C. 1632.
Fig. 107.
1.18 x 0.955 m.
Bought in Seville by F. N. Standish.
London: Louis-Philippe sale (1853). Wallace Collection.
C 135 M 270 LR 303.
Reproduced by permission of the Trustees of the Wallace Collection.

71. PHILIP IV (1605-1665)
The paper in the King's hand bears the inscription "Señor-Diego Veláz-
quez pintor de V. Mg.".
C. 1632-1633.
Figs. 108 & 109.
1.995 x 1.13 m.
Madrid: Royal Palace. Presented by Joseph Bonaparte to General Dessolle
in 1810; sold in London in 1882.
London: National Gallery.
C 117 M 216 LR 246.
Howard, Francis: *The Silver Philip.* "The Connoisseur", March 1937,
page 153.
Reproduced by courtesy of the Trustees, the National Gallery, London.

72. QUEEN ELIZABETH OF BOURBON (1602-1644)
C. 1632-1633.
Fig. 106.
2.03 x 1.14 m.
Madrid: Palace of El Buen Retiro (1701).
London: Louis-Philippe sale (1853). Private collection.
C 232 M 47 LR 339.
Crombie, Theodore: "The Connoisseur", 1958, page 238.
Lafuente Ferrari, Enrique: *Velázquez y la Reina Isabel de Borbón.* "Arte-
Hogar", No. 183, 1960, page 25.

73. EQUESTRIAN PORTRAIT OF THE COUNT-DUKE OF
OLIVARES (1587-1645)
C. 1632-1633.
Figs. 110 & 111.
3.13 x 2.39 m.
This work belonged to the family of the Count-Duke.
Madrid: Royal Palace (1772 inventory). Prado Museum.
C 166 M 309 LR 211.
By courtesy of the Prado Museum.

74. EQUESTRIAN PORTRAIT OF THE COUNT-DUKE OF
OLIVARES (1587-1645)
C. 1632-1633.
This work has considerable variations in relation to Cat. 73. The present
author believes it to be the work of Velázquez.
Fig. 112.
1.25 x 1.015 m.
Paris: M. Lemotteux.
Broomhall, Fifeshire, Scotland: Earl of Elgin (1806).
New York: Metropolitan Museum.
C 168 M 313 LR 216.
By courtesy of the Metropolitan Museum of Art, Fletcher Fund, 1952.

75. WHITE HORSE
C. 1632.
Fig. 135.
3.1 x 2.45 m.
This may be the canvas mentioned in the inventory of Velázquez's
estate drawn up after his death: "another large canvas, showing a white
horse, without any figure". Discovered during the restoration of a pic-
ture representing Saint James, in the Royal Palace of Madrid.
Madrid: Salamanca Collection. Royal Palace.
LR 220.
Lozoya, Marqués de: *El caballo blanco de Velázquez.* "Varia Velaz-
queña", Vol. I, page 323.
By courtesy of the Patrimonio Nacional.

76. THE SURRENDER OF BREDA ("LAS LANZAS")
Spinola receiving the key of the fortress of Breda from Justin of Nassau
(June 5th 1625). Painted for the "Salon of the Kingdoms" in the Palace
of El Buen Retiro.
1634-1635.
Figs. 113-117.
3.07 x 3.67 m.

Madrid: Palace of El Buen Retiro. Prado Museum.
C 36 M 78 LR 80.
Camón Aznar, José: *Las lanzas.* "Goya", Nos. 37-38, July-October 1960, page 74.
Contreras y López de Ayala, Juan: *La rendición de Breda.* "Obras maestras del Arte Español", X, Barcelona, 1955.
Soria, Martín S.: *Las lanzas y los retratos ecuestres de Velázquez.* "Archivo Español de Arte", 1954, page 93.
Caturla, María Luisa: *Cartas de pago de los doce cuadros de batallas para el Salón de Reinos del Buen Retiro.* "Archivo Español de Arte", 1960, pages 333-355.
By courtesy of the Prado Museum.

77. EQUESTRIAN PORTRAIT OF PRINCE BALTASAR CARLOS (1629-1646)
Painted for the "Salon of the Kingdoms" in the Palace of El Buen Retiro.
1634-1635.
Figs. 118 & 119.
2.09 x 1.73 m.
Madrid: Palace of El Buen Retiro. Prado Museum.
C 131 M 261 LR 199.
By courtesy of the Prado Museum.

78. EQUESTRIAN PORTRAIT OF PHILIP IV (1605-1665)
Painted for the "Salon of the Kingdoms" in the Palace of El Buen Retiro.
1634-1635.
Camón Aznar has advanced the hypothesis that the image revealed by radiography under the painting now visible may be the equestrian portrait of Philip IV painted by Velázquez in 1625.
3.01 x 3.14 m.
Fig. 120.
Madrid: Palace of El Buen Retiro. Prado Museum.
C 97 M 185 LR 187.
By courtesy of the Prado Museum.

79. EQUESTRIAN PORTRAIT OF MARGARITA OF AUSTRIA (1584-1611)
According to Camón Aznar, this canvas may be the equestrian portrait of Queen Margarita that Bartolomé González painted around 1625, enlarged and partly repainted by Velázquez.
1634-1635.
Fig. 122.
2.97 x 3.09 m.
Madrid: Royal Palace (1625 ?). Palace of El Buen Retiro (1635). Prado Museum.
C 230 M 466 LR 209.
By courtesy of the Prado Museum.

80. EQUESTRIAN PORTRAIT OF ELIZABETH OF BOURBON (1602-1644)
According to Camón Aznar, this canvas may be the equestrian portrait of Philip IV's wife that was painted by Eugenio Caxés around 1625, enlarged and partly repainted by Velázquez.

1634-1635.
Figs. 121 & 123.
3.01 x 3.14 m.
Madrid: Royal Palace (1625 ?). Palace of El Buen Retiro (1635). Prado Museum.
C 231 M 467 LR 210.
By courtesy of the Prado Museum.

81. EQUESTRIAN PORTRAIT OF PHILIP III (1578-1621)
According to Camón Aznar, this canvas may be the equestrian portrait of Philip III that was painted by Vicente Carducho around 1625, enlarged and partly repainted by Velázquez.
1634-1635.
Fig. 124.
3 x 3.14 m.
Madrid: Royal Palace (1625 ?). Palace of El Buen Retiro (1635). Prado Museum.
C 96 M 180 LR 185.
By courtesy of the Prado Museum.

82. PRINCE BALTASAR CARLOS ON HORSEBACK (1629-1646)
C. 1635.
Fig. 125.
1.32 x 1.02 m.
Madrid: Bought by Samuel Rogers in 1828.
London: Wallace Collection.
M 266 LR 205.
Reproduced by permission of the Trustees of the Wallace Collection.

83. PRINCE BALTASAR CARLOS ON HORSEBACK (1629-1646)
This may be the canvas mentioned in 1648 in the collection of the Marquesa del Carpio.
Palomino mentions the same canvas as being in the collection of Diego Gaspar de Haro, son of the Marquesa del Carpio.
C. 1635.
Fig. 126.
1.448 x 0.965 m.
Eccleston, England: Duke of Westminster.
C 134 M 267 LR 206.
Pita Andrade, José Manuel: *Los cuadros de Velázquez y Mazo que poseyó el séptimo Marqués del Carpio.* "Archivo Español de Arte", Vol. XXV, page 223.
By courtesy of the Duke of Westminster.

84. SIBYL
This work figures in the 1746 inventory taken in the Palace of La Granja.
C. 1631-1632.
Fig. 127.
0.62 x 0.5 m.
Madrid: Prado Museum.
C 261 M 557 LR 590.
By courtesy of the Prado Museum.

85. JUAN MATEOS (C. 1575-?)
C. 1631-1632.
Fig. 128.
1.08 x 0.895 m.
Modena: Galleria Ducale (catalogued as a Velázquez in 1685).
Dresden: (Since 1746) Staatliche Gemäldesammlung.
C 225 M 345 LR 504.
Orwochrom-Farbenfotografie, Gerhard Reinhold, Leipzig-Moldau.

86. THE SCULPTOR MARTINEZ MONTAÑES (1568-1649)
1635.
Fig. 129.
1.09 x 0.87 m.
El Pardo: Royal Collection (Quinta del Duque del Arco).
Madrid: Prado Museum.
C 152 M 347 LR 503.
Sánchez Cantón, F. J.: *Sobre el 'Martínez Montañés' de Velázquez.* "Archivo Español de Arte", 1961, page 25.
By courtesy of the Prado Museum.

87. DON PEDRO DE BARBERANA Y APARREGUI (1579-1649)
C. 1635.
Figs. 130 & 131.
1.982 x 1.118 m.
New York: Private collection.
López-Rey, José: *An unpublished Velázquez; a knight of Calatrava.* "Gazette des Beaux-Arts", Volume LXXX, July-August 1972, page 61.

88. PORTRAIT OF A LADY
C. 1635.
(Unfinished.)
Fig. 132.
1.29 x 0.99 m.
Madrid: José de Salamanca (1867).
West Berlin: Staatliche Museen.
M 551 LR 593.
Justi, Carl: *Ein Damenbildnis von Velázquez.* "Jahrbuch der preuszischen Kunstsammlungen", VIII, 1887, page 174.
By courtesy of the Staatliche Museen.

89. PORTRAIT OF A YOUNG MAN
Bought in Madrid by Count Harrach in 1678 (as a work by "Velasco").
C. 1635.
Fig. 133.
0.59 x 0.48 m.
Vienna: Galerie Harrach.
Washington, D. C.: National Gallery.
M 389 LR 568.
Bredius, Abraham: *A forgotten Velázquez.* "Zeitschrift für bildense Kunst", XIII, 1902, page 110.
By courtesy of the National Gallery, Washington, D.C., Andrew Mellon Collection.

90. A HAND FROM THE PORTRAIT OF ARCHBISHOP FERNANDO VALDES (d. 1639)

Fragment of a full-length portrait signed "Diego Velázquez".
C. 1633.
Fig. 134.
0.24 x 0.27 m.
Madrid: José de Salamanca. Royal Palace (1848).
M 424 LR 480.
Ainaud de Lasarte, Juan: *Velázquez y los retratos de D. Fernando de Valdés.* "Varia Velazqueña", page 310.
By courtesy of the Patrimonio Nacional.

91. ARCHBISHOP FERNANDO VALDES (d. 1639)
Fragment of a full-length portrait.
C. 1639.
Fig. 136.
0.685 x 0.596 m.
Madrid: José Madrazo.
London: Sir David Wilkie (1828). National Gallery.
LR 476.
Reproduced by courtesy of the Trustees, the National Gallery, London.

92. PHILIP IV (1605-1665)
Executed in Velázquez's studio, partly by the painter himself.
(Unfinished.)
C. 1632.
Fig. 137.
1.28 x 0.865 m.
Vienna: Kunsthistorisches Museum.
C 121 M 220 LR 246.
By courtesy of the Kunsthistorisches Museum.

93. ELIZABETH OF BOURBON (1602-1644)
Executed in Velázquez's studio, partly by the painter himself.
(Unfinished.)
C. 1637-1638.
Fig. 138.
1.285 x 0.99 m.
Vienna: Kunsthistorisches Museum.
M 482 LR 346.
By courtesy of the Kunsthistorisches Museum.

94. FRANCISCO DE QUEVEDO (1580-1645)
Copy of a lost original by Velázquez.
C. 1635.
Fig. 139.
0.6 x 0.54 m.
Seville: Francisco de Bruna (C. 1775).
London: Lady Stuart. Wellington Museum.
C 191 M 362 LR 531.
Victoria and Albert Museum Copyright.

95. JUAN DE CALABAZAS (CALABACILLAS)
See Cat. 104.
C. 1633.
Fig. 140.
1.75 x 1.06 m.

Paris: Duc de Persigny (1863).
Richmond: Sir Herbert Cook.
Cleveland: Museum of Art.
C 75 M 445 LR 423.
Cook, Herbert: A rediscovered Velázquez. "Burlington Magazine", Vol. X, No. XLV, 1906, page 171.
By courtesy of the Cleveland Museum of Art. Purchase: Leonard C. Hanna Jr. Bequest.

96. THE CORONATION OF THE VIRGIN
C. 1635.
Figs. 141 & 142.
1.76 x 1.34 m.
Madrid: The Queen's Oratory (Real Alcázar). Prado Museum.
C 5 M 17 LR 23.
By courtesy of the Prado Museum.

97. SAINT ANTHONY ABBOT AND SAINT PAUL THE HERMIT
C. 1635-1640.
Figs. 143 & 144.
2.57 x 1.88 m.
Madrid: Hermitage of St Anthony in the gardens of El Buen Retiro (1701). Royal Palace. Prado Museum.
C 13 M 38 LR 42.
Angulo Iñíguez, Diego: El 'San Antonio abad y San Pablo ermitaño' de Velázquez. Algunas consideraciones sobre su arte de componer. "Archivo Español de Arte", 1946, pages 18-34.
By courtesy of the Prado Museum.

98. CHRIST OF SAN PLACIDO
C. 1632.
Fig. 145.
2.48 x 1.69 m.
Madrid: Church of San Plácido.
Paris: Condesa de Chinchón.
Madrid: Prado Museum.
C 12 M 13 LR 14.
Gómez Moreno, Manuel: El Cristo de San Plácido. "Boletín de la Sociedad Española de Excursiones", XXIV, page 177.
By courtesy of the Prado Museum.

99. PRINCE BALTASAR CARLOS IN SHOOTING DRESS (1629-1646)
Inscription: "Anno aetatis suae VI".
1635-1636.
Fig. 146.
1.91 x 1.03 m.
El Pardo: Torre de la Parada.
Madrid: Royal Palace (1772). Prado Museum.
C 137 M 271 LR 304.
By courtesy of the Prado Museum.

100. PHILIP IV IN SHOOTING DRESS (1605-1665)
C. 1635-1636.
Fig. 147.
1.91 x 1.26 m.

El Pardo: Torre de la Parada.
Madrid: Royal Palace (1772). Prado Museum.
C 108 M 222 LR 250.
By courtesy of the Prado Museum.

101. THE INFANTE FERNANDO IN SHOOTING DRESS (1609-1641)
C. 1632-1636.
Figs. 148-150.
1.91 x 1.07 m.
El Pardo: Torre de la Parada (1701).
Madrid: Royal Palace (1772). Prado Museum.
C 145 M 303 LR 331.
By courtesy of the Prado Museum.

102. THE BOAR HUNT (LA TELA REAL)
C. 1636-1637.
Figs. 151-155.
1.82 x 3.02 m.
El Pardo: Torre de la Parada.
Madrid: Royal Palace (1747).
London: Sir Henry Wellesley. National Gallery.
C 37 M 131 LR 138.
Justi, Carl: Das Jagbild des Velázquez in der Londoner National Gallery. "Repertorium für Kunstwissenschaft", L, 1929, page 255.
Lance, George: Carta sobre 'La tela real'. "The Athenaeum", April 7th 1855, page 407.
Stirling-Maxwell, William: The Velasquez 'Boar Hunt'. "The Athenaeum", No. 1,508, September 1856.
Reproduced by courtesy of the Trustees, the National Gallery, London.

103. FRANCISCO LEZCANO (NIÑO DE VALLECAS)
At the Court the sitter was known by the nicknames of "Niño de Vallecas" and "Enano Vizcaíno".
His life is documented between 1634 and his death in 1649.
C. 1637.
Figs. 156 & 157.
1.07 x 0.83 m.
El Pardo: Torre de la Parada.
Madrid: Royal Palace (1714). Prado Museum.
C 67 M 457 LR 429.
By courtesy of the Prado Museum.

104. JUAN DE CALABAZAS (CALABACILLAS)
The sitter was jester to the Cardinal-Infante Don Fernando, and died in 1639.
C. 1637.
Figs. 158 & 159.
1.06 x 0.83 m.
El Pardo: Torre de la Parada.
Madrid: Royal Palace (1772). Prado Museum.
C 66 M 446 LR 424.
By courtesy of the Prado Museum.

105. DIEGO DE ACEDO (EL PRIMO)
The sitter is documented between 1635 and his death in 1660.

C. 1637.
Figs. 160 & 171.
1.07 x 0.82 m.
El Pardo: Torre de la Parada.
Madrid: Royal Palace (1772). Prado Museum.
C 69 M 452 LR 420.
By courtesy of the Prado Museum.

106. SEBASTIAN DE MORRA
The sitter was in the service of the Cardinal-Infante Don Fernando during the latter's regency in Flanders. He died in Madrid in 1649.
C. 1645.
Fig. 161.
1.06 x 0.81 m.
Madrid: Real Alcázar (1666). Palace of El Buen Retiro (1746). Royal Palace (1772). Prado Museum.
C 68 M 451 LR 430.
By courtesy of the Prado Museum.

107. PABLO DE VALLADOLID (PABLILLOS)
The sitter is documented between 1632 and his death in 1648.
C. 1637.
Figs. 162 & 170.
2.09 x 1.23 m.
Madrid: Palace of El Buen Retiro (1701). Royal Palace. Prado Museum.
By courtesy of the Prado Museum.

108. MARS
C. 1637-1640.
Fig. 163.
1.79 x 0.95 m.
El Pardo: Torre de la Parada (1703).
Madrid: Royal Palace (1772). Prado Museum.
C 31 M 54 LR 61.
By courtesy of the Prado Museum.

109. AESOP
C. 1637-1640.
Figs. 164 & 166.
1.79 x 0.94 m.
El Pardo: Torre de la Parada (1703).
Madrid: Royal Palace (1772). Prado Museum.
C 30 M 65 LR 73.
By courtesy of the Prado Museum.

110. MENIPPUS
C. 1637-1640.
Figs. 165 & 167.
1.79 x 0.94 m.
El Pardo: Torre de la Parada (1703).
Madrid: Royal Palace (1772). Prado Museum.
C 32 M 66 LR 78.
By courtesy of the Prado Museum.

111. CRISTOBAL DE CASTAÑEDA Y PERNIA (BARBARROJA)
The sitter is documented between 1633 and 1649.
C. 1637-1640.
Figs. 168 & 172.
1.98 x 1.21 m.
Madrid: Palace of El Buen Retiro (1701). Royal Palace (1772). Prado Museum.
C 70 M 450 LR 428.
By courtesy of the Prado Museum.

112. DON JUAN DE AUSTRIA
The sitter is documented from 1632.
C. 1637-1640.
Figs. 169 & 173.
2.1 x 1.23 m.
Madrid: Palace of El Buen Retiro (1771). Royal Palace (1772). Prado Museum.
C 72 M 453 LR 422.
By courtesy of the Prado Museum.

113. ARCHBISHOP GASPAR DE BORJA (1611-1645)
Fragment of a full-length portrait.
C. 1637.
Fig. 175.
0.76 x 0.635 m.
Somerset: Baron Taunton (d. 1869).
New York: Kress Foundation.
Ponce (Puerto Rico): Museo de Arte.
M 420 LR 466.
Ceán Bermúdez, Juan Agustín: *Diálogo entre el Cardenal D. Gaspar de Borja y Velasco... y D. Juan Carreño de Miranda.* "El Censor", II, September 23rd 1820, page 97, Madrid.
López-Rey, José: *On Velazquez's portrait of Cardinal Borja.* "Art Bulletin", Vol. XXVIII, 1946.
Mayer, August L.: *A rediscovered portrait by Velázquez.* "International Studio", XCV, No. 395.
Gudiol, José: *Las Pinturas españolas de la colección Kress en el Museo de Ponce.* "Goya", 1964-1965, page 384.
By courtesy of the Museo de Arte, Ponce.

113a. STUDY FOR THE PORTRAIT OF GASPAR DE BORJA
(Cat. 113).
Pencil drawing on paper.
C. 1637.
Fig. 174.
18.6 x 11.7 cm.
Madrid: Academy of San Fernando.
M 605 LR 644.
By courtesy of the Royal Academy of San Fernando.

114. PRINCE BALTASAR CARLOS (1629-1646)
Copy of a lost original by Velázquez. Probably by Mazo.
C. 1639.
Fig. 176.
1.285 x 0.995 m.

Vienna: Kunsthistorisches Museum.
C 141 M 288 LR 319.
By courtesy of the Kunsthistorisches Museum.

115. PRINCE BALTASAR CARLOS (1629-1646)
Copy of a lost original by Velázquez. Probably by Mazo.
C. 1639-1640.
Fig. 177.
1.48 x 1.11 m.
The Hague: Mauritshuis.
C 139 M 285 LR 316.
By courtesy of the Mauritshuis Museum.

116. THE COUNT-DUKE OF OLIVARES
The head, which appears to be the work of Velázquez, was reproduced
by Hermann Paneels in 1638 in an engraving bearing the inscription:
"Ex Archetypo Velázquez". It may be an unfinished canvas. In the
Staatliche Gemäldesammlung of Dresden there is a more complete
contemporary work from Velázquez's workshop, painted from the
same model.
Purchased by Tsar Alexander I in 1815.
Fig. 178.
0.67 x 0.545 m.
Leningrad: Hermitage.
C 175 M 328 LR 511.
By courtesy of the Hermitage Museum.

117. FRANCESCO II D'ESTE, DUKE OF MODENA (1610-1658)
1638.
Fig. 179.
0.68 x 0.51 m.
Modena: Galleria Estense. Pinacoteca di Modena.
M 307 LR 337.
Venturi, Adolfo: *Velásquez e Francesco d'Este.* "Nueva Antología",
XXIX, 1881, page 44.
By courtesy of the Pinacoteca di Modena.

118. LADY WITH FAN
C. 1640-1642.
Figs. 181 & 183.
0.928 x 0.685 m.
London: Lucien Bonaparte sale (1816).
Paris: Luis Aguado sale (1843).
London: Wallace Collection.
C 265 M 559 LR 599.
Reproduced by permission of the Trustees of the Wallace Collection.

119. YOUNG LADY
(Unfinished.)
C. 1640-1642.
Figs. 180 & 182.
0.71 x 0.47 m.
Chiswick House: Earl of Burlington (d. 1753).
Chatsworth: Duke of Devonshire.

C 266 M 561 LR 600.
By courtesy of the Trustees of the Chatsworth Settlement.

120. HEAD OF A GIRL
This may be the canvas described as "Another portrait of a girl" in
Velázquez's house according to the inventory drawn up after the paint-
er's death.
C. 1640-1642.
Fig. 184.
0.515 x 0.41 m.
London: Sir William Knighton sale (1885).
Paris: Rudolph Kann.
New York: Hispanic Society of America
M 569 LR 608.
Trapier, Elizabeth du Gué: *Velázquez. New data on a group of portraits.*
"Notes Hispanic", IV, 1944, page 37.
By courtesy of the Hispanic Society of America, New York.

121. PHILIP IV (1605-1665)
In all probability this is the portrait painted by Velázquez at Fraga
in 1644.
Fig. 185.
1.335 x 0.985 m.
Parma: Ducal Palace (1748).
Switzerland: Castle of Wastegg (1859).
Austria: Castle of Schwattzau.
Vienna: Prince Elie de Bourbon-Parma. Sold in London in 1911.
New York: Frick Collection.
M 228 LR 255.
Beruete, Aureliano de: *El Velázquez de Parma. Retrato de Felipe IV,
pintado en Fraga.* Madrid, Blass, 1911. Pamphlet.
Fry, Roger: *The Fraga Velázquez.* "Burlington Magazine", Vol. XIX,
No. XCVII, 1911, page 5.
By courtesy of the Frick Collection, New York.

122. PHILIP IV (1605-1665)
Detail of the head of an allegorical portrait which was an anonymous
copy of an original by Rubens (1628-1629).
This portrait figures in the 1651 inventory of the Gaspar Méndez de
Haro Collection as a copy of a work by Rubens and described as "la
caveça de Diego Velázquez".
C. 1644.
Fig. 186.
Madrid: Gaspar Méndez de Haro (1651).
Florence: Palazzo Pitti.
C 103 M 195 LR 198.
Boix, Félix: *La estampa dedicada por Rubens al Conde-Duque de Olivares
y el perdido retrato ecuestre de Felipe IV, pintado por el mismo artista
durante su segundo viaje a España.* "Arte Español", VII, 1924, page 93.
By courtesy of the Museum of the Palazzo Pitti.

123. ADMIRAL ADRIAN PULIDO PAREJA (1606-1660)
Copy of a lost original by Velázquez, attributed to Mazo.
Apocryphal signature: "Did. Velaz. Philip IV acubiculo eiusqᵉ. pic-

tor 1639". The sitter wears the scallop-shell badge of the Order of St. James, awarded to the Admiral in 1647.
Fig. 187.
2.04 x 1.145 m.
London: John Calcraft sale (1778). National Gallery.
C 178 M 357 LR 524.
Beruete, Aureliano de: *Retratos de Pulido Pareja. Datos para un problema pictórico (Velázquez y Mazo).* Madrid, Blass, 1916. Pamphlet.
Reproduced by courtesy of the Trustees, the National Gallery, London.

124. PORTRAIT OF A MAN
C. 1645.
Fig. 188.
0.64 x 0.45 m.
Paris: Durand Ruel (1892).
Lugano-Castagnola: Castle of Rohoncz.
Present whereabouts unknown.
M 394 LR 545.

125. PORTRAIT OF AN UNKNOWN GENTLEMAN
C. 1645.
Fig. 189.
0.76 x 0.597 m.
Madrid: Royal Palace (1789). (Sequestered by Joseph Bonaparte.) Given to Wellington by Fernando VII.
London: Wellington Museum.
C 209 M 378 LR 550.
Victoria and Albert Museum Copyright.

126. JUAN FRANCISCO DE PIMENTEL, 10th CONDE DE BENAVENTE (1584-1652)
(Unfinished.)
C. 1648.
Fig. 190.
1.09 x 0.88 m.
La Granja: Royal Palace (1746).
Madrid: Royal Palace (1814). Prado Museum.
C 182 M 333 LR 487.
By courtesy of the Prado Museum.

127. PORTRAIT OF A GIRL
C. 1648.
Fig. 191.
Bergamo: Accademia Carrara delle Belle Arti.
Suida, Wilhelm: *An unrecorded Velázquez.* "Apollo", VI, 1927, page 218.
By courtesy of the Accademia Carrara delle Belle Arti.

128. KNIGHT OF THE ORDER OF ST. JAMES
Possibly painted in Italy in 1650.
Fig. 212.
0.665 x 0.56 m.
Modena: Prince Cesare Ignazio d'Este (1685).
Dresden: Staatliche Gemäldesammlung, since 1747.

C. 226 M 372 LR 539.
Orwochrom-Farbenfotografie, Gerhard Reinhold, Leipzig-Moldau.

129. VIEW OF ZARAGOZA (DETAIL)
Work signed by Mazo in 1647.
In my opinion some of the figures in the foreground are by Velázquez.
Fig. 193.
1.81 x 3.31 m.
Madrid: Royal Palace. Prado Museum.
Arco, Ricardo del: *Tricentenario de un cuadro famoso: La 'Vista de Zaragoza', por Mazo-Velázquez.* "Heraldo de Aragón", Zaragoza, April 13th 1947.
López Giménez, José: *Sobre la 'Vista de Zaragoza' del Museo del Prado.* "Seminario de Arte Aragonés", VII-VIII-IX, 1957, page 119.
Lorente Junquera, Manuel: *La 'Vista de Zaragoza' por Velázquez y Mazo.* "Archivo Español de Arte", 1960, page 183.
Salas, Xavier de: *Una carta del pintor Mazo.* "Archivo Español de Arte y Arqueología", 1931, page 181.
By courtesy of the Prado Museum.

130. GROUPS OF FIGURES AGAINST A LANDSCAPE BACKGROUND
Two fragments of a composition.
C. 1645-1648.
Figs. 192 A & B.
0.435 x 0.535 m.
London: Earl of Cowley.
Bonn: Städtische Kunstsammlungen.
M 135 & 136 LR 144 & 145.
By courtesy of the Städtische Kunstsammlungen.

131. GROUPS OF FIGURES AGAINST A LANDSCAPE BACKGROUND
Two fragments of a composition.
C. 1645-1648.
Figs. 194 A & B.
0.19 x 0.248 m.
0.178 x 0.228 m.
London: Meade sale (1851).
Keir: Dunblane, Sir William Stirling-Maxwell, Bart. At dealer's.
C 63 & 64 M 139 & 140 LR 146 & 147.

132. THE TOILET OF VENUS (THE ROKEBY VENUS)
C. 1645-1648.
Figs. 195 to 197.
1.225 x 1.77 m.
Madrid: Gaspar Méndez de Haro (1651). Duke of Alba (1688). Manuel Godoy (1808).
England: Rokeby Hall, Yorkshire.
London: National Gallery.
Lasso de la Vega y López de Tejada, Miguel: *Un pintor desconocido del siglo XVII: Domingo Guerra Coronel.* "Arte Español", XV, 1944, page 43.
MacLaren, Neil: *Velázquez. The Rokeby Venus.* London, National Gallery, "The Gallery Books", No. 1 (1943).

Sánchez Cantón, F. J.: *La Venus del espejo*. "Archivo Español de Arte", 1960, page 137.

Soria, Martín S.: *Sources and interpretation of the Rokeby Venus*. "The Art Quarterly", Detroit, XX, 1957, page 30.

Tolnay, Charles de: *La 'Vénus au miroir', de Velázquez*. "Varia Velazqueña", page 339.

Gaya Nuño, Juan Antonio: *Historias viejas en torno a la Venus del espejo*. "Clavileño", No. 17 (September-October 1952).

Reproduced by courtesy of the Trustees, the National Gallery, London.

133. THE FABLE OF ARACHNE (THE SPINNERS)
Considerably enlarged canvas.
The original work measured approximately 1.69 x 2.50 m.
C. 1645-1648.
Figs. 198 to 201.
Madrid: Pedro de Arce (1664 inventory). Alcázar (1734). Royal Palace (1772). Prado Museum.
C 23 M 130 LR 56.
Angulo Iñiguez, Diego: *Las Hilanderas. Sobre la iconografía de Aragne*. "Archivo Español de Arte", 1948, page 1.
"Archivo Español de Arte", 1952, page 67.
Caturla, María Luisa: *El coleccionista madrileño D. Pedro de Arce, que poseyó 'Las Hilanderas', de Velázquez*. "Archivo Español de Arte", 1948, page 293.
Tolnay, Charles de: *'Las Hilanderas' and 'Las Meninas'. An interpretation*. "Gazette des Beaux-Arts", XXXV, 1949, page 21.
By courtesy of the Prado Museum.

134. WOMAN IN PROFILE
C. 1644-1648.
Fig. 202.
0.64 x 0.58 m.
Milan: Private collection.
Munich: Boehler Collection.
New York: Private collection.
M 570 LR 591.

135. JUAN DE PAREJA (1610-1670)
Painted in Rome in 1649-1650.
Figs. 203 & 204.
0.74 x 0.60 m.
Naples: Baranello Collection. Sir William Hamilton (1798).
London: Sold in 1801. Sold in 1970.
New York: Metropolitan Museum.
C 181 M 352 LR 517.
Rousseau, Theodore & Fahy, Everett: *Studies on the "Juan de Pareja"*. Metropolitan Museum, 1971.
Purchased by the Metropolitan Museum of Art in 1971, principally out of purchase funds bequeathed by Isaac D. Fletcher and Jacob S. Rogers, supplemented by gifts from the friends of the Museum.
By courtesy of the Metropolitan Museum.

136. POPE INNOCENT X (1576-1655)
Dedicated and signed: "Alla San^ta di N^ro Sig^re Innocencio X° per Diego de Silva Velazquez dela Camera di S. M^ta Catt^co".

Painted in Rome in 1650.
Figs. 205 & 206.
1.40 x 1.20 m.
Rome: Prince Doria-Pamphili, Galleria Doria-Pamphili.
C 183 M 409 LR 443.
Pantorba, Bernardino de: *El retrato de Inocencio X*. "La Esfera", June 1928.
By courtesy of the Galleria Doria-Pamphili.

137. POPE INNOCENT X (1576-1655)
Painted in Rome in 1650.
Fig. 207.
0.49 x 0.42 m.
Norfolk: Walpole Collection.
Acquired by Catherine II of Russia in 1779.
Leningrad: Hermitage.
Washington, D. C.: National Gallery of Art.
C 186 M 411 LR 448.
By courtesy of the National Gallery of Art, Washington, D. C., Andrew Mellon Collection.

138. CARDINAL CAMILLO ASTALLI (1616-1663 ?)
Painted in Rome in 1650.
Fig. 208.
0.61 x 0.485 m.
Rome: Private collection.
Paris: Trotti Collection.
New York: Hispanic Society of America.
M 427 & 428 LR 458.
Nicolle, Marcel: *Portrait d'un cardinal par Velázquez*. "Revue de l'Art", January 1904, page 21.
Trapier, Elizabeth du Gué: "Notes Hispanic", Vol. IV, 1944.
Toesca, Pietro: *Le vicende di un ritratto del Velázquez*. "L'Arte", VII, 1904, page 509.
By courtesy of the Hispanic Society of America.

139. MICHEL ANGELO
It was Mayer who first suggested that this canvas was the portrait of Michel Angelo, Innocent X's barber, one of the pictures Palomino includes among the works done by Velázquez in Rome in 1650.
Fig. 209.
0.483 x 0.444 m.
Chilham Castle: Sir Edmund Davis.
New York: Private collection.
M 229 G M 463 LR 482.
Mayer: *Velázquez*. Paris, 1950.

140. MONSIGNOR CAMILLO MASSIMI (1620-1677)
Chamberlain to Innocent X.
1650.
Fig. 211.
0.73 x 0.58 m.
Rome: Diego Gaspar de Haro.
Bologna: Acquired prior to 1821 by an ancestor of Mr. Ralph Bankes.
Kingston Lacy, Wimborne, Dorset.

C 218 & 229d M 432 LR 471.

Harris, Enriqueta: *El Marqués del Carpio y sus cuadros de Velázquez.* "Archivo Español de Arte", 1957, page 136.

Velázquez's portrait of Camillo Massimi. "Burlington Magazine", 1958, page 279.

141. PORTRAIT OF A GIRL
C. 1649-1650.
Fig. 210.
0.60 x 0.645 m.
Naples: Diego Gaspar de Haro (1689).
Rome: Private collection.
New York: Private collection.

142. PORTRAIT OF CRISTOFORO SEGNI (Majordomo to Innocent X between 1645 and 1653)
Inscribed on the paper the cleric is holding: "Alla Santta de Nro Sigre Innocentio Xo Monsre Maggiordomo ne parti a S Sta Per Diego de Silva Velasq. e Pietro Martire Neri".
According to Palomino, Velázquez painted a portrait of the Pope's majordomo in 1650. This may be a canvas begun by Velázquez and drastically repainted by Pietro M. Neri.
Fig. 213.
1.14 x 0.92 m.
Paris: Sale of José de Salamanca's collection (1867). Duchess of Dreyfus-González.
Krentzligen (Switzerland): Heins Kister.
C 156 M 426 LR 474.
Mayer, August L.: *Pietro Martire Neri, ein italianischer Nachahmer des Velázquez.* "Belvedere", XIII, September 1928, page 60.
Voss, Hermann: *Über das Bildnis des Maggiordomo Segni von Velázquez.* "Varia Velazqueña", page 335.

143. SELF-PORTRAIT
(Unfinished.)
C. 1645.
Fig. 214.
0.455 x 0.38 m.
Seville: Private collection.
Madrid: Queen Elizabeth Farnese.
Valencia: Farinelli (d. 1792) Collection. José Martínez Blanco. Provincial Museum.

144. THE INFANTA MARIA TERESA (1638-1683)
(Unfinished.)
C. 1651.
Fig. 215.
0.48 x 0.37 m.
Cadiz: Zenón Collection.
Paris: Trotti Collection.
New York: Metropolitan Museum.
M 515 LR 384.
Mayer, August L.: *An Infanta portrait of Velázquez.* "Art in America", II, April 1914.
By courtesy of the Metropolitan Museum.

145. THE INFANTA MARIA TERESA (1638-1683)
(Unfinished.)
C. 1651.
Fig. 216.
0.33 x 0.375 m.
Paris: Ledieu Collection (c. 1874).
New York: Payne Bingham Collection. Metropolitan Museum.
C 249 M 521 LR 385.
By courtesy of the Metropolitan Museum of Art, Bache Collection.

146. PHILIP IV (1605-1665)
C. 1651-1652.
Fig. 217.
0.69 x 0.56 m.
Madrid: Royal Palace. Prado Museum.
C 128 M 246 LR 266.
By courtesy of the Prado Museum.

147. MARIANA OF AUSTRIA (1634-1696)
Canvas enlarged at the top.
1652.
Figs. 218 & 219.
2.31 x 1.31 m.
Monastery of the Escorial (1700).
Madrid: Prado Museum.
C 237 M 484 LR 355.
By courtesy of the Prado Museum.

148. MARIANA OF AUSTRIA (1634-1696)
Replica of Cat. 147.
1652.
2.09 x 1.25 m.
Madrid: Alcázar (1734). Royal Palace (1772). Prado Museum.
Paris: Louvre Museum.
C 236 M 486 LR 357.
Bazin, Germain: *Les échanges franco-espagnols.* "Revue des Beaux-Arts de France", 1942-1943, page 71.
By courtesy of the Louvre Museum.

149. MARIANA OF AUSTRIA (1634-1696)
Replica of Cat. 147.
Sent to Vienna on February 23rd 1653.
2.04 x 1.27 m.
Vienna: Schönbrunn Palace. Kunsthistorisches Museum.
M 485 LR 356.
By courtesy of the Kunsthistorisches Museum.

150. THE INFANTA MARIA TERESA (1638-1683)
(Unfinished.)
This is probably the portrait sent to the Emperor Ferdinand III of Austria on February 22nd 1633.
C. 1652.
Fig. 220.
1.27 x 0.99 m.

Vienna: Kunsthistorisches Museum.
M 517 LR 386.
By courtesy of the Kunsthistorisches Museum.

151. THE INFANTA MARIA TERESA (1638-1683)
(Unfinished.)
Replica of Cat. 150.
This is probably the portrait sent to Duke Leopold Wilhelm, Governor
General of Flanders, in 1653.
1.27 x 0.98 m.
Vienna: Kunsthistorisches Museum.
Boston: Museum of Fine Arts.
M 518 LR 387.
H. C. H.: *Portrait of the infanta Maria Teresa by Velázquez.* "Boston
Museum of Fine Arts Bulletin", February 1922.
By courtesy of the Boston Museum of Fine Arts.

152. THE INFANTA MARGARITA (1651-1673)
1653.
Figs. 221 & 222.
Vienna: Kunsthistorisches Museum.
C 253 M 524 LR 394.
By courtesy of the Kunsthistorisches Museum.

153. THE INFANTA MARGARITA (1651-1673)
Replica, with variations, of Cat. 152.
1653.
1.15 x 0.91 m.
*Madrid: Duke of Alba (1796). Palace of Liria, Museum of the House of
Alba.*
C 254 M 525 LR 395.
By courtesy of the Museum of the House of Alba.

154. THE INFANTA MARGARITA (1651-1673)
Replica of a lost original.
1653.
0.70 x 0.59 m.
Paris: Louvre Museum.
C 255 M 527 LR 398.
By courtesy of the Louvre Museum.

155. THE MAIDS OF HONOUR (LAS MENINAS)
1656.
Figs. 223-227.
3.18 x 2.76 m.
Madrid: Alcázar. Prado Museum.
C 21 M 166 LR 229.
Lasso de la Vega y López de Tejada, Miguel: *En torno a 'Las Meninas' y
sus personajes.* "Arte Español", XV, 1944, page 125.
Moya, Ramiro: *El trazado regulador y la perspectiva en Las Meninas.*
"Arquitectura", Year 3, No. 25, January 1961, page 1.
Sánchez Cantón, Francisco J.: *Las Meninas y sus personajes.* Editorial
Juventud, Barcelona.
Mestre Fiol, Bartolomé: *Los tres personajes invisibles de las Meninas.*

"Mayurga", No. 8, 1972.
By courtesy of the Prado Museum.

156. THE INFANTA MARGARITA (1651-1673)
1656.
Fig. 228.
1.05 x 0.88 m.
Vienna: Kunsthistorisches Museum.
M 531 LR 402.
By courtesy of the Kunsthistorisches Museum.

157. THE INFANTA MARGARITA (1651-1673)
(Unfinished.)
Sent to the Emperor Leopold in 1659.
Figs. 229 & 230.
1.27 x 1.07 m.
Vienna: Kunsthistorisches Museum.
M 534 LR 406.
By courtesy of the Kunsthistorisches Museum.

158. THE INFANTE PHILIP PROSPER (1657-1661)
Sent to the Emperor Leopold in 1659.
Figs. 231-233.
1.29 x 0.99 m.
Gratz: Imperial Castle.
Vienna: Imperial Palace. Kunsthistorisches Museum.
C 147 M 304 LR 334.
By courtesy of the Kunsthistorisches Museum.

159. MERCURY AND ARGOS
This canvas has been made higher.
C. 1659.
Figs. 234 & 235.
0.835 x 2.48 m.
Madrid: Alcázar. Royal Palace. Prado Museum.
C 33 M 55 LR 62.
By courtesy of the Prado Museum.

160. WOMAN SEWING
Probably Juana Pacheco.
C. 1650.
Fig. 236.
0.74 x 0.60 m.
Paris: Christiane de Poles.
Washington, D. C.: National Gallery of Art.
M 558 LR 605.
Mayer, August L.: *A portrait by Velázquez.* Paris, Les Beaux-Arts,
Edition for Wildenstein and Co., New York. Pamphlet.
Sánchez Cantón, F. J.: "The Burlington Magazine", Vol. 87, 1945.
*By courtesy of the National Gallery of Art, Washington, D. C., Andrew
Mellon Collection.*

161. MARIANA OF AUSTRIA (1634-1696)
(Unfinished.)

C. 1656.
0.465 x 0.43 m.
Paris: Wildenstein. Baron Maurice de Rothschild.
M 493 LR 364.

162. MARIANA OF AUSTRIA (1634-1696)
C. 1656.
Fig. 237.
0.647 x 0.546 m.
Paris: E. G. sale (1876).
London: W. de Zoete sale (1935).
Lugano-Castagnola: Château de Rohoncz Foundation (Baron Henry Thyssen-Bornemisza).
C 243d M 501 LR 365.
By courtesy of Baron Henry Thyssen-Bornemisza.

163. PHILIP IV (1605-1665)
Reproduced in an engraving by Pedro de Villafranca, 1657.
C. 1657.
Fig. 238.
0.641 x 0.537 m.
Florence: Prince Anatole Demidoff (1862).

Paris: Emmanuel Sano.
London: National Gallery.
C 123 M 247 LR 273.
Reproduced by courtesy of the Trustees, the National Gallery, London.

164. HEAD OF A YOUNG WOMAN
Charcoal on white paper.
Early work.
Fig. 239.
15 x 11.7 cm.
Madrid: José Madrazo (1859). National Library.
M 603 LR 649 Barcia Cat. 493.
By courtesy of the National Library.

165. BUST OF A YOUNG WOMAN
Charcoal on white paper.
Early work.
Fig. 240.
20 x 13.5 cm.
Madrid: Valentín Carderera. National Library (1867).
M 604 LR 650 Barcia Cat. 492.
By courtesy of the National Library.

INDEX

INDEX OF WORKS AND NAMES

GEOGRAPHICAL INDEX

Valencia
Provincial Museum. Cat. 143

SWITZERLAND

Krentzligen
Heins Kister Collection. Cat. 142

Lugano-Castagnola
Château de Rohoncz Foundation (Baron Henry Thyssen-Bornemisza).
Cat. 162

U.S.A.

Boston
Isabella Stewart Gardner Museum.
Cat. 40
Museum of Fine Arts. Cat. 32, 37,
66, 151

Chicago
Art Institute. Cat. 4, 14, 25

Cleveland
Museum of Art. Cat. 95

Dallas
The Meadows Museum. Cat. 36

Detroit
The Detroit Institute of Arts. Cat. 48

Los Angeles
Boso N. Maric Collection. Cat. 10

New York
Frick Collection. Cat. 121
Hispanic Society of America. Cat. 41,
120, 138
Metropolitan Museum. Cat. 29, 35,
74, 135, 144, 145
Private collection. Cat. 60, 87, 134,
139, 141

Sarasota
John and Mabel Ringling Museum of
Art. Cat. 45

Toledo (Ohio)
Toledo Museum of Art. Cat. 52

Washington, D. C.
National Gallery. Cat. 89, 137, 160

PUERTO RICO

Museo de Ponce. Cat. 113

U.S.S.R.

Leningrad
Hermitage. Cat. 6, 7, 116

AT DEALER'S: Cat. 131

PRESENT WHEREABOUTS
UNKNOWN: Cat. 124

BIBLIOGRAPHY

Ainaud de Lasarte, Juan: *Ribalta y Caravaggio.* "Anales y Boletín de los Museos de Arte de Barcelona", 1947, page 345.

Alpers, Suetlana: *The Decoration of the Torre de la Parada.* Arcade Press. Brussels, MCMLXXI.

Angulo Iñíguez, Diego: *Fábulas mitológicas de Velázquez.* "Goya", 37-38, July-October 1960.

Velázquez, cómo compuso sus principales cuadros. "Laboratorio de Arte de la Universidad de Sevilla", 1947.

La fábula de Vulcano, Venus y Marte y 'La Fragua' de Velázquez. "Archivo Español de Arte", 1960, page 149.

Velázquez y la Mitología. "Publicaciones del Instituto de España", 3rd Centenary of Velázquez's death, Madrid, 1961.

Azcárate, José María de: *Noticias sobre Velázquez en la Corte.* "Archivo Español de Arte", 1960, page 357.

Beruete, Aureliano de: *Velázquez.* Henri Laurens, Paris, 1898. *Velázquez.* Methuen and Co., London, 1906.

Bonet Correa, Antonio: *Velázquez, arquitecto y decorador.* "Archivo Español de Arte", 1960, page 215.

Velázquez y los jardines. "Goya", 37-38, July-October 1960.

Borenius, Arón: *Études sur Velázquez.* Linkoping, Norstedt Sönners Förlag, 1949.

Calvert, Albert Frederick: *Velázquez.* London, New York, 1908.

Camón Aznar, José: *Retratos de Infantas.* "Goya", 37-38, July-October 1960.

El impresionismo en Velázquez. "Goya", 37-38, July-October 1960.

La envidia y Velázquez. Instituto de Cultura Hispánica, Madrid, 1961.

Velázquez. Espasa-Calpe, 1964.

El retrato en Velázquez. "Publicaciones del Instituto de España", 3rd Centenary of Velázquez's death, Madrid, 1961.

Carducci, Vincenzio: *Diálogos de la pintura.* Madrid, 1633.

Caturla, María Luisa: *Cartas de pago de los doce cuadros de batallas para el Salón de Reinos del Buen Retiro.* "Archivo Español de Arte", 1960, page 333.

Ceán Bermúdez, Juan Agustín: *Diálogo entre el Cardenal D. Gaspar de Borja y Velasco... y D. Juan Carreño de Miranda.* "El Censor", September 23rd, 1820, v. 2, pages 97-117.

Chueca Goitia, Fernando: *Espacio, tiempo y existencia en Velázquez.*

El Alcázar interior de Velázquez. "Goya", 37-38, July-October 1960.

Cirici-Pellicer, Alexandre: *Quirología de Velázquez.* "Instituto de Cultura Hispánica", Madrid, 1961.

Cruzada Villamil, Gregorio: *Anales de la vida y de las obras de Diego de Silva Velázquez.* Madrid, 1885.

Informaciones de las cualidades de Diego de Silva Velázquez para el hábito de la Orden de Santiago. "Revista Europea", II, 1874, No. 20, July 12th, pages 39-43; No. 21, July 19th, pages 80-84; No. 22, July 26th, pages 105-110; No. 27, August 30th, pages 275-278; No. 31, September 27th, pages 402-406.

Curtis, Charles Berwick: *Velázquez and Murillo.* New York, London, 1883.

Davillier, Baron Jean Charles: *Mémoir de Velázquez sur quarante et un tableaux envoyés par Philippe IV à l'Escurial.* Paris, 1874.

Ford, Richard: *The life of Diego Rodríguez de Silva y Velázquez.* "Penny Cyclopaedia", London, 1874.

Gállego, Julián: *Velázquez, pintor de retratos.* "Goya", 37-38, July-October 1960.

Gaya, Ramón: *Velázquez, pájaro solitario.* Barcelona, 1969.

Gaya Nuño, Juan Antonio: *Después de Justi. Medio siglo de estudios velazquistas.* In the Spanish edition of Justi's *Diego Velázquez und sein Jahrhundert.* Espasa-Calpe, Madrid, 1953.

Bibliografía, crítica y antología de Velázquez. Fundación Lázaro Galdiano, Madrid, 1965.

Velázquez. Ediciones Destino, Barcelona, 1970.

Picaresca y tremendismo en Velázquez. "Goya", 37-38, July-October 1960.

Harris, Enriqueta: *La misión de Velázquez en Italia.* "Archivo Español de Arte", 1960, page 109.

Hernández Perera, Jesús: *Velázquez y las joyas.* "Archivo Español de Arte", 1960, page 251.

Justi, Carl: *Diego Velázquez und sein Jahrhundert.* First edition: Cohen Sohn, Bonn, 1888.

Diego Velázquez and his time. H. Crevel & Co., London, 1889.

Velázquez y su siglo. Espasa-Calpe, Madrid, 1953.

Kehrer, Hugo Ludwig: *Velázquez.* Munich, 1919.

Lafuente Ferrari, Enrique: *Velázquez.* Phaidon Press, London, New York, 1945.

Velázquez. Ediciones Selectas, Barcelona, 1944.

Velasquez. Editions d'Art Albert Skira, Geneva, 1960. (In the collection entitled "Le goût de notre temps".)

Mundo y estilo en Velázquez. "Publicaciones del Instituto de España", 3rd Centenary of Velázquez's death, Madrid, 1961.

Velázquez y los retratos del Conde-Duque de Olivares. "Goya", 37-38, July-October 1960.

Velasquez. Infantes and Infantas. Methuen and Co., London.

Lefort, Paul: *Velázquez.* Paris, 1888.

López Navío, José: *Velázquez tasa los cuadros de su protector D. Juan de Fonseca.* "Archivo Español de Arte", 1961, page 53.

Matrimonio de Juan B. del Mazo con la hija de Velázquez. "Archivo Español de Arte", 1960, page 387.

López-Rey, José: *Nombres y nombradía de Velázquez.* "Goya", 37-38, July-October 1960.

Velázquez, a catalogue raisonné of his oeuvre. Faber & Faber, London, 1963.

Lorente Junquera, Manuel: *La "Vista de Zaragoza" por Velázquez y Nazo.* "Archivo Español de Arte", 1960, page 183.

Lozoya, Marqués de: *Velázquez, paisajista.* "Goya", 37-38, July-October 1960.

Maravall, José Antonio: *Velázquez y el espíritu de la modernidad.* Ediciones Guadarrama, Madrid, 1960.

Marlier, Georges: *Rubens en la Corte de Felipe IV al lado de Velázquez.* Instituto de Cultura Hispánica, Madrid, 1961.

Martín González, J.J.: *Velázquez, pintor religioso.* "Goya", 37-38, July-October 1960.

Sobre las relaciones entre Nardi, Carducho y Velázquez. "Archivo Español de Arte", 1958, page 59.

Martínez, Jusepe: *Discursos practicables del nobilísimo Arte de la Pintura.* Madrid, 1866.

Mayer, August L.: *Velázquez: a catalogue raisonné of the pictures and drawings.* London, 1936.

Melida, José Ramón: *Memoria de las pinturas que... Philipe IV embia al Monasterio de San Laurencio el Real del Escorial... Descriptas y colocadas por Diego de Sylva Velázquez... La ofrece... Don Iván de Alfaro.* "Real Academia Española", Madrid. *Memorias.* 1871, 2nd year, vol. 3, pages 500-520.

Mestas, Alberto: *Descendencia regia de un pintor de reyes.* "Hidalguía", 1960, page 661.

Moreno Villa, José: *Locos, enanos, negros y niños palaciegos.* Mexico, 1939.

Orozco Díaz, Emilio: *El barroquismo de Velázquez.* Ediciones Rialp, S.A., Madrid, 1965.

Ortega y Gasset, José: *Velázquez.* "Revista de Occidente", Madrid.

Papeles sobre Velázquez y Goya. "Revista de Occidente", Madrid, 1950.

Pacheco, Francisco: *Arte de la Pintura, su antigüedad y grandezas.* Seville, 1649. Other editions by Cruzada Villamil (Madrid, 1866) and by F.J. Sánchez Cantón (Madrid, 1946).

Palomino de Castro y Velasco, Acisclo Antonio: *El museo pictórico y escala óptica.* Madrid, 1715-24, 5 vols. Published by M. Aguilar, Madrid, 1947.

Pantorba, Bernardino de: *La vida y la obra de Velázquez.* Madrid, 1955.

Pita Andrade, José Manuel: *Dos recuerdos del segundo viaje a Italia.* "Archivo Español de Arte", 1960, page 287.

Salas, Xavier de: *Velázquez.* Ediciones Noguer, 1962.

Salazar, Concepción: *El testamento de Pacheco.* "Archivo Español de Arte y Arqueología", 1928, page 155.

Sánchez Cantón, Francisco Javier: *Cómo vivía Velázquez; inventario descubierto por D. F. Rodríguez Marín.* "Archivo Español de Arte", No. 50, March-April 1942, pages 69-91 and supplement.

Fuentes literarias para la Historia del Arte Español. Madrid, 1933-1934, vols. 2-3.

La librería de Velázquez. Homenaje a Don Ramón Menéndez Pidal, vol. III. Madrid, 1925.

Stirling-Maxwell, Sir William, Bart.: *Velázquez and his works.* London, 1855.
Annals of the artists of Spain. John Ollivier, London, 1848.

Tolnay, Charles de: *Las pinturas mitológicas de Velázquez.* "Archivo Español de Arte", No. 133, 1961, page 31.

Tormo, Elías: *Velázquez, el Salón de Reinos del Buen Retiro, y el poeta del palacio y del pintor.* "Boletín de la Sociedad Española de Excursiones", XIX, 1911, pages 24-44, 85-111, 191-217, 274-305; XX, 1912, pages 60-63. With 15 plates.

Trapier. Elizabeth du Gué: *Velázquez.* The Hispanic Society of America, New York, 1948.

Velázquez: New data on a group of portraits. In "Notes Hispanic", The Hispanic Society of America, New York, 1944, vol. 4, pages 37-63.

Válgoma y Díaz-Varela, D. de la: *Una injusticia con Velázquez: sus probanzas de ingreso en la Orden de Santiago.* "Archivo Español de Arte", 1960, page 191.

Varela Hervias, Eulogio: *La Academia de San Fernando y la sepultura de Diego Velázquez.* "Archivo Español de Arte y Arqueología", May-August 1935, page 217.

Varia velazqueña. Homenaje a Velázquez en el III Centenario de su muerte.

Vol. I. Studies on Velázquez and his work, with texts by: Azorín, Vázquez Díaz, Gómez de la Serna, Hugo Kehrer, Roque Pidal, Mario de Oliveira, José A. Maravall, Reynaldo dos Santos, J. López Ibor, Rof Carballo, José María Pemán, Paulino Garagorri, Pedro Rocamora, Condesa de Campo Alange, José Camón Aznar, A. Cirici-Pellicer, Fernando Chueca, Pedro Laín, Juan Eduardo Cirlot, John Walker, Angel Valbuena Prat, Emilio Orozco, José López-Rey, Kurt Gerstenberg, Ann Laprair Livermore, Halldor Soehner, Arón-Borelius, Juan J. Martín González, Manuel Lorente, Luis Díez del Corral, Luisa Becherucci, Estella Brunetti, Condesa de Yebes, Juan Ainaud de Lasarte, Jacqueline Prévost-Auzas, Elizabeth du Gué Trapier, Marqués de Lozoya, Roberto Longhi, Herman Vos, Charles de Tolnay, José María Azcárate, Concepción G. de Marco, Ernest H. Buschbeck, Magnus Grönvold, Paul Eeckhout, Arturo Perera, Bernardino de Pantorba, José M. Pita Andrade, José Gudiol, José López de Toro, Juan Temboury Alvarez, Manuel Casares Hervás, Harold E. Wethey, Martín S. Soria, María Luisa Caturla, Juan A. Gaya Nuño, Jesús Hernández Perera, Matilde López Serrano, Rafael Benet, Felipe M. Garín, Bernard Dorival, Jeannine Baticle, Yves Bottineau, Paul Guimard, Enrique Pardo Canalís, Enrique Lafuente Ferrari, Miguel Herrero García, Guillermo Díaz-Playa, William L. Fitcher, F. J. Sánchez Cantón, Francisco Iñiguez Almech, D. de la Válgoma y Díaz-Varela, Manuel Gómez Moreno, Esteban García Chico, César Pemán and Antonio Bonet Correa.

Vol. II. Poetic eulogies. Critical texts and commentaries. Documents. Chronology.

Dirección General de Bellas Artes, Ministerio de Educación Nacional, Madrid, 1960.

Velázquez y lo velazqueño. Ministerio de Educación Nacional, Madrid, 1960. Catalogue of the Exhibition in homage to Diego de Silva Velázquez on the Third Centenary of his death.

Velázquez. Homage on the Third Centenary of his death. Instituto Diego Velázquez, Madrid, 1960. Prologue by Diego Angulo Iñíguez.

Viñosa, Cipriano Muñoz y Manzano, Conde de la: *Adiciones al Diccionario Histórico de los más ilustres profesores de las Bellas Artes en España de D. Juan Agustín Ceán Bermúdez.* Madrid, 1894, vol. 3, page 109; vol. 4, pages 20-32.

Zarco del Valle, Manuel Ramón: *Documentos inéditos para la Historia de las Bellas Artes en España.* Madrid, 1870, vol. 55, pages 201-640.

El itinerario de Velázquez en su segundo viaje a Italia. "Goya", 37-38, July-October 1960.

Cien fichas sobre Velázquez. "El Libro Español", June 1960.

Los cuadros de Velázquez y Mazo que poseyó el séptimo Marqués del Carpio. "Archivo Español de Arte", 1952, page 225.